CONCEPTS OF VALUE IN EUROPEAN MATERIAL CULTURE, 1500–1900

Concepts of Value in European Material Culture, 1500–1900

Edited by
BERT DE MUNCK AND DRIES LYNA

ASHGATE

© The editors and contributors 2015

All rights reserved. No part of this publication may be reproduced, stored in a retrieval system or transmitted in any form or by any means, electronic, mechanical, photocopying, recording or otherwise without the prior permission of the publisher.

Bert De Munck and Dries Lyna have asserted their right under the Copyright, Designs and Patents Act, 1988, to be identified as the editors of this work.

Published by
Ashgate Publishing Limited
Wey Court East
Union Road
Farnham
Surrey, GU9 7PT
England

Ashgate Publishing Company
110 Cherry Street
Suite 3-1
Burlington, VT 05401-3818
USA

www.ashgate.com

British Library Cataloguing in Publication Data
A catalogue record for this book is available from the British Library

The Library of Congress has cataloged the printed edition as follows:
Concepts of value in European material culture, 1500-1900 / edited by Bert De Munck and Dries Lyna.
 pages cm. -- (The history of retailing and consumption)
 Includes bibliographical references and index.
 ISBN 978-1-4724-5196-5 (hardcover: alkaline paper) -- ISBN 978-1-4724-5197-2 (e-book) -- ISBN 978-1-4724-5198-9 (epub)
 1. Consumption (Economics)--Europe--History. 2. Material culture--Europe--History. 3. Capital market--Europe--History. 4. Fair value--Europe. 5. Valuation--Europe. I. Munck, Bert De, 1967- author editor of compilation. II. Lyna, Dries, author editor of compilation.

HC240.9.C6C657 2015
339.4'70940903--dc23

2015004398

ISBN: 9781472451965 (hbk)
ISBN: 9781472451972 (ebk – PDF)
ISBN: 9781472451989 (ebk – ePUB)

Printed in the United Kingdom by Henry Ling Limited,
at the Dorset Press, Dorchester, DT1 1HD

Contents

General Editor's Preface *vii*
List of Illustrations *ix*
Notes on Contributors *xi*

1. Locating and Dislocating Value: A Pragmatic Approach to Early Modern and Nineteenth-Century Economic Practices 1
Bert De Munck and Dries Lyna

Part I Expanding Markets and Market Devices 31

2. Labelling with Numbers? Weavers, Merchants and the Valuation of Linen in Seventeenth-Century Münster 33
Christof Jeggle

3. Words of Value? Art Auctions and Semiotic Socialization in the Austrian Netherlands (1750–1794) 57
Dries Lyna

4. From a 'Knowledgeable' Salesman towards a 'Recognizable' Product? Questioning Branding Strategies before Industrialization (Antwerp, Seventeenth to Nineteenth Centuries) 75
Ilja Van Damme

5. Golden Touchstones? The Culture of Auctions of Paintings in Brussels, 1830–1900 103
Anneleen Arnout

Part II Conventions, Material Culture and Institutions 131

6. The Justness of *Aestimatio* and the Justice of Transactions: Defining Real Estate Values in Early Modern Milan 133
Michela Barbot

7. Vehicles of Disinterested Pleasure: French Painting and Non-Remunerative Value in the Eighteenth Century 151
Tomas Macsotay

vi *Concepts of Value in European Material Culture, 1500–1900*

 8 Usefulness, Ornamental Function and Novelty: Debates on Quality in Button and Buckle Manufacturing in Northern Italy (Eighteenth to Nineteenth Centuries) 171
 Barbara Bettoni

Part III The Old and the New **207**

 9 *Façon de Venise*: Determining the Value of Glass in Early Modern Europe 209
 Corine Maitte

10 The Veneer of Age: Valuing the Patina of Silver in Eighteenth-Century Britain 239
 Helen Clifford

11 The Value of a Collection: Collecting Practices in Early Modern Europe 255
 Adriana Turpin

Index *285*

The History of Retailing and Consumption
General Editor's Preface

It is increasingly recognized that retail systems and changes in the patterns of consumption play crucial roles in the development and societal structure of economies. Such recognition has led to renewed interest in the changing nature of retail distribution and the rise of consumer society from a wide range of academic disciplines. The aim of this multidisciplinary series is to provide a forum of publications that explore the history of retailing and consumption.

Gareth Shaw, University of Exeter, UK

List of Illustrations

3.1	Extract from a reprint of De Piles' *Balance des Peintres* (Amsterdam, 1766).	67
3.2	Title page of the *Nieuwen Almanach der Konst-Schilders, Vernissers, Vergulders en Marmelaers* (Ghent, 1777).	71
4.1	Sebastiaan Vrancx, *A View of Antwerp Harbour with the Kraanenhoofd and the Werf Gate* (1608).	90
4.2	Porcelain card for the Antwerp shop 'Manufactures anglaises et écossaises', Joseph Ratinckx, c. 1855.	93
5.1	Preserved catalogues of painting auctions in Brussels, 1831–1900.	107
5.2	Auctions of paintings per type of location in Brussels, 1831–1900.	109
5.3	Auction rooms, art and antiquity trade in Brussels, 1830s.	110
5.4	Auction rooms, art and antiquity trade in Brussels, 1850s.	111
5.5	Auction rooms, art and antiquity trade in Brussels, 1880s.	112
5.6	Auction rooms, art and antiquity trade in Brussels, 1914.	113
5.7	Brussels auctions of paintings with collections mentioned in catalogues, 1831–1900.	117
6.1	Giuseppe Antonio Alberti, *Istruzioni pratiche per l'Ingegnere civile. Sezione Prima, Tavola I, Tavoletta pretoriana e accessori* (1798).	148
8.1	Buttons covered with fabric and spun materials.	194
8.2	Metal button-makers in their workshop.	195
9.1	Bertrand Clavez, sketch of a furnace in Altare, based on a painting by San Rocco.	215
9.2	Bernard Perrot's workshop, group of objects with red glass decorations. Orléans, France, seventeenth century.	235
10.1	Detail of the reverse of a silver dinner plate, London, c. 1750.	241
10.2	Detail of the obverse of a silver dinner plate, London, c. 1750.	252

11.1	Frontispiece of Ferrante Imperato, *Dell' historia naturale* (Naples, 1599).	267
11.2	Frontispiece of Pierre Remy and Jean-Baptiste Glomy, *Catalogue of the Sale of the Duc de Tallard* (Paris, 1756).	273
11.3	Abraham Bosse, *L'Atelier du peintre* (c. 1642), etching published by Jacques Leblond.	275

Notes on Contributors

Anneleen Arnout holds a PhD fellowship at the Research Foundation – Flanders (FWO). She is affiliated with the University of Leuven and the University of Antwerp, where she defended her dissertation on shopping cultures in the cityscape of nineteenth-century Brussels in May 2015.

Michela Barbot holds a European Chair of Excellence at the French CNRS Unit IDHE, Ecole Normale Supérieure de Cachan (France). She works on the history of value, housing prices and property rights in Europe. Her latest publication in this field is *Property Rights and their Violations: Expropriations and Confiscations, 16th–20th Centuries*, ed. with Luigi Lorenzetti and Luca Mocarelli (Bern, 2012).

Barbara Bettoni is Assistant Professor of Economic History at the University of Brescia (Italy). Her research interests focus on material culture and consumer models in early modern Italy. She is the author of *I beni dell'agiatezza. Stili di vita nelle famiglie bresciane dell'età moderna* (Milan, 2005). Her more recent studies centre on fashion and innovation, particularly in Italian button manufacturing, from the Renaissance to the twentieth century.

Helen Clifford completed her doctorate at the Royal College of Art (in conjunction with the Victoria and Albert Museum, London). Her dissertation concerned a partnership of eighteenth-century London goldsmiths; it was published in 2004, by Yale University Press, as *Silver in London*. She combines academic work with operating Swaledale Museum, North Yorkshire and freelance curating, research and writing. She has been a Research Fellow at Warwick University since the 1990s, working with Professor Maxine Berg on various projects connected with early modern consumption and luxury. She is currently museum consultant to *Trading Eurasia: Europe's Asian Centuries 1600–1850* at Warwick and *The East India Company at Home 1757–1857* at University College London.

Bert De Munck is Professor in the Department of History at the University of Antwerp (Belgium). His teaching includes courses in social and economic history of the early modern period, history and social theory and public history. He is the Director of the Centre for Urban History at the same university and of the Scientific Research Community (WOG) *Urban Agency: Setting*

the Research Agenda of Urban History. He has worked on apprenticeship, craft guilds, labour and civil society. His current research interests include vocational training and the circulation of technical knowledge, guilds and civil society, and the 'repertoires of evaluation' regarding skills and products.

Christof Jeggle is a Postdoctoral Research Associate at the University of Bamberg (Germany) and of the ANR research project *Les privilèges économiques en Europe, XVe–XIXe siècles: étude quantitative et comparative*, Université Paris 1, Panthéon–Sorbonne/ENS Lyon (France). His research interests include pre-industrial economies, production, distribution, commerce, consumers, markets, and economic sociology as an approach for research.

Dries Lyna is an Assistant Professor of History at the Radboud University Nijmegen (the Netherlands), where he has lectured on various topics in the social, economic and cultural history of the early modern and modern periods. His areas of interest include urban history, the historical art market and academies of fine arts. He has received fellowships and awards from the Fulbright Commission, the Getty Research Institute, the International Economic History Association and the Belgian American Educational Foundation.

Tomas Macsotay is a Marie Curie/Gerda Henkel Stiftung Postdoctoral Fellow, currently affiliated with the *Departament d'Art i de Musicologia* of the Universitat Autònoma de Barcelona (Spain). He has published on Diderot's art criticism of the French Academy in Paris and Rome and eighteenth-century sculpture, and is currently completing his first book, *The Order of Work*, on the French Academy's relationship to sculptors in the eighteenth century. A recipient of grants from the Henry Moore Foundation, the Fondation Marianne & Roland Michel and Marie Curie/Gerda Henkel Stiftung, he is presently investigating the academic reform of religious sculpture in Valencia, Spain (c. 1715–1808).

Corine Maitte is a Full Professor of Modern History at the University of Paris-Est Marne-la-Vallée (France). Her research focuses on the social and economic history of Italy, crafts and guilds, the history of migrations, wool and glass production. Her latest publication is *Les chemins de Verre. Migrations des artisans d'Altare et de Venise (XVI–XIXe siècle)* (Rennes, 2009).

Adriana Turpin is Academic Director of the Institut d'Etudes Supérieures des Arts Paris (IESA), where she oversees the MA programme in the History and Business of Art and Collecting. Previously, she was Deputy Director at

Sotheby's Institute, where she specialized in the history of decorative arts. She has written numerous articles on the history of collecting practices, curiosities from the New World and English furniture.

Ilja Van Damme is Associate Professor in the Department of History at the University of Antwerp, where he teaches courses in urban history and other areas. He is affiliated with the Centre for Urban History at the same university and the Fund for Scientific Research – Flanders (Belgium). He has worked on the history of urban consumption, retailing, fashion and advertising from the sixteenth to the nineteenth centuries. He is currently spearheading a research project on cities as agents of creativity and economic innovation.

Chapter 1
Locating and Dislocating Value: A Pragmatic Approach to Early Modern and Nineteenth-Century Economic Practices*

Bert De Munck and Dries Lyna

Introduction: Value between Economy and Culture

How people attribute value to objects and actions is crucial for understanding not just economic practices but virtually all human behaviour. Hence, anthropologists, via the concept of value, explore the most fundamental attitudes towards artefacts and objects in a given society – such as when assessing the degree to which the circulation of objects should be framed within either a gift or an exchange economy.[1] Historians have an even more complicated relationship with value. It is now generally agreed that value has an economic and a cultural dimension in which the two elements are never entirely distinct; however, the classical political philosophers and historical sociologists, from Smith to Marx to Weber, each variously described a changing relationship between culture and economy in European history – a development in which culture was gradually becoming subordinate to market forces. Especially notable in this respect was Karl Polanyi, who regarded the emergence of capitalism as a process in which social relations eroded and the (European) economy became 'disembedded'.[2]

Yet ever since Polanyi's seminal work was published in 1944, historians and anthropologists have noted the persistent entanglement of markets on the one hand and culture and social institutions on the other. For example, historians studying gift exchange have drawn attention to the monetary and instrumental dimensions of gifts. In medieval towns gifts could be expressed in monetary

* This introduction has profited substantially from the comments, suggestions and reflections of Bruno Blondé, Florike Egmond and Ilja Van Damme.

[1] Stimulating introductions to anthropological theories and research on value include David Graeber, *Toward an Anthropological Theory of Value: The False Coin of Our Own Dreams* (New York, 2001), and Arjan Appadurai (ed.), *The Social Life of Things: Commodities in Cultural Perspective* (Cambridge, 1986), pp. 3–63.

[2] Karl Polanyi, *The Great Transformation* (Boston, 1944).

terms, and such terms continue to serve a gift function in our own culture.[3] Something similar applies to non-Western societies, where money could alter social relations and systems of meaning even as it was appropriated into systems of gift exchange.[4] Moreover, Polanyi's view is difficult to reconcile with the proliferation of institutions which, as in the nineteenth and twentieth centuries, support and shape economic practices rather literally.[5] From the perspective of culture and systems of meaning, one could argue that, in advanced capitalism, markets are over-determined, that is, shaped by institutions and culture alike.[6] Even for neo-classical economists, for whom value is reduced to utility or consumer preferences, culture has the final say – for the notorious 'black box' of preference or taste is largely a cultural category (otherwise, all consumer preferences would be reducible to biological needs).[7] Hence, the challenge is still to understand how the relationship of social contexts, institutions and culture, on the one hand, and economic practices, on the other, transformed in the run-up to the modern industrial and consumer society.

The aim of this book is to link economic practices to broader historical transformations from the late Middle Ages through the nineteenth century. A central problem for current research is academic specialization and the wide variety of sub-fields in which the relationship of economy and culture is addressed. While for classical economists the origin of value is ultimately found

[3] Martha C. Howell, *Commerce before Capitalism in Europe, 1300–1600* (Cambridge, 2010), chapter 3; Irma Thoen, *Strategic Affection? Gift Exchange in Seventeenth-Century Holland* (Amsterdam, 2007), pp. 9–23. See also Gadi Algazi, Valentin Groebner and Bernhard Jussen (eds), *Negotiating the Gift: Pre-Modern Figurations of Exchange* (Göttingen, 2003).

[4] Webb Keane, 'Money is No Object: Materiality, Desire, and Modernity in an Indonesian Society', in Fred Myers (ed.), *The Empire of Things: Regimes of Value and Material Culture* (Oxford, 2001), pp. 65–90.

[5] Pioneering works include Ronald Coase, 'The Nature of the Firm', *Economica*, 4/16 (1937): pp. 386–495; George A. Akerlof, 'The Market for Lemons: Qualitative Uncertainty and the Market Mechanism', *Quarterly Journal of Economics*, 84 (1970): pp. 488–500; Oliver Williamson, *The Economic Institutions of Capitalism: Firms, Markets, Relational Contracting* (New York, 1985); Joseph Stiglitz, 'The Causes and Consequences of the Dependence of Quality on Price', *Journal of Economic Literature*, 25 (1987): pp. 1–48. There is a synthesis in Oliver E. Williamson, 'The New Institutional Economics: Taking Stock, Looking Ahead', *Journal of Economic Literature*, 38 (2000): pp. 595–613.

[6] With this term, we deliberately refer to the work of Louis Althusser, who bridged Marxism and post-structuralism.

[7] Some founding literature on the history of consumer preferences: Neil McKendrick, John Brewer and John Harold Plumb (eds), *The Birth of a Consumer Society: The Commercialization of Eighteenth-Century England* (London, 1982); John Brewer and Roy Porter (eds), *Consumption and the World of Goods* (London, 1993); Ann Bermingham and John Brewer (eds), *The Consumption of Culture, 1600–1800: Image, Object, Text* (London, 1995).

in (utilitarian) consumer preferences and determined via price mechanisms, anthropologists have pointed to social institutions and cultural systems of meaning as the ultimate source of (the perception of) value. Marxist scholars have situated value in the labour of producers, although in a market economy such value is again subsumed in market exchange.[8] While the sheer range of approaches affords certain advantages, a dearth of cross-fertilization inhibits adequate understanding. For example, both labour historians and historians studying material culture confront the questions of classical historical sociology; however, because of their separate approaches, they fail to fully account for one of the main issues, namely, the role of labour and skills in the value of products.[9] Likewise, because changing conceptions of visuality are examined apart from economic history and almost exclusively by art and science historians, our resultant understanding of the value of material culture, especially as it is displayed in houses, on the street and in shops, is likely to be inadequate.[10] In order to surmount this problem, we have decided to tackle the issue of 'value' from a broad multi-dimensional perspective, in an attempt to, in a way, encircle it. As such, we will confront the issue of value head-on, at the point where it is still largely implicit in other historical research or, as in most current examinations, just beyond the historian's focus.

Locating Value in Historical Literature: On Institutions and Material Culture

Economic historians now stress the interconnection of *institutions* (including families, clans, and social and religious networks and organisations of all sorts) and economic practice.[11] Whereas an earlier, Marxist perspective regarded institutions (from the family to the state) as parts of a hegemonic system intended to naturalize class differences and consolidate owners' exploitation of

[8] Some introductions to economic anthropology are Stuart Plattner, *Economic Anthropology* (Stanford, 1989); Richard Wilk, *Economies and Cultures: Foundations of Economic Anthropology* (Boulder, 1996); James G. Carrier (ed.), *A Handbook of Economic Anthropology* (Cheltenham, 2005).

[9] One exception is Richard Biernacki, *The Fabrication of Labor: Germany and Britain, 1640–1941* (Berkeley, 1995).

[10] Bob Scribner, 'Ways of Seeing in the Age of Dürer', in Dagmar Eichberger and Charles Zika (eds), *Dürer and his Culture* (Cambridge, 1998), pp. 93–117; Peter de Bolla, *The Education of the Eye: Painting, Landscape, and Architecture in Eighteenth-Century Britain* (Stanford, 2003).

[11] For a recent overview of historical studies which incorporate a neo-institutional view, see Sheilagh Ogilvie, '"Whatever is, is Right?" Economic Institutions in Pre-Industrial Europe', *Economic History Review*, 60/4 (2007): pp. 649–684.

capital, virtually all institutions (including guilds and even feudalism) are now recognized as embedding economic transactions.[12] Institutions, by binding the contracting partners socially and culturally or by functioning as a type of third party, serve to ensure that contracts will be honoured and hence stimulate actors to engage in transactions in the first place. Moreover, institutions are said to have the capacity to resolve information asymmetries. As one party (usually the buyer, but sometimes also the seller, particularly in cases of assurances and the like) is likely to hold less information about product quality than does the other, the former will either refrain from buying or be willing to pay only a relatively low price. In this context, instruments such as hallmarks and certificates – and their related rules and regulations – help to provide information about quality, and therefore generate trust.[13]

This perspective has obviously opened a range of relevant research questions. For example, historians and archaeologists have examined how marks, brands and other signs affixed to products resolved problems of information asymmetry. As such investigations have shown, these processes are especially related to the socio-cultural context of production and distribution, and to the meanings attached to human and social qualities.[14] Yet this has hardly resulted in a more effective understanding of value. Indeed, the idea of 'providing information on product quality' is based on the assumption that product quality is an inherent or objective quality of a product. It presupposes that product quality is 'out there', ontologically independent and external to the instruments rendering the information in question.

The issue of value has been more straightforwardly addressed by historians investigating *material culture and consumer preferences*. Such research has tended to lean somewhat uncritically on one-dimensional sociological concepts like

[12] See especially Douglas C. North, *Structure and Change in Economic History* (New York, 1981); idem, *Institutions, Institutional Change and Economic Performance* (Cambridge, 1990). For recent perspectives, see Avner Greif, *Institutions and the Path to the Modern Economy: Lessons from Medieval Trade* (Cambridge, 2006).

[13] Akerlof, 'The Market for Lemons'. On the role of late medieval and early modern guilds from this perspective, see Bo Gustafsson, 'The Rise and Economic Behaviour of Medieval Craft Guilds', *Scandinavian Economic History Review*, 35 (1987): pp. 1–40. A recent volume in which guilds are approached from a neo-institutional perspective is Larry Epstein and Maarten Prak (eds), *Guilds, Innovation and the European Economy, 1400–1800* (Cambridge, 2008).

[14] Gary Hamilton and Chi-Kong Lai, 'Consumerism without Capitalism: Consumption and Brand Names in Late Imperial China', in Henry J. Rutz and Benjamin S. Orlove (eds), *The Social Economy of Consumption* (Boston, 1989), pp. 253–280; David Wengrow, 'Prehistories of Commodity Branding', *Current Anthropology*, 49/1 (2008): pp. 7–25; Karl Moore and Susan Reid, 'The Birth of Brand: 4000 Years of Branding', *Business History*, 50/4 (2008): pp. 419–432.

'emulation', 'conspicuous consumption' (Thorstein Veblen) and 'distinction' (Pierre Bourdieu).[15] These concepts have the merit of having helped generate a wealth of information about the material culture of historical groups, yet the underlying (if often implicit) framework that they present is that of an overly simple shift: one from a situation in which material culture consolidates and reproduces the status quo of a society of orders, to a situation in which material culture, through innovation and fashion, helps dislodge these same orders.[16] Economic historian Jan De Vries has described this shift as one from 'old' to 'new luxuries', situating it in the seventeenth- and eighteenth-century urban centres in northwest Europe, where the widespread availability of cheaper 'new' luxuries such as porcelain, decorative silverwork, paintings and *populuxe* goods stood out.[17] For De Vries, this is related to changes in the allocation of labour (the so-called 'industrious revolution') and both labour and consumption increasingly being located outside the home, but as soon as an anthropological perspective is included, the long-term trend is often considered a shift from patronage and a gift economy to commodity exchange.

Moreover, historical literature on material culture largely reduces value to a semiotic problem. Although a more straightforward focus on objects and materiality has recently developed – such as in emphasizing the shifting perceptions of luxury or the increasing importance of comfort and 'sense value'[18] – the shifting value of different types of materiality has not been directly addressed. The cultural turn, and post-structuralism in particular, has instead induced an approach in which objects are regarded as 'signs' and value is

[15] Some overviews are Neil McKendrick, 'Introduction: The Birth of a Consumer Society: The Commercialization of Eighteenth-Century England', in McKendrick, Brewer and Plumb (eds), *The Birth of a Consumer Society*, pp. 1–8; Cissie Fairchilds, 'Consumption in Early Modern Europe: A Review Article', *Comparative Studies in Society and History*, 35 (1993): pp. 850–858; Peter N. Stearns, 'Stages of Consumerism: Recent Work on the Issues of Periodization', *Journal of Modern History*, 69 (1997): pp. 102–117; Paul Glennie, 'Consumption within Historical Studies', in Daniel Miller (ed.), *Acknowledging Consumption: A Review of New Studies* (London, 1995), pp. 164–203; Sara Pennell, 'Consumption and Consumerism in Early Modern England', *The Historical Journal*, 42/2 (1999): pp. 549–564.

[16] Appadurai, *The Social Life of Things*, passim. Also, among many others: Daniel Roche, *La culture des apparences. Essai sur l'histoire du vêtement aux XVIIe et XVIIIe siècles* (Paris, 1989).

[17] Jan De Vries, *The Industrious Revolution: Consumer Behavior and the Household Economy, 1650 to the Present* (Cambridge, 2008), chapter 4.

[18] Maxine Berg and Helen Clifford (eds), *Consumers and Luxury: Consumer Culture in Europe, 1650–1850* (New York, 1999); Maxine Berg and Elizabeth Eger (eds), *Luxury in the Eighteenth Century: Debates, Desires and Delectable Goods* (New York, 2002); Michael Kwass, 'Ordering the World of Goods: Consumer Revolution and the Classification of Objects in Eighteenth-Century France', *Representations*, 82 (2003): pp. 87–116; Maxine Berg, *Luxury and Pleasure in Eighteenth-Century Britain* (Oxford, 2005).

generally synonymous with meaning.[19] The value of a product is thus considered to be dependent upon its position amidst a range of products, that is, the result of its place in a differential system of signs. Value itself, however, is attributed by subjects who are themselves subject to culture, that is, a system of meaning external to the object in question.

Either way, historical approaches risk constructing teleological views. While institutions are seen as having helped bridge the gap between 'natural' price or value (as something inherent and already there) and the actual price (which, in the absence of reliable institutions, would be too high), buyers are depicted as customers who gradually become emancipated from a society of orders. In current literature, consumption is connected either to the act of creating an individual or collective identity or to the modern pursuit of comfort, pleasure, intimacy and the like.[20] Consequently, it is as if the natural correspondence between supply and demand finally emerged in the early modern period. In the meantime, the changing relationship of producers to their products has hardly appeared on the historical agenda. Historians have abundantly examined processes of proletarianization,[21] yet late medieval and early modern products continue to be regarded as having been already entirely commodified, stripped of possible gift-like dimensions and religious connotations. In the same vein, money is generally considered to have functioned as a neutral medium for the creation of equivalencies and for making products commensurate, rather than as an unstable, shifting category within the field of tensions between a precious type of possession, a debt relation and its abstract value.[22]

Studies of one product category in particular have challenged this paradigm of continuing product commodification and externalization of value during

[19] See, for example, Grant McCracken, 'Culture and Consumption: A Theoretical Account of the Structure and Movement of the Cultural Meaning of Consumer Goods', *Journal of Consumer Research*, 13 (1986): pp. 71–84; Mary Douglas and Baron Isherwood, *The World of Goods: Towards an Anthropology of Consumption* (New York, 1979). For new perspectives, see Frank Trentmann, 'Materiality in the Future of History: Things, Practices, and Politics', *Journal of British Studies*, 48 (2009): pp. 283–307.

[20] Richard A. Goldthwaite, *Wealth and the Demand for Art in Italy, 1300–1600* (Baltimore, 1993); Berg, *Luxury and Pleasure*; Clive Edwards, *Turning Houses into Homes: A History of the Retailing and Consumption of Domestic Furnishings* (Aldershot, 2005).

[21] Two debates stand out: the so-called Brenner Debate, and the debate on proto-industrialization. See, for example, C. Trevor Henry Aston and Charles Harding English Philpin (eds), *The Brenner Debate: Agrarian Class Structure and Economic Development in Pre-Industrial Europe* (Cambridge, 1976); Markus Cerman and Sheilagh Ogilvie, *European Proto-Industrialization* (Cambridge, 1996).

[22] For a critical account and further references, see Evelyn Welch, 'Making Money: Pricing and Payments in Renaissance Italy', in Michelle O'Malley and Evelyn Welch (eds), *The Material Renaissance* (Manchester, 2007), pp. 71–84.

the early modern period. Whereas historical literature from the 1980s onwards increasingly reoriented towards the consumption of goods, art historians – and by extension social and economic historians analysing *the art market* – expanded upon their pre-existing interests in the sphere of production, and, more specifically, in the complex and dynamic interplay between artists and society, on the one hand, and the intrinsic relationship between artists and their works of art, on the other.[23] Often inspired by interdisciplinary research methods that became *en vogue* in recent decades, this literature not only contextualized artistic value in relationship to market forces and fluctuating modes of art consumption, but also incorporated the social, cultural and economic contexts in which artists functioned.[24] Although diverse in historical and geographical scope, these assessments share an underlying paradigm of artistic emancipation, an idea born in Renaissance Italy and further developed in sixteenth- and seventeenth-century France and the Low Countries. According to this paradigm, over the course of the early modern period, artists gradually became emancipated from their artisanal backgrounds; painters in particular strove to distinguish themselves from 'mechanical' artisans and emphasized the creative and 'liberal' character of their calling.[25]

As a result, the perceived value of a work of art was now a construction, consisting not just of the mere cost of the raw materials and labour involved: the ineffable quality of artistic ingenuity was valued as well.[26] In other words,

[23] Michael Montias' early work on Vermeer and his fellow artists in Delft is often cited as being seminal in the socio-economic study of art production. Michael Montias, *Artists and Artisans in Delft: A Socio-Economic Study of the Seventeenth Century* (Princeton, 1982); idem, *Vermeer and his Milieu: A Web of Social History* (Princeton, 1989).

[24] Elizabeth A. Honig, 'The Beholder as a Work of Art: A Study in the Location of Value in Seventeenth-Century Flemish Painting', in Reindert Falkenburg, Jan de Jong, Herman Roodenburg and Frits Scholten (eds), *Beeld en zelfbeeld in de Nederlandse kunst/ Image and Self-Image in Netherlandish Art, 1550–1750* (Zwolle, 1995), pp. 253–297. Recent contributions to these debates are offered in Anna Tummers and Koenraad Jonckheere (eds), *Art Market and Connoisseurship: A Closer Look at Paintings by Rembrandt, Rubens and their Contemporaries* (Amsterdam, 2008); Richard Spear and Philip Sohm, *Painting for Profit: The Economic Lives of Seventeenth-Century Italian Painters* (New Haven and London, 2010).

[25] This is most notably articulated in Nathalie Heinich, *Du peintre à l'artiste. Artisans et académiciens à l'âge classique* (Paris, 1993). The foundation of Academies of Fine Arts in the sixteenth and seventeenth centuries is often seen through the prism of this emancipation. Miedema rightfully argues that this widespread presupposition dates at least to Jacob Burkhardt's *Die Kultur der Renaissance in Italien* from 1860. Hessel Miedema, 'Kunstschilders, gilde en academie. Over het probleem van de emancipatie van de kunstschilders in de Noordelijke Nederlanden van de 16de en 17de eeuw', *Oud Holland*, 101 (1987): p. 1.

[26] Neil De Marchi and Hans J. Van Miegroet, 'Art, Value, and Market Practices in the Netherlands in the Seventeenth Century', *The Art Bulletin*, 76/3 (1994): pp. 451–464; idem,

the changing relationship between producers/artists and their products/works of art clearly influenced the (perceived) value of the work of art. Yet the historians studying this have in a way reproduced the strategies and discourses of early modern painters seeking to distinguish themselves from mere craftsmen. After all, it was precisely this reigning paradigm of artistic emancipation that stimulated art historians – and *mutatis mutandis* other historians – to stress the unique position of these works as compared to other product categories. Still, the way this strand of literature has foregrounded the often overlooked changing relationship between producer and produce has the potential to motivate other historians to address the matter, and to expand upon this notion not only as concerns the visual and decorative arts but also other product categories.

Towards a New Perspective? Conventions, Repertoires of Evaluation and Market Devices

In order to avoid teleological thinking, it is necessary to re-evaluate the evolving relationship between institutions, cultural systems of meaning, objects and subjects in the process of creating value. Traditional historical sociology à la Marx, Weber and Simmel was about understanding the fundamental transformations within that scenario of change. This volume will link with this tradition by drawing together current approaches and adopting a genuine historical perspective. Of course, the previously noted historical-sociological approach was teleological as well, and this is why our volume assumes a more 'pragmatic' stance. The so-called 'pragmatic' or 'practice turn' in social sciences arose from a certain unease about orthodox critical approaches and dissatisfaction with the interminable debate between, on the one hand, methodological individualism (of economists) and, on the other, Marxist determinism and Bourdieu's orthodoxy (the sociological or structuralist approach).[27]

In endeavouring to resolve this issue, various French economists and sociologists conceptualized the so-called convention theories, or economics of convention ('théories des conventions').[28] The protagonists of this school of ideas

'Pricing Invention: "Originals", "Copies", and their Relative Value in Seventeenth-Century Netherlandish Art Markets', in Victor Ginsburgh and Pierre Michel Menger (eds), *Economics of the Arts: Selected Essays* (Amsterdam, 1996), pp. 27–70.

[27] Theodore Schatzki, Karina Knorr Cetina and Eike von Savigny (eds), *The Practice Turn in Contemporary Theory* (London and New York, 2001); Richard J. Bernstein, *The Pragmatic Turn* (Cambridge, 2010).

[28] Introductions with additional references include André Orléan (ed.), *Analyse économique des conventions* (Paris, 1994); Philippe Batifoulier (ed.), *Théorie des conventions* (Nanterre, 2001). For recent attempts to connect this to historical approaches (and further references), see the special issue on 'Conventions and Institutions from a Historical

have sought to reconcile the dominant paradigm of economics (rational choices of utilitarian actors) with that of French sociology (structures predetermining actors' choices). This resulted in a 'heterodox' view, in which actors are seen to pragmatically base their decisions on the 'conventions' at hand in a certain context or network. Agreement on the value of products and services is thus always situated within specific 'repertoires of evaluation'.[29] These convention theories thus inhibit teleological perspectives via which certain economic shifts are then regarded as having been requisite steps in the ascendance of a free market economy.[30] What common sense now recognizes as a free market economy is in fact merely another type of economy – with other repertoires of evaluation, types of justification and systems of ranking individuals and artefacts.

Yet, notwithstanding the importance of historical contingency, convention theory nonetheless presents obstacles for historical research too,[31] most fundamentally because the problem of defining 'conventions' remains largely unresolved. While some historians refer to conventions as theories or paradigms,[32] others call them cognitive models,[33] systems of knowledge,[34] or simply 'common

Perspective/Konventionen und Institutionen in historischer Perspektive', from *Historical Social Research/Historische Sozialforschung* in 2011.

[29] For the application of these theories to product quality, see François Eymard-Duvernay, 'Conventions de qualité et formes de coordination', *Revue Économique*, 40 (1989): pp. 329–359; idem, 'Coordination des échanges par l'entreprise et qualité des biens', in Orléan, *Analyse économique*, pp. 331–358; Pierre-Yves Gomez, *Qualité et économie des conventions* (Paris, 2002); Lucien Karpik, *L'économie des singularités* (Paris, 2007). For recent perspectives, see André Orléan, *L'Empire de la valeur: Refonder l'économie* (Paris, 2011).

[30] Philippe Minard, 'Die Zünfte in Frankreich am Ende des 18. Jahrhunderts: Analyse ihrer Abschaffung', in Heinz-Gerhard Haupt (ed.), *Das Ende der Zünfte: ein europäischer Vergleich* (Göttingen, 2002), pp. 181–195; idem, 'Les corporations en France aux XVIIIe siècle: métiers et institutions', in Steven Kaplan and Philippe Minard (eds), *La France, malade du corporatisme? XVIIIe–XXe siècles* (Paris, 2004), pp. 39–51; Alessandro Stanziani (ed.), *La qualité des produits en France, XVIIIe–XXe siècle* (Paris, 2004); idem, *Histoire de la qualité alimentaire XIXe–XXe siècle* (Paris, 2005).

[31] For one, the scholars involved do not agree on what type of conventions (or common superior principles) actually exist. While Boltanski and Thévenot have identified six conventions, others have used different, albeit familiar, categories. Luc Boltanski and Laurent Thévenot, *Les économies de la grandeur* (Paris, 1989); Luc Boltanski and Laurent Thévenot, *De la justification. Les économies de la grandeur* (Paris, 1991); Michael Storper and Robert Salais, *Worlds of Production: The Action Frameworks of the Economy* (Cambridge, MA, 1997).

[32] André Orléan, 'Pour une approche cognitive des conventions économiques', *Revue Economique*, 40/2 (1989): pp. 241–272.

[33] Olivier Favereau, 'Marchés internes, marchés externes', *Revue Economique*, 40/2 (1989): pp. 273–328.

[34] Robert Salais, 'L'analyse économique des conventions du travail', *Revue Economique*, 40/2 (1989): pp. 199–240.

sense'.[35] When connecting this approach to the problem of information asymmetries, conventions appear to be synonymous with implicit knowledge. But what, then, is the relationship with standardization? Is standardization a specific convention, or does every convention, in a way, serve to standardize product quality? Also, how are conventions related to institutions, organizations and culture? Do institutions emerge from pre-existing conventions, or vice versa? Where should conventions be situated on the axis between formal and informal institutions, and how should they be related to culture as a system of symbols and meaning?

In advanced versions of pragmatic approaches to markets, scholars include both the social and material contexts, suggesting, for instance, that prices (and hence value) depend on the material organization of auctions and markets, the availability of price lists and calculating aids, and myriad 'market devices'. From an historical perspective, this allows the issue of 'calculability' to be tackled, which commences from processes wherein objects are 'disentangled' (detached from their physical and cultural environment) and 'framed' (made measurable).[36] These concepts are especially notable in that they allow the much-debated issues of commodification and the shift from gift exchange to commodity exchange to be addressed, without becoming entrapped in ideological channels a priori.

In seeking to critically build on these approaches without becoming dependent on any specific 'school', we have adopted the term 'location of value' as a conceptual shorthand. While trying to avoid teleological and ahistorical trappings, we will examine how the 'location of value' shifted – for different products, labour and services – between the late Middle Ages and the nineteenth century.[37] The first and most simple question to address is: which aspect of a market element – a piece of footwear, for example – determines its worth? Is it the comfort that it provides, its durability or perhaps its design? Certain characteristics of objects and humans are often isolated as being *the* crucial factor in the appreciation and assessment of quality; such characteristics, however, are contingent upon the geographical, social and historical context in question, and thus often vary from case to case. This raises the question of how producers and consumers agree on establishing value, and what role is played in

[35] Jean-Pierre Dupuy, 'Convention et Common Knowledge', *Revue Economique*, 40/2 (1989): pp. 361–400.

[36] Michel Callon, 'Introduction: The Embeddedness of Economic Markets in Economics', in Michel Callon, *The Laws of the Markets* (Oxford, 2005), pp. 1–57; idem, 'What Does It Mean to Say That Economics Is Performative?', in Donald MacKenzie, Fabian Muniesa and Lucia Siu (eds), *Do Economists Make Markets? On the Performativity of Economics* (Princeton, 2007), pp. 311–357; Fabian Muniesa, 'Market Technologies and the Pragmatics of Prices', *Economy and Society*, 36/1 (2007): pp. 377–395.

[37] We have borrowed the phrase 'location of value' from Honig, 'The Beholder as a Work of Art'.

such negotiations by the often complex structures and networks of production and distribution that are involved, and by the material context, measuring instruments, marks and other market devices. A pragmatic approach, with an eye to the social and material components of the conventions involved, offers potential to shed new light on this process.

To be sure, this is not a matter of simply choosing certain characteristics of a product. Depending on the factors involved, the 'objectification' of product quality and value will occur in different 'locations'. Quality can be situated in the relevant raw materials when 'intrinsic value' is significant, yet it can also be 'constructed' discursively by shop signs, trade cards, catalogues, bills and the like – and thus be 'located' in external media.[38] When display is involved, product quality may depend upon the location of the product within a taxonomy of such items – and hence upon the product's difference from other products.[39] As concerns 'human qualities', quality may be located in the mindset or physical skills of the artisans involved; likewise, it may be dependent upon the artisan's place within a taxonomy (hierarchy) of producers, as was the case with guild-based artisans. Moreover, these artisans will often be actively involved in the process of locating value, for example, in their use of hallmarks or when articulating a certain discourse about labour or the quality of their products.[40]

This volume aims to examine how the location of value evolved across markets and products, beyond the emergence of the creative consumer and beyond overly simple dichotomies like gift exchange versus commodity exchange, or moral economy versus free market economy. An interdisciplinary range of art, economic and cultural historians have explored broader long-term transformations related to the 'conventions' or 'repertoires of evaluation' involved in the 'location' of value. Rather than starting from a specific concept or theory, they have – by focusing on the discourses, rules, instruments and

[38] Neil McKendrick, 'Josiah Wedgwood: An Eighteenth-Century Entrepreneur in Salesmanship and Marketing Techniques', *Economic History Review*, 12 (1960): pp. 408–433; idem, 'Introduction'; Claire Walsh, 'The Advertising and Marketing of Consumer Goods in Eighteenth-Century London', in Clemens Wishermann and Elliott Shore (eds), *Advertising and the European City: Historical Perspectives* (Aldershot, 2000), pp. 89–95; Maxine Berg and Helen Clifford, 'Selling Consumption in the Eighteenth Century: Advertising and the Trade Card in Britain and France', *Cultural & Social History*, 4 (2007): pp. 145–170.

[39] Claire Walsh, 'Shop Design and the Display of Goods in Eighteenth-Century London', *Journal of Design History*, 8 (1995): pp. 157–176; Andrew Hann and Jon Stobart, 'Sites of Consumption: The Display of Goods in Provincial Shops in Eighteenth-Century England', *Cultural and Social History*, 2 (2005): pp. 165–188; Patrick Wallis, 'Consumption, Retailing and Medicine in Early Modern London', *The Economic History Review*, 61/1 (2008): pp. 26–53.

[40] Bert De Munck, 'The Agency of Branding and the Location of Value: Hallmarks and Monograms in Early Modern Tableware Industries', *Business History*, 54/7 (2012): pp. 1–22.

material circumstances involved – empirically unwrapped the often implicit assumptions on which agreements on the value of products were based. These essays, ranging chronologically from the late medieval period to the end of the nineteenth century, thus pinpoint the 'location' of value for an array of products in their specific respective historical contexts, from Venetian glass and German textiles to Flemish paintings and antiques. In order to avoid a priori reductions to exclusively economic or cultural logic, we have adopted a perspective that is not only interdisciplinary but also includes the perceptions and attitudes of collectors and the correspondence between value and meaning.

This approach allows the authors to offer a rare glimpse into both the underlying market and non-market conventions that implicitly and explicitly govern the valuation processes in question. Although diverse in nature and scope, this collection of essays as a whole indicates that early modern repertoires of evaluation were continuously (re)created and (re)shaped in perpetual interaction with three historical fields of tension: the expansion and contraction of (supra)regional trade networks; the evolution of institutional frameworks; and the shifting of agency structures between different economic agents. Via these essays, there emerges a new perspective on the shift from 'early modern' to 'modern' economic practices.

Diverging Markets and Changing Conventions

When examined from traditional perspectives such as technological process innovations and economies of scale, the early modern period may appear to have been an uneventful period most notable for having unfolded in between the late medieval economic expansion and the large-scale industrial growth of the nineteenth century. However, as this volume suggests, especially in linking to research on the history of material culture and the valuation and assessment of art, the period in fact witnessed considerable, and dynamic, changes to its market mechanisms. Following the advent of colonial trade to Asia and Africa from the sixteenth century onwards, the European product market underwent a gradual transformation. Previously rare and hardly known products, ranging from coffee, tea and chocolate to porcelain and Indian cotton, were imported from overseas, and quickly came to influence the daily practices and material culture of European families. Items like teapots, tableware and pipes became integral parts of seventeenth-century household effects and stimulated new practices of sociability.[41] Parallel to the arrival of new goods from overseas, a series of product and (to a lesser extent) process innovations diversified the existing

[41] An interesting case study is Brian Cowan, *The Social Life of Coffee: The Emergence of the British Coffeehouse* (New Haven and London, 2011).

material culture, including through import substitution. Partly in response to these macro-economic evolutions, substantial components of urban production capacity – mainly in the textile industry – were relocated to the countryside, spurring the rise of rural industries and reorienting economic city–hinterland relationships. The growth of colonial trade also intensified intra-European shipping in the seventeenth and eighteenth centuries, and, on a (sub)regional scale, spurred the development of canal systems, inland shipping and, especially in the eighteenth century, substantial improvements to road infrastructures that connected capital and port cities to the hinterland.[42]

Besides noting overseas expansion, traditional approaches to explaining such transformations have typically referred to transport prices or relative prices in general. Yet such approaches become entangled in ideological debates about the primacy of demand versus supply-side factors.[43] This volume seeks to venture beyond these debates and to address the changing interaction between actors on the supply and demand sides of economic transacting. As Christof Jeggle's work on linen production in seventeenth-century Münster illustrates, the growing interconnectedness of markets exerted pressure on the local repertoires of evaluation.[44] When the market for German linens gradually opened in the early seventeenth century, the Münster brotherhood of weavers installed a self-organized quality control for all local weavers. The goal was to provide local customers with a form of guarantee that the producing weaver was of good repute and had received appropriate training. Significantly, this also allowed the weavers to offer their linens as standardized products on the foreign Dutch and English markets. These Münster weavers purposefully shifted from a convention of interpersonal production to a convention of serial production.[45] Moreover, this new market situation required new forms and instruments – in this particular case a number-based labelling system – enabling market actors to gauge quality and calculate price. In short, because of the weavers' interaction with the growing markets for German textiles, the valuation of Münster linen was no longer directed by local conventions, but rather by the conventions and instruments necessary on the wider markets where their merchandise was now offered for sale.

Nor was market expansion alone in having the potential to generate considerable changes in local conventions. Dries Lyna's account of the struggling art auctions in the late eighteenth-century Austrian Netherlands shows

[42] For recent perspectives, see Prasannan Parthasarathi, *Why Europe Grew Rich and Asia Did Not: Global Economic Divergence, 1600–1850* (Cambridge, 2011); Jean-Laurent Rosenthal and Roy Bin Wong, *Before and Beyond Divergence: The Politics of Economic Change in China and Europe* (Cambridge, 2011).

[43] McKendrick, 'Introduction', passim.

[44] See the contribution by Jeggle in this volume.

[45] See Storper and Salais, *Worlds of Production*, for this distinction.

how unfavourable market conditions interacted with existing repertoires of evaluation.[46] From the 1760s onwards, Flemish dealer-auctioneers progressively attempted to construct the value of their merchandise by implementing a novel discourse about paintings; this discourse was articulated via printed auction catalogues which were distributed weeks before the actual sales. French dealer-auctioneers had been successful in the 1740s and 1750s in discursively locating the value of paintings in external media (that is, catalogues). Detailed descriptions and explicit criteria of appreciation provided people outside the established art community with the tools to engage in a learning process of 'semiotic socialization'. By gradually internalizing the mental accounting schemes of art valuation based on individual judgement, newcomers were afterwards able to formulate their personal valuation in relationship to the underlying conventions governing the auction markets. From an economic perspective, importing this French practice was insufficient to counter dwindling market conditions in cities such as Antwerp and Brussels; in the long run these discursive shifts were central to the establishment of a veritable auction culture.

Here again, new market conditions induced new repertoires of evaluation and new instruments (auctions and auction catalogues) by which to 'locate' and demarcate value. Yet it would be unproductive to read these and other such case studies simply as teleological signs of the ascendance of a free market economy. Indeed, conventions could change in expanding as well as contracting economies and in a manner seemingly detached from conjunctures – which suggests that the market economy was not actually the sole force underlying shifting conventions, but rather that more structural underlying shifts were involved.

Economic anthropology compels us to critically address the evolving relationship between economy and culture (next to social institutions). One means to achieve this is through the history of collecting. Historians and art historians have often understood collecting as an epistemic activity, that is, as a means to wield knowledge, power and control. It was not coincidental that the emergence of a specifically European culture of collecting was associated with overseas expansion, discovery of continents and confrontation with the 'Other'. The precious stones, coins, art, shells, exotic animals and plants of the sixteenth- and seventeenth-century *Wunderkammern* were the result of attempts to 'collect the world'. Collectors were, in a sense, seeking to restore order and systemization into the chaos created by all things new. Collecting offered a symbolic way to regain control over a newly distorted reality and to restore ideas about what was good and just.[47]

[46] See the contribution by Lyna in this volume.

[47] Susan M. Pearce, *On Collecting: An Investigation into Collection in the European Tradition* (London and New York, 1995); Thomas Dacosta Kaufman, 'From Treasury to Museum: The Collection of the Austrian Habsburg', in John Elsner and Roger Cardinal

As such, collecting was not only an intellectual activity. While it involved merchants and profoundly impacted value, it was related to the most fundamental relationship of people to things.[48] In her essay on the location of value in early modern collections, Adriana Turpin directs our attention to the agency of the collector and provides ample proof of how the conventions of collecting sometimes fundamentally diverged from reigning market principles.[49] Most European aficionados of the sixteenth and seventeenth centuries appeared to value their collections in ways that were hardly quantifiable, especially as practices generally emphasized the social and cultural dimensions of status, refinement and taste. Collections could facilitate entry into certain social networks; as such, collectibles were not so much valued in relation to other products on the market, but gained significance through their relationship to other collections. Nonetheless, with social and geographical expansion of the art market in the late eighteenth and nineteenth centuries, collectors came to acquire other – and more quantifiable – repertoires of evaluation. As a result, the value of an art object became the object's expected resale value, and thus a convention dictated by market logic.

At first glance, then, quantification and free market logic would seem to have superseded existing repertoires of evaluation during the early modern period – yet this does not automatically result in markets becoming 'disembedded'. Even with the growing commercialization of the art world from the late eighteenth century onwards, market logic remained bound to a larger system of conventions. Helen Clifford's chapter addresses the value of products becoming less embedded in a society of orders, yet she points to a specific dialectic between the advent of new consumer durables and the gift- and heirloom-like function of products.[50] Specifically, she observes that the eighteenth century did not mark the end of the importance of 'patina' ('the weathering or aging of the exposed surface of a material') as the sign of an object being old and already used.[51] Rather, the growing importance of novelty and fashionability coincided with both a growing interest in old things and the increasing importance of 'patina'

(eds), *The Cultures of Collecting* (London, 1994), pp. 137–154; Anthony Allan Shelton, 'Cabinets of Transgression: Collections and the Incorporation of the New World', in Elsner and Cardinal (eds), *The Cultures of Collecting*, pp. 177–203.

[48] Pamela H. Smith and Paula Findlen (eds), *Merchants and Marvels: Commerce, Science, and Art in Early Modern Europe* (London and New York, 2002); Harold J. Cook, *Matters of Exchange: Commerce, Medicine, and Science in the Dutch Golden Age* (New Haven and London, 2007).

[49] See Turpin's contribution to this volume.

[50] See Clifford's contribution to this volume.

[51] Contrary to Grant McCracken, *Culture and Consumption: New Approaches to the Symbolic Character of Consumer Goods and Activities* (Indiana, 1990), p. 37.

– which now also served as a marker of authenticity.[52] In silverware, markers of old and new could even merge in a single product – such as when forms referring to antique models were made with the latest techniques, or when new silver was engraved with crests and mottoes.[53]

In short, while there are signs that quantification and market imperatives became more important in the early modern period, such developments were accompanied by new ways of fashioning product authenticity. Moreover, market mechanisms continued to be predicated upon conventions and material devices which rendered value and prices calculable – such as standardization, external discourses (like in art and auction catalogues) about value, and personal contacts and proximity (as with heirlooms). As the literature on auctions shows, the material setting and infrastructure can be seen as having been precisely the mechanism that allowed for the market mechanism to prevail.[54]

Markets and Institutions: Beyond the Neo-Institutional Approach

Accordingly, then, this volume confronts the question of the role of institutions. As concerns Münster linen, shifting repertoires of evaluation were clearly related to shifting institutional mechanisms. Number-based labelling was enforced by the city council, which, in its urgent quest to generate and maintain revenue, seized control of the brotherhood's quality control efforts.[55] Likewise, the rise of specialized secondary luxury markets in the southern Netherlands over the course of the eighteenth century transpired at the expense of older means of assessing the value of art, particularly ways that had been controlled by local corporations such as old-cloth sellers and the Guild of Saint Luke. Books, paintings and musical instruments were separated from traditional estate sales and sold at specialized auctions outside the guilds' control; this particular process saw a small, core group of dealers assume all matters of appraising and valuing these luxury objects in *post-mortem* sales.[56] While cause and effect are

[52] See similar observations in Bruno Blondé and Ilja Van Damme, 'Fashioning Old and New or Moulding the Material Culture of Europe (Late Seventeenth–Early Nineteenth Centuries)', in Bruno Blondé, Natacha Coquery, Jon Stobart and Ilja Van Damme (eds), *Fashioning Old and New: Changing Consumer Patterns in Western Europe (1650–1900)* (Turnhout, 2009), pp. 1–14; Bruno Blondé, 'Conflicting Consumption Models? The Symbolic Meaning of Possessions and Consumption amongst Antwerp Nobility at the End of the Eighteenth Century', in Blondé et al. (eds), *Fashioning Old and New*, pp. 61–80.

[53] Blondé, 'Conflicting Consumption Models?', p. 68.

[54] See Lyna's contribution to this volume.

[55] See Jeggle's contribution to this volume.

[56] Dries Lyna, 'Power to the Broker: Shifting Authorities over Public Sales in Eighteenth-Century Antwerp', in Jon Stobart and Ilja Van Damme (eds), *Modernity*

typically difficult to disentangle, it is clear that new institutions emerged with new conventions and repertoires, and vice versa. The next question is whether any broad patterns are discernible in the transformation of the institutional context and the connection between conventions and institutions.

Michela Barbot's contribution offers proof that conventions were specific to institutions and, hence, power.[57] The so-called College of Milan essentially pre-structured the repertoires of evaluation governing the real estate market. This guild-like institution controlled the training of aspiring engineers in Milan; this was an intensive training geared solely towards acquiring practical knowledge of the local monetary and measuring systems. The college held so profoundly to this philosophy that its statutes proclaim that measuring effectively was far more important to aspiring engineers than drawing well, a view that contrasted sharply with the general opinions about engineer training elsewhere in early modern Europe. However, upon the Austrian Habsburgs seizing power over the city in the early eighteenth century, the Viennese government installed *manu militari* its own system of land registration.[58] Besides having to abandon its own century-old conventions and practices of valuing houses, the College of Milan was also forced to undergo additional structural alterations, thereby ensuring its gradual demise over the course of the eighteenth century. Consequently, the Milanese real estate market, which had long been governed (and perhaps even immured) by the college's local conventions of measuring and valuing houses, now gradually became a competitive market wherein houses were increasingly perceived as commodities, the value of which was primarily measured by their ability to yield future revenue.

This is reminiscent of various European countries abolishing guild privileges in the eighteenth century. The standard account of how the guilds' privileges came to be eliminated refers to both the increasing dominance of territorial princes and their administrations and the liberation of the labour market per the influence of French physiocrats and Scottish political economists.[59] Barbara Bettoni's contribution is to an extent in line with this research, although she reveals that the guilds' regulations became obsolete, not because of shifts on the labour market or in the sphere of labour relations, but rather because of transformations on the product market.[60] Her chapter on late eighteenth- and

and the Second-Hand Trade: European Consumption Cultures and Practices, 1700–1900 (Basingstoke, 2010), pp. 158–174.

[57] See Barbot's contribution to this volume.

[58] For the importance of modern land registration (including in a material sense) in the emergence of a 'modern' housing and land market, see Timothy Mitchell, *Rule of Experts: Egypt, Techno-Politics, Modernity* (Berkeley, 2002), chapter 3.

[59] For a recent state of the art and additional references, see Haupt (ed.), *Das Ende der Zünfte*.

[60] See Bettoni's contribution to this volume.

early nineteenth-century button and buckle production in northern Italy neatly sketches a history of local guilds becoming obsolete in the context of shifting definitions of value. Guilds in the sector of luxury accessories faced difficulties, especially as the variety of products and production techniques increased during the eighteenth and early nineteenth centuries. Guild regulations were circumvented by entrepreneurs, many of whom were aided in such efforts by local governments, who granted them privileges so as to counter imports of fashionable French and English products. Eventually, product quality control was wrested from the guilds and entrusted to other actors, such as craftsmen from the Mint rather than the Guild of Goldsmiths, or to designated sellers, who acted as intermediaries between producers and consumers, and communicated the presence of characteristics attractive to consumers. This development also had a material dimension, for while products were henceforth controlled 'ex-post', the traditional stamps of guild-based masters (indicating the origin and quality of the product in question) were now bound to become obsolete.

Bettoni's contribution thus links to recent views forwarded by neo-institutional economic historians about the role of guilds. The recent reassessment of the guilds in academic literature has resulted in a view in which their rules, regulations and practices straightforwardly answered a need to reduce transaction costs. Their rules and regulations related to product quality – including product standardization, workshop searches and collective hallmarks – are considered to have been developed to address problems of information asymmetry, in which buyers, and sometimes sellers, refrained from a transaction due to holding insufficient information concerning product quality, resulting in sub-optimal prices.[61] In addition, guild regulations are also considered to have had contract enforcement objectives, such as concerned apprenticeship requirements. According to S.R. (Larry) Epstein, the obligation to serve a minimum term, among other related mechanisms, prevented apprentices from absconding and thus produced contract-enforcing effects. Even the obligation to pay an apprenticeship fee and the mere existence of a labour market monopsony are seen from this perspective, in that they served as bonds and end-term rewards respectively.[62]

[61] Gustafsson, 'The Rise and Economic Behaviour of Medieval Craft Guilds'; Maarten Prak, 'Guilds and the Development of the Art Market during the Dutch Golden Age', *Simiolus: Netherlands Quarterly for the History of Art*, 3 & 4/30 (2003): pp. 236–251; Bert De Munck, 'Gilding Golden Ages: Perspectives from Early Modern Antwerp on the Guild Debate, c. 1450–c. 1650', *European Review of Economic History*, 15 (2011): pp. 221–253.

[62] Stephan R. Epstein, 'Craft Guilds, Apprenticeship, and Technological Change in Pre-Industrial Europe', *Journal of Economic History*, 58/3 (1998): pp. 684–713; idem, 'Craft Guilds in the Pre-Modern Economy: A Discussion', *Economic History Review*, 61/1 (2008): pp. 155–174; Gary Richardson, 'Guilds, Laws, and Markets for Manufactured Merchandise in Late Medieval England', *Explorations in Economic History*, 41 (2004): pp. 1–25.

From this perspective, the guilds' loss of credibility at the end of the *ancien régime* is now even more difficult to explain than before. Bettoni's chapter, however, suggests that guilds could ensure market transparency for one type of product (that is, products of high intrinsic value evidenced by the related hallmarks and stamps), but not for other, more complex product forms.[63] An important implication of this is that different forms of expertise and workmanship are involved. Earlier research has shown that artisans at the end of the *ancien régime* began to attend drawing schools and art academies in order to learn how to draw.[64] In all likelihood, this can be linked to the increasing importance of design and decoration which material cultural historians ascribe to the seventeenth and eighteenth centuries.[65] However, this was not simply a matter of acquiring additional skills: art academies have been shown to have generated new definitions of skill and talent, and thus to have generated new repertoires of evaluation.[66]

In his chapter on the role of the French *Académie Royale de la Peinture et Sculpture* in valuing art in the eighteenth century, Tomas Macsotay analyses the often neglected mediatory role of this institution in the Parisian art world. The *Académie*, founded in 1648 by Colbert, constructed a new image of fine arts practice, not by playing upon traditional hierarchies, but by advancing a 'series of devices that implied a community of viewers, connecting empiricism and deliberation, inspection and introspection'.[67] By establishing a social space for creating art, and creating a new identity for painters by means of friendship

[63] See Bettoni's contribution to this volume. For similar arguments, see Bert De Munck, 'Skills, Trust and Changing Consumer Preferences: The Decline of Antwerp's Craft Guilds from the Perspective of the Product Market, ca. 1500–ca. 1800', *International Review of Social History*, 53/2 (2008): pp. 197–233.

[64] Anne Puetz, 'Design Instruction for Artisans in Eighteenth-Century Britain', *Journal of Design History*, 12/3 (1999): pp. 217–329; Bert De Munck, *Technologies of Learning: Apprenticeship in Antwerp from the 15th Century to the End of the Ancien Régime* (Turnhout, 2007). For recent perspectives and additional references, see Catharina Lis and Hugo Soly, *Worthy Efforts: Attitudes to Work and Workers in Pre-Industrial Europe* (Leiden, 2012), pp. 388–400.

[65] John Styles, 'Manufacturing, Consumption and Design in 18th-Century England', in Brewer and Porter (eds), *Consumption and the World of Goods*, pp. 527–554; Maxine Berg, 'New Commodities, Luxuries and Their Consumers in Eighteenth-Century England', in Berg and Clifford (eds), *Consumers and Luxury*, pp. 63–86; John Styles, 'Product Innovation in Early Modern London', *Past and Present*, 168 (2000): pp. 124–170; Maxine Berg, 'From Imitation to Invention: Creating Commodities in Eighteenth-Century Britain', *Economic History Review*, 55 (2002): pp. 1–30.

[66] Bert De Munck, 'Le produit du talent ou la production de talent? La formation des artistes à l'Académie des beaux-arts à Anvers aux XVIIe et XVIIIe siècles', *Paedagogica Historica*, 37/1 (2001): pp. 569–607.

[67] Quoted in Macsotay's contribution to this volume.

bonds with other artists and *amateurs*, the *Académie* managed to bolster not only its own status but also that of the artist and ultimately that of the artwork itself. In this case the sum proved to amount to far more than the individual parts, as not only artists but also an institution such as the French Academy proved capable of influencing the repertoires of evaluation regarding artwork, if not directly, then certainly 'backstage' in the eighteenth-century Parisian art world.

Macsotay's view on the social construction of the value of art is highly instructive in illustrating that such construction was not a matter of individuals becoming emancipated from institutions in the context of laissez-faire thinking. Whereas the anti-guild discourse of Renaissance artists might be initially interpreted as such, Macsotay's focus on a second rupture, this one around the turn of the eighteenth century, reveals the paradoxical nature thereof. Art was now to be freed from all contextual determinants, not only political and cultural, but also economic, utilitarian and pecuniary ones. Paradoxically, however, this freedom was predicated upon social and material circumstances, that is, the presence of amateurs and artist-friends, and the nature and use of space in the academy. Specifically, the new form of authenticity here was excellence, which materialized by shielding it from market imperatives.[68] Whereas the value of art came about by insulating it from the mechanisms and mentalities of the market, excellence was to be achieved via retreat into the artists' studio and engagement in genteel conversations about art as an autonomous activity.

Thus, what was at stake was a transformation at the level of the most elementary relationship between markets and institutions. The most important institutional shift may have been the guilds' loss of power and credibility, including their eventual abolition. Following the work of Philippe Minard, this can be regarded as having been part of a shift from an 'économie de l'offre' to an 'économie de la demande',[69] or from a 'regulated quality' (based on the quality of raw materials) to a 'deliberated quality' (based on conventions).[70] Yet this is not to say that the guilds collapsed into obsolescence due to the advent of free market economics, 'modern' economic practices and changing consumer preferences. Although the relationship between markets, institutions and conventions had indeed changed, nineteenth-century markets were likewise

[68] For similar arguments, see Elizabeth Honig, 'Art, Honor, and Excellence in Early Modern Europe', in Michael Hutter and David Throsby (eds), *Beyond Price: Value in Culture, Economics, and the Arts* (Cambridge, 2008), pp. 89–105.

[69] Cf. Philippe Minard, 'Les corporations en France aux XVIIIe siècle: métiers et institutions', in Kaplan and Minard (eds), *La France, malade du corporatisme?*, pp. 39–51.

[70] Philippe Minard, 'Micro-Economics of Quality and Social Construction of the Market: Disputes among the London Leather Trades in the Eighteenth Century', *Historical Social Research*, 36/4 (2011): pp. 150–168.

shaped and fabricated judicially and institutionally.[71] Moreover, as the chapters by Barbot, Bettoni and others suggest, focusing on institutions should not lead us to overlook the involvement of power in creating conventions.

Given that the guilds acted as manufacturer collectives and that artists cultivated their own individual talents, it would be productive to examine the situation from an actor perspective. Traditional historiography, in framing individual actors as either independent from or totally subject to social institutions, has rendered an inadequate understanding of the sophisticated interconnection and interaction between actors, markets and institutions. This becomes especially clear when analysing the literature on guilds. Guilds have long been considered monolithic economic players which crippled individual initiative, as opposed to meeting grounds for different actor groups, yet economic historians now reduce them to instruments via which economic problems could be solved. In reality guilds were, of course, path-dependent institutions whose customs, rules and material elements were shaped and manipulated by a range of actors and actor groups – which in turn continually adapted to changing circumstances and shifting balances of power. Moreover, institutions such as guilds always confronted actor groups performing partly or entirely beyond the guild frame. For example, manufacturing masters competed with urban authorities and/or large merchants over the control of product quality and entitlements to apply collective hallmarks.[72] Regarding the sale of products, manufacturing masters confronted large merchants and retailers alike, all of whom fought the guild-based master monopolies related to the sale of their products.[73] Thus the next question that arises is: who in fact held the agency to construct conventions and define value in the first place?

Actors, Agency and the Relationship with Products

Traditionally, the history of consumption was largely the history of mass consumption as it emerged in the nineteenth century along with warehouses and supermarkets. This emergence was related not only to a fundamental restructuring of distribution networks and channels, but also to the history of

[71] See, for example, Stanziani, *La qualité des produits en France*; idem, *Histoire de la qualité alimentaire*; Kaplan and Minard (eds), *La France, malade du corporatisme?*

[72] De Munck, 'The Agency of Branding'.

[73] Catharina Lis and Hugo Soly, 'Craft Guilds in Comparative Perspective: A Survey', in Catharina Lis, Jan Lucassen, Maarten Prak and Hugo Soly (eds), *Craft Guilds in the Early Modern Low Countries: Work, Power and Representation* (London, 2006), p. 15; Bert De Munck, 'One Counter and Your Own Account: Redefining Illicit Labour in Early Modern Antwerp', *Urban History*, 37/1 (2010): pp. 39–43.

industrialization and standardization. Beginning in the 1980s, the emergence of a modern consumer society was increasingly sought for in the early modern period (in northwestern Europe) and in the Renaissance (in Italy).[74] Inevitably it was no longer linked to industrialization and Romanticism, but rather to socio-cultural transformations, such as the so-called civilization process. In this sense, it is argued that the introduction of handkerchiefs, forks and restrooms came about due to new sensitivities about the human body and the internalization of discipline and shame. Such assessments spurred questions regarding emulation and distinction, and hence about the driving force of consumer changes.[75] Yet how did distribution channels transform over the long run and what role did standardization play in this context?

Historians have surveyed the rise of the retail sector prior to the nineteenth century,[76] yet they have refrained from linking this to communication about product quality – notwithstanding explicit signs that producers were losing control over such communications with customers.[77] Considering that communication regarding product quality involves at

[74] See, for example, Cissie Fairchilds, 'The Production and Marketing of Populuxe Goods in Eighteenth-Century Paris', in Brewer and Porter (eds), *Consumption and the World of Goods*, pp. 228–248; Richard Goldthwaite, 'The Empire of Things: Consumer Demand in Renaissance Italy', in Francis William Kent and Patricia Simons (eds), *Patronage, Art and Society in Renaissance Italy* (Oxford, 1997), pp. 153–175; Lisa Jardine, *Wordly Goods: A New History of the Renaissance* (London and Basingstoke, 1997); Evelyn Welch, *Shopping in the Renaissance: Consumer Cultures in Italy, 1400–1600* (New Haven and London, 2005); Bruno Blondé, 'Cities in Decline and the Dawn of a Consumer Society: Antwerp in the 17th–18th Centuries', in Bruno Blondé, Eugenie Briot, Natacha Coquery and Laura Van Aert (eds), *Retailers and Consumer Changes in Early Modern Europe: England, France, Italy and the Low Countries* (Tours, 2005), pp. 37–52.

[75] Lorna Weatherill, *Consumer Behaviour and Material Culture in Britain, 1660–1760* (London and New York, 1988); Brewer and Porter (eds), *Consumption and the World of Goods*.

[76] David Alexander, *Retailing in England during the Industrial Revolution* (London, 1970); Alison Adburgham, *Shops and Shopping 1800–1914* (London, 1981); Hoh-Cheung Mui and Lorna Mui, *Shops and Shopkeeping in Eighteenth-Century England* (London, 1989). For recent perspectives, see Bruno Blondé, Peter Stabel, Jon Stobart and Ilja Van Damme (eds), *Buyers and Sellers: Retail Circuits and Practices in Medieval and Early Modern Europe* (Turnhout, 2006).

[77] Exceptions include Carolyn Sargentson, *Merchants and Luxury Markets: The marchands merciers of Eighteenth-Century Paris* (London, 1996); Giorgio Riello, *A Foot in the Past: Consumers, Producers, and Footwear in the Long Eighteenth Century* (Oxford, 2006); Ilja Van Damme, 'Middlemen and the Creation of a "Fashion Revolution": The Experience of Antwerp in the Late Seventeenth and Eighteenth Centuries', in Beverly Lemire (ed.), *The Force of Fashion in Politics and Society: Global Perspectives from Early Modern to Contemporary Times* (Aldershot, 2010), pp. 21–40.

least some degree of defining that particular quality, it would seem that entrepreneurs and middlemen were gradually becoming more engaged in value-creating processes than before. In his chapter on the branding strategies of the seventeenth- and eighteenth-century Antwerp product market, Ilja Van Damme neatly contextualizes the growing importance of middlemen in (re)constructing repertoires of evaluation.[78] Producers in early modern Antwerp did not employ brand names and labels in the same manner as today's product market where, due to advanced levels of industrialized production and the targeted marketing of standardized goods, the products seem almost to speak for themselves, and customers require evidence of a brand only as a convincing marker of trust and reputation. In seventeenth- and eighteenth-century Antwerp, branding was employed primarily as a producers' strategy, aimed at protecting their political interests and existing labour relations. According to Van Damme, however, notwithstanding the guilds' and manufacturing masters' marks, which defined and communicated standardized values for an object, it was in fact retailers who held the true agency in enamouring potential customers and establishing perceptions of products. Given the growing importance of retail during the early modern period, creating the value of an object had largely become a process embedded within the ongoing social relationship between retailer and client, much more so than between producer and client.

In the nineteenth century, the creation of brands and trademarks by large producers and firms may have in turn afforded producers opportunities to directly communicate with their customers – even when their products were being sold through shops and middlemen;[79] however, the transition to the nineteenth century cannot be summarized as a conversion from face-to-face contacts between buyers and sellers based on personalized trust to an anonymous market in which trust stems from product standardization. In her chapter on the commercial culture surrounding Brussels' art auctions in the young Kingdom of Belgium, Anneleen Arnout sketches how auctioneers apparently followed in the footsteps of their eighteenth-century predecessors (cf. Lyna's article) by creating an ever more specialized and sophisticated auction culture.[80] In their endeavours to add value to the paintings for sale, auctioneers demonstrated an elegant flexibility in responding to shifting cultural circumstances and recuperating existing discourses on art. Yet, as the golden age of Brussels auctioning waned at the close of the nineteenth

[78] See Van Damme's contribution to this volume.

[79] For a conceptual overview on branding, see Philip Kotler, Kevin Lane Keller and Peggy Cunningham, *Marketing Management* (Toronto, 2006). See also Lionel Bently, Jennifer Davis and Jane Ginsburg (eds), *Trade Marks and Brands: An Interdisciplinary Critique* (Cambridge, 2008).

[80] See Arnout's contribution to this volume.

century, numerous auctioneers, including even the most prestigious, temporarily abandoned the public sales system and retreated to the retailing business of art. Similar to the strategies employed by early modern retailers, a permanent art gallery offered far more opportunities to establish durable client relations, which were crucial in the historical and contemporary markets for luxury goods.

Likewise, the dominant position of middlemen in communicating value in the nineteenth century should not be uncritically related to the diminished importance of craftsmanship in the value of products during the early modern period. Indeed, during the Renaissance the opposite evolution appears to have occurred. In her article on conventions surrounding the valuation of Venetian glass in the fifteenth and sixteenth centuries, Corine Maitte describes how the invention of *cristallo* and *cristallino* glass related to a newfound respect for human genius. The sophistication of fine glass was considered to derive from 'the effects of genius and art applied to elements of nature'.[81] Of course, the value of craftsmanship was subject to ex ante processes of objectification and naturalization too. While craftsmanship could be related to the implicit and empirical knowledge through which certain effects are produced, in Renaissance Italy it was associated with ingenuity and scholarly writing. These processes were strongly associated with existing labour relations and power issues in Italian cities. The (forced) collaboration between artisans and painters in the Venetian glass industry reflects the failure of glass-makers to become fully recognized as 'artful'. This corresponds with recent views of art historians and historians of science that the early modern period, starting with the Renaissance era, witnessed fundamental transformations in the perception and valuation of the 'mechanical arts'.[82]

Italian painters and sculptors increasingly strove to distinguish themselves from 'mechanical' artisans and emphasized the 'liberal' character of their calling. Such views were first articulated in the early sixteenth century, in Milanese humanist artist circles that centred around no less an historical personage than Leonardo da Vinci. An ideological programme, advanced through the writings of artists and humanist theorists such as Leonardo, Vasari and Zuccaro, became conceptualized such that painting, sculpture and architecture were raised to the level of a liberal art; the newly erected Academies of Fine Arts served as their ideological instruments. These institutions were considered the metaphorical midwives that would assist in

[81] See Maitte's contribution to this volume.
[82] Pamela Smith, *The Body of the Artisan: Art and Experience in the Scientific Revolution* (Chicago, 2004); Peter Dear, Lissa Roberts and Simon Schaffer (eds), *The Mindful Hand: Inquiry and Invention from the Late Renaissance to Early Industrialization* (Amsterdam, 2007); Pamela Long, *Artisan/Practitioners and the Rise of the New Science* (Corvallis, 2011).

the birth of the artist as a creative genius, whereby he could claim a higher social and economic position for himself and his art in sixteenth-century Italian urban society. This example would soon be followed, albeit often unsuccessfully, throughout the transalpine Europe of the late seventeenth and early eighteenth centuries.[83]

Here as well, however, the 'modernity narrative' is contradicted or at least complemented by important counter-examples. As the contribution of Maitte shows, a group of immigrant Altare glass producers in sixteenth-century France were keenly aware of the economic importance of their profession presenting a high social status. Unlike their Italian comrades, they succeeded in purposefully constructing a positive image. As 'Sires', they even acquired privileges as gentlemen glass-makers from the French king. These craftsmen recognized the reigning sixteenth-century convention in valuing luxury objects, whereby the status of the producer greatly contributed to the value of the product, in their case Murano glass. Other artisans were not so lucky, at least not if they clung to specific 'traditional' types of product in which the emphasis was on 'intrinsic value'.[84]

In summary, while skills and technical knowledge became more important, guild-based masters nonetheless appear to have lost the battle on two fronts. On the one hand, the Renaissance era witnessed a stronger emphasis on talent and ingenuity on the part of some artisans – notably those who had begun to regard themselves as artists and, in the process, distanced themselves from 'mere' handcrafts.[85] On the other hand, some manufacturing masters (but not all, as made clear by Maitte) were forced to abandon at least some degree of their capacity to sell their products directly to customers; consequently, they also lost control not only over how product quality was communicated, but also over how a good product was actually defined. Nevertheless, this should not suggest that shifting locations of value are reducible to shifting power relations and altering agency (at least not as power and agency have been traditionally defined). We would rather suggest that transitions at the level of markets, institutions and agency should be linked to transformation at the level of the relationship of subjects to objects. What changed, after all, was the very relationship of individuals and groups to products and, ultimately, to matter and materiality.

[83] Carl Goldstein, *Teaching Art: Academies and Schools from Vasari to Albers* (Cambridge, 1996), passim.

[84] See Bettoni's contribution to this volume; also De Munck, 'Skills, Trust and Changing Consumer Preferences'; and idem, 'The Agency of Branding'.

[85] For similar ideas and additional references, see Bert De Munck, 'Corpses, Live Models, and Nature: Assessing Skills and Knowledge before the Industrial Revolution (Case: Antwerp)', *Technology & Culture*, 51/2 (2010): pp. 332–356.

Conclusion and Avenues for Future Research

While starting from a 'heterodox' view in which different conventions and repertoires of evaluation were active in different historical contexts and for different types of products and markets, these essays nonetheless point to broader historical transformations in Europe. On the surface, they point to a process in which consumers became more important as actors in the 'location of value'. Yet, due to the integration of supply and demand side perspectives, they venture beyond such current perspectives of historians studying material culture as, among others, the transformation of houses into homes and the emergence of intimacy;[86] the rise of fashion and the creation of group and individual identities (including gender differences);[87] and the introduction of exotic products, modern tableware and the importance of sociability.[88] While these perspectives successfully connect the broader social context to preferences and tastes, our volume adds new insights about the relationship between markets, institutions, power relations and, last but not least, market devices.

As we suggested earlier, the standard account relates a shift away from durable products with high 'intrinsic value' (the value of the raw materials used) and high potential for resale and recycling, and towards cheaper, more fragile and more fashion-sensitive products which needed to be replaced (and thrown away) ever faster.[89] According to the aforementioned Jan De Vries, this qualitative shift in the composition of household 'consumption bundles' was linked to the increasing importance in the field of material culture of bourgeois middling groups for which some forms of consumption became more individuated, and sociability was, as it were, increasingly 'consumed' outside the home.[90]

While this account has generated a plethora of notable research, much of it tends to reduce the question of materiality to a matter of substitution (by

[86] Annick Pardailhé-Galabrun, *La naissance de l'intime: 3000 foyers parisiens, XVIIe–XVIIIe siècles* (Paris, 1988); Raffaella Sarti, *Europe at Home: Family and Material Culture 1500–1800* (New Haven and London, 2002); Marta Ajmar-Wollheim and Flora Dennis (eds), *At Home in Renaissance Italy* (London, 2006); Giorgio Riello, 'Fabricating the Domestic: The Material Culture of Textiles and the Social Life of Home in Early Modern Europe', in Lemire (ed.), *The Force of Fashion in Politics and Society*, pp. 41–66.

[87] Roche, *La culture des apparences*; Ulinka Rublack, *Dressing Up: Cultural Identity in Renaissance Europe* (Oxford, 2010). For recent perspectives and additional references, see Lemire (ed.), *The Force of Fashion in Politics and Society*.

[88] For example, Cowan, *The Social Life of Coffee*.

[89] Helen Clifford, 'A Commerce with Things: The Value of Precious Metalwork in Early Modern England', in Berg and Clifford (eds), *Consumers and Luxury*, pp. 147–168.

[90] On the commodification of culture, see, among others, John Brewer, '"The Most Polite Age and the Most Vicious": Attitudes towards Culture as a Commodity, 1660–1800', in Bermingham and Brewer (eds), *The Consumption of Culture*, pp. 341–361.

'populuxe goods') and relative prices. Most of the contributions in this volume, however, refer to both diverging and more fundamental transformations. Corine Maitte stresses that the linear and teleological idea of the emergence of a consumer revolution à la De Vries and the related distinction between the Italian Renaissance and the seventeenth- and eighteenth-century transformation in northwest Europe should be qualified.[91] Glass, for example, is made from low-cost materials like sand, ashes and lime, and so its value and luxuriousness cannot be reduced to intrinsic value. Thus the glass sector in fifteenth- and sixteenth-century Italy already saw not only differing qualities for different market segments but also different value systems for the appreciation of goods. Moreover, interest in this 'new luxury' was not limited to bourgeois middling groups. While the prices for the finest glassware were less than those for precious stones and metals, the emergence of glass as an important new product cannot be attributed solely to Italian 'middle classes' turning to glass replicas of financially unaffordable objects. Rather, fine glass was introduced by the aristocratic elites and the princely courts of the Renaissance, who were apparently seeking novel ways to distinguish themselves from the growing numbers of people who were capable of imitating their tastes and purchases.

Moreover, the waning importance of intrinsic value is not reducible to a shift from acts of 'investment' to pure acts of consumption, but should also be connected to changing notions about the craftsmanship invested in a product. The establishment of 'façon de Venise' glass as a new ostentatious luxury product was related to new ways of perceiving skills, talent and workmanship, which cannot be reduced to a process in which artisans and artists simply learned to manipulate new types of raw material.[92] While Helen Clifford, in her chapter, hints at a process in which artisans crafting new luxuries created certain effects related to old luxuries – with new and sophisticated techniques being used to render 'old' effects – Bettoni reveals that there was an institutional component to this. Traditionally, the guilds had defended their privileges and regulations that referred to honesty and market transparency (related to intrinsic value). Their rules and hallmarks guaranteed that customers knew what they were buying in terms of raw materials and alloys.[93] Consequently, the guilds' complaints frequently targeted artisans who specialized in new metal alloy techniques and cast engraving with which the effects of the traditional products were imitated. Embroiderers and button-makers who used cheaper materials (especially camel, goat and horse hair), but offset this via their labour rather than deception, were less hindered.

[91] See Maitte's contribution to this volume.
[92] Berg, *Luxury and Pleasure*, p. 24.
[93] See Bettoni's contribution to this volume; also De Munck, 'Skills, Trust and Changing Consumer Preferences'.

This institutional dimension should not, in turn, lead us to reduce this to the issue of market transparency. In Barbot's case study as well, intrinsic value appears to have faded as a factor in the location of value. This case study addresses conventions related to real estate and involves two 'repertoires of assessment': an 'objective' one, based upon certain characteristics of the real estate, and a 'subjective' one, related to the transacting parties. The objective repertoire includes the function, location and architectural characteristics of the building (and neighbouring buildings) in question, thus referring to a certain 'intrinsic value' too. The subjective one involves the relationship between the contractual parties (family and other relationships, previous business-like connections, and so on) and social status, that is, the correspondence between the 'nature of things' and the 'quality' of the people who own them. Barbot expresses the latter relationship via the following observation: 'If the socially stronger party is the seller, the value of the property, generally speaking, is increased in his favour; but if instead he is the purchaser, the opposite occurs.'[94]

Besides the institutional context, the importance of the social relations involved is here confirmed – although without this justifying a reduction to a shift from a supply side to a demand side perspective, let alone changing labour relations. The overall view is one of profound inter-related transformations of European society which seem to warrant a careful return to the tradition of historical sociology – where economic, social and cultural dimensions were not only intertwined, but where the very emergence of the *homo economicus* was at stake. Ours is of course not a plea for a return to the modernity narratives involved, but we do believe that issues involved in Marxist and Polanyian approaches to commodification and Weberian perspectives on 'rationality' and 'calculability' should again take central stage. The above-mentioned concepts of 'framing' and 'disentanglement' of Michel Callon and others enable doing so without falling into Eurocentric and teleological traps.[95]

In addition, the inclusion of new perspectives about the field of tension between gift and commodity may make sense. As is well known among historians of material culture, anthropologists such as Marshall Sahlins and Arjun Appadurai have argued that whether an exchanged object should be regarded as a gift or a commodity depends on the social relations and the cultural contexts involved.[96] As such, they have transcended the gift–commodity dichotomy while remaining firmly on the axis of debates between Marxist or post-structuralist approaches and without really problematizing the materiality

[94] See Barbot's contribution to this volume.

[95] Bert De Munck, 'Conventions, the Great Transformation and Actor Network Theory', *Historical Social Research/Historische Sozialforschung*, 37/4 (2012): pp. 103–124.

[96] Marshall Sahlins, *Stone Age Economics* (Chicago, 1972), chapters 4 and 5; Appadurai, 'Introduction', in *The Social Life of Things*.

of both the gifts or commodities concerned and the material devices involved in the circulation and valuation thereof.[97] Our volume not only suggests that the material contexts and market devices and technologies mattered as well, but also that the post-structural approach to value may itself have been a product of history. After all, the creation of outward effects, as alluded to in the chapters by Clifford and Bettoni, may have been part of a broader shift, in which 'sign value' took centre stage at the expense of 'intrinsic value', or an approach in which the value of the product held gift characteristics because of the 'spirit' of the giver or producer connected to it.[98] Consequently, further research should also include epistemological perspectives so as to stimulate conceptual criticism and self-reflexivity. We hope that the current volume will serve as a stimulus for that.

[97] One alternative approach is elaborated in Webb Keane, 'Semiotics and the Social Analysis of Material Things', *Language and Communication*, 23 (2003): pp. 409–425. Also idem, *Christian Moderns: Freedom and Fetish in the Mission Encounter* (Berkeley, 2007).

[98] This idea is further developed in Bert De Munck, 'Guilds, Product Quality and Intrinsic Value: Towards a History of Conventions?', *Historical Social Research/Historische Sozialforschung*, 36/4 (2011): pp. 103–124. See also Bert De Munck, 'Artisans, Products and Gifts: Rethinking the History of Material Culture in Early Modern Europe', *Past & Present*, 224 (August 2014): pp. 39–74.

PART I
Expanding Markets and Market Devices

Chapter 2

Labelling with Numbers? Weavers, Merchants and the Valuation of Linen in Seventeenth-Century Münster

Christof Jeggle

Introduction

The labelling of textiles has been a common practice since the Middle Ages.[1] In many cases different kinds of labels were attached to the textiles, indicating the producer, the guild of the producer, a place of origin or specific product qualities.[2] At the different places where labels for textiles were issued, specific systems for marking the textiles were practised. The practices of attributing value to products in early modern production and distribution are still among the desiderata of research, also for the reason that detailed documentation often tends to be scarce. The relations between the marking of products and the attribution of value are a subject which has only recently been approached more systematically.[3] For most of commercial history, the marking of textiles

[1] Reinhold Kaiser, 'Mittelalterliche Tuchplomben – Überreste, Sammelobjekte und technik-, textil-, und wirtschaftsgeschichtliche Quellen', in Horst Kranz and Ludwig Falkenstein (eds), *Inquirens subtilia diversa. Dietrich Lohrmann zum 65. Geburtstag* (Aachen, 2002), pp. 375–390; see also Evamaria Engel, 'Signum Mercatoris – Signum Societatis. Zeichen und Marke im Wirtschaftsleben deutscher Städte des Spätmittelalters', in Gertrud Blaschitz, Helmut Hundsbichler, Gerhard Jaritz and Elisabeth Vavra (eds), *Symbole des Alltags – Alltag der Symbole. Festschrift für Harry Kühnel zum 65. Geburtstag* (Graz, 1992), pp. 209–231.

[2] See, for example, Reinhold Kaiser, 'Imitationen von Beschau- und Warenzeichen im späten Mittelalter. Ein Mittel im Kampf um Absatz und Märkte', in *Vierteljahrschrift für Wirtschafts- und Sozialgeschichte*, 74 (1978): pp. 457–478; idem, 'Fälschungen von Beschauzeichen als Wirtschaftsdelikte im spätmittelalterlichen Tuchgewerbe', in *Fälschungen im Mittelalter. Internationaler Kongreß der Monumenta Germaniae Historica, München, 16.–19. September 1986, Teil V, Fingierte Briefe, Frömmigkeit, Realienfälschungen* (Hannover, 1988), pp. 723–752.

[3] See especially Bert De Munck, 'La qualité du corporatisme. Stratégies économiques et symboliques des corporations anversoises, XVIe–XVIIIe siècles', *Revue d'histoire moderne et contemporaine*, 54 (2007): pp. 116–144; idem, *Technologies of Learning: Apprenticeship in Antwerp Guilds from the 15th Century to the End of the Ancien Régime* (Turnhout, 2007), pp. 236–249; idem, 'Skills, Trust, and Changing Consumer Preferences: The Decline of

is considered as a kind of branding that allowed for the trading of textiles as standardized fungible commodities of a certain origin and made commerce more efficient.[4] This view is acceptable when defining certain product qualities to constitute a good that may be commoditized as a specified product for being distributed in long-distance trade, and which, as a serial product, was designed to be traded in an economy of scale. Artisan historians, however, have posited that the labelling of textiles prescribed by the authorities served to exploit producers rather than to guarantee qualified goods.[5] The following case study will show that this point could be an important issue for political negotiations between artisans and political authorities. The relevance of the labels of origin, which were usually provided by guilds or by institutions maintained by political authorities,[6] was a result of the artisan-based forms of production. All kinds of mass-produced products were manufactured by single artisans or small workshop teams who often constituted a whole network of production. With this decentralized form of production, within which most artisans organized themselves in some form of collective sociability, it would have been difficult for a single producer to act as a representative of an individual brand and to establish a producer's brand.[7] Producers' names as brands

Antwerp's Craft Guilds from the Perspective of the Product Market', *International Review of Social History*, 53 (2008): pp. 197–233.

[4] For example, Wolfgang Von Stromer, *Die Gründung der Baumwollindustrie in Mitteleuropa. Wirtschaftspolitik im Spätmittelalter* (Stuttgart, 1978), pp. 148–152; Lukas Clemens and Michael Matheus, 'Tuchsiegel – eine Innovation im Bereich der exportorientierten Qualitätsgarantie', in Uta Lingren (ed.), *Europäische Technik im Mittelalter. Tradition und Innovation* (Berlin, 1996), pp. 479–480.

[5] Cf. Hans Medick, *Weben und Überleben in Laichingen 1650–1900. Lokalgeschichte als allgemeine Geschichte* (Göttingen, 1996), pp. 127–130; Philippe Minard, 'Normes et certification des qualités: les règles du jeu manufacturier au XVIIIe siècle', in Jean-Christophe Cassard (ed.), *Bretagnes. Art, négoce et société de l'Antiquité à nos jours. Mélanges offerts au professeur Jean Tanguy* (Brest, 1996), pp. 173–190, at 184–190; Claus Peter Clasen, *Die Augsburger Weber. Leistungen und Krisen des Textilgewerbes um 1600* (Augsburg, 1981), pp. 381–382, 387; Marcel Boldorf, *Europäische Leinenregionen im Wandel. Institutionelle Weichenstellungen in Schlesien und Irland (1750–1850)* (Cologne, Weimar and Vienna, 2006), pp. 128–132. Markus Küpker, *Weber, Hausierer, Hollandgänger. Demografischer und wirtschaftlicher Wandel im ländlichen Raum: Das Tecklenburger Land 1750–1870* (Frankfurt am Main and New York, 2008), pp. 88–89, doubts if the inspection of linen on the *leggen* in Westphalia was of any use for the textile trades. In his view the *leggen* were only designed for raising fiscal income.

[6] Concerning the forms of organization, a large variety can be observed throughout Europe. In many cases these institutions were part of the fiscal regime and fees for the inspection of products had to be paid.

[7] Cf. also the remarks of Von Stromer, *Die Gründung der Baumwollindustrie in Mitteleuropa*, 148.

only turned up for highly valued specialized goods. From the late fifteenth century onwards, single producers of artworks represented themselves as artists and established their names as brands; and from the sixteenth century onwards, highly specialized artisans for high-value goods, such as goldsmiths, manufacturers of special products, such as scientific instruments, or publishers started to market their products with a personalized label. Products were usually labelled with indications of a denominated place of origin, because the single producer was less important than the guarantee of certain qualities of the product which customers were expecting. For mass-produced textiles the indicated place of origin on the label was not necessarily the place where it was fabricated, because in some cases the fabrics were brought to the certifying institution from abroad. Bert De Munck has emphasized that most labels were designed to guarantee the quality and quantity of the raw materials, because these were decisive for the value of a product.[8] In the medieval beginnings of marking products, these labels were closely linked to certain groups of local producers who often tried to protect a privileged production of specific products or product designs with the aim of exclusively profiting from the returns of highly valued goods. Fraud and imitation, not only of products but also of labels, were a common reason for conflict among competing places of production.[9] Especially in the case of textiles, these practices were maintained in principle until the nineteenth century, when the industrial producers' brands became more important for product labelling than the particular place of origin.[10]

[8] De Munck, 'La qualité du corporatisme', pp. 128–134; idem, *Technologies of Learning*, pp. 236–249; idem, 'Skills, Trust, and Changing Consumer Preferences', 215–222. For the current state of discussion, see Chapter 1 of this volume.

[9] Cf. Kaiser, 'Immitationen'; idem, 'Fälschungen'; Alfons K.L. Thijs, 'Perceptions of Deceit and Innovation in the Antwerp Textile Industry (Sixteenth and Seventeenth Centuries)', in Toon von Houdt, Jan L. De Jong, Zoran Kwak, Marijke Spies and Marc van Vaeck (eds), *On the Edge of Truth and Honesty: Principles and Strategies of Fraud and Deceit in the Early Modern Period* (Leiden and Boston, 2002), pp. 127–147; Simonne Abraham-Thisse, 'La fraude dans la production des draps au Moyen Âge: un délit?', in Gérard Béaur, Hubert Bonin and Claire Lemercier (eds), *Fraude, contrefaçon et contrebande de l'Antiquité à nos jours* (Geneva, 2006), pp. 431–456; Gérard Gayot, 'Réflexions sur les fraudes textiles', in Béaur, Bonin and Lemercier (eds), *Fraude, contrefaçon et contrebande*, pp. 511–514; on linen from Münster and Osnabrück, see Christof Jeggle, 'Copier et contrefaire des textiles au temps de la Renaissance', in Pascale Mounier and Colette Nativel (eds), *Copier et contrefaire à la Renaissance. Faux et usage de faux* (Paris, 2014), pp. 293–306.

[10] William M. Reddy, 'The Structure of a Cultural Crisis: Thinking about Cloth in France before and after the Revolution', in Arjun Appadurai (ed.), *The Social Life of Things: Commodities in Cultural Perspective* (Cambridge, 1986), pp. 261–284.

This short outline shows that the labelling of products and the attribution of valuation could be related in several respects. Certain labels could influence the value because they were promising certain qualities, such as a particular quality of raw materials, a certain product design or some exclusive distinction from comparable products. As the labels and the attribution of value were often closely linked, violations were usually rigidly prosecuted, because the owners of the labels, in many cases political authorities, feared a devaluation of their original products. Violations were also considered as an immediate offence against the political authority.

The brotherhood of the linen weavers in the Westphalian city of Münster sent a petition to the city council in December 1668 claiming that certain practices of labelling their linens at the municipal inspection would cause the risk of a devaluation of their products on the linen market in Amsterdam, which they considered their most important selling location. Such devaluation would not only cause harm to their trade, but also to the merchants of Münster who were dealing with their linen in Amsterdam. The weavers explained to the city council in some detail how, in their view, the business with their linen on one of the most important European markets worked, and how the linen had to be designed to receive sufficient estimation of value by customers.[11]

In Münster the linens fabricated by professional producers for export markets were inspected by the municipal institution for inspecting and labelling linen, called the *legge*. For the weavers, the way in which the fabrics were labelled after having passed the inspection of the *legge* and the attribution of value on markets were closely linked. In the following paragraphs, this relationship will be analysed to understand how these two practices were related, where and how the attribution of value took place, and why the weavers were very particular on this point.

Before analysing the question of how product quality, labelling and evaluation could be related on the basis of these conflicts, the development of the professionalized production of linen in the city of Münster will be outlined, because the conflicts during the 1660s which provide the material for a detailed analysis were not new and have to be seen against the background of the historical development of local linen production.

[11] Stadtarchiv Münster (StdAM), A XI, Nr. 9, f. 17, 14 December 1668. This article is based on the research for my PhD dissertation – Christof Jeggle, 'Leinen aus Münster im 16. und 17. Jahrhundert' (Free University Berlin, 2009) – which provides detailed evidence on the archival material. The documents of the municipal archive of Münster/Westphalia for this study comprise the records of the city council, municipal account books and documents of the brotherhood of the linen weavers and of the *legge*. Data on the social situation are mainly based on the analysis of tax registers, testaments and inventories.

The Inspection of Linen in Münster

Research to date has not been able to reveal when the label of origin of the city of Münster for linens was established. During the fourteenth century linen originating from Münster was recorded in English customs registers.[12] The first evidence for the establishment of the *legge* as an institution for the inspection of linen in Münster is found for 1458.[13] Perhaps the city council had set it up for drawing the trade with rural linens into the city, while it never succeeded in its claim to direct the whole linen trade carried out within the city to the *legge*. The institutional basis of the inspection procedures taking place on the *legge* remains unknown until the 1530s. With the re-establishment of urban government in 1535 after the defeat of the Baptists, who had burned the archive of the city council, the oaths and rules of the city were recollected. For the first time an oath for the *legger* describing the essential part of the procedures for linen inspection was preserved.[14] Now the *legge* was maintained by an employee of the city council called the *legger* who was assisted by his wife. In the course of the inspection at the *legge* the linens had to be laid on a table for measuring and control. The pieces of linen had to meet certain quality standards. They had to be made of pure flax and woven with a proper and even texture. The length of the linens had to be written on each piece and when the quality met the requirements, the seal of the city was stamped onto it. The width of the linens was not subject to these first rules. Later versions indicate that the width of the linens seems to have followed the convention of measuring several quarters of an ell and possibly indicated different sorts of linen.[15]

After the inspection, each piece was wrapped into a roll and the kind of wrapping was designed to signal certain qualities of the linen. The most important criteria were the pureness of the material, since only the use of pure flax was allowed, and the size of the piece that would indicate the volume of the material. The way the roll was tied and labelled signalled some classifications of

[12] Thanks to Angela Ling Huang for providing this information; for details, see her dissertation: Angela Huang, *Die Textilien des Hanseraums. Produktion und Distribution einer spätmittelalterlichen Fernhandelsware* (Cologne, Weimar and Vienna, in print).

[13] Karl-Heinz Kirchhoff, 'Hinweise auf die Leinen-Legge zu Münster 1456–1569', *Westfälische Forschungen*, 31 (1981): pp. 119–123. For the terminology of organization, institution and convention, see Rainer Diaz Bone, 'Konvention, Organisation und Institution. Der institutionentheoretische Beitrag der "Économie des conventions"', in *Historical Social Research/Historische Sozialforschung*, 34/2 (2009): pp. 235–264.

[14] StdAM, A III, Nr. 2, f. 33, s.d.; cf. also the editions of Robert Krumbholz, *Die Gewerbe der Stadt Münster bis zum Jahre 1661* (Stuttgart, 1898; reprinted Osnabrück, 1965), pp. 304–307.

[15] This seems to have been common practice in many places and deserves more comparative research.

the quality of the workmanship, which seemed to follow certain conventions and were not defined by the rules. These linens were classified as *schmal* ('narrow') or *legge* linens, for which the *legge* only guaranteed a general quality frame. Within this quality frame it is likely that the linens were distinguished in a large variety of more specialized qualities and sorts that were defined by conventions and not by institutional rules. After the inspection the linens were sold on specialized markets constituting customers that were interested in buying specific qualities.[16] Some of the linens were sold as bulk ware on the large European textile markets. *Münsterisch* linen as a trademark of origin for linens with guaranteed qualities was established on the markets in the late fifteenth century because the city of Lübeck, in a letter from 1465, expected that the quality standards would be observed.[17] Until the late sixteenth century linen labelled as originating from Münster was not produced inside the city, as the linens being inspected came from the sideline production in the surrounding Münsterland. This kind of label of origin was not linked to an urban trade. At the *legge* the rather incidentally produced rural linens were transformed into a marketable commodity and some basic standards of quality were guaranteed. Unfortunately, the lack of price data does not allow any detailed analysis of the attributions of commercial value for this kind of linen. It can thus only be suspected that passing the inspection successfully and receiving the labels of the *legge* allowed the trading of these linens on specialized business-to-business markets for branded textiles. This qualification could have increased the value of the linens. Besides this commercial trade, quite a lot of linen seems to have been traded without any inspection or labelling within the city of Münster on the basis of interpersonal exchange.

Establishing a Professionalized Urban Trade for 'Broad' Linen

The city itself only became a significant location for the production of linen after weavers had migrated to the city from 1580 onwards. Most of them originated from a few places in the northwestern part of the Münsterland. They were probably trying to escape the obstacles created by the Eighty Years War in the nearby Netherlands which also affected the Münsterland.[18] In 1602

[16] On sorting out batches of specific qualities, cf. Pierre Claude Reynard, 'Manufacturing Quality in the Preindustrial Age: Finding Quality in Diversity', in *Economic History Review*, 53 (2000): pp. 493–516.

[17] *Urkunden-Buch der Stadt Lübeck*, ed. Verein für Lübeckische Geschichte und Alterthumskunde, Zehnter Teil, 1461–1465 (Lübeck, 1898), No. DCLXIX, pp. 676–677, 15 October 1465. The letter refers only to some implicit convention of proper quality which the linens were expected to have and does not offer any details.

[18] For a detailed analysis, see Christof Jeggle, 'Leinenproduktion und regionale Migration nach Münster in Westfalen von 1580 bis 1635', in Dittmar Dahlmann and

some of these weavers petitioned the city council to accept the establishment of a brotherhood of weavers.[19] The weavers claimed that they would produce linen on contract for citizens who would provide them with yarn. They declared themselves as citizens and complained about immigrant weavers, who did not acquire citizenship and therefore would not contribute to the burdens and services of the city, such as paying taxes. These other weavers would benefit from this irregular advantage. The petitioners also claimed to have problems with their journeymen and apprentices, because they lacked authority in the case of a conflict. These inexperienced weavers would start to work on hired looms, messing up the yarn of their customers. In addition, the weavers mentioned there were unqualified producers who would damage their business. To protect their business, the petitioners asked the city council to accept a brotherhood for the production of the so-called *breit* ('broad') linen, while the production of 'narrow' and *legge* linen should remain open to everyone, men and women.[20] In 1602 the city council was not interested and rejected the demand; nevertheless, the weavers went ahead and founded an informal brotherhood. In 1612 this informal brotherhood repeated its demand and asked the city council to delegate one of its members as an administrator of the brotherhood.[21] The complaints were the same and, after reminding the council with a draft of the statutes for the brotherhood, the city council finally accepted the brotherhood in May 1613 by decreeing the rule and delegating members as administrators.[22] The rule did not describe the product; it regulated access to the trade by defining the conditions for obtaining mastership, and most of the articles addressed the treatment of journeymen and apprentices. After its foundation, the brotherhood does not seem to have been very exclusive as long as the candidates for membership could

Margrit Schulte-Beerbühl (eds), *Perspektiven in der Fremde? Arbeitsmarkt und Migration von der Frühen Neuzeit bis zur Gegenwart* (Essen, 2011), pp. 75–93.

[19] Krumbholz, *Die Gewerbe der Stadt Münster*, pp. 297–298. The text of this edition is abridged.

[20] In Münster, there were 17 established guilds that were part of the political system constituting the council of the *alder-* and *mesterleute*; cf. Karl-Heinz Kirchhoff, 'Gesamtgilde und Gemeinheit in Münster (Westf.), 1410 bis 1661. Zur Entwicklung einer bürgerschaftlichen Vertretung innerhalb der Ratsverfassung', in Franz Petri, Peter Schöller, Heinz Stoob and Peter Johanek (eds), *Forschungen zur Geschichte von Stadt und Stift Münster. Ausgewählte Aufsätze und Schriftenverzeichnis* (Warendorf, 1988), pp. 235–279. Trades who were not represented by these guilds could ask the city council to accept the foundation of a secular brotherhood for organizing themselves. In contrast to the guilds, the brotherhoods were supervised by the city council; cf. Krumbholz, *Die Gewerbe der Stadt Münster*, pp. 3–12.

[21] Krumbholz, *Die Gewerbe der Stadt Münster*, pp. 298–299. The text of this edition is abridged.

[22] Ibid., p. 300.

meet the requirements. After having established the brotherhood, the weavers produced their linen without leaving many traces in the documents.

Some changes in the production of the weavers were indicated in 1635 when a supplementary article to the rule of the brotherhood was amended. In this article the council gave the order that every master had to provide proper length and width for each piece of 'broad' linen, which had to measure seven half quarters (of an ell) of width and 48 ells of length.[23] Each master had to attach his mark to the piece to allow it to be traced back to the producer, in case of complaints. The marks had to be registered in the book of the brotherhood.[24] The principals of the brotherhood had the duty of inspecting each piece of linen on the loom and of controlling the measures. Cases of infringement had to be fined. But it seems as though the linens were not labelled after having passed the inspection; therefore these procedures were invisible to customers.

This supplementary article provides for the first time some indicators of the specific qualities of 'broad' linen produced by the brotherhood. It also suggests that some changes in the production of the weavers of the brotherhood had taken place. As they claimed in their petitions, the members of the brotherhood seemed to produce mainly on contract for local citizens who provided the material. This kind of 'Lohnwerk'[25] was based on the interpersonal relationship between the producer and the customer, who could negotiate the kind of qualities of each piece of linen. It can only be assumed that these contracted pieces of linen did not necessarily meet a pre-set general standard; instead they had to meet the specific demands of the customer. This way of production can be interpreted as an interpersonal convention of production.[26] The specific qualities of the product were subject to a special interpersonal agreement between the buyer and the producer. Hence, independent labelling of the linens was not necessary. The weavers were maintaining a production market only directed upstream,[27]

[23] StdAM, A XI, 237a, f. 7, 20 August 1635. In Münster, the ell had a length of about 58 cm.

[24] Unfortunately this book has not been preserved.

[25] Literally 'waged labour', the term was introduced by the German Historical School of Economics, cf. Reinhold Reith, 'Lohnwerk', *Enzyklopädie der Neuzeit* (Stuttgart and Weimar, 2008), vol. 7, cols 999–1001.

[26] The idea of certain conventions of production refers to Robert Salais and Michael Storper, *Les mondes de production. Enquête sur l'indentité économique de la France* (Paris, 1993) – on the interpersonal convention of production, see p. 45; see also Christof Jeggle, 'Pre-Industrial Worlds of Production: Conventions, Institutions and Organizations', in Rainer Diaz-Bone and Robert Salais (eds), *Conventions and Institutions from a Historical Perspective/Konventionen und Institutionen in historischer Perspektive*, Special Issue – *Historical Social Research/Historische Sozialforschung*, 36 (2011): pp. 125–149.

[27] The model of production markets directed upstream or downstream in the production network refers to Harrison C. White, *Markets from Networks: Socioeconomic Models of Production* (Princeton, 2002), pp. 177–199.

from where they were provided with raw material by their customers and returned the finished product to them. The weavers offered linen production as a service, but they did not organize the acquisition of raw material and the distribution of their products, which was done by their customers. Within this setting the founders of the brotherhood intended to guarantee a certain degree of professional training for its members to stabilize the quality frame of their production market in a very competitive field of linen production. The weavers tried to attract their customers with the reputation of an organization of professionally trained artisans who distinguished themselves from those producers they considered insufficiently trained and unreliable in their business practices. Missing data means that it is impossible to know how successful the members of the brotherhood were in comparison to other weavers. The second petition shows that the informal brotherhood complained about its lack of authority and asked for an organization based on the institution of a formal rule established and supervised by the city council. For governing their trade, the weavers found it necessary to draw on the authority of the council. The question concerning the location of value would be: did the reputation and maybe an above average level of workmanship based on professional training lead to an attribution of more value to the linens? Unfortunately the lack of data does not allow any further inquiry.

Until 1635 the weavers seem to have changed their production methods, because now precise measurements for each piece were defined and it seemed necessary to control the right measurements. In case of complaints, the weavers could be identified. These first steps towards introducing formalized quality control standards can be taken as an indicator of a shift to a production convention directed at selling the linens beyond the range of immediate personal relationships, as standardized products on markets. Still it seemed sufficient to provide the correct measurements with procedures that were invisible to customers. Twenty-two years after its foundation, the brotherhood had developed a production market based on a quality frame for standardized serial products, which was now directed downstream to customers beyond the interpersonal relations of the weavers. The brotherhood seems to have shifted from a predominant convention of interpersonal production to a convention of serial production.[28] With this change to another production convention, new forms of reducing uncertainty in the relationship between producers and customers were necessary. How the reputation of the brotherhood was being represented in the business relations of the weavers is not documented, but it

[28] Salais and Storper, *Les mondes de production*, p. 44, call this kind of convention a 'convention of industrial production'. At least for the pre-industrial period it seems more appropriate to speak of a convention of serial production.

is obvious that the brotherhood was expected to provide a certain quality of product. The brotherhood had not invented a new kind of linen; rather the weavers had refined and professionalized the production of an already established sort.[29] Hence it operated in a climate where numerous competitors outside of the brotherhood were offering linens with qualities close to the quality frame of the brotherhood. The weavers had to maintain their quality standard carefully in order to retain their production market.[30] After they had turned from their customers upstream, who had provided the yarn, to the customers on the markets downstream, the weavers now had to take care of supplying themselves with yarn. The provisioning of the yarn took place on the upstream side of their production market, but there are no indications of difficulties or extensive competition; moreover, competition was now being directed downstream to the customers of a finished product.[31]

The attribution of value to the linens and the negotiation of prices now took place on the markets where the linens were offered. It is not clear how and to whom the weavers sold their products. As standardized goods, these linens could be traded as bulk ware with an economy of scale. Within the large variety of sorts, the weavers' linens had to meet a quality standard that was recognized by the customers as of a particular quality, for which they would pay a reasonable price. As the conflicts discussed in the following indicate, the prices on the linen markets seem to have been very sensitive to small quality differences. Since the margins that the weavers were obtaining made up a smaller part of the price that they could accept, it was important for them to find a favourable balance between the investment in raw materials and workforce and the prices that could be negotiated on the markets. The volume of invested workforce was decisive for the number of linens that each weaver could produce in a certain period of time, which seemed to be no more than around 11 pieces per annum for the higher qualities. Hence, producing one piece more or less seemed to be of some relevance for annual income. The volume of material was decisive for the quality, especially the density, of the fabric; and it was also crucial for its evaluation, which was based on the value of the raw materials.[32] The cost of the yarn seemed to be a rather large investment for each weaver in comparison to his wealth; thus the margin of profitability for the investment in material was of some relevance for the weavers. When quality standards and the volume of material could

[29] There are indications of the production of 'broad' linens since the late sixteenth century, but the size of these linens seemed to follow a convention of fairly accurate measures. Part of the innovation is the task of keeping the given measures as precise as possible.

[30] White, *Markets from Networks*, pp. 84–87.

[31] Ibid., pp. 5–12, 27–48. Unfortunately the documents only offer scarce evidence for the details of the trade with yarn.

[32] On the valuation of raw material, see Chapter 1 of this volume.

be guaranteed and the quality of workmanship could be kept at a level above average within the quality frame without requiring too much investment in workforce, it was more likely that they could achieve an advantageous price level. For interpersonal production conventions, the weavers only had to observe the local conventions of attributing value and pricing, and they could readjust the balance between investment and return for each piece. For serial products they had to recognize the practices of attributing value on distant markets and, with the increasing length of the distribution chains, could only react to the volume of pieces sold and to the price levels at which their products were valued.

Enforced Inspection of 'Broad' Linen on the *Legge*

This form of self-organized quality control might have continued to satisfy the brotherhood for a long time, but in 1638 the city council was trying to increase fiscal revenues wherever possible. The city was deeply in debt due to the burden of maintaining its own troops for defending itself during the Thirty Years War.[33] The revenue raised from fees for the inspection of linen on the *legge* had decreased with the decline in the number of linens passing the inspection. The city council had already discussed the obligation of an inspection of the 'broad' linen on the *legge* several times without taking action, although the trade in 'broad' linen had been recognized and considered to be of increasing importance. In the spring of 1638 the city council finally announced a new rule for the *legge*, directed at the inspection of 'broad' linen.[34]

The new rule ordered the weavers to deliver all 'broad' linens that they produced, including those for their own use, to the *legge*. Before delivery to customers, the linens had to be registered by the inspectors and had to pass the *legge*, where the fee was paid. In addition to the employed inspector (*legger*), two weavers from the brotherhood were delegated to assist as additional inspectors. In particular the weavers had to identify and classify the weaving combs with the numbers eight to 18. There is no explanation as to what these numbers indicated. Since the width of the 'broad' linens had a fixed measure, the numbers

[33] StdAM, A II, Nr. 20, Bd. 70, 1638; cf. Helmut Lahrkamp, 'Münsters Verteidigung 1633/34. Ein Beitrag zur Geschichte des Dreißigjährigen Krieges im Münsterland', in Helmut Lahrkamp (ed.), *Beiträge zur Stadtgeschichte* (Münster, 1984), pp. 273–292.

[34] Krumbholz, *Die Gewerbe der Stadt Münster*, pp. 311–312. Already the previous rules for the *legge* demanded that all pieces of linen being traded within the city were delivered to the *legge*, but the city council obviously accepted the production and sale of 'broad' linen without it having passed through the *legge*, and even ordered the brotherhood to maintain a quality control of its own besides the *legge*. The reasons for these practices are not explicitly discussed in the documents.

probably referred to the number of warps, signifying the density of the texture.[35] These numbers had to be written on the linens, which were then stamped with the seal of the city council. Another article ordered all fabricants of 'broad' linen to straighten and measure their pieces at home and then inform the *legger* as to which number they would estimate for their linen when putting it up for sale. Afterwards the owners of the linens had to bring these to the *legge* – on Monday evening for an inspection on Tuesday, and on Thursday evening for an inspection on Friday. It would seem that the inspection was carried out in the absence of the weavers. After the inspection, the linen was at the free disposal of its owners, but the marks of the *legge* had to remain visible. Finally the principals of the brotherhood were ordered to collect weekly registers on the volume of production and customers from each member and to present them to the *legge*.

The new rule seems to have been decreed by the city council without any consultation with the brotherhood, and the weavers submitted their protest instantly.[36] They had proposed to inspect the linens at home without bringing them to the *legge*. In a first reaction the council reduced the fee from three to two schillings for each piece of linen, but this was the only concession and after some internal quarrels with the *Alter- und Mesterleute* of the guilds, the council enforced the rule. In a first supplementary article, a fine of 20 *Reichsthaler* was imposed if the new rule was neglected. The weavers continued to protest, claiming that it would be impossible to distinguish the combs by numbers, in particular when they were inspecting the linens without viewing the combs. In their view the numbers had to be estimated on the basis of conscience and not by the weavers, while the merchants had to recognize the numbers. The permanent protests against labelling with numbers caused the city council to delegate the first inspectors of the brotherhood to the *legge* while suspending the duty of estimating the numbers for the first month. Besides other revisions of the rule in 1639, the council decided that the combs had to be inspected on the loom, but it remains unclear if this order was carried out in practice. These revisions caused a new wave of protest from the weavers, who were fined by the council. Despite the protests, the number of linens that were inspected on the *legge* increased quickly, with 2,281 pieces in 1638, 3,700 pieces in 1639, and 3,630 in 1640. In 1641 more than 4,000 pieces passed the *legge*, but in 1642 this number decreased to 3,650 pieces.[37] Bearing in mind that each weaver could produce about 11 pieces of 'broad' linen per annum on each loom, while being allowed to operate four looms, the volume of pieces seems to indicate

[35] Cf. Bettina Schleier, *Territorium, Wirtschaft und Gesellschaft im östlichen Münsterland (1750–1850)* (Warendorf, 1990), pp. 142–143, for comparable procedures in nearby Warendorf.

[36] The following is based on StdAM, A II, Nr. 20, Bd. 70, 1638; Bd. 71, 1639.

[37] StdAM, A VIII, Nr. 188a, Bd. 60, 1638; Nr. 188c, Bd. 1–21, 1639–1661. The number of linens is calculated on the basis of records of incoming fees to the *legge*.

that the weavers of the brotherhood, which did not seem to have more than 30 members, delivered a good part of their production to the *legge*. Moreover, the number of pieces indicates that there must have been other sources besides the brotherhood's production. Although the city council primarily – and, in the end, successfully – focused its efforts on raising fiscal revenues, the introduction of the new procedures of inspecting and labelling 'broad' linen also seems to have met the interests of the producers and customers of these linens; otherwise probably much fewer pieces of linen would have appeared on the *legge*. From 1643 to 1660 between 4,000 and almost 6,000 pieces passed the *legge* each year. With the conquest of the city by its prince bishop Christoph Bernhardt von Galen in 1661, the numbers fell to between 2,100 and 3,600 pieces.

Despite these developments, the city council did not seem to be satisfied with the inspection procedures, because in 1642 a commission of the council proposed revisions to the rule, which were in effect a new rule for the *legge*.[38] Again the *legger* and two inspectors had to inspect each piece of 'broad' linen and estimate the number of the comb. The requirements concerning quality were much more detailed than before. The linens had to be tidied up; knots and loose pieces of yarn had to be cut off by the masters. The masters were still supposed to attach their mark, but now it had to be sewn in at the corner so as to be invisible and prevent partiality at the inspection. The yarn of each piece had to be of even quality. As before, the linens had to be delivered the day before the inspection took place, most likely to prevent stretching and other forms of manipulation. Each piece had to be stamped on both ends to avoid cutting off parts of it after the inspection. Since all pieces were supposed to have a length of 48 ells, the weavers had to fold the linens in six layers of eight ells and tie these loosely into a bundle for delivery to the *legge*. At the same time a new table of eight ells' length was installed at the *legge*, for the inspection. The inspectors had to control each piece layer by layer, while the size of the table was designed to indicate the correct length. For each sort, indicated by the numbers, a reliable sample (*stalen*) was to be kept ready at the *legge* as a reference to classify the linens. The finished linens had to be delivered by the weaver within eight days after fabrication. The weavers were also charged with picking them up after inspection or informing the owner. The council decided to supervise the operations of the *legge* more closely and delegated two of its members as supervisors. These supervisors had to lock in the stamps, and the operation of the *legge* was only allowed in their presence. With this change, the *legger* lost part of his authority as the head of the *legge*.

The rule of 1638 appears to be an attempt to combine the brotherhood inspection with the procedures of the *legge*. With their distinction between owners and producers, these rules still offer indications that many weavers

[38] StdAM, A XI, Nr. 32, f. 13–15; A XI, Nr. 9, 21 August 1642.

seemed to be working on contract. The revised rules of 1642 were obviously directed at an efficient inspection of highly standardized linens. These rules no longer referred to production on contract. It is only mentioned that the weaver was not necessarily the owner of the piece. Based on this rule, the *legge* was operated until its decline in the early eighteenth century. At least some of the weavers seemed to be interested in selling their linen with the *legge* labels for 'broad' linen, in spite of all the conflicts surrounding the operation of the *legge*, which also continued until the eighteenth century. The wars led by Christoph Bernhardt von Galen against the Netherlands in the years 1665/66 and 1672–1674 effectively reduced the volume of linens that passed the *legge*.[39] The wars blocked commerce with the Amsterdam markets and some of the brotherhood weavers turned to production of other sorts, which they did not want to put through inspection at the *legge*. They seem to have smuggled these linens out of the city to other places like Warendorf, a place known for its *legge* for fine linens, most likely to have them inspected and labelled there.[40] In consequence the volume of inspected linens on the *legge* in Münster declined from 3,500 in 1668 to a level of 1,100 to 1,200 pieces after 1672 and to 835 in 1710. Even these comparatively low numbers show that some weavers were still interested in having their linens labelled. Later on during the eighteenth century, the number of weavers decreased to 12, and they returned to the interpersonal production on contract for local customers.

Since the inspection of the linens had been passed from the brotherhood to the *legge*, it seems that the brotherhood found it necessary to establish further regulations for protecting their privileges. On the very day that the new rule for the *legge* was issued by the city council, a treaty with the so-called 'narrow weavers' was added to the rules of the brotherhood.[41] The articles prohibited 'narrow weavers' from making use of looms designed for linen broader than six half quarters of an ell, which was one half quarter less than the regular width of 'broad' linen. In any case, even for personal needs, only the members of the brotherhood would be allowed to weave the linens broader than six half quarters,

[39] Norbert Reimann, 'Die Haupt- und Residenzstadt an der Wende zum 18. Jahrhundert', in Franz-Josef Jacobi (ed.), *Geschichte der Stadt Münster*, 3 vols (Münster, 1993), vol. 1, pp. 334–336.

[40] On Warendorf, see Wilfried Reininghaus, 'Warendorfs Wirtschaft vor 1806', in Paul Leidinger (ed.), *Geschichte der Stadt Warendorf. Bd. 1: Vor- und Frühgeschichte, Mittelalter, Frühe Neuzeit (vor 1800)* (Warendorf and Münster, 2000), pp. 583–587.

[41] StdAM, A XI, Nr. 237a, f. 7r/8v, 24 October 1642. The term 'narrow weavers' does not seem to have referred to an organized group of weavers, since weaving linen has to be considered as a rather common practice within the city. It only appears in the context of the treaty and some related conflicts. The 'narrow weavers' as a group were probably only constructed for the purposes of the treaty, defining those weavers that were excluded from producing 'broad' linen.

while the brotherhood could fine the 'narrow weavers' who breached this rule. The brotherhood could carry out visitations as long as they did not hamper the 'narrow weavers'. Although these rules could have caused conflicts, only a few have been documented. In practice the policies of the brotherhood seem to have been twofold: on the one hand, it was considered necessary to privilege access to the inspection and certification of 'broad' linen on the *legge* by restraining the production of the 'narrow weavers'; on the other hand, there is evidence that there were producers besides the brotherhood weavers. As already mentioned, the volume of production went beyond the capacities of the brotherhood, while some of its more wealthy members were trading in linens, and the inspection of linens coming from outside the city made up about 12 percent of those being inspected during the winter of 1658/59.[42]

Once Again: Conflicts over Labelling with Numbers

While the reform of the rules of 1642 did not cause an obvious revival of the protests, the two delegates of the city council on the *legge* were aided by a bailiff to prosecute trespassers; the question of labelling linens with the numbers of the combs turned up again in 1663 after several interventions by the brotherhood.[43] The city council suspended the rule to indicate the numbers for half a year, and afterwards it was not explicitly restored. Nobody seemed to care until July 1667, when the city council deliberated the petitions which two groups of merchants had presented.[44] The merchants complained that the linen trade would be harmed if the weavers classified their linen themselves and they wanted the city council to return to the numbering carried out by the inspectors of the *legge* which, authorized with the stamp of the seal of the city, would provide reliable labels. The merchants demanding numbering originated from Hamm and other

[42] After complaints from the brotherhood of being disadvantaged by imported linens, the city council raised an extra fee for linens coming from outside the city during December 1658 and January 1659. It was abolished after two months because the city council considered it useless due to the low volume of linens and fiscal revenue; StdAM, A VIII, Nr. 188c, Bd. 18, 1658, f. 21–2; Bd. 19, 1659, f. 20–22.

[43] StdAM, A XI, Nr. 9, f. 20; A II, Nr. 23, 15 October 1663.

[44] StdAM, A XI, Nr. 34, f. 6–7, s.d. These conflicts were probably not affected by the consequences of the wars that Christoph Bernhard von Galen led against the Netherlands, since the first attack had taken place in 1665/66, leaving some obstacles for commercial relations but without substantially damaging the linen trade, while the volume of inspected linens decreased significantly after the second attack in 1672; cf. Reimann, 'Die Haupt- und Residenzstadt', pp. 334–336; Zeger Willem Sneller, 'De stapel der westfaalsche Linnens te Rotterdam 1669–1672', *Bijdragen voor Vaderlandsche Geschiedenis en Oudheidkunde*, 7/2 (1932): pp. 179–218.

places in southern Westphalia. The city council decided to agree to their request and re-enacted the rule to label the linens with numbers, using the argument that it would prevent fraud and provide reliable merchant goods.[45]

The brotherhood protested instantly, claiming that the weavers were stunned because the city council was following the arguments of some inexperienced merchants from Langenberg[46] who were dealing with rather rough sorts of linen that did not find their way to the Netherlands.[47] These linens would be produced in small places like Billerbeck, Borghorst and the like, but not in Münster.[48] The merchants would bring these low quality linens to the *legge* to have them stamped. Though there are no indications of the inspection of large batches of imported linens, the weavers claimed that these practices would ruin their business and that the merchants of the city would lose their position on the linen markets in the Low Countries if the linens were to carry numbers again. Expecting that the city council would be inclined to believe its own merchants rather than those from abroad, they delivered testimonies, attested by a notary, of those merchants of Münster who would direct their trade to the staples for linen in the Netherlands and England. In the testimony nine merchants, followed by three other merchants a few days later, confirmed the question that 'it would improve the continuance of trade with linens to Holland and England, where it finds its staples and the masters their sales, when the linens were not being sold by numbers, but on their appearance'.[49] Moreover, the numbering would cause damage to the brotherhood and subsequently to the trade on the staples in Holland and England; therefore it would be best to measure the width and length on the *legge* without adding any numbers. The city council did not make a decision until the merchants from southern Westphalia petitioned again in November 1668.[50] Drawing on the rules for the *legge* of 1638 and 1642 and its resolution in 1667, the city council now decided to re-enact labelling with numbers from the beginning of the following year and also announced fines for offenders. The packer of the rolls of linen, a sworn-in officer who had to take care that the

[45] StdAM, A II, Nr. 23, 6 July 1667; A XI, Nr. 9, f. 13, 6 July 1667.
[46] One of the places of origin of the merchants in the southeast of the Münsterland.
[47] StdAM, A XI, Nr. 34, f. 2, s.d.
[48] Many of the migrated weavers who had founded the brotherhood originated from Borghorst. After the Thirty Years War the production of linen in Borghorst recovered, and after 1667 the newly founded guild had as many professional weavers as the whole city of Münster; cf. Hans Jürgen Warneke, 'Die Leinenweber oder *Dockmaker*, ihre Gilde und die "Borghorster Herren"', in Andreas Hartmann, Peter Höher, Christiane Cantauw, Uwe Meiners and Silke Meyer (eds), *Die Macht der Dinge. Symbolische Kommunikation und kulturelles Handeln. Festschrift für Ruth-E. Mohrmann* (Münster, 2011), pp. 485–499.
[49] StdAM, A XI, Nr. 34, f. 4, 12–15, 9 July 1667, 29 July 1667.
[50] StdAM, A XI, Nr. 34, f. 10–11, 11 November 1668.

goods were properly assembled and packed, was ordered only to pack linens labelled with numbers into the rolls.[51]

The weavers reacted by submitting another petition, repeating their arguments.[52] The numbers on the linens would only help the merchants of Hattingen, Langenberg and other places to sell rough linens, which they had bought in neighbouring towns and villages, with the stamps and the numbering from the *legge* of Münster on the staples in Holland and England. The masters of the brotherhood would also sell their products as *Münsterisch* linen on the same market and, with the linens coming from outside of Münster, the merchants in Holland and England would be defrauded. If the linens of the brotherhood, which were sold by the merchants of Münster, carried the same stamps and numbers, these would suffer similarly. The sale of linen would be difficult or the best pieces would be selected and sold at low prices and the rest would remain unsold and have to be returned. This way the weavers would be ruined. Finally they claimed that these practices would be unheard of in cities of the Roman Empire.

In January 1669 the city council reacted in a reserved manner, asking for more evidence for the arguments of the weavers. The confrontation continued only when the brotherhood handed in another petition in spring 1670, which was supplemented with the recent documents on the conflict.[53] Despite these arguments, the city council decided to continue with the numbering of linens.[54] In response to the demand to provide further evidence for their arguments, the brotherhood handed in the testimony of nine linen merchants in Amsterdam,[55] who also confirmed that they would prefer to deal with linen without having it labelled with numbers. The merchants stated that it was their experience that in everyday business, the numbers were not a reliable way of appraising linens for trade. Linen labelled with low numbers turned out to be of better quality, while linens labelled with high numbers would turn out to be overestimated. In this case, in the view of the customers, the reputation would be considerably damaged. Therefore the numbers would be a great disadvantage for trading linen. They recommended relinquishing the numbers for trading linen on view, as was common practice in all other places.

[51] StdAM, A II, Nr. 23, 23 November 1668. Ever since 1601, when the office was established, had the packer been ordered to pack the rolls of broad linen.

[52] StdAM, A XI, Nr. 9, f. 17, 14 December 1668. This is the only document carrying the signatures of each of the weavers, although the brotherhood seemed to have a few more members than those 25 who had signed.

[53] StdAM, A XI, Nr. 9, f. 19/21, 6 March 1670.

[54] StdAM, A II, Nr. 23, 26 March 1670.

[55] StdAM, A XI, Nr. 34, f. 18, f. 17/20. Their names were Isaack Warnsinck, Jacob Tegou, Jacob Winter, Johannes Haeswindius, Barent Holthuisen, Thyman Itomker, Catharina Dickenson, de Wedwe van Jan Dickenson and Lambert Telghuys.

The weavers should aim to produce linen of good quality rather than quarrel about numbers. The quantity of the linens should be measured as before and afterwards they would be estimated by the merchants to the benefit of the weavers. With this statement the documentary evidence of this conflict ceases and no decision by the city council is handed down.

Conclusion

As other examples show, one of the notorious conflicts found in many regions producing textiles was caused by the attempts of authorities to impose the use of weaving combs, with a certificate indicating the specified number of warps for the sort of textile being produced.[56] The aim of the authorities, but also of merchants, was usually to prevent embezzling by the weavers through using fewer warps than specified. At the same time weavers denied that weaving combs would be a precise indicator for the number of warps and rejected the use of certified combs. Since the late sixteenth century the city council of Münster had made several attempts to improve 'narrow' linens by inspecting the combs, apparently without any effect. At the request of influential linen merchants it also tried to establish combs broader than the ones preferred by the weavers in 1631, imitating the measures of the much demanded linens that were labelled on the *legge* at nearby Osnabrück. Besides delivering another example for these conflicts, the case of the labelling of 'broad' linens also provides important insights into the evaluation of qualities and the estimation of value of early modern products.

The weavers of the brotherhood obviously knew the markets abroad where their linen was selling very well. It was the artisans who cared about the labelling of their *Münsterisch* linen to keep up their sales in Amsterdam, one of the largest and most competitive European marketplaces for linens. The merchants of Münster do not seem to have taken a very active part in this conflict, and the merchants of Amsterdam were also asked for their statement by the weavers. The only merchants who were playing an active role were those from southern Westphalia, whom the weavers considered an obstacle to their business. The expertise of the merchants does not appear to be more sophisticated than that of the weavers. The conflict was more about differing interests. Perhaps the merchants of Münster did not care that much, although they confirmed the arguments of the weavers, since they could adjust themselves to the changing

[56] Cf. Eduard Schoneweg, *Das Leinengewerbe in der Grafschaft Ravensberg. Ein Beitrag zur niederdeutschen Volks- und Altertumskunde* (Bielefeld, 1923; reprinted Osnabrück, 1985), p. 128; Boldorf, *Europäische Leinenregionen im Wandel*, pp. 124–125, 128.

opportunities which the markets offered, while the weavers were attached to the production of linen. With their political initiative, the weavers tried to prevent ending up in an unfavourable position with the kinds of merchants that shaped other textile trades. They accused the merchants of southern Westphalia of importing linens to the *legge* of lower quality than those produced in Münster, and for selling these linens labelled as *Münsterisch* on markets in the Netherlands, where these lower qualities would not usually be in demand or would be classified as of simple quality. In these practices the brotherhood saw the risk of damage to the reputation of the trademark of origin signalled by the seal of the city of Münster; the effect would be that their linen, which in their view was a higher quality, would be devalued. In the worst case, the best pieces would be skimmed off and sold at a low price, and most of the linens would remain unsold. Besides the general risk of being ruined, the weavers claimed that they had to finance production with the income from their sales without any advance payment. As inventories show, the yarn was the weavers' most valuable property. Since each weaver could produce around 11 pieces of 'broad' linen a year, the estimation of the value of each piece was of great importance.

The arguments of the weavers, as obvious as they seem to be, also pose some questions. Besides the fact that there is no evidence of large volumes of imported linens being inspected on the *legge*, the weavers seem to overemphasize this point as an instrument of political communication. It also has to be considered that all pieces which were sold with labels of *Münsterisch* linen had passed the inspection of the *legge*, where two members of the brotherhood were responsible for the control of product quality. In the case of a significant lack of quality, the inspectors had the duty to reject the labelling and to prosecute the deliverer. Not only the inspectors, but also most of the *leggers* originated from the brotherhood, which was almost certainly well informed about the linens passing through the *legge*. At the same time in 1668, for example, the weavers rejected the appointment of one of their brothers as an inspector at the *legge* because, as they claimed, he would deal with linens and the weavers saw the risk that he would let linens of insufficient quality pass the inspection and skim off the best pieces to buy them up, leaving only the medium pieces for open sale. In the eyes of the brotherhood, both practices could leave them at a severe disadvantage.[57] Therefore the conflicts were most likely directed at rather fine distinctions of quality and primarily to positioning on markets.[58]

In the view of the brotherhood, merchants from abroad tried to establish the trade of standardized mass-produced linens at the lower end of the quality scale,

[57] StdAM, A II, Nr. 23, 14 September 1668; A XI, Nr. 9, f. 14–15, 28 September 1668. The weavers seemed to be very aware of the disadvantageous constellation between producers and merchants described by Minard, 'Normes et certification des qualités', pp. 184–190.

[58] The following arguments are based on White, *Markets from Networks*.

as practised in Silesia. This kind of trade allowed the merchants to operate at an economy of scale with increasing margins by passing the largest volume possible through the lowest level of quality control, while competing with low prices on the European markets.[59] The pressures of production expenses were handed down to the producers for whom it was not efficient to invest in the quality of their production beyond the minimum standard. Moreover, with this form of fabrication new production markets for irregular products that had failed quality control could develop, offering niches for producers with low capital. At the same time it put under pressure producers of higher quality that met the requirements of the certificates, since they had more competitors producing at lower prices, while the merchants could trade with all kinds of qualities at the same time.[60]

The weavers of Münster mentioned the risk of an unravelling production market by shifting quality to the lower end of the scale when they talked of their customers in Amsterdam being defrauded.[61] The aims of the brotherhood were directed towards offering a higher value standardized niche product. The inspection on the *legge* was used to confirm the correct measures of the pieces, and probably also guaranteed a certain standard of workmanship, but the weavers were very keen to avoid certificates going beyond this general quality frame and to leave the uncertainties of evaluating the specific product quality to their customers. Weavers and merchants seem to agree about certifying the quantity of material and the correct measures, while rejecting detailed certificates for the quality of workmanship. The brotherhood seems rather to draw on its reputation, which therefore had to be maintained.[62] Weavers and merchants could negotiate the attribution of value and as a consequence the pricing of linen more independently; this meant that they could avoid dependency for both sides and subordination on the side of the weavers. To establish their niche on the large and very competitive wholesale markets in Amsterdam and England, the weavers knew very well that they had to maintain their product label and that the way they designed the labelling had to meet the demands of their customers. Obviously the weavers considered themselves price-takers in a demand economy. On the other hand they were

[59] Cf. Boldorf, *Europäische Leinenregionen im Wandel*, pp. 128–132.

[60] Cf. Medick, *Weben und Überleben in Laichingen*, pp. 127–130; Minard, 'Normes et certification des qualités' 184–190; Clasen, *Die Augsburger Weber*, pp. 381–382, 387.

[61] Besides unravelling caused by lowering the quality of the products and disappointing customers, lowering quality standards might also lead to an overproduction that destabilizes the market, cf. Clasen, *Die Augsburger Weber*, pp. 308–317.

[62] This confirms the observations that Bert De Munck has made for some Antwerp trades: De Munck, 'La qualité du corporatisme', pp. 128–134; idem, *Technologies of Learning*, 236–249; idem, 'Skills, Trust, and Changing Consumer Preferences', 215–222. For further views, see Chapter 1 of this volume.

obviously not interested in maintaining business relations with the merchants of southern Westphalia.

In the conflict with the merchants, the brotherhood did not demand protectionist privileges to protect its production market, but the chance to operate in their favourite target market in a way they considered best for their interests. The protectionist privileges given to the brotherhood by the city council were employed to establish a professionalized production market with a quality frame positioned slightly above the average production and for maintaining the reputation of the brotherhood by offering the opportunity to control access to the production and labels. The risk of unravelling the production market caused by lowering the quality level had to be prevented, as did the risk of being substituted by weavers outside of the brotherhood. Therefore the brotherhood weavers had to qualify as apprenticed masters and, with the contract of 1642, the production of 'broad' linen became the exclusive privilege of the brotherhood. It remains unclear how far this privilege was executed in practice, since there are only a few documented cases of prosecuting so-called 'narrow weavers', and some producers of 'broad' linen outside the brotherhood must have been accepted. The weavers tried to improve the value of their standardized product by maintaining certain standards of quality of workmanship while limiting the volume of production.

The merchants of southern Westphalia, at least in the view of the brotherhood, tried to upgrade the value of linen originating from small places in the western Münsterland with the quality control labels of the *legge* in Münster, drawing on a system of fixed quality standards for some aspects of workmanship, perhaps with the aim of making profits from pieces that just passed the minimal standards of the quality frames in an economy of scale. With their product quality positioned between the cheap and simple sorts of mass production and the established but expensive sorts of fine linens, the weavers possibly offered a comparatively affordable product that could be distinguished from the more simple sorts to supply the increasing demand for textiles in England.[63] With this position among the production markets for linen, the sale of linen could be disadvantaged by getting too close to the quality standards of simple mass-produced linens and being substitutable. This way the opportunity to obtain higher prices, which made the production of higher qualities profitable, would diminish significantly. Against this background, the insistence of the weavers on dropping labelling with numbers becomes more understandable, since they had to prevent all strategies that could offset this distinction. The attribution of value to the linens was closely linked to the inspection of certain qualities and the way the linens were labelled.

[63] David Ormrod, *The Rise of Commercial Empires: England and the Netherlands in the Age of Mercantilism, 1650–1770* (Cambridge, 2003), pp. 150–153, 161.

On the customer side, the labelling of textiles was an important basis for trading certain sorts of textiles as bulk ware in the long distance trade in an economy of scale. In comparison with other labels of origin such as Osnabrück, *Münsterisch* linen as a label of origin did not leave many traces in the documents on textile trade. Perhaps in Amsterdam the 'broad' linens from Münster were mixed with linens of the same kind and distributed as a sort based on the size and quality of the texture, or the linens were traded as a very specialized sort with a volume too small to leave many traces. The final customers who were using the linen as consumers for their personal purposes, and who might only have bought a cut-off piece, probably did not care much about the particular origin of these linens. Cutting the pieces would also substantially change their certified quality because the original labels indicated a guaranteed size. The linens were part of the mass consumption of textiles and did not constitute a very exclusive quality. They were bought because consumers accepted the ratio of quality and price with which they were offered by local retailers; finally the particular situation of local retail sale, the aesthetic qualities and the tastes of customers helped them to make their choice. The relevance of the labelling of linens has to be located primarily in the business-to-business relations and not so much in the commerce between business and consumers. This location might also explain the importance of the volume of material among the criteria for certificates, because as the commodity chain gets closer to the final consumer, the merchants seem to have selected those pieces which they considered would best meet the demands of their particular customers. For the larger batches at the beginning of the commodity chain, the value of the volume of the material could have been more important than the details of the aesthetic quality of each single piece, but the closer the commodity chain gets to the consumer, the more relevant the aesthetic qualities are as a criterion for sorting the smaller batches for local trade which had to meet a particular demand at a particular place. When selling the textiles to consumers, the aesthetic quality of the particular piece was probably the decisive factor in the attribution of value by the buyer, while the volume depended on the purposes for which the cut-off piece was bought.

The location where the labelling of the *Münsterisch* 'broad' linens was most important for their evaluation seems to have been the market in Amsterdam. This location was very important for the producers, because their economic subsistence depended on this particular attribution of value to each of their products. Further down the distribution line these labels seem to have been less important, and for the merchants who were trading these linens they were just one sort among many others and their existence did not depend on this particular kind of linen. The consumers of these linens designed for mass consumption probably cared very little about the particular origin of these kinds of textiles. The qualities of the linens from Münster were not so distinctive that they could be considered as some kind of fashionable product. If they had had

such a quality, the guaranteed origin would have been of relevance even for the final consumers and the relative scarcity of the product might have created more specialized commodity chains, with several locations where the original labels were of significant relevance in the evaluation of the textiles. Further comparative research on different kinds of textiles seems to be necessary to find out more about the differentiated locations of value of textiles.

Chapter 3

Words of Value? Art Auctions and Semiotic Socialization in the Austrian Netherlands (1750–1794)

Dries Lyna

Introduction

In his 2005 seminal work on the market for contemporary art, sociologist Olav Velthuis again challenged the neo-classical economic notion of price as a mere result of the interplay between supply and demand, thereby following the earlier profound critique of Sahlins and Appadurai.[1] Velthuis further elaborated on their anthropological theories that economic value rather relies on cultural beliefs and practices, but added a more sociological analysis of prices. He conceptually approached them as symbols, with meanings that are 'far from unequivocal, and always need to be interpreted by actors'.[2] His seemingly subjective attitude towards prices did not necessarily imply ad-random valuation; on the contrary, throughout his book Velthuis showed how works of contemporary art are systematically priced in relation to underlying conventions governing the market. Similar to studying a foreign language, only after a learning process are actors able to interpret the relationship between price and quality, dubbed 'semiotic socialization' by Velthuis.[3]

However, by departing from Sahlins and Appadurai and overemphasizing the social structures that steer markets, the pendulum swung too far in the other direction. Both formal cultural practices (beliefs, rituals) and informal ones (everyday habits, language) were ignored by Velthuis, and by fellow sociologists

[1] Marshall Sahlins, *Stone Age Economics* (New York, 1972); Arjan Appadurai (ed.), *The Social Life of Things: Commodities in Cultural Perspective* (Cambridge, 1986).

[2] Olav Velthuis, *Talking Prices: Symbolic Meanings of Prices on the Market for Contemporary Art* (Princeton, 2005), p. 169.

[3] Velthuis adopted this concept from the Swiss linguist and godfather of semiotics Ferdinand de Saussure (1857–1913), who studied language as the product of social interaction. Velthuis elaborated on the concept of semiotic socialization in chapter 7 of his book, also published as an article. Olav Velthuis, 'Symbolic Meanings of Prices: Constructing the Value of Contemporary Art in Amsterdam and New York Galleries', *Theory and Society*, 32/2 (2003): pp. 181–215.

of art in general.[4] Indeed, processes of price formation are not merely embedded in social networks, but equally interact with far less tangible webs of meanings, a gauntlet that Velthuis graciously invited other scholars to take up.[5]

This chapter aspires to answer Velthuis' call, by invoking culture as an *explanans* for the historical development of the specialized auction market for Old Masters in the late eighteenth-century Austrian Netherlands, a crucial timeframe for the careful construction of the canon of the Flemish School of Painting several decades later. From the 1760s onwards art dealers in cities such as Antwerp and Brussels consciously (re)constructed the art auction into a dignified cultural event when attempting to broaden their customer base. This case study allows us to elaborate on Velthuis' concept of 'semiotic socialization', as this developing auction scene was constantly embedded in and interacting with cultural practices, most prominently discursive shifts. In their printed catalogues the art dealers and auctioneers both articulated and influenced a specific way of talking and thinking about paintings, offering them as pleasure-yielding bundles of characteristics to their potential clients. Detailed descriptions and explicit criteria of appreciation allowed newcomers to gradually internalize the mental accounting schemes, to afterwards structurally paint their own valuation against an establish canvas of conventions. A detailed analysis of the catalogues' language will reveal the mechanisms of this discursive learning process and show how these actors could relatively easily acquire literacy about the underlying conventions. Despite a remarkable price decline at the end of the eighteenth century, the endeavours of art dealers to simultaneously educate and enlarge their customer base was successful in the long run, contributing to the further development of a highly popular market for arts and antiques in the Kingdom of Belgium during the nineteenth century.[6]

From Public Sale to Art Auction

In the course of the eighteenth century public sales of paintings in the Austrian Netherlands were gradually transformed from mere economic transactions, aimed at quick redistribution of *post mortem* stock value, into semi-cultural

[4] With this thesis Velthuis inscribed himself in the debates surrounding the work of, among others, Charles W. Smith, *Auctions: The Social Construction of Value* (New York, 1989); idem, 'Markets as Definitional Practices', *Canadian Journal of Sociology*, 32/1 (2007): pp. 1–39. The last article was followed by a discussion in Patrik Aspers, Karin Knorr Cetina, Robert Prus and Charles W. Smith, 'The Practice of Defining Markets: A Comment on Charles W. Smith', *Canadian Journal of Sociology*, 32/4 (2007): pp. 477–486.

[5] Velthuis, *Talking Prices*, p. 11.

[6] For more on this nineteenth-century development, see Arnout's contribution to this volume.

events that aspired to attract the local upper middle class and – in the latter decades – increasingly more international collectors.[7] The changing material culture of the early eighteenth century had caused the art auction to emancipate from rummage sales of household effects. Local art dealers slowly took control of these specialized auctions.[8] These intermediaries implemented a series of incremental adaptations in the way art was sold on the secondary markets, creating a veritable 'auction culture' that became evermore visible in the closing decades of the century.

Probably the most visible shift for contemporary outsiders was the change of *décor*, whereby – parallel to the product segmentation – rummage sales in marketplaces and other traditional *loci* of selling were strategically abandoned for specialized art auctions in multi-purpose halls that were also used for urban leisure events, such as theatre, music and other performances.[9] It allowed the auctioneers to physically and mentally separate their concept of auctions from the organization of past public sales, and to convey a message of exclusivity to the audience.[10] Antwerp art dealers, for example, moved their auctions to the Kolveniershof, a reception hall for the eponymous shooting guild that had assumed major prominence within the Antwerp cultural scene after 1750, hosting puppet shows, performances of tightrope walkers, waxwork exhibitions and so-called *redoutes* or high-end balls.[11]

Interestingly, the endeavours of Antwerp and Brussels art dealers closely resembled changes in the eighteenth-century leisure culture of high society,

[7] Filip Vermeylen, 'Adulterous Women on the Loose: Rubens Paintings Sold at Auction in Antwerp During the Eighteenth Century', in Katlijne Van Der Stighelen (ed.), *Munuscula amicorum: Contributions on Rubens and his Colleagues in Honour of Hans Vlieghe* (Turnhout, 2006), pp. 185–194; Dries Lyna and Filip Vermeylen, 'Rubens for Sale: Art Auctions in Antwerp During the Seventeenth and Eighteenth Centuries', in Dries Lyna, Filip Vermeylen and Hans Vlieghe (eds), *Art Auctions and Dealers: The Dissemination of Netherlandish Art During the Ancien Régime* (Turnhout, 2009), pp. 139–153.

[8] Dries Lyna, 'Power to the Broker: Shifting Authorities over Public Sales in Eighteenth-Century Antwerp', in Jon Stobart and Ilja Van Damme (eds), *Modernity and the Second-Hand Trade: European Consumption Cultures and Practices, 1700–1900* (Basingstoke, 2010), pp. 158–174.

[9] Dries Lyna, 'Changing Geographies and the Rise of the Modern Auction: Transformations on the Second-Hand Markets of Eighteenth-Century Antwerp', in Bruno Blondé, Natacha Coquery, Jon Stobart and Ilja Van Damme (eds), *Fashioning Old and New: Changing Consumer Preferences in Europe (17th–19th Centuries)* (Turnhout, 2009), pp. 169–184.

[10] For another example of how geography and social distinction went hand in hand on the second-hand markets, see Manuel Charpy, 'The Auction House and its Surroundings: The Trade in Antiques and Second-Hand Items in Paris During the Nineteenth Century', in Blondé et al. (eds), *Fashioning Old and New*, pp. 227–228.

[11] Lyna, 'Changing Geographies', pp. 175–177.

which increasingly pursued segregation from lower strata in daily life and in leisure.[12] This quest for distinction had a strong spatial characteristic, which was apparent in the shift from the old city centre to the arterial roads and the town periphery.[13] Especially in Antwerp the dealer-auctioneers followed a similar path of differentiation by redistributing the luxury second-hand trade from the mercantile open-air environment to the semi-cultural salesrooms at the edge of town and, more importantly, by attempting to transform the auction into a distinguished cultural event. Auctioneers wished to differentiate between old and new style auctioning, as complaints about previously aggressive discourse and salesmanship in open-air selling were not unusual.[14] Even in the eighteenth century such grievances about the general secondary market were heard in the Austrian Netherlands: in nearby Ghent around 1753 second-hand dealers accused several of their colleagues of trying 'to allure the countrymen and other passing people to their houses, whether they intended to buy something or not, taking their clothes with such a violence, that these are torn from their bodies, and that people who wanted to buy something did not dare to enter their street'.[15] When art dealers in the 1760s started to develop a distinct secondary art scene, not only was a geographical relocation away from old public sales necessary, but also a discursive shift specifically tailored to the needs of their merchandise – paintings – as well as their potential clients.

Auction Catalogues and the Discursive Shift

The geographic relocation of specialized art auctions in the Austrian Netherlands was accompanied by a second innovation which, although less visible, proved equally – if not more – fundamental: from the 1760s onwards,

[12] Bruno Blondé, 'Indicatoren van het luxeverbruik? Paardenbezit en conspicuous consumption te Antwerpen (zeventiende-achttiende eeuw)', *Bijdragen tot de geschiedenis*, 84/4 (2001): pp. 497–512; idem, 'Cultural Transfers in European Cities: The Social Importance of Changing Consumption Patterns, Urban Manners and the Use of Space in Antwerp, 16th–18th Centuries' (unpublished paper, European Science Foundation, Ghent, May 2001).

[13] Blondé, 'Indicatoren', p. 510; idem, 'Cultural Transfers'.

[14] For details on aggressive salesmanship on the popular weekly Friday Market, see Ilja Van Damme, *Verleiden en verkopen. Antwerpse kleinhandelaars en hun klanten in tijden van crisis (ca. 1648–ca. 1748)* (Amsterdam, 2007), pp. 91–92.

[15] Harald Deceulaer, 'Second-Hand Dealers in the Early Modern Low Countries: Institutions, Markets and Practices', in Laurence Fontaine (ed.), *Alternative Exchanges: Second-Hand Circulations from the Sixteenth Century to the Present* (Oxford and New York, 2008), p. 18.

Table 3.1 Language distribution of all preserved art auction catalogues for Antwerp and Brussels (1716–1794).

	Antwerp			Brussels		
	French (%)	Dutch (%)	Number of catalogues	French (%)	Dutch (%)	Number of catalogues
Before 1758	20.0	80.0	5	66.7	33.3	9
1758–1767	37.5	62.5	8	100.0	0.0	22
1768–1777	47.6	52.4	21	74.3	25.7	35
1778–1787	68.4	31.6	19	90.9	9.1	22
1788–1794	90.9	9.1	11	100.0	0.0	19
Total	57.8	42.2	64	86.9	13.1	107

printed auction catalogues witnessed a notable discursive shift.[16] Despite the fact that the vast majority of Antwerp and Brussels[17] citizens spoke Dutch, auction catalogues were increasingly written in French (see Table 3.1), the *lingua franca* of the rich and civilized, and the preferred language for theatre, literature and debates.[18] As Spanish traveller Diego de Galvez noted in 1755

[16] Such catalogues were in themselves hardly innovative, as they had been around as pre-sale selection guides since art auctions first came to the fore in late seventeenth-century England and the Dutch Republic. Brian Cowan, 'Arenas of Connoisseurship: Auctioning Art in Later Stuart England', in Michael North and David Ormrod (eds), *Art Markets in Europe, 1400–1800* (Aldershot, 1998), pp. 153–166; David Ormrod, 'The Origins of the London Art Market, 1660–1730', in North and Ormrod (eds), *Art Markets in Europe*, pp. 167–185; Neil De Marchi, 'Auctioning Paintings in Late Seventeenth-Century London: Rules, Segmentation and Prices in an Emergent Market', in Victor A. Ginsburgh (ed.), *Economics of Art and Culture* (Amsterdam, 2004), pp. 97–128; Brian Cowan, 'Art and Connoisseurship in the Auction Market of Later Seventeenth-Century London', in Neil De Marchi and Hans Van Miegroet (eds), *Mapping Markets for Paintings in Europe and the New World, 1450–1750* (Turnhout, 2006), pp. 263–280; Marten Jan Bok, '"Paintings for Sale": New Marketing Techniques in the Dutch Art Market of the Golden Age', in Marten Jan Bok, Martine Gosselink and Marina Aarts (eds), *At Home in the Golden Age: Masterpieces from the Sor Rusche Collection* (Zwolle, 2008), pp. 9–29.

[17] Hervé Hasquin, 'De demografische en sociale evolutie. Het begin van de verfransing, langzame verfransing', in Jean Stengers (ed.), *Brussel. Groei van een hoofdstad* (Antwerp, 1979), pp. 130–145.

[18] Marcel Deneckere, *Histoire de la langue française dans les Flandres (1770–1823)* (Ghent, 1954), pp. 76–80; Hasquin, 'De demografische en sociale evolutie', p. 240; Bernard Desmaele, 'Coup d'oeil sur quelques bibliothèques privées bruxelloises du XVIIIe siècle', in Hervé Hasquin and Roland Mortier (eds), *Le livre à Liège et à Bruxelles au XVIIIe siècle*

when visiting Brussels: 'although the language here is Flemish, nearly all fashionable people also speak French'.[19]

Probably inspired by the elaborate catalogues of the Parisian auctioneer François-Edme Gersaint which revolutionized the French art auction scene in the 1730s and 1740s,[20] auctioneers in Antwerp and Brussels adopted a lofty discourse based on politeness, honesty and gentlemanship. While there were rarely forewords in the earlier catalogues, in the second half of the century so-called *avertissements* became widespread. In addressing their readers, the art dealers became ever more polite, with a touch of aristocratic etiquette:

> We offer here to the Noble Amateurs of Painting, Sculpture & Engraving, the Sale of a small but very precious collection of elite Paintings, Statues, Engravings and Drawings, gathered with lots of care, taste and effort by NN ... hoping that the Noble Residents and Foreigners, secular or ecclesiastical, would deign to honour this Sale with their presence.[21]

In addition, descriptions of paintings in catalogues generally became longer, more detailed and increasingly more precise.[22] In only 20 years the median length of the narratives in the catalogues had multiplied by six (see Table 3.2). Whereas landscapes in most early catalogues in Antwerp and Brussels were described in rather limited fashion – for example: 'A very nice landscape enriched with figures and animals' (*Un tres-beau Paysage enrichi de Figures & Animaux*) – after 1760 auctioneers offered readers sophisticated accounts that elaborated extensively on the subject matter, the technical skills of the artist and the provenance of the painting. In the 1791 catalogue of the Peytier de Merchtem auction, a landscape was described as follows:

(Brussels, 1987); Marie Cornaz, *L'édition et la diffusion de la musique à Bruxelles au XVIIIe siècle* (Brussels, 2001), p. 21.

[19] ('quoique la langue soit ici la flamande, tous les gens à la mode parlent aussi le français'). Quoted in Georges-Henri Dumont and André Uyttebrouck (eds), *Bruxelles, mille ans de vie quotidienne* (Brussels, 1979), p. 195.

[20] Andrew McClellan, 'Watteau's Dealer: Gersaint and the Marketing of Art', *Art Bulletin*, 78 (1996): p. 439; Neil De Marchi and Hans Van Miegroet, 'The History of Art Markets', in Victor Ginsburgh and David Throsby (eds), *Handbook of the Economics of Art and Culture* (Amsterdam, London and Tokyo, 2006), p. 157.

[21] ('On offre, ici, au Nobles Amateurs de la Peinture, Sculpture & Gravure la Vente d'un receuil peu en nombre mais des plus précieux elite Tableaux: statuë, Estampes de desseins, tous recueilli avec depences soins, gout & peines par NN ... esperant que la Noblesse habitans & etrangers tant seculiers qu'Eclesiastiques daigneront honorer cette Vente de leurs presence') (anonymous sale, Antwerp, 1788).

[22] These are general evolutions, as catalogues with short descriptions could still be found at the end of the eighteenth century, though far less frequently.

A mountainous landscape decorated with beautiful trees, of which the barks are rendered very artistically: the front is enriched with a Gentlemen and a Lady who are walking, an old woman, dogs and two servants, of which one is holding a white horse, and the other a brown one by the reins. The drawing of the heads, the hands and the figures is elegant in this piece: the whitish jacket and the skirt of red silk of Damascus, of which we made mention, are wonderfully treated, just as the clothing of the other figures: all is detailed with smoothness and truth.[23]

Table 3.2 Length of descriptions and number of words in 36 Antwerp and Brussels auction catalogues (1758–1794)[24]

	Number of catalogues	Number of lots	Median length of descriptions in tokens (median)
1758–1767	7	840	28
1768–1777	11	974	106
1778–1787	7	1,412	169
1788–1794	11	1,302	56*
Overall	36	4,528	78

* The remarkable drop in the median length in the last period is difficult to explain, but can probably be related to the parallel price decline on the auction market and the lesser economic situation following the turmoil of the Brabantine Revolution at the end of the 1780s. More research on the early nineteenth century is needed to determine whether or not this drop was temporary, or if the hausse of the 1770s and 1780s was exceptional.

[23] ('Un Paysage montagneux orné de beaux arbres, dont les écorces sont très-artistement rendues: le devant est enrichi d'un Seigneur, d'une Dame se promenant, d'une vieille femme, de chiens & de deux valets, dont l'un tient un cheval blanc, l'autre un cheval brun par la bride. Le dessein des têtes, des mains & des figures est élégant dans ce morceau: la jaquette blanchâtre & la jupe de soie rouge de la Dama, dont nous avons fait mention, sont traitées à merveille, de même que les habillements des autres figures: tout en est détaillé avec finesse & vérité') (Peytier de Merchtem, Antwerp, 1791, lot 12: Gonsales Coques & Immeraet).

[24] These 36 catalogues are part of a sample of 41 catalogues, minus three in Dutch as being not comparable to the other French descriptions (Snijers, Antwerp, 1758; Vergelo-Beschey, Antwerp, 1768; Balthazar Beschey, Antwerp, 1776) and the two from the period before 1758, namely 1739 (Sansot, Brussels) and 1741 (De Wit, Antwerp), because this number is too small to calculate a meaningful median. For more on the composition of this sample, see the Appendix to Dries Lyna, 'Name-Hunting, Visual Characteristics and New Old Masters: Tracking the Taste for Paintings at Art Auctions in Antwerp and Brussels (1739–1794)', *Eighteenth-Century Studies*, 46/1 (2012): pp. 57–84.

These notable changes to the catalogue format reveal the auctioneers' ambitions to discard the mercantile auctioning language of the past. Similar to the reasoning behind the geographical shift from the market setting to semi-cultural salesrooms, the organizers of art auctions adapted their discourse to appeal to an audience that sought distinction. But the incremental adaptation of the fashionable French language, the overtly polite manner of addressing readers and the considerable growth of descriptions of paintings is to be analysed not merely as a communicative endeavour, but also as part of a larger wave that introduced aspiring aficionados to the underlying conventions of the art world.

Paintings as Bundles of Characteristics

The expanding vocabulary not only employed legions of words to describe paintings more exactly, but also spurred a wild proliferation of imprecise adjectival phrases (for example, *d'une touche fiere, d'un bel effet*), descriptive adjectives (for example, *beau, magnifique, admirable*) and subjective comments (for example, *du bon temps de ce Maître, le premier rang dans le cabinet le plus célèbre*).[25] These persuasive expressions were not at the core of the discursive shifts, but merely an inexorable side effect. Behind these adjectival utterances infesting auction catalogues from the middle of the eighteenth century onwards, a continental discourse at the crossroads between art and commerce was given articulation.[26] In a seminal article from 1979, Pomian went so far as to label

[25] Michel links the Parisian rise of these mercantile expressions after 1750 to the growing popularity of the *Dictionnaires*, which institutionalized this commercial-artistic jargon. Patrick Michel, *Le commerce du tableau à Paris dans la seconde moitié du 18e siècle: acteurs et pratiques* (Villeneuve d'Ascq, 2007), p. 243. A Parisian catalogue of Remy in 1767 can be seen as the first one that clearly employed an exaggerated discourse on art. Contemporaries in the French capital complained that after 1780 there was no stopping this type of catalogue. Linda Whiteley, 'The Language of Sale Catalogues, 1750–1820', in Monica Préti-Hamard and Philippe Senechal (eds), *Collections et marché de l'art en France 1789–1848* (Rennes, 2005), pp. 40–41.

[26] There is, however, a notable difference between English and continental catalogues, where the former can be categorized as a drier version, with shorter and more compact descriptions of the products and a less appealing layout. During the eighteenth century the difference between the two types of catalogues would grow, when the French merchant Gersaint lifted the continental catalogue to a new level, while the British stuck to their old type of cataloguing. Cowan, 'Arenas of Connoisseurship'; Burton Fredericksen, 'Introduction', in Burton Fredericksen (ed.), *Corpus of Paintings Sold in the Netherlands During the Nineteenth Century* (Los Angeles, 1998), IX. For more on the broader role of catalogues in London before 1770, see Iain Pears, *The Discovery of Painting: The Growth of Interest in the Arts in England 1680–1768* (New Haven and London, 1988). For a visual comparison of the lay-out of a British and a French catalogue, see Hans J. Van Miegroet, 'The Market for Netherlandish Paintings in Paris, 1750–1815', in Jeremy Warren and

the Parisian exponent of this European-wide evolution *un nouveau genre littéraire*.[27] The unusual yet interesting mix of commercial and artistic language was previously only seldom – if ever – made explicit in art-related writings. This 'literary genre', however, served a greater purpose, as in its articulation of otherwise implicit conventions about paintings and their values, the catalogues could be interpreted as part of a 'semiotic socialization' into the art world.

First of all, whereas early catalogues in the Austrian Netherlands hardly mentioned whether the painting for sale was a landscape or a seascape, catalogues from the 1760s onwards described subject matter in an increasingly detailed manner, by mentioning the exact number of figures on a canvas, identifying different animals, analysing the fabrics of clothing and sketching the wide array of colours. Typifying architectural or landscape elements and their specific characteristics contributed to the *ekphrasis*[28] and helped readers to construct a mental image of the painting:

> A Landscape. One sees to the right a peasant driving a cart drawn by an ox charged with vegetables, with a woman sitting on these commodities. A little more to the front, we see another woman, two children and a dog: in the middle of the composition is a small river where a herd of cows and sheep gather to drink: the distance offers a hill with a house on top. This picture is well composed, it has a nice colour, and the animals are very well rendered.[29]

A second and less obvious shift implies a deconstruction of the 'geography' of the painting, as is evident in the example above and common in Antwerp and Brussels catalogues from the 1770s onwards. Like a surgeon handling a scalpel, authors of auction catalogues would spatially 'dissect' a painting in their

Adriana Turpin (eds), *Auctions, Agents and Dealers: The Mechanisms of the Art Market 1660–1830* (Oxford, 2007), p. 46.

[27] Krystzof Pomian, 'Marchands, connaisseurs, curieux à Paris au XVIII siècle', *Revue de l'art*, 43 (1979): p. 35.

[28] Of course the authors of the catalogues did not invent this discourse altogether; on the contrary, translating visual experience into an ingeniously written résumé or *ekphrasis* was something that dated back to the Greek writers of Antiquity. The idea was to describe a work of art (often paintings) in such a way that the reader could visualize it and become a virtual spectator. Gottfried Boehm and Helmut Pfotenhauer (eds), *Beschreibungskunst, Kunstbeschreibung: Ekphrasis von der Antike bis zur Gegenwart* (Munich, 1995).

[29] ('Un Paysage. On y voit vers la droite un paysan qui conduit une charette attelée d'un boeuf & chargée de légumes, avec une femme assise sur ces denrées. Un peu plus sur le devant, l'on remarque une autre femme, deux enfants & un chien: au milieu de la composition est une petite rivière, dans laquelle un troupeau de vaches & de moutons entre pour boire: l'éloignement offre une montagne couverte d'une maison. Ce tableau est bien composé, il est d'une couleur agréable, & les animaux y sont très-bien rendus'). (Dormer, Antwerp, 1777, lot 43: Pierre van Bloemen).

accounts, offering comprehensible quadrants that could be appreciated by the readers, rather than the painting as a whole: first describing what is happening on the left side of the painting; elaborating later on all the action on the right side (for example, *gauche-droite*); subdividing the painting in a two (for example, *devant-lointain*), three (for example, *premier plan-milieu-fond*) or even multi-layered (for example, *plus loin*) reproduction of reality. To allow their readers to fully 'step into' the space of a painting, auctioneers had to provide them with basic guidelines, proverbially taking newcomers by the hand in the foreword: 'While speaking about the right or the left in the descriptions of the paintings, one refers to the right or the left of the person who is looking at the piece in question.'[30]

These two changes become even more interesting when considered from an educational point of view: with the printed catalogues in hand, readers were consequently trained to actually appreciate a painting meticulously, by dissecting it spatially and taking in all the necessary details stroke by stroke (with the number of figures and animals as seemingly important features). But even more important were the four aesthetic criteria of evaluation used to ascribe (artistic) value to a piece, namely drawing (*dessein*), colour (*coloris*), composition and expression. By explicitly employing these criteria, the auctioneers laid bare the conventions that governed price formation in their markets; sometimes they elaborated on one or two characteristics, sometimes on all four. As the eighteenth century progressed, other abstract notions were introduced to describe paintings, such as *effect* and *intelligence*. In the 1785 catalogue of the Knijff sale, even an unimportant painting by the otherwise unknown Henri Van Daelen was described elaborately as follows:

> The Rape of the Sabines, *composition* of many figures: one sees well *expressed* the force of Roman soldiers, and the fear of the Sabine women; their silk dresses, white & yellow & etc., are very well made & of a nice choice, the *colours* of this piece are delicate and vigorous, well-connected groups, the light placed with *intelligence*, the beautiful *drawing* and the surprising effect. This piece is one of the best made by this Master.[31]

[30] ('En parlant de la droite ou de la gauche dans la Description des Tableaux, on a entendu la droite ou la gauche de la personne qui regarde la Pièce dont il est question'). (Dormer, Antwerp, 1777, Avertissement).

[31] ('L'Enlèvement des Sabines, compositions d'un grand nombre de figures: l'on y voit bien exprimées la force des soldats Romains, & la frayeur des Sabines; leurs habillements de soie blanche & jaune & c. y sont très-bien rendus & d'un beau choix; le coloris de ce Morceau est délicate & vigoureux, les groupes bien liés, la lumière placée avec intelligence, le dessein beau & l'effet surprenant. Ce Morceau est du meilleur faire de ce Maître'). (Knijff, Antwerp, 1785, lot 206: Henri Van Daelen).

NOMS des Peintres les plus connus.	Composition.	Dessein.	Coloris.	Expression.
Rubens.	18	13	17	17
S				
Fr. Salviati.	13	15	8	8
Le Sueur.	15	15	4	15
T				
Teniers	15	12	13	6
Pietre Teste.	11	15	0	6
Tintoret.	15	14	16	4
Titien.	12	15	18	6
V				
Vanius.	13	15	12	13
Vandeïk.	15	10	17	13
Z				
Tadée Zuccre.	13	14	10	9
Fréderic Zuccre.	10	13	8	8

Figure 3.1 Extract from a reprint of De Piles' *Balance des Peintres* (Amsterdam, 1766).

Conventions of Art Valuation

These aesthetic criteria and the conventional undercurrent transcended the Austrian Netherlands both in time and space, as they were already frequently employed in seventeenth-century French artistic writings on aesthetics. The explicit linkage of these criteria to valuation processes was propagated in 1709 by the French art theorist Roger De Piles, who appended a ranking of artists to his *Cours de peinture par principes* (see Figure 3.1), wherein he assigned a score between 0 and 20 to numerous Old Masters in these four categories.[32] The English artist and art critic Jonathan Richardson adapted and enlarged these categories in 1715.[33]

Their joint ideas influenced the French auctioneer Gersaint (who apparently owned a copy of Richardson) in his novel approach to selling

[32] Ginsburgh and Weyers wrote an article in which they compared De Piles' ranking with our current canon of painters. Victor Ginsburgh and Sheila Weyers, 'On the Contemporaneousness of Roger de Piles' "Balance des Peintres"', in Jack Amariglio, Stephen Cullenberg and Joseph Childers (eds), *Sublime Economy: On the Intersection of Arts and Value* (London, 2003), pp. 112–123.

[33] Neil De Marchi, 'Confluences of Value: Three Historical Moments', in Michael Hutter and David Throsby (eds), *Beyond Price: Value in Culture, Economics, and the Arts* (Cambridge, 2008), pp. 205–207.

paintings in the 1730s and 1740s, by applying these theoretic criteria to market valuations in his renowned catalogues. If buyers approached paintings as a set of different visual characteristics, artistic substitutes could be found in different price brackets within the same 'family cluster', following Gersaint's idea of democratization.[34] If auction attendees were looking for Italianate landscapes, and a Lorrain was too expensive, they could settle for a Berchem, who offered a set of similar visual characteristics. And if even Berchem was beyond reach, the less wealthy buyer could still go for a cheaper Both.[35] According to De Marchi and Van Miegroet, this approach to art allowed Gersaint to tap into a new buying public, one that was less wealthy but highly interested in paintings. Thanks to the more elaborated semiotic language, the valuation of paintings thus became much less complex than before. Personal viewing became the basis for appreciation, with lack of formal education, wealth and artistic literacy no longer stopping individuals from engaging in art collecting.[36] Auctioneers in Antwerp and Brussels absorbed these ideas and articulated in their catalogues a similar way of looking at paintings and attributing value to them, hoping to broaden their customer base.

Nor were auction catalogues the only medium that was used to articulate these conventions of individual valuation. A wave of popular art historical literature simultaneously reached the Southern Netherlands from the 1760s onwards. Besides different versions of art dictionaries (the so-called *Dictionnaire portatif* and *abrégé*),[37] two well-known examples for the region were Guillaume Mensaert's 'The amateur and curious painter' (*Le peintre amateur et curieux*, 1763) and Jean-Baptiste Descamps' 'Picturesque journey' (*Voyage pittoresque*, 1769).[38] The latter two authors took the reader on a tour of

[34] Neil De Marchi and Hans Van Miegroet, 'Transforming the Paris Art Market, 1718–1750', in Neil De Marchi and Hans Van Miegroet (eds), *Mapping Markets for Paintings in Europe and the New World, 1450–1750* (Turnhout, 2006), p. 387.

[35] De Marchi and Van Miegroet, 'Transforming the Paris Art Market', pp. 397–398.

[36] De Marchi, 'Confluences of Value', p. 207.

[37] For a short introduction and overview of such *dictionnaires*, see Alex Ross, 'Encyclopedias and Dictionaries of Art', in Jane Turner (ed.), *The Dictionary of Art* (London and New York, 1996). These booklets provided untrained amateurs with the discourse to talk about art in a respectable manner. William Ray, 'Talking About Art: The French Royal Academy Salons and the Formation of the Discursive Citizen', *Eighteenth-Century Studies*, 37 (2004): p. 531.

[38] Guillaume Pierre Mensaert, *Le peintre amateur et curieux, ou: Description générale des tableaux des plus habiles maîtres qui sont l'ornement des eglises, couvents, abbayes, prieurés & cabinets particuliers dans l'étendue des Pays-Bas autrichiens* (Brussels, 1763); Jean-Baptiste Descamps, *Voyage pittoresque de la Flandre et du Brabant, avec des réflexions relativement aux arts & quelques gravures* (Paris, 1769). Based on the numerous reprints, Descamps' work was

the artistic treasures of the Southern Netherlands, in both public and private possession.[39] The descriptions in these guides closely resembled the elaborate ones in the auction catalogues, both in structure and style.[40] Descamps, for example, depicted Rubens' altarpiece in the Brussels Church of the Capuchins thus:

> The painting of the great Altar by Rubens ... represents Jesus Christ on his mother's lap, at the moment that he will be brought to the tomb, an angel holding a spear; beside him is Saint Francis. It is a great and rich picturesque *composition*, the heads are beautiful, and the *expressions* are very varied and true, the *colour* is just as nature shows; looking at this table more closely, it amazes by the ease and the steadiness of the learned brushstroke of this great man. This painting was engraved twice by P. Pontius & S.A. Bolswert.[41]

far more popular than that of Mensaert, who had only one edition. The *Voyage pittoresque* had a pirate version in Antwerp, and even a German reprint in 1771. Gaëtane Maës, 'Guide de voyage et édition critique: Mensaert ou Descamps?', *Archives et bibliothèques de Belgique*, 74 (2003): pp. 99–113.

[39] While these booklets had the form of a travel guide, only Descamps' work fit the genre: Mensaert's 'The amateur and curious painter' should be considered part of the promotion of the arts under the new governor Prince Charles Alexandre of Lorraine, a well-known Maecenas of the arts in the southern Netherlands. For more information on the contemporary importance of these booklets, read the articles by Gaëtane Maes, such as Maës, 'Guide de voyage'.

[40] Less known today is Gerard Berbie's city guide to Antwerp entitled 'Description of the most important paintings' (*Description des principeaux tableaux*, 1755), although it was probably quite important for the common traveller with an interest in the arts. The guide was available at all hotels in the city and was often bought by art lovers on visits there. Kees Van Strien, *Touring the Low Countries: Accounts of British Travellers, 1660–1720* (Amsterdam, 1998), p. 194. For example, some Dutch visitors from Alkmaar bought it on their trip to Antwerp in 1763. Frederik Clijmans, *Hollandsche toeristen op hun wandel in het achttiend'eeuwsche Antwerpen* (Antwerp, c. 1942), p. 7. The English traveller Joseph Marshall also referred to it in his journal: 'And the only account I have seen of them [paintings in Antwerp churches] is a little catalogue sold at the inns in Antwerp, and by the booksellers there, written in French.' Joseph Marshall, *Travels through Holland, Flanders, Germany, Denmark, Sweden, Lapland, Russia, the Ukraine and Poland in the Years 1768, 1769, and 1770* (London, 1772), p. 61.

[41] ('Le Tableau du grand Autel peints par Rubens, t. 1, p. 297, représente Jesus-Christ mort sur les genoux de sa Mere, au moment où il va être porté au tombeau, un Ange y tient une lance; près de lui est Saint François. C'est une grande & riche composition pittoresque, les têtes sont belles, & les expressions y sont très-variées & vraies, la couleur est également comme la nature l'indique; en regardant ce Tableau ce près, le faire étonne par la facilité & la fermeé de la touche sçavante de ce grand homme. Ce Tableau a été gravé deux fois par P. Pontius & par S.A. Bolswert'). Descamps, *Voyage pittoresque*, p. 67.

Auction catalogues, portable art dictionaries and travel guides each in their own way had the potential to inform and educate outsiders, people who were little acquainted with the art world. By reading and analysing the new-style catalogues, auction attendees in the eighteenth-century Austrian Netherlands were offered an opportunity to enter into a learning process of 'semiotic socialization', by which they acquired the necessary discourse to think and talk about art, and to reconstruct their own value patterns in relation to conventional market valuations.

Semiotic Socialization and the Auction Market

Comparing records of auction attendees with lists of aficionados in Austrian Netherlandish art guides seems to confirm that a considerable number of outsiders engaged in the learning process during the second half of the eighteenth century. In the aforementioned renowned art guide 'The amateur and curious painter' from 1763, the Brussels painter Mensaert took note of 75 art lovers in Antwerp and Brussels; 15 years later an anonymous Ghent almanac counted 80 collectors and dealers in the two cities (see Figure 3.2).[42] This relatively stable number of potential buyers from the local art worlds needs to be put into perspective, however, as a selection of annotated catalogues from the period 1763–1777 reveals at least 231 unique buyers at Antwerp and Brussels auctions.[43] While plausibly not all of these 150 buyers can be classified as newcomers to the art community as such,[44] roughly half of the recorded actors at auctions were recruited outside the regular circle of art lovers. Although further research is certainly needed, these first results confirm that the mentioned discursive shifts surrounding art auctions enabled a considerable number of newcomers to engage in a learning process of 'semiotic socialization'.

Parallel to these discursive shifts in the auction markets of the Austrian Netherlands, prices for paintings at public sales remained fairly stable in the

[42] Mensaert, *Le peintre amateur*, pp. 56–69 and 260–267; anonymous, *Nieuwen almanach der konst-schilders, vernissers, vergulders en marmelaers* (Ghent, 1777), pp. 4–5 and 14–15.

[43] As these annotated catalogues only cover about 25 per cent of recorded art auctions, the number of unique buyers was much higher. For more on the selection procedure, see Dries Lyna, 'The Cultural Construction of Value: Art Auctions in Antwerp and Brussels (1700–1794)' (unpublished doctoral dissertation, University of Antwerp, 2010), chapter 7.

[44] We know of art dealer Spruijt from Ghent participating in Antwerp and Brussels auctions, and the Polish count Potomski was active at one auction in the region during this period of time. Lyna, *The Cultural Construction*, chapter 7.

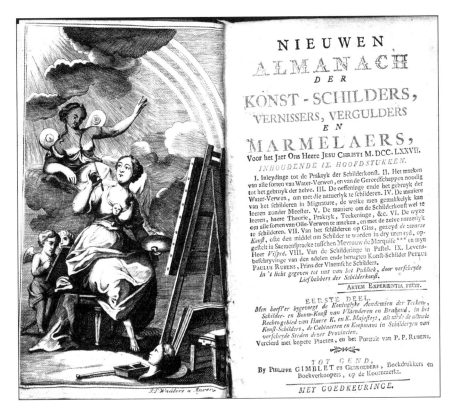

Figure 3.2 Title page of the *Nieuwen Almanach der Konst-Schilders, Vernissers, Vergulders en Marmelaers* (Ghent, 1777).

1760s and 1770s.[45] After 1780 the prices of secondary paintings declined, and two intertwined dynamics could explain this unexpected price evolution: first of all, since the early eighteenth century the general demand for paintings had been dropping in the Southern Netherlands, mainly due to changes in individual taste and interior decoration. Probate inventory research has convincingly shown that the well-to-do in particular lost their appetite for the arts, and the efforts of picture dealers to (re)connect to the leisure culture of high society could not prevent prices from falling.[46] Secondly, the collapse in the 1780s was

[45] For more on this price evolution, see Bruno Blondé and Dries Lyna, 'De culturele constructies voorbij? Prijsevoluties op de veilingmarkt voor schilderijen in de Oostenrijkse Nederlanden (1739–1794)', *Tijdschrift voor Sociale en Economische Geschiedenis/The Low Countries Journal of Social and Economic History*, 9/1 (2012): pp. 57–86.

[46] Inez Bourgeois, 'Dekoratieve voorwerpen en binnenhuisversiering te Gent in de 18de eeuw. Vloer- en wandbekleding, gordijnen, schilderijen, spiegels', *Oostvlaamse Zanten*,

a direct result of a temporary oversupply of paintings. After the abolishment of the Jesuits and the religious orders in the Southern Netherlands by the Austrian ruler, their artistic patrimony was auctioned off in 1777 and 1783 respectively, which unloaded thousands of paintings on to the resale markets. The auction scene could not cope with this additional blow and as a result, the monetary value of secondary paintings dropped considerably. All in all, at best the adapted commercial culture – with the discursive shifts at its heart – slowed down the inevitable price decline that was bound to impact the Antwerp and Brussels auction markets of the late eighteenth century.

However, it would be wrong to read the 'success' of the discursive shifts merely in economic terms. Although the altered commercial discourse on paintings did not prevent the monetary value of paintings from gradually declining in the short term, in the long run the cultural and economic implications were perhaps more important than previously assumed. As Von Stockhausen argues, the quality of the catalogue descriptions after the turn of the nineteenth century decreased to such an extent that the language of the catalogues was forgotten.[47] But by implementing De Piles' and Richardson's deconstructive rhetorical model into the commercial sphere, auctioneers in eighteenth-century western Europe unleashed easily accessible mental categories in the minds of the consumers, which allowed more people to enter into the art world. These discursive changes were crucial for the development of the auction as a cultural institution. By semantically deconstructing the painting's subject, space and technique, the writers of the catalogues separated the elements they could use to (re)construct a painting's monetary value. As such, this changing commercial culture of eighteenth-century auctions likely paved the way for a highly popular market for arts and antiques in the nineteenth century. For the period between 1830 and 1900, preserved Belgian catalogues testify to at least 700 specialized art and luxury auctions, whereas the second half of the eighteenth century only left us with a little over 100 catalogues. In addition, the number of specialized art and antique shops flourished like never before in Antwerp and Brussels.[48] Whereas

63/2 (1988): 88–91; Bruno Blondé, 'Art and Economy in Seventeenth- and Eighteenth-Century Antwerp: A View from the Demand Side', in Simonetta Cavaciocchi (ed.), *Economia e arte. XIII – XVIII. Istituto internazionale di storia economica 'D. Datini' Prato (Serie II, 33, II – Atti delle 'settimane di studi' e altri convegni 33, Atti della 'Trentatreesima settimana di studi', 30 aprile – 4 maggio 2001)* (Florence, 2002), pp. 379–391; Veerle De Laet, *Brussel binnenskamers. Kunst- en luxebezit in het spanningsveld tussen hof en stad, 1600–1735* (Amsterdam, 2009), p. 284.

[47] Tilmann Von Stockhausen, 'Formen des Ordnens: Auktionskataloge des 18. Jahrhunderts als Beginn der modernen Kunstgeschichte', in Markus Bertsch and Johannes Grave (eds), *Räume der Kunst. Blicke auf Goethes Sammlungen* (Göttingen 2005), pp. 89–101.

[48] For more on this, see Arnout's chapter on late nineteenth-century Brussels.

the eighteenth century was the era of the discovery of the discursive potential of printed catalogues to educate potential actors about the conventions of art valuation, the nineteenth century witnessed the definite breakthrough of the art auction as a cultural and commercial institute.

Chapter 4

From a 'Knowledgeable' Salesman Towards a 'Recognizable' Product? Questioning Branding Strategies before Industrialization (Antwerp, Seventeenth to Nineteenth Centuries)

Ilja Van Damme

The Birth of a Brand

Nowadays it seems common sense to use 'brand name creation' and 'brand name validation' as a sensible marketing strategy to launch new products or subsidiaries of an existing brand. The reasoning goes that brands are ideally suited to enter into direct communication with an 'end-consumer'.[1] A company does not speak personally to the consumers of its products, but the *brand*, *mark*, *label* or *logo* mediates typical demand-side concerns regarding trust, quality of the product, satisfaction, and so on.[2] As such, branding strategies not only pretend to offer objective information on the origin and attributes of commodities, but they simultaneously 'objectify' product meaning, image or brand 'personality' (by persuasively stressing certain benefits, thoughts, feelings, experiences, and so on).[3]

[1] Jennifer L. Aaker, 'Dimensions of Brand Personality', *Journal of Marketing Research*, 34 (1997): pp. 347–356; Kevin Lane Keller, 'The Multidimensionality of Brand Knowledge', *Journal of Consumer Research*, 29 (2003): pp. 595–600.

[2] Casper J. Werkman, *Trademarks: Their Creation, Psychology and Perception* (Amsterdam, 1974).

[3] Vanitha Swaminathan, Karen Stilley and Rohini Ahluwalia, 'When Brand Personality Matters: The Moderating Role of Attachment Styles', *Journal of Consumer Research*, 35 (2009): pp. 985–1002. Also see Naresh K. Malhotra, 'A Scale to Measure Self-Concepts, Person Concepts and Product Concepts', *Journal of Marketing Research*, 18 (1981): pp. 456–464; Russell W. Belk, 'Possessions and the Extended Self', *Journal of Consumer Research*, 2 (1988): pp. 139–168; Susan Schultz Kleine, Robert E. Kleine and Jerome B. Kernan, 'Mundane Consumption and the Self: A Social Identity Perspective', *Journal of Consumer Psychology*, 2 (1993): pp. 209–235.

Although a consumer's evaluation and loyalty to a brand is hardly rational – and is skewed, among other factors, by ethnicity, age, social peers and individual idiosyncrasies – the branding system is assumed to work.[4] Producers operating in mass-market segments, in which it becomes hard to distinguish one product from another, primarily employ it as a competitive weapon.[5] Thus, branding became increasingly widespread with late eighteenth-century industrialization, which primarily focused on producing standardized and substitutable products competing for mass appeal. For present-day consumers, the meaning of Wedgwood pottery, even more so of Packwood shaving blades, seems lost in time.[6] Yet the mineral-enriched soda water of Jacob Schweppe or the coffee of Douwe Egberts – late eighteenth-century contemporaries of Josiah Wedgwood and George Packwood – still adorn many a retail outlet (and even Wedgwood ware can still be found in the more exclusive design stores).[7] For these early industrial entrepreneurs, attaching the company's name to its products yielded the power to supersede some of the duties formally associated with locally and regionally operating retailers. Rather than putting these salesmen under pressure to stock an individual manufacturer's product, marketing was geared towards persuading consumers to ask for branded items in retail stores.[8] By exploiting technical innovations in the communication media, floods of new logos and iconographical vignettes increasingly vied for customers' attention, the latter recognizing or referring to these 'product brands' in face-to-face shopping transactions. Brands gained the power to 'create' and distinguish a new product from substitutable alternatives. As such,

[4] See, amongst others, Daryl Travis, *Emotional Branding: How Successful Brands Gain the Irrational Edge* (Roseville, 2000); Leonard Lee, On Amir and Dan Ariely, 'In Search of Homo Economicus: Cognitive Noise and the Role of Emotion in Preference Consistency', *Journal of Consumer Research*, 36 (2009): pp. 173–187.

[5] Richard Schmalensee, 'Product Differentiation Advantages of Pioneering Brands', *The American Economic Review*, 72 (1982): pp. 349–365.

[6] On Wedgwood and Packwood, see Neil McKendrick, 'Josiah Wedgwood and the Commercialisation of the Potteries', and idem,'George Packwood and the Commercialisation of Shaving: The Art of Eighteenth-Century Advertising or "the Way to Get Money and be Happy"', both in Neil McKendrick, John Brewer and John H. Plumb, *The Birth of a Consumer Society: The Commercialisation of Eighteenth-Century England* (London, 1982), pp. 100–194.

[7] On Schweppes, see Douglas A. Simmons, *Schweppes: The First 200 Years* (Washington, 1983). On Egberts and other early Dutch companies, see Wim Wennekes, *Eeuwenoud: de lange levens van zeven Nederlandse bedrijven: Van Eeghen, Wessanen, Van Lanschot, Bols, Douwe Egberts/Van Nelle, Mees & Hoppe, Scholten Linde* (Amsterdam, 1989).

[8] Roy Church, 'Advertising Consumer Goods in Nineteenth-Century Britain: Reinterpretations', *Economic History Review*, 53 (2000): p. 636.

recognizable 'product brands' tied the role of the retailer to the marketing strategies of almost vertically integrated production facilities.[9]

Today brands are an essential part of the everyday ballet surrounding buying and selling. Most existing brands came to be designed, coined and protected in the course of the past 250 years as principal, and often criticized, star performers within our 'affluent society'.[10] They are valued and criticized because of their presumed power to persuade or even 'manipulate' consumers' preferences. Indeed, branding literature – a strand of research that has become increasingly popular within consumption and marketing studies – makes an important distinction between three central and interconnecting features to define what makes a brand a brand: firstly, its trademark or proprietary function; secondly, its function as a guarantee or warranty; and thirdly, its advertising function.[11] This last function is particularly acknowledged as being central to branding practices.[12] Brands are crucial for marketing purposes – a tool for influencing customer choice, or, at best, a cognitive shortcut for helping to make shopping decisions.

However, while admitting that any definition of a 'brand' should always include a relationship with an end-consumer – who is being seduced by the brand, or at least uses the brand for shopping decision making – it can also be argued that so-called 'proto-brands' or 'pre-industrial brands' did not always function as clear predecessors of present-day brands at all.[13] At least a distinction should be made between different sorts of branding practices that were used in the *ancien régime*, both by retailers and by craftsmen-producers. Moreover, in any interpretation of pre-industrial branding strategies, the relationship between the materiality of the product, its brand and the end-consumer should take centre stage. Not all products were branded, nor did all goods need branding strategies to reach their consumers.

As such, this chapter goes against all too linear narratives on branding, equating its history with one of incremental complexity, increasing

[9] Roy Church and Andrew Godley, 'The Emergence of Modern Marketing: International Dimensions', in Roy Church and Andrew Godley (eds), *The Emergence of Modern Marketing* (London, 2003), pp. 1–5.

[10] Frank I. Schechter, *The Historical Foundations of the Law Relating to Trade Marks* (New York, 1925); Johanna Bellaar Spruyt, *Het collectieve merk en de merkenbescherming in Nederland* (Den Haag, 1934), pp. 5–16; Rudolf Callman, *The Law of Unfair Competition and Trade-Marks* (2nd edn, Chicago, 1950), vol. 3, pp. 974–986; Lionel Bently, Jennifer Davis and Jane C. Ginsburg (eds), *Trade Marks and Brands: An Interdisciplinary Critique* (Cambridge, 2008).

[11] Callman, *The Law of Unfair Competition*.

[12] Keller, 'The Multidimensionality of Brand Knowledge'.

[13] See also Jonathan E. Schroeder, 'Brand Culture: Trade Marks, Marketing and Consumption', in Bently, Davis and Ginsburg (eds), *Trade Marks and Brands*, pp. 161–176.

pervasiveness and growing sophistication in image and meaning.[14] This is not to imply that 'commodity branding is a unique feature of [modern] Western capitalist societies'; or, to put it bluntly, that branding practices were harbingers of industrial modernization.[15] My key issue concerns the question of what particular historical features of early modern branding remained constant or, inversely, have been subject to change since industrialization. Crucial in this aspect, I believe, is a fundamental re-questioning of the (lack of) value that end-consumers attached to the sort of practices and strategies normally associated with early modern branding. For some goods, branding mattered; for others, it clearly did not. Thus, in early modern times, so the reasoning goes, branding did not necessarily engage with customers, but could be aimed at the stakeholders involved in the production and distribution of commodities, be it a craftsman or an intermediary, like a merchant or retailer.

Central to my argument of change will be notions relating to commodity marketing, buyer persuasion and decision making. How did consumers in the late seventeenth and early eighteenth century relate to branded products? Were trust, satisfaction and quality of goods established through branding practices, or did producers and retailers alike resort to other means and sale strategies? How, in fact, was the gap between supply and demand bridged in this period? Drawing on archival evidence from extensive research on the Antwerp retail context from the seventeenth to nineteenth centuries, I will establish how the customer's awareness and valuation of brands was relative to his knowledge and trust in the type of goods he was buying. In other words: the greater the lack of transparency of the commodity markets – the shortage of recognizable and recurrent characteristics of consumer goods – the more likely a customer was to resort to other means than product brands for making choices and decisions.[16]

[14] See, for instance, Karl Moore and Susan Reid, 'The Birth of Brand: 4000 Years of Branding', *Business History*, 50 (2008): pp. 419–432. A similar concern for all too linear historical writing on marketing phenomena is framed in Ronald A. Fullerton, 'How Modern is Modern Marketing? Marketing's Evolution and the Myth of the Production Era', *Journal of Marketing*, 52/1 (1988): pp. 108–125; Fuat Firat and Nikhilesh Dholakia, 'Rewriting Marketing History: Why?', *CHARM-proceedings*, 4 (1989): pp. 107–119; Terence Nevett, 'Historical Investigation and Practice of Marketing', *Journal of Marketing*, 55 (1991): pp. 13–23.

[15] David Wengrow, 'Prehistories of Commodity Branding', *Current Anthropology*, 49 (2008): p. 7.

[16] For more details on this ongoing archival research, see Ilja Van Damme, *Verleiden en verkopen. Kleinhandelaars en hun klanten in tijden van crisis (ca. 1648–ca. 1748)* (Amsterdam, 2007); idem (in co-operation with Laura Van Aert), 'Antwerp Goes Shopping! Continuity and Change in Retail Space and Shopping Interactions from the Sixteenth to Nineteenth Century', in Jan-Hein Furnée and Clé Lesger (eds), *The Landscape of Consumption: Shopping Streets and Cultures in Western Europe, 1600–1900* (Houndsmills, 2014), pp. 78–103.

Untransparent Commodity Markets

A first, essential distinction one has to make concerns the functioning of the early modern product markets on the one hand, and those which started emerging with widespread industrialization from the end of the eighteenth century onwards on the other. Indeed, it is sometimes forgotten how the structure of the early modern commodity markets necessitated a relationship between consumers and their 'world of goods' which differed significantly from today. Most, if not all, seventeenth- and eighteenth-century goods lacked recognizable, 'standardized' characteristics, and were wrapped and packaged in a non-homogeneous manner. Certainly, the barriers to assessing durable products (textiles are a case in point) in seventeenth- and eighteenth-century Antwerp were much higher than in the nineteenth century. Even an experienced shopper faced difficulties finding goods of the right measures, quality, texture, strength, materials, appearance, place of production, and so on. Much shopping merchandise had irregular characteristics and unobservable attributes that were not easy to detect before purchase (regarding durability, safety, effectiveness, comfort, and so on).[17]

This untransparent and heterogeneous character of the early modern product markets was in itself becoming more and more complex in the seventeenth and eighteenth centuries due to a widening material culture in which new materials, goods and designs were produced and imported in ever-faster succession by commercial middlemen.[18] When entering the market in seventeenth- and eighteenth-century Antwerp, customers were confronted with a growing product diversity and variability: shoppers were faced with alternative choices and different price levels for almost each and every good. Public pricing or ticketing of wares, if applied, could serve as a first index of justifying the quality of substitutable products.[19] But regarding price-fixing too, uncertainty about the value and diversity of currencies in circulation, and the non-standardization of weights and measures, dominated almost each and every transaction in a retailer's or craftsman's shop, or in the marketplace alike.[20]

Elaborating on the famous article by Clifford Geertz regarding Moroccan suqs, Laurance Fontaine recently described this sort of economic ordering

[17] See also Garry Richardson, 'Brand Names before the Industrial Revolution', *NBER Working Paper No. 13930* (April 2008): pp. 6–13.

[18] See Ilja Van Damme, 'Middlemen and the Creation of a "Fashion Revolution": The Experience of Antwerp in the Late Seventeenth and Eighteenth Centuries', in Beverly Lemire (ed.), *The Force of Fashion in Politics and Society: Global Perspectives from Early Modern to Contemporary Times* (Ashgate, 2010), pp. 21–39.

[19] See Tibor Scitovsky, 'Some Consequences of the Habit of Judging Quality by Price', *Review of Economic Studies*, 12 (1945): pp. 100–105.

[20] Van Damme, *Verleiden en verkopen*, pp. 173–183.

in the seventeenth and eighteenth centuries as *'une économie du bazar'*.[21] Although this metaphor is debatable, it has the advantage of stressing the actual physical contacts and bartering interactions between consumers and salesmen. These prolonged and extended negotiations between buyers and sellers were essential in reducing the problems of 'information asymmetries' and 'multiple quality assessments' associated with untransparent commodity markets.[22] In the absence of strict government-controlled, standardized and homogenized product markets, which only started emerging from the nineteenth century onwards, negotiations regarding trust, reputation and quality of goods were normally transferred to the person doing the sale. Indeed, what seems to have been crucial in consumer choice and decisions – and for the possibility of legal redress in case of fraud or bad judgement – was not so much a clear pedigree of the product one was buying, but tacit knowledge about the reputation and legal status of the dealer.

Indeed, the intense verbal contacts, pitch, discourse and the direct physical experience which always accompanied early modern dealings made these moments themselves a central event for tackling uncertainty and objectifying trust and respect.[23] It was really during these negotiations that the customer could gauge the quality or reputation of the salesmen: questions were asked that could pinpoint the economic, social and cultural position (or capital) of the retailer. Thus, a negotiation was not in the first place a choice for the 'best price' or for the quickest and cheapest distribution of goods (a modern maximalization of profit and time). Shopping interactions could include an inductive search of mutual acquaintances, economic wellbeing and creditworthiness. Customers responded to certain expected gestures, manners and behaviour, while salesmen explained and objectified products

[21] Laurence Fontaine, *L'économie morale. Pauvreté, crédit et confiance dans l'Europe préindustrielle* (Paris, 2008), p. 255. Reference is made to Clifford Geertz, 'Suq: The Bazaar Economy in Sefrou', in Clifford Geertz, Hildred Geertz and Lawrence Rosen, *Meaning and Order in Moroccan Society* (London, 1979), pp. 123–264. See also Frank S. Fanselow, 'The Bazaar Economy or How Bizarre Is the Bazaar Really?', *Man*, 25 (1990): pp. 250–265.

[22] On the importance of 'information mechanisms' in an economy, see George A. Akerlof, 'The Market for Lemons: Qualitative Uncertainty and the Market Mechanism', *Quarterly Journal of Economics*, 84 (1970): pp. 488–500; Joseph E. Stiglitz, 'The Causes and Consequences of the Dependence of Quality on Price', *Journal of Economic Literature*, 25 (1987): pp. 1–48; François Eymard-Duvernay, 'Conventions de qualité et formes de coordination', *Revue économique*, 40 (1989): pp. 329–359.

[23] According to John Styles, 'Product Innovation in Early Modern London', *Past & Present*, 168 (2000): p. 168, these shopping interactions between buyers and sellers were 'an extended process of negotiation between the two, through which their expectations might be adjusted and their interests reconciled, in some sense at least'.

with meaning and context.[24] Only by building a relationship – which at least had the potential of being vested on mutual, long-term beneficial grounds – could trust and respect be secured. Despite the fact that salesmen at all levels of society had multiple opportunities to fool consumers into a one-time lucrative bet (a negative incentive of information asymmetries), most retailers – even the much maligned and criticized peddlers on the street – had much more to gain by securing a loyal, long-term client base. Therefore, profit and time maximalization was also less important than balancing reciprocity between buyers and sellers: securing mutual trust, understanding, obligations and eventually gratitude.[25]

Certain formal aspects of the deal, such as haggling, bargaining and the importance of credit, all reinforced these aspects of trust, understanding and reciprocity. They were ideally suited to establishing long-term, personal relationships between buyers and sellers, and as such could accommodate problems related to uncertainty and un-transparency on the product market.[26] Price-fixing through bargaining and haggling was indeed commonplace in early modern Antwerp. Public pricing or ticketing of goods was considered improper: instead consumers had to ask about the prices of products. Salesmen could then name a price, but did not expect that customers would agree on it immediately. Rather, in the ensuing process of negotiation, trust had be secured on the origin and quality of the goods, on the reputation of the dealer and conversely about the creditworthiness of the customer himself. Indeed, credit played a crucial aspect in establishing a personal bond between a salesman and his customers; it created sociability built upon personal relationships.[27] Credit could be extended from week to week, until the next market day, or be given for longer periods,

[24] Nancy Cox and Karin Dannehl, *Perceptions of Retailing in Early Modern England* (Ashgate, 2007), p. 157, points to the same importance of social relationships between retailers and their clients in early modern England.

[25] Ilena Ben-Amos, 'Gifts and Favors: Informal Support in Early Modern England', *Journal of Modern History*, 72 (2000): pp. 295–338; Peter Stabel, 'Negotiating Value: The Ethics of Market Behaviour and Price Formation in the Late Medieval Low Countries', in Marc Boone and Martha Howell (eds), *In But Not of the Market: Movable Goods in the Late Medieval and Early Modern Economy* (Brussels, 2007), pp. 53–69. On the economic rational of such 'gift economies', read Yunxiang Yan, 'The Gift and Gift Economy', in James G. Carrier (ed.), *A Handbook of Economic Anthropology* (Cheltenham and Northampton, 2005), pp. 246–261; Aafke Komter (ed.), *The Gift: An Interdisciplinary Perspective* (Amsterdam, 1998).

[26] These aspects have been excellently researched for Antwerp by Bart Willems, *Leven op de pof. Krediet bij de Antwerpse middenstand in de achttiende eeuw* (Amsterdam, 2009).

[27] More on the importance of credit in early modern shopping transactions can be found in Craig Mulrew, *The Economy of Obligation: The Culture of Credit and Social Relations in Early Modern England* (London, 1998); Laurence Fontaine, 'Antonio and Shylock: Credit and Trust in France, ca. 1680–ca. 1780', *Economic History Review*, 54 (2001): pp. 39–57.

depending on the established affinity. Clearly, if customers risked being fooled into buying worthless goods, salesmen too faced uncertainty when granting credit. Only a personal long-term bond could mediate such problems. During such an extended process of bargaining, haggling and balancing of reciprocity, long-term mutual bonds could be forged and information asymmetries overcome. Due to an economic framework that benefited negotiation over short-term gains, competitive strife between different salesmen in the seventeenth and eighteenth centuries was mainly directed at securing a loyal clientele (a positive incentive of information asymmetries).

It is sometimes assumed that these problems of untransparent commodity markets could be mediated by product markings or 'proto-brands'. These were supposedly used by merchants and craftspeople 'to protect themselves *and consumers* against inferior quality' (my italics).[28] Alternatively, trademarks are supposed 'to have been elemental to markets since traders first marked their goods as a guarantee *for customers* who lived beyond face-to-face contact' (again, my italics).[29] Such statements, however, conflate the meaning of proto-brands or pre-industrial brands with those in use today. Certainly, a long-running continuity can be seen in employing product marks for protecting or 'legalizing' the political interests, labour relations and property claims of the stakeholders involved in the production and distribution of goods – correctly framed as a function of 'economies of scale'.[30] But no such continuity can be found in the use of commercial marks as an advertising or marketing tool towards end-consumers. Economic actors often had other goals in mind than reaching end-consumers when branding products. A lot depended on the sort of products one was selling or producing. To make this point clear, I will start by elaborating on branding practices employed by producers and early modern institutions (such as city and guild authorities). Next I will question whether intermediaries (merchants and retailers) did in fact need these sorts of 'brands' to deliver their goods to an end-consumer.

Producing 'Recognizable' Goods

The most common, and certainly most well-known, branding strategies were the ones employed by producers. However, this act of imprinting commodities with recognizable and recurrent marks, vignettes or monograms by craftsmen and

[28] Philip Kotler, Kevin L. Keller and Peggy H. Cunningham, *Marketing Management* (Toronto, 2006), p. 274.
[29] Douglas B. Holt, 'Comments', *Current Anthropology*, 49 (2008): p. 22. Also see idem, 'Why Do Brands Cause Trouble? A Dialectical Theory of Consumer Culture and Branding', *Journal of Consumer Research*, 29 (2002): pp. 70–90.
[30] Wengrow, 'Prehistories of Commodity Branding', p. 7.

artisans requires some further specifications before explaining its logic from a marketing perspective. First of all, one has to discern between the practice where the product itself becomes an 'identity' and the practice where commodities were stamped or signed by important early modern institutions, such as city and guild officials.

Garry Richardson has written an extensive paper on the ways in which medieval manufacturers sought to produce commodities with 'conspicuous characteristics' to overcome the obstacles of adverse selection and counterfeiting.[31] As such, he refers to production practices – already known from Antiquity – to distinguish between substitutable products, such as textiles, potteries, leather, metallic or wood wares, on the basis of unique 'identifiable' singularities (regarding length, width, colour, weight, shape, design, and so on). Such goods were not easy to copy for several reasons: by exploiting local raw materials with 'one-of-a-kind chemical properties'; by applying manufacturing 'secrets' not widely shared and known; by investing in specialized equipment; and so on. As a result, one commonly refers – in sources of various kinds – to, for instance, 'copper of Cyprus', 'red slipped ceramics of Tyre', 'steel from Damascus', 'Parmesan cheese', 'Burgundy wine', 'white cloth from Ghent', 'London pewter', 'diamonds from Antwerp', 'lace from Bruges', and so on, and so on.[32] Although Richardson acknowledges how such 'type-town' or 'type-region' product names corresponded to old linguistic conventions of identifying objects and individuals with descriptive suffixes, he insists on calling these the 'brand names before the Industrial Revolution'.[33] He motivates this decision by pointing out how such identifiable products could influence consumer decisions, product prices and manufacturer profits.

However, the suggestion that 'type-town' product names 'carry' the goods towards the customer in a similar vein as present-day brands do remains particularly contentious. For one thing, most of the products that Richardson is referring to were export goods. This implies two things. Firstly, the original manufacturers were dependent on a whole line of intermediated actions (by merchants, wholesalers, retailers) before their goods actually reached their places of destination. Thus, products with conspicuous characteristics reinforced the power of producers in business-to-business contacts with intermediaries, but, again, there remains a dispute as to whether they were always of practical use to end-consumers. In the absence of vertically integrated and producer-controlled distribution lines – which, from the nineteenth-century onwards, tried to directly link the goods of a production unit with an end-consumer – locally and regionally operating retailers still had a lot of freedom in early modern times

[31] Richardson, 'Brand Names'.
[32] For more examples, see Richardson, 'Brand Names'; Moore and Reid, 'The Birth of Brand'.
[33] Richardson, 'Brand Names', p. 27.

to devise a marketing strategy on their own. At the places of destination, and depending on the sort of goods that were being sold, retailers could again repack or unwrap exported commodities, or, even more radically, re-form or re-fashion the original merchandise altogether for local use and re-appropriations.

A roll of cloth was cut into smaller parts, or already mated into an item of clothing; metal parts could be melted or re-assembled; furniture remodeled into fashionable combinations; earthenware and ceramics re-painted. The original manufacturers had little resort to legal channels to control the sale of their products over longer distances.[34] Only when a manufacturer was well known and wealthy enough could he actually supervise the distributive chains of his products.[35] However, only a tiny, specialized luxury segment of the market boasted such powerful industrial entrepreneurs before the eighteenth century. Much more common were the type of mercantile or commercial 'capitalists' experienced in expropriating the profits of industrial activity and relocating their businesses as deemed fit.[36]

Of course, within such a balance of power, mercantile and manufacturing interests did not always coincide.[37] Despite the use of 'conspicuous characteristics', manufacturers still had to trust the salesmen to guarantee that 'type-town' product names did not become associated with substitutable – although not exactly matching – merchandise from other regions and towns. In eighteenth-century Antwerp, for instance, cottons of very different origin and kind were often sold as '*Indiennes*', although most of them were no longer produced in India.[38] And 'London cloth' was traded all over Europe, not because it had been made in the city but because it was distributed from there.[39] These examples

[34] It was only from the nineteenth century onwards that universal legal protections for intellectual property became regulated in a coherent way – although, today, illicit trading and counterfeiting still remains omnipresent all over the world. See, for instance, Gene Grossman and Carl Shapiro, 'The Counterfeit-Product Trade', *The American Economic Review*, 78 (1988): pp. 59–75.

[35] Regarding the business practices of Matthew Boulton, see, for instance, Shena Mason, *Matthew Boulton: Selling What All the World Desires* (Yale, 2009).

[36] Herman Van der Wee, 'Industrial Dynamics and the Process of Urbanization and De-Urbanization in the Low Countries from the Late Middle Ages to the Eighteenth Century: A Synthesis', in Herman Van der Wee (ed.), *The Rise and Decline of Urban Industries in Italy and in the Low Countries (Late Middle Ages–Early Modern Times)* (Leuven, 1988), pp. 307–381.

[37] Catharina Lis and Hugo Soly, 'Different Paths of Development: Capitalism in the Northern and Southern Netherlands during the Late Middle Ages and the Early Modern Period', *Review*, 20 (1997): pp. 211–242.

[38] Alphons K.L. Thijs, *Van 'werkwinkel' tot 'fabriek'. De textielnijverheid te Antwerpen (eind 15de–begin 19de eeuw)* (Brussels, 1987).

[39] Derek Keene, 'Material London in Time and Space', in Lena C. Orlin (ed.), *Material London ca. 1600* (Philadelphia, 2000), pp. 55–74.

already indicate how merchants could be very inventive in 'creating' product innovations and new fashions, which undermined or precisely fostered the competitive position of one region against another.[40] Antwerp itself experienced such a decline in the last quarter of the seventeenth century, when all things 'French' eclipsed Antwerp's renowned luxury export industries.

Secondly, customers too had to be wary about imported goods, and still had to rely on a 'knowledgeable' salesman rather than on supposedly recognizable or identifiable product characteristics – given that this information was still in place when the merchandise eventually reached the market, auction or shop. Indeed, the existence of 'type-town' product names pinpoints the origin of a good, but does not mediate problems of trust regarding 'quality' or 'provenance' of the maker. The prestigious and successful 'Antwerp silk', for instance, was of an observable colour and texture, but could still cause confusion and questions from customers such as: was the silk manufactured in Antwerp by a member of the silk-weavers guild, by some other guild in the city, by a non-corporate Antwerp artisan, or by a craftsman living somewhere else, but working on account for an Antwerp merchant?[41] Thus, the existence of 'conspicuous characteristics' still did not unambiguously connect producers to products like brand names do today: even if customers knew and interpreted certain attributes as belonging to a particular region or town, their worries were not all over. They could learn from consumer experience that certain goods warranted their price and investment, but rather than using these 'type-town' product names as a heuristic shortcut towards consumer decisions, such names only opened certain avenues for intensified discussions with a salesman. And, vice versa, salesmen – not producers – could seduce or persuade customers by selling the 'real McCoy' only when customer awareness and interest already existed and further information and proof of trust was provided.

The Logic of Commodity Marking by Early Modern Institutions

City authorities often choose to mark outgoing merchandise with some sort of city emblem or symbol, but this was more of a 'police mark' than a brand. It provided information that the goods in question had been taxed for custom duties in the place of origin. If customers were able to spot and recognize this information – which sometimes was no longer possible – it

[40] Styles, 'Product Innovation', pp. 124–169; Maxine Berg, 'From Imitation to Invention: Creating Commodities in Eighteenth-Century Britain', *Economic History Review*, 55 (2002): pp. 1–30.

[41] Richardson, 'Brand Names', p. 24, recognizes this problem, but does not question its implications from a consumer-side perspective.

connected 'type-town' product names to an actual location. Again, however, it did not corroborate producer provenance, nor was it particularly devised and protected for advertising purposes (although it could be used as such by a clever salesman). When city marks were used on goods without specific characteristics or 'type-town' specifications, customers could also ignore it, because it did not guarantee against hidden defects or unobservable attributes of the merchandise in question. Usually early modern governments did not bother to protect customers' trust, which was left to being mediated outside the public sphere during personal buying and selling interactions.[42] This, however, provided the salesmen, again, with considerable leeway to manipulate the name and fame of a certain place, as is indeed illustrated in an amusing anecdote recorded by Pieter Cardon at the end of the seventeenth century.[43] When an Antwerp textile trader is unsuccessful at selling his homemade silks of the highest quality, even at rock-bottom prices, the retailer sets up an intriguing deal with a fellow merchant of Cambrai. This last trader sells the Antwerp silks at double the price in France, and sends the lesser textiles back to the Antwerp merchant, but now with the label *fabriqué à Paris* attached to them. And lo and behold! The same products that were not wanted 'because of the name of the city of Antwerp' are now eagerly bought by 'all the principal ladies in town'. And everybody, unwilling to follow this 'new, French fashion', is mocked as a 'hypocrite and a fool, not knowing what fashion was'.[44]

Guild officials too marked their merchandise. Textiles were stamped, or a piece of lead was attached to the cloth; precious metalwork usually had more than one inscription, giving information on the assay, master of the guild and place of origin.[45] So, again, an indication of 'location', but curiously enough also some sort of 'warranty' seems to have been essential to guild marks. This is, indeed, confirmed by the eighteenth-century *Dictionnaire Universel de Commerce*, describing 'marques' as: 'certain caractères qui s'appliquent & s'impriment sur plusieurs sortes de marchandises, soit pour connaître le lieu

[42] Philippe Minard, 'Réputation, normes et qualité dans l'industrie textile française au XVIIIe siècle', in Alessandro Stanziani (ed.), *La qualité des produits en France, XVIIIe–XXe siècles* (Paris, 2004), pp. 69–92; Sheilagh Ogilvie, 'The Use and Abuse of Trust: Social Capital and its Deployment by Early Modern Guilds', *CESifo Working Paper nr. 1302* (October 2004): pp. 11–20.

[43] Pieter Cardon, *Den oorspronck van de ruïne en armoede der Spaensche Nederlanden* (Luik, 1699).

[44] Cardon, *Den oorspronck van de ruïne en armoede*, pp. 17–18: 'al degene die dese nieuwe Parijsche mode niet naer en volgden, wirden uyt-gemaeckt voor hypocryten oft slechthoofden en als niet wetende wat de mode was'.

[45] Albert Michielsen, *De evolutie van de handelsorganisatie in België sedert het begin van de 18de eeuw* (Turnhout, 1938), pp. 235–239; Joost Jonkers and Kathy Sluyterman, *Thuis op de wereldmarkt. Nederlandse handelshuizen door de eeuwen heen* (Den Haag, 2000), p. 188.

de leur fabrique, soit pour rendre garants de leur bonté les ouvriers qui les ont fabriquées ou apprêtées'.[46]

The question now arises as to what guilds hoped to accomplish with this commodity marking. Several hypotheses have been forwarded so far. Older interpretations connected these guild marks to processes of standardization and homogenization, which would have related recognizable products to an identifiable collective organization – sometimes even an individual master or firm – highly comparable to branding practices in use today.[47] By closely monitoring the 'quality of goods' – so the reasoning goes – guilds hoped to secure defect-free goods and establish reputations based on recognizable product identities, which could then be exploited for advertising and sales towards end-consumers. Evidence abounds that Antwerp guilds indeed made intensive, although not fail-proof, efforts to control the quality of their merchandise before and after production (thereby using methods common to other early modern guilds, such as controlling apprenticeships, inspecting workshops and marking the masters' produce).[48] But rather than being aimed at standardizing or homogenizing the shape, look or observable characteristics of the good – which anyhow depended on the product – guilds sought to secure the superiority of their merchandise by controlling the quality of unobservable raw materials.

In 1621, for instance, Antwerp furniture made of 'Spanish wood' had to be marked with the letter S, not to achieve uniformity of some sort, but to prevent other wood being sold as Spanish.[49] The mark warranted unobservable attributes or took a position against hidden defects: it guaranteed a 'fair' construction, free of tinkering with the costly raw materials. If the alloy of metals, the sort of leather, cloth or some other basic material was subject to change, the marks of the guilds involved had to change similarly. Thus, on 3 June 1710 the Antwerp pewter- and lead-makers were ordered 'to make new marks', since the old ones had been used to represent its raw materials in a fallacious way, 'thus disreputing their manufacture and deceiving the community'.[50] In short, marks sought to

[46] Savary des Bruslons, *Dictionnaire Universel de Commerce* (Copenhagen, 1759–1765), vol. 1, pp. 1821–1822 ('enseigne'), vol. 2, p. 1262 ('marque').

[47] Michielsen, *De evolutie van de handelsorganisatie*, pp. 235, 237 and 239; Richardson, 'Brand Names', p. 4.

[48] For Antwerp in this regard, see Bert De Munck, *Technologies of Learning: Apprenticeship in Antwerp from the 15th Century to the End of the Ancien Régime* (Turnhout, 2008).

[49] Bert De Munck, 'Leerpraktijken. Economische en sociaal-culturele aspecten van beroepsopleidingen in Antwerpse ambachtsgilden, 16de–18de eeuw' (unpublished doctoral dissertation, Free University Brussels, 2002), pp. 382–391.

[50] City Archives Antwerp (CAA), *Gilden en ambachten* (*GA*), nr. 4264: city ordinance of the 3rd of June 1710.

legitimize the supposedly superior manufacture of raw materials (a 'reputation') for end-customers (the 'community') in comparison to similar, but unmarked, products – which, in the relative open economies of the early modern towns, could never be completely monopolized.[51]

Guild marks as such were similar to city marks: they were of a compulsory nature, not optional. Therefore, recent reasoning goes that guild marks have to be seen not so much as brands, but rather as precursors of collective warranty marks. They guaranteed against fraud and constructed 'quality' according to closely prescribed and regulated rules regarding the processing of raw materials, similar to an ecological or fair trade label today.[52] Did guilds, however, succeed in employing these marks for marketing purposes, thus influencing consumer preferences by stressing 'the excellence of the product in question and thereby the creation of a psychological need for that product'?[53] This was certainly part of the rhetoric used by the Antwerp guilds: again and again guild members represented themselves in accustomed and worn-out phrasings as 'guardians' of consumers. When, for instance, in 1649 the guild of Second-Hand Dealers ('Oudekleerkopers') was selling imported furniture on the Friday Market next to products of the Antwerp Joiners guild, the latter demanded a clear distinction. According to the Joiners, the imported wares were made of 'bad wood', thus demanding that their 'superior' products be marked with a sign 'which can be known by the buyers'.[54] In similar phrasings, the Antwerp Skin and Leather Makers ('Huidenvetters') demanded a ban on the import of English and Irish leather by the Shoemakers to 'safeguard' the community against the shoddy nature of these non-local raw materials.[55] And towards the end of the seventeenth century, the Hatters complained about the import of French hats and felts by the 'hat-sellers' – a profession which belonged to the Retailers guild. The 'sealing' of merchandise should make clear to everyone that only the Antwerp Hatters were selling 'clean, good, strong and pleasant hats', and at 'better prices'.[56]

[51] A similar argument is made in Erik Aerts and Frank Daelemans, 'Sociaal-economische aspecten van het 16de-eeuwse Brussel', *Tijdschrift voor Brusselse Geschiedenis*, 1 (1984): pp. 5–44.

[52] Bellaar Spruyt, *Het collectieve merk*, p. 5.

[53] Schechter, *The Historical Foundations*, p. 78. Cited in Wengrow, 'Prehistories of Commodity Branding', p. 29.

[54] De Munck, *Leerpraktijken*, p. 383.

[55] See, in this regard, Ann-Katrien De Clippele, *Sociaal-economische studie van het huidevetters- en schoenmakersambacht te Antwerpen in de 17de eeuw* (unpublished master's thesis, Free University Brussels, 1997).

[56] CAA, *GA*, nr. 4255: request of the Raad van Financiën (dated 12 June 1665); statement of Laureijs Willemsen, public notary with the Raad van Brabant (dated 28 February 1665).

These examples make at least one thing clear: although in rhetoric and justification they claimed otherwise, the Antwerp producer guilds used marks mainly to protect their own interests and the stakes involved. Commodity marking was not so much aimed at binding customers to a brand, or even preventing adverse selection, as it was directed against imports of similar products or, in general, manufacturing outside the local guild system. It differentiated products made by guild masters, and represented them as honest, skilful and of good reputation. Thus, early modern 'branding' strategies by guilds have to been seen as 'power struggles' which relate to a particular political context and labour situation – as recently and convincingly argued by Bert De Munck.[57] For Antwerp, the default lines of this 'battle' have yet to be analysed in more detail, but they clearly separated (small) manufacturing masters – allowed to sell only their own wares – from merchant-manufacturing entrepreneurs and retailers, importing goods or ordering merchandise from workers operating inside or outside the guild context.[58] As such, product marks could be used as quality *premia* to demand higher prices and secure the guild masters' profit. But this was only a successful strategy if customers effectively used marks as heuristic shortcuts for decision making and appreciated 'quality' in the same way as the guilds tried to construct it (that is, as a function of the skilful and honest processing of raw materials).

'Branding' Practices by Commercial Middlemen

The practice of 'marking' goods for long-distance trade bears witness to the peculiar troubles that traders faced in shipping or transporting wares from point A to point B. By 'branding' seals, initials or heraldic signs on jars, baskets or barrels, merchants sought to identify their property in case of theft, infraction, loss, accidental misplacement or substitution – thus as a way of keeping track of the movement of objects. Archaeological evidence from as far-reaching places as the Indus valley, China, and antique Europe, indeed, confirms the widespread and long-running existence of such activities.[59] It has to be stressed, however, that these trademarks bore a primarily proprietary and logistical function connected to origin of ownership, sorting, storage and transportation – very similar to a

[57] Bert De Munck, 'The Agency of Branding and the Location of Value: Hallmarks and Monograms in Early Modern Tableware Industries', *Business History*, 54 (2012): pp. 1–22.

[58] See Bert De Munck, 'Skills, Trust and Changing Consumer Preferences: The Decline of Antwerp's Craft Guilds from the Perspective of the Product Market, ca. 1500–ca. 1800', *International Review of Social History*, 53 (2008): pp. 197–233; idem, 'One Counter and Your Own Account: Redefining Illicit Labour in Early Modern Antwerp', *Urban History*, 37 (2010): pp. 26–44.

[59] Moore and Reid, 'The Birth of Brand', pp. 422–428.

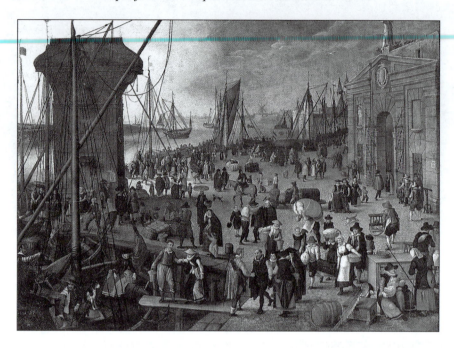

Figure 4.1 Sebastiaan Vrancx, *A View of Antwerp Harbour with the Kraanenhoofd and the Werf Gate* (1608). Oil on panel, 58 × 92 cm. Private collection.

farmer 'branding' his cattle.[60] For Antwerp at least, there is hardly any evidence that these marks were used for actually communicating with potential buyers, or for promoting or advertising wares in shops, auctions or the marketplace. Moreover, most of these marks were found on the containers of goods, not on the goods themselves, which is indeed confirmed by Antwerp paintings, letters and early modern business documents.[61] For example, in a 1608 painting by Sebastiaan Vrancx, merchants are marking bales of goods that have just arrived in the Antwerp harbour (Figure 4.1, middle left).

As soon as these barrels, bottles or packages arrived at their destination, wholesalers and retailers took over. Thus, merchant trademarks could help in mediating business-to-business contacts between the different intermediary lines. Orders were placed on the basis of samples, and in book-keeping and correspondence sources, reference was made to marks of received packages. Marks guaranteed and reassured the wholesaler and retailer that ordered goods

[60] See, for instance, Jonkers and Sluyterman, *Thuis op de wereldmarkt*, pp. 188–189.

[61] Van Damme, *Verleiden en verkopen*, p. 154; Michielsen, *De evolutie van de handelsorganisatie*, pp. 235–239.

were properly delivered. Once at their destination, however, it was very common for retailers to unwrap closed packages and re-open sealed boxes and barrels. On 18 January 1773, for instance, the Antwerp Retailers guild (*meerseniersambacht*) described its activities as 'breaking out and breaking open barrels, casks, and packages, which arrive closed and tied, and selling out of these by using weights or measures'.[62] Similarly, in the *Encyclopédie* of Diderot and D'Alembert, 'retailing' was described as:

> fait négoce à plus petites mesures & a plus petits poids qu'il ne l'a achetée, qui la coupe & la divise pour en faire le débit [...] ils ne vendent pas les balles entières et sous corde, et les pièces d'étoffes avec cap & queue, mais qu'ils les coupent ou les divisent pour en donner, soit au poids, soit à quelqu' autre mesure ce que chacun de leurs chalands peuvent en demander & en avoir besoin.[63]

Admittedly, these definitions do not exclude the fact that customers could actually check the original branded containers or product vessels, placed, for instance, behind the retailer in nests or drawers, or stacked on the floor of the shop. However, since these barrels and packages were already opened, the customer still had to trust the salesman's opinion and advice on the provenance and content of the containers.[64] Moreover, 'noticing' trademarks is just one aspect of the buying process; 'knowing' and 'interpreting' these marks of merchants is something else entirely.[65] Even today, customers are mostly unknowing of the meaning of similar proprietary and logistical information on the packaging of goods, which is usually provided next to the brand in the form of a 'barcode' or separate label. So, from a marketing perspective these merchant trademarks

[62] OCMW-Antwerp Archives, *Godshuizen* (*GH*), Rekeningen, nr. 88: resolutieboek meerseniers, f. 525v° (18 January 1773): 'Het verkopen en detail bestaet in het uytbreken en openbreken van vaten, fusten, en packen, aenkomende gesloten & gebonden, ende daer uyt verkogt wordende, bij elle, andere maten ofte gewichte'.

[63] Denis Diderot and Jean le Rond d'Alembert (eds), *Encyclopédie ou dictionnaire raisonné* (Stuttgart, 1966 [1754]), vol. 4, p. 900.

[64] It is important to note, also, that sealed packaging did not automatically obviate the measurement of individual products at the point of purchase, since weights and measures in themselves were seldom standardized. At the end, retailers still had ample opportunities for manipulation before the actual exchange took place. See, for instance, the recurrent remarks on fraud of retailers in Jaques Savary, *Le parfait négociant ou instruction générale pour ce qui regarde le commerce des marchandises de France & des Pays Etrangers* (Paris, 1749); Daniel Defoe, *The Complete English Tradesman in Familiar Letters: Directing Him in all the Several Parts and Progressions of Trade* (New York, 1969 [1727]).

[65] Alan Durant, '"How Can I Tell the Trade Mark on a Piece of Gingerbread from All the Other Marks on It?" Naming and Meaning in Verbal Trade Mark Signs', in Bently, Davis and Ginsburg (eds), *Trade Marks and Brands*, pp. 107–139.

were not very effective for persuading or seducing customers, nor could they be simply used as a heuristic shortcut in consumer decision making – essential features of contemporary brands.[66]

When interacting with a customer, however, the retailer could always choose to promote his own 'respected' or 'knowledgeable' status and place of sale: his reputation and shop, rather than the branded products themselves, were central to his marketing practices. Indeed, Antwerp archives make it abundantly clear that shopkeepers in particular were experienced in advertising their personal name and businesses to a local and regional clientele. Shopkeepers tried to get their names across by, firstly, consciously employing a shop sign or business name – a practice that reached back to at least Roman times, according to David Garrioch.[67] Some of these shop signs had no clear advertising function, their existence being closely tied to personal expressions of (neighborhood) identity, or connected to guild regulations – certainly regarding the ateliers of corporate organized craftsmen.[68]

But shops signs could be used for more direct, promotional schemes as well, a practice that tended to become even more important as the early modern period progressed. Retailers' signs kept on increasing in number until at least the middle of the eighteenth century when several European cities, like Amsterdam, Paris, Lyon and London, took (unsuccessful) measures to stop their proliferation in the urban landscape.[69] In Antwerp as well, the city authorities regulated in 1765 how *uythangberden* (shop signs) had to be restricted in size, and were to be attached flat against the wall. Passers-by risked being injured if they were positioned close to the ground; they blew around in the wind or were blamed for blocking the light of adjacent housing.[70] Especially heavy iron signboards could be very large, as Antwerp probate inventories indicate.[71] Some of these placards tried to attract customers using humour or associating themselves with fashionable places: a famous eighteenth-century Antwerp textile dealer,

[66] Holt, 'Comments', p. 22.

[67] David Garrioch, 'House Names, Shop Signs and Social Organisation in Western European Cities', *Urban History*, 21 (1994): pp. 26–42.

[68] De Munck, *Leerpraktijken*, pp. 381–382.

[69] Ambrose Heal, *The Signboards of Old London Shops* (New York, 1957), p. 2; Carolyn Sargentson, 'The Manufacture and Marketing of Luxury Goods: The Marchands Merciers of Late 17th- and 18th-Century Paris', in Robert Fox and Anthony Turner (eds), *Luxury Trades and Consumerism in Ancien Régime Paris: Studies in the History of the Skilled Workforce* (Aldershot, 1998), p. 126; Frans De Potter, *Het boek der vermaarde uithangborden* (Ghent, 1861), p. 62.

[70] CAA, *Privilegiekamer* (*Pk*), nr. 927, f. 36: city ordinance of 18 March 1765. The ordinance was repeated again in 1787.

[71] CAA, *Notariaat* (*Not*), G.C. Gerardi, nr. 1722 (1732): probate inventory of Melis Geertruyd.

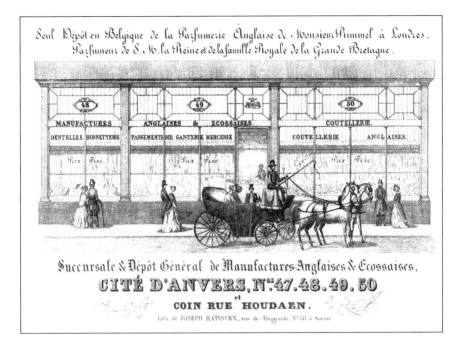

Figure 4.2 Porcelain card for the Antwerp shop 'Manufactures anglaises et écossaises', Joseph Ratinckx, c. 1855. Private collection.

for instance, promoted itself with the consciously chosen name 'Au magasin de Paris'.[72] A seller in lace used a pleasant rhyming scheme to advertise his shop.[73] From the nineteenth century onwards, however, shop signs began to decline in popularity, their function being absorbed by other, more fashionable 'eye-catchers', such as attractive window displays behind plate-glass-decorated shop fronts (themselves liable to change due to new technologies in glass and steel construction). Early nineteenth-century promotional material indicates how such shops often placed the name of the retail business on the walls or straight onto the glass (Figure 4.2).[74]

[72] CAA, *Insolvente Boedelkamer* (*IB*), nrs 2354–2372; Marguerite Coppens, 'Au magasin de Paris. Une boutique de mode à Anvers dans la première moitié du XVIIIe siècle', *Belgisch tijdschrift voor oudheidkunde en kunstgeschiedenis*, 52 (1983): pp. 81–107.

[73] Jeroen Jeroense [Cornelis Sweerts], *Koddige en ernstige opschriften op luyffels, wagens, glazen, uithangborden, en andere taferelen*, 4 vols (Amsterdam, 1683–1698).

[74] See the pictures in Frans Lauwers, *Nie warm nie wille! Antwerpen, een geschiedenis van het marktleven* (Zwijndrecht, 2006). On these advertising schemes, see Stefan Haas, 'Visual Discourse and the Metropolis: Mental Models of Cities and the Emergence of Commercial

There were other methods of drawing attention to the name or business of retailers in the eighteenth century. Early investments in conspicuous shop design and display have, for instance, been recently researched as early modern business strategies to mediate reputation and trustworthiness in the problematic and untransparent early modern product markets, such as the medicine business.[75] Although these shop design schemes were largely missing in Antwerp, local salesmen/producers of medicine and all kinds of 'quack' treatments were very early in using other marketing tools.[76] From the end of the seventeenth century onwards, they were one of the first to advertise their name and products in an almost brand-like manner in the local newspaper, the *Gazette van Antwerpen*. Most Antwerp retailers, however, did not bother to follow in their footsteps. Moreover, the persuasive or manipulative force of printed media was scarcely tapped into: those Antwerp retailers that did publish advertisements appear to have placed more importance on providing plain information on their whereabouts, rather than giving enticing specifications of branded products.[77] This corresponded neatly to the above-described shopping culture adapted to untransparent commodity markets, cluttered with a wide variability and qualitative diversity of goods. It fitted into a sales environment that expected a restrained, respectful and honest engagement with customers over all too open and aggressive sales techniques.[78] And again, it supported the importance of the actual moment of interaction between buyers and sellers through which knowledge and trustworthy advice on the product market could be secured.

Essentially, eighteenth-century printed media, such as advertisements, but also the (in Antwerp, less widely distributed) trade cards, had to further intensify a long-term relationship between a retailer and his mainly local or regional customer base, and attract new customers on the basis of the retailer's long-standing reputation. Trade cards formed part of a much broader and older world of commercial prints on which, again, not so much branded products, but

Advertising', in Clemens Wischermann and Elliott Shore (eds), *Advertising and the European City: Historical Perspectives* (Aldershot, 2000), pp. 54–78.

[75] See Patrick Wallis, 'Consumption, Retailing, and Medicine in Early-Modern London', *Economic History Review*, 61 (2008): pp. 26–53. On the importance of shop design and display in early modern retailing, see Claire Walsh, 'Shop Design and the Display of Goods in Eighteenth-Century London', *Journal of Design History*, 8 (1995): pp. 157–176.

[76] On shop design strategies in Antwerp, see Bruno Blondé and Ilja Van Damme, 'The Shop, the Home and the Retail Revolution: Antwerp, Seventeenth–Eighteenth Centuries', *Città & storia*, 2 (2007): pp. 335–350.

[77] Dries Lyna and Ilja Van Damme, 'A Strategy of Seduction? The Role of Commercial Advertisements in the Eighteenth-Century Retailing Business of Antwerp', *Business History*, 51 (2009): pp. 100–121.

[78] William T. Kelley, 'The Development of Early Thought in Marketing and Promotion', *Journal of Marketing*, 21/1 (1956): pp. 62–67.

the name and address of the retailer figured prominently, often even employing an iconography that paralleled the shop sign (similar to handbills, street posters, letterheads, credit notices, and so on).[79] But contrary to many of these other, early forms of advertising, trade cards were only given to customers *after* purchase. They were described in the eighteenth-century *Dictionaire Universel de Commerce* as 'souvenirs' or commemorative tokens, which reminded customers of the shop or place of transaction.[80] Their function was to encourage customers to return, or to disseminate knowledge of a trustworthy business from existing, loyal clients to new, interested buyers.[81] For similar reasons, retailers could self-consciously put their name on the wrapping paper or containers of goods, or even start marking the goods they sold – as, indeed, became more common as the eighteenth century progressed.[82]

Even in the more openly competitive spirit that evolved with industrialization, the promotion of a personal sign or name of the retailer, often being the male owner's name, did not disappear. Retailers came to expect the (family) business to go on after their death, successive relatives taking over the reputation of the original salesman, akin to branding practices used by producers at the time. So even after standardized, recognizable, branded products invaded the shops and warehouses of intermediaries, salesmen still played an important role in advising, seducing and getting the consent of customers: the name of, for instance, the local grocery shop sometimes being more well-known or respected than the branded products its sold, or functioned as a 'brand' itself (as a marker of ownership, a guarantee and a label for advertising purposes).[83] Even today, a trustworthy, personal relationship with a retailer can still dominate sales transactions, especially in economic sectors where, again, market transparency is disputed or liable to expert advice (like the second-hand car market or the sale of sophisticated electronics).[84]

[79] Maxine Berg and Helen Clifford, 'Commerce and the Commodity: Graphic Display and Selling New Consumer Goods in Eighteenth-Century England', in Michel North and David Omrod (eds), *Art Markets in Europe, 1400–1800* (Aldershot, 1998), pp. 187–200; Maxine Berg and Helen Clifford, 'Selling Consumption in the Eighteenth Century: Advertising and the Trade Card in Britain and France', *Cultural & Social History*, 4 (2007): pp. 145–170; Edouard Fournier, *Histoire des enseignes de Paris* (Paris, 1884).

[80] Savary des Bruslons, *Dictionnaire Universel de Commerce*, vol. 1, pp. 1821–1822.

[81] Also see Margaret Hale, 'The Nineteenth-Century American Trade Card', *The Business History Review*, 74 (2000): pp. 683–688.

[82] On these aspects, see also Pamela Pilbeam, 'Madame Tussaud and the Business of Wax: Marketing to the Middle Classes', *Business History*, 45 (2003): pp. 6–22.

[83] See Frans Lauwers, *Antwerpen in de 20e eeuw. Winkels en markten* (Zwolle, 1998), pp. 571–590.

[84] For these twentieth-century evolutions in retailing, see especially Uwe Spiekermann, 'From Neighbour to Consumer: The Transformation of Retailer–Consumer Relationships

Locating the Value of Product Markings for Early Modern Consumers

Could guild-based producers overcome the power of a trustworthy salesman at the counter by pressing them to sell marked commodities, which were known and recognized by end-consumers in a similar vein as present-day brands? Everything depended on the transparency of the sold commodities – the recurrence of identifiable consumer product characteristics – which in itself was a function of the sort of merchandise a master was producing, and the labour and sales relations involved. Was the craftsman specialized in the production of luxury goods, or basic household effects, or something in between? Did he work in an export-oriented industry or mainly for the local market? Was he aiming to reach a large and possibly widening consumer base or only a select and elitist clientele? Such questions matter if one really wants to understand the function of guild marks as 'proto-brands' or precursors of modern branding strategies.

For export industries, guild marks could be used as sort of enhanced 'typetown' product characteristics, not only mediating consumer problems relating to location, but also giving information regarding 'quality' or 'provenance' of the maker. As such, far away customers had much more information to decide upon – if they were familiar with these enhanced 'type-town marks' in the first place. In the event that they were, merchants and retailers would make certain to use guild marks for advertising purposes, similar to branding practices. But this depended solely on the business strategies of the intermediaries involved. As already indicated, merchants and retailers had much freedom to adapt products to the specificities of far-away demand, or to sell marked and unmarked substitutable wares next to each other to target a wider social base of customers. Elitist clientele or customers keen on 'defect-free' merchandise could buy the produce of the export industries at quality *premia*, but less wealthy customers had to be given other options too – which were not necessarily worse, or unfashionable, but simply lacked guild 'warranties'. For products manufactured outside the official guild system, the good name and reputation of the salesman in question could overcome customers' lingering doubts and fears of being tricked. Naturally, these conflicting interests between producers and intermediaries could give rise to conflicts and litigation, especially when it involved the sale of competing non-guild merchandise on the local market.[85]

Guild marks were no liability either, but could become an asset – susceptible to reputation and marketing strategies – if a master was working in a very

in Twentieth-Century Germany', in Frank Trentmann (ed.), *The Making of the Consumer: Knowledge, Power and Identity in the Modern World* (Oxford, 2006), pp. 147–174.

[85] Bert De Munck, 'La qualité du corporatisme. Stratégies économiques et symboliques des corporations anversoises du XVe siècle à leur abolition', *Revue d'histoire moderne et contemporaine*, 54 (2007): pp. 116–144; Van Damme, *Verleiden en verkopen*, pp. 233–239.

specific branch of industry with highly personalized (non-homogeneous) output and a lot of added value (such as in the upper echelons of the art business, tapestry weaving, precious metalwork, costly furniture trade, and so on).[86] In these branches the use of a 'personal mark' or 'name of the master' was very widespread. The use of such marks was sometimes obligatory, to be able to track down masters who infringed guild regulations. But such individual 'master marks' also opened up commercial opportunities.[87] As such, a product not only represented traceability and guaranteed guild 'quality', but consciously boosted attributes which were unique and only retrievable from this particular producer (product characteristics like beauty, design and style).[88] In such high-end market segments, skilful masters could become very powerful, famous and wealthy, advertising their 'artistry' and 'producer-product' names not only to attract local patronage, but also to build international fame and reputation. One such famous master of seventeenth-century Antwerp, Pieter Paul Rubens, a member of the guild of Saint Luke, succeeded in attracting customers to his workshop from all over Europe. Customers were willing to pay high-quality *premia* if they had 'proof' (a mark or signature) that Rubens himself had worked on the painting. Lower prices were asked when the pupils in his workshop – sometimes making copies of already existing 'creations' – executed commissions.[89] And since, of course, intellectual property was not protected, clever merchants and artisans tried to cash in on the fame and name of Rubens too, by producing cheap and illegal copies outside the master's workshop. Wealthy customers, however, made sure to steer away from such 'forgeries' by buying directly from the master, or only employing, again, trustworthy salesmen – thus avoiding a monetary and social 'faux-pas'.

[86] See also Harold Deceulear, *Pluriforme patronen en een verschillende snit. Sociaal-economische, institutionele en culturele transformaties in de kledingsector in Antwerpen, Brussel en Gent, 1585–1800* (Amsterdam, 2001), p. 372.

[87] See Peter Baudouin, 'Verkenning van de Antwerpse edelsmeedkunst in de zeventiende eeuw', in *Antwerpen in de XVIIde eeuw* (Antwerp, 1989), pp. 379–404; Ria Fabri, 'Bijdrage tot de geschiedenis van het meubel te Antwerpen tijdens de zeventiende eeuw', in *Antwerpen in de XVIIde eeuw*, pp. 405–425. More generally, see Maurits Smeyers and Christine Van Vlierden (eds), *Merken opmerken. Merk- en meestertekens op kunstwerken in de Zuidelijke Nederlanden en het Prinsbisdom Luik. Typologie en methode* (Leuven, 1990).

[88] Helen Clifford, 'A Commerce with Things: The Value of Precious Metalwork in Early Modern England', in Maxine Berg and Helen Clifford (eds), *Consumers and Luxury: Consumer Culture in Europe 1650–1850* (Manchester, 1999), pp. 154–160.

[89] Arnout Balis, 'De nieuwe genres en het burgerlijk mecenaat', in Jan Van der Stock (ed.), *Stad in Vlaanderen: cultuur en maatschappij, 1477–1787* (Brussels, 1991), pp. 237–254; idem, 'Antwerpen voedster der kunsten: haar bijdrage tot de artistieke cultuur in Europa in de 17de eeuw', in Jan Van der Stock (ed.), *Antwerpen, verhaal van een metropool. 16de–17de eeuw* (Ghent, 1993), pp. 115–127.

All of this makes clear how, contrary to plain 'type-town' product names, guild marks and individual guild master marks could and did function in ways similar to present-day branding strategies. Three further reservations have to be made, however. Firstly, the 'product-producer' names were only effective in high-end specialized businesses, working for a particularly well-informed clientele with specific demands and desires. Producers connected to export industries had only very limited control over the ensuing distribution lines. Often, guild-organized producers had to rely on the same merchant-entrepreneurs who controlled alternative production processes by guild or non-guild (rural) labourers working in subcontracting arrangements or according to putting-out systems.[90] In essence, these merchant-entrepreneurs (and small-scale retailers) had nothing to gain by consciously and repetitively advertising solely the guilds' produce – thus keeping customers tied to the advice of a trustworthy and 'knowledgeable' salesman, always happy to provide customers with other and (often) cheaper alternatives. Only towards the end of the eighteenth century did industrial entrepreneurs gain the upper hand over merchant-entrepreneurs, precisely by installing vertically integrated distribution lines and providing branded products with standardized and homogenized characteristics and recognizable packaging (eventually to be protected by nineteenth-century laws).

Secondly, 'product-producer' names only lasted for as long as the master was alive. Sometimes a relative could capitalize on the name of an internationally famous or locally respected member, like the Breugel family did.[91] But more often than not, this was no longer possible. Since guild-marked products too were usually connected to very specific fashion-conscious goods, their success could be quickly outpaced and their fame outmoded when consumer preferences changed. Helen Clifford, amongst others, has made it clear how, especially from the end of the seventeenth century onwards, consumer demand was changing towards constant variability, novelty and fashionable change. In short, ephemeral design became attractive; sustained product durability became subordinate to style.[92] In such a context, guild marks (warranting fine and honest processing of raw materials) and personal master signs (promising extra-added artistry within these regulated boundaries) became more and more of a liability from a marketing perspective. Customers demanded entrepreneurs who could precisely and quickly respond to the 'fashion' of the year by changing colour, design or texture, or by consciously crossing

[90] Catharina Lis and Hugo Soly, 'Corporatisme, onderaanneming en loonarbeid. Flexibilisering en deregulering van de arbeidsmarkt in Westeuropese steden (veertiende-achttiende eeuw)', *Tijdschrift voor sociale geschiedenis*, 20 (1994): pp. 365–390.

[91] Peter Van den Brink (ed.), *De firma Brueghel* (Ghent, 2001).

[92] Clifford, 'A Commerce with Things', pp. 165–166.

corporate restrictions regarding production techniques (for instance, by contracting members of different guilds, or setting up illegal subcontracting arrangements).[93] Early industrial capitalists, including again the likes of Wedgwood, Boulton, Packwood and many, many others, took this lesson to heart. Their brand names became flexible entities: always ready to conquer new market segments or latch onto new fashions and trends.

Thirdly, guild and master marks differed from present-day brands in the sense that they were originally designed for relatively closed and personal markets, where local customers knew their producers and interpreted the commodity marking by guild members in a fairly straightforward way. However, the many commercial circuits in seventeenth- and eighteenth-century Antwerp, inter-crossing and overlapping each other, seriously complicated this situation.[94] Ateliers or workshops of producers were not necessarily the most important outlets for consumers to buy their merchandise: markets, peddlers or retail shops, all boosting pristine, second-hand or even older alternatives, could do as well. In shops of the Antwerp Retailers guild, for instance, variability and diversity ruled, with marked goods of local or foreign provenance sitting next to goods lacking 'product-producer' or even 'type-town'-specific indications. A large body of evidence shows that many producers chose to work for retailers, or were forced to do so due to social-economic considerations.[95] The above-described consumer changes probably even accelerated this situation, precisely because retailers had much more freedom to criss-cross corporate restrictions, engage in production and distribution at the same time, and create or design newness and novelty in their own right.[96] In such a context, subcontracted producers no longer needed marks of any kind, since customers relied anyhow on the advice of a trustworthy and knowledgeable salesman, who advertised not so much branded products as his reputation and name through trade cards, advertisements, and so on. Industrialized production and the conscious marketing of standardized, branded products changed all this: producers made

[93] John Styles, 'Manufacturing, Consumption and Design in Eighteenth-Century England', in John Brewer and Roy Porter (eds), *Consumption and the World of Goods* (London and New York, 1993), pp. 529–535; Ilja Van Damme, 'Changing Consumer Preferences and Evolutions in Retailing: Buying and Selling Consumer Durables in Antwerp (c. 1648–c. 1748)', in Bruno Blondé, Peter Stabel, Jon Stobart and Ilja Van Damme (eds), *Buyers and Sellers: Retail Circuits and Practices in Medieval and Early Modern Europe* (Turnhout, 2006), pp. 199–223.

[94] Van Damme, *Verleiden en verkopen*, pp. 63–102.

[95] See, again, the writings of Bert De Munck in this aspect.

[96] Bruno Blondé and Ilja Van Damme, 'Retail Growth and Consumer Changes in a Declining Urban Economy: Antwerp (1650–1750)', *The Economic History Review*, 63 (2010): pp. 638–663.

certain that the products could speak for themselves all over the world. The products themselves, rather than the salesmen, became the focus of attention.[97]

Conclusions

In 1867, Karl Marx famously criticized nineteenth-century consumption by pointing to the 'commodity fetishism' of his fellow shoppers: the tendency of consumers to express only a narrow concern for the observable attributes and characteristics of the commodity itself, thus leaving the moral reality of labour relations and economies of exploitation by industrial entrepreneurs willingly or unknowingly obscured.[98] His objections to such 'commoditized' human relations were well timed: increasing industrialization started to change the nature of western European commodity markets, and gradually also altered the relationship between consumers and their world of goods. Whereas in early modern times, buying and selling was embedded in a web of social relations to overcome typical consumer problems (regarding trust, quality, credit, and so on), nineteenth-century products began to 'speak' for themselves. Depending on the product, customers needed less explanation and context to buy new commodities, since increasingly standardized, homogenized and institutionally protected and guaranteed product brands began to carry the wares to the minds and homes of the customer. Not so much the seller but the product name itself was becoming a well-known and respected marker of trust and reputation.

As such, spreading industrialization changed the important advisory task of a salesman: nineteenth-century producers began to devise extensive marketing schemes for branded goods, targeted at impersonal mass markets. Via brands, producers were able to 'reach over the shoulder of the retailer and across the latter's counter to the ultimate consumer'.[99] But via brands, too, industrial producers could engage more fully with customer wants and desires, persuasively objectifying certain subjective thoughts and feelings connected to the act of acquisition. The growing belief that product brands could actually influence consumer decisions solidified their success, eventually also convincing customers that brands were a solid entry to product knowledge,

[97] Ronald A. Fullerton, 'Modern Western Marketing as a Historical Phenomenon: Theory and Illustration', in Terence Nevett and Ronald A. Fullerton (eds), *Historical Perspectives in Marketing: Essays in Honor of Stanley C. Hollander* (Lexington, 1988), pp. 70–89.

[98] See http://www.marxists.org/archive/marx/works/1867-c1/ch01.htm. Karl Marx, *Das Kapital*, chapter 1, section 4 (the fetishism of commodities and the secret thereof) (consulted on 29 February 2012).

[99] Cited in Callman, *The Law of Unfair Competition*, p. 981.

rather than a marketing ploy. Thus, culturally speaking, the growing value that end-consumers attached to brands and branding practices paralleled an epistemological shift in their utility and supposed effects.

No such general belief in the use and value of product brands was present in early modern Antwerp. Although at various stages in the marketing of goods, producers and intermediaries resorted to product markings and other practices similar to present-day branding strategies – depending on the sorts of products that one was selling – a fundamental engagement of the mark with an end-consumer was missing. Neither buyers nor sellers believed that product brands could always mediate the fundamental problems of information asymmetries and multiple quality assessments associated with untransparent early modern commodity markets. Branding was mainly used for protecting or 'legalizing' the political interests, labour relations and property claims of the institutions and stakeholders involved in the production and distribution of goods. Only for certain types of products, and within certain niches, were brands employed as a communicative tool towards customers.

Ironically, recent marketing and communication studies have undermined our common beliefs in the usefulness and power of brands to persuade or assist in customer decisions: more emphasis is given to the sometimes unexpected ways in which consumers process and filter advertised messages.[100] The idea that, in the end, people, not products, do the selling would sound surprisingly familiar to someone living in seventeenth-century Antwerp.

[100] See, for instance, Michael Schudson, *Advertising, the Uneasy Persuasion: Its Dubious Impact on American Society* (London, 1993).

Chapter 5
Golden Touchstones?
The Culture of Auctions of Paintings in Brussels, 1830–1900

Anneleen Arnout

Introduction

On 17 April 1883, a public auction of paintings was held at the Quai au bois à Bruler in Brussels. The sale of the collection of the deceased, Edmond Ruelens, lasted five days. Auctioneer Louis Lampe, directing the event, started the catalogue's preface as follows: 'La vente d'une belle collection de tableaux fait toujours époque dans le monde artistique.'[1] The public sale of a beautiful collection of paintings was always a thrilling event, stirring the art world. Art auctions had developed from traditional estate sales. Together with this specialization, a distinct culture took shape, visible in the development of advertisements, auction catalogues and auction rooms built in the wealthier neighbourhoods of the city. Luxurious auctions turned into social events where value was socially and culturally constructed. In this chapter, it is the evolution of the social and cultural construction of value at auction that will be examined.

In historiography the discovery of the art auction is a relatively recent phenomenon. During the last two decades, research has mainly focused on its earliest stages of development. Studies have shown how the specialized art auction emancipated itself from the more general estate sales in the course of the eighteenth century and how it grew into its own distinct commercial genre.[2] The art auction manifested itself as a social space where commodities were exchanged

[1] L42899: *Catalogue de la belle collection de tableaux anciens des écoles* … (Brussels, 1883), pp. xi–xii. In referring to auction catalogues, I have made use of the numbers in the Lught repertoire, a repertoire of Western art auction catalogues edited by Fritz Lught.

[2] Cynthia Wall, 'The English Auction: Narratives of Dismantlings', *Eighteenth Century Studies*, 31 (1997): pp. 1–25; Brian Cowan, 'Arenas of Connoisseurship: Auctioning Art in Later Stuart England', in Michael North and David Ormrod (eds), *Art Markets in Europe, 1400–1800* (Aldershot, 1998), pp. 153–164; John Michael Montias, *Art at Auction in 17th-Century Amsterdam* (Amsterdam, 2002); Monica Preti-Hamard and Philippe Sénéchal (eds), *Collections et marché de l'art en France 1789–1848* (Rennes, 2005); Dries Lyna, Filip Vermeylen and Hans Vlieghe (eds), *Art Auctions and Dealers: The Dissemination of Netherlandish Art during the Ancien Régime* (Turnhout, 2009); and Dries Lyna, *The Cultural

and redistributed. It was presented as a social arena in which social and artistic relations and conventions were continuously negotiated. The most recent research concerning the eighteenth and early nineteenth century has highlighted the social and cultural dimension of the auction. While the traditional markets for second-hand goods lost respectability and prestige, specialized art auctions moved to luxurious rooms in fashionable entertainment districts. This gentrification of the public art auction found a parallel in the development of a new sophisticated artistic language in auction catalogues and advertisements. Research on Paris has shown how auction rooms were increasingly wrapped up in an urban spectacular culture. Parisian auction houses settled along one of the new boulevards, where *flâneurs* gazed at each other and feasted on the visual splendours of the marvellous window displays, spectacular department stores and theatres. Auction houses were even decorated as if they were theatres. Auctioneers dressed up in costumes, took up their mallet and convincingly played their part in a dramatic show. The public actively participated in a play revolving around the display of artistic expertise, while the setting elicited the construction and articulation of social hierarchies. Value was thus not only located in the auction catalogues, as it had been before, but was progressively attached to the genteel spectacle in the auction room. Auctioneers deployed this theatrical culture of excitement and spectacle in an attempt to grasp the erratic character of the auction game. However, this strategy did not guarantee success. Research has indeed shown that the rise of art auctions and their distinct elitist culture barely influenced the prices paid for auctioned paintings in eighteenth-century Brussels and Antwerp.[3]

The evidence for eighteenth-century Antwerp and Brussels sharply contrasts with older auction histories. For example, in Brian Learmount's *A History of the Auction* (1995) the successful stories of art auction houses such as Sothebys, Christies and Hôtel Drouot are blown up. A study such as Gerald Reitlinger's

Construction of Value: Art Auctions in Antwerp and Brussels (1700–1794) (unpublished PhD dissertation, University of Antwerp, 2010).

[3] Dries Lyna, 'Changing Geographies and the Rise of the Modern Auction: Transformations on the Second-Hand Markets of Eighteenth-Century Antwerp', in Bruno Blondé, Natacha Coquery, Jon Stobart and Ilja Van Damme (eds), *Fashioning Old and New: Changing Consumer Patterns in Western Europe (1650–1900)* (Turnhout, 2009), pp. 169–185; Charlotte Guichard, 'From Social Event to Urban Spectacle: Art Auctions in Late Eighteenth-Century Paris', in Blondé et al. (eds), *Fashioning Old and New*, pp. 203–216; Manuel Charpy, 'The Auction House and its Surroundings: The Trade in Antiques and Second-Hand Items in Paris during the Nineteenth Century', in Blondé et al. (eds), *Fashioning Old and New*, pp. 217–231; and Lyna, *The Cultural Construction of Value*, pp. 251–280. Manuel Charpy studied the Parisian auction culture as part of his PhD research, entitled 'Le théâtre des objets. Espaces privés, culture matérielle et identité sociale. Paris 1830–1914'.

The Economics of Taste: The Rise and Fall of Picture Prices (1760–1960), published in the 1960s, has a different failing. Concentrating on the sale prices of art, it completely neglects the social and cultural implications of the auction as a market form.[4] On the whole, the historiography about nineteenth-century auctions is sparse and limited because of its focus on the triumphs made by famous auction houses. Moreover, by fixing too much of its attention on Paris and London, the research has been biased.[5] Indeed, together with London, the French metropolis was the most important marketplace for art.

This contribution addresses the question of value and the culture of Brussels auctions for paintings during the nineteenth century. It will focus on specialized art auctions, that is, auctions for paintings and general art auctions where paintings were hammered with other artistic or antiquarian objects (such as sculptures, drawings, antiquities or coins). The evolution of these specialized auctions offers a unique insight into the repertoires of evaluating art in the nineteenth-century city. Indeed, apart from furniture, often described in historical terms, art was never combined with household goods in the auctions under study here, as they were or might have been in estate sales. Therefore, studying them allows us to isolate the way in which auctioneers constructed and located the value of art specifically – rather than in a mix with different kinds of consumer goods. As mentioned in the introduction to this volume, with artists no longer considered artisans, the perceived value of their products was no longer even partially located in the amount of work put in or the materials used for its construction. Value was determined by a whole set of factors, which could be influenced by middlemen trying to gain a higher price for their goods. In this chapter, I will argue that, during the nineteenth century, Brussels auctioneers designed and directed their auctions in such a way that it would raise the prices – or so they hoped.

To be sure, Brussels was smaller than Paris, both in size and reputation. It nevertheless had a flourishing art market and an ample customer base. The city had its gaze firmly fixed on Paris.[6] As in Paris, Brussels auctioneers preferred

[4] Gerald Reitlinger, *The Economics of Taste: The Rise and Fall of Picture Prices (1760–1960)*, 2 vols (New York, 1961–1962); and Brian Learmount, *A History of the Auction* (London, 1995).

[5] Except for a couple of dissertations concerning Antwerp auctions: Myriam Heuvelman, 'De Antwerpse kunstveilingen, 1890–1918. De schilderijen' (unpublished dissertation, KU Leuven, 1993); and Joke Van de Vel, 'De Antwerpse kunstveilingen, 1851–1870' (unpublished dissertation, KU Leuven, 1999).

[6] Saskia de Bodt, *Halverwege Parijs. Willem Roelofs en de Nederlandse schilderskolonie in Brussel 1840–1890* (Ghent, 1995), pp. 23–39 and 61–68; Sophie de Schaepdrijver, 'Brussel 1850–1914. Drie portretten van een hoofdstad op zoek naar een eigen gezicht', in Anne Pingeot and Robert Hoozee (eds), *Parijs Brussel Parijs. Realisme, impressionisme, symbolisme, art nouveau. De artistieke dialoog tussen Frankrijk en België 1848–1914* (Antwerp, 1997),

settling in fashionable entertainment districts. Whether this geographical association between auctions and leisure was more meaningful than a simple coincidence remains a question, but it is clear that the spatial relations did evolve. As the century progressed, auction houses settled in different parts of the city and by 1900 auction houses had even decreased in number. Parallel to the geographical changes were changes in the organization of the auction business and the discourse about auctions and art. The ambition of this chapter is to track those changes for the period between 1830 and 1900, and to try to understand them by interpreting the locational evolutions, as well as the development of the marketing discourse deployed by auctioneers. First, the organizational changes will be mapped out. Commercial directories, in which Brussels artisans, shopkeepers and entrepreneurs were listed by profession, allow us to reconstruct the locations, social backgrounds and organization of Brussels' auctions and auction houses. Despite their limitations, directories are the most convenient starting point for this kind of research. Second, I will analyse how auctioneers discursively tried to attribute value and quality to their merchandise and how this related to the spatial changes. This discourse will be analysed using the prefaces of auction catalogues, retrieved from the *Art Sales Catalogues Online* (ASCO). This database contains the sales information of all preserved auction catalogues up to 1900, as described by art historian Fritz Lught. He gathered all the art auction catalogues published between 1600 and 1925 and preserved in public collections.[7]

The Golden Age of the Auction?

The eighteenth-century rise of specialized art auctions was accompanied by the development of the auction catalogue.[8] Auction catalogues were initially intended as a means of advertising the paintings put up for sale. Gradually they took on a documentary function. Knowledge of prices that (comparable) paintings had fetched at earlier auctions proved vital while bidding. 'Amateurs' annotated their catalogues, giving them a new life after the sale as a source of information. However, even though catalogues were increasingly published for

pp. 34–40; and Claire Billen, 'Kruispunt van culturen', in Robert Hoozee (ed.), *Brussel. Kruispunt van culturen* (Antwerp, 2000), pp. 19–25.

[7] *Art Sales Catalogues Online*, http://asc.idcpublishers.info. The boundaries of the period under research are tributary to these sources: commercial directories only became relevant guides in the 1830s, while the ASCO ends in 1900. Apart from these sources, a few press clips and building files were used.

[8] Linda Whiteley, 'The Language of Sale Catalogues (1750–1820)', in Preti-Hamard and Sénéchal (eds), *Collections et marché de l'art*, pp. 35–45; and Lyna, *The Cultural Construction of Value*, pp. 6–10.

the less prestigious sales as well, it is most likely that the ensemble of preserved catalogues only represents the highest segments of the market.[9] The contemporary and art historical value of annotated catalogues encouraged preservation, but did not make it self-evident. Not every published catalogue was preserved and not every preserved catalogue ended up in a public collection – and consequently in this research. Therefore, the number of catalogues mentioned is merely a first indication of the true proportions of the commercial circuit of art auctions.

The ASCO database contains 1,100 Brussels catalogues of art auctions held between 1830 and 1900. Eight hundred and thirty-six of them list paintings, sometimes combined with other artistic or antiquarian objects such as sculptures, prints, drawings, books, medallions, sculptures, period furniture, faience and porcelains. The nineteenth century witnessed an explosion in the number of preserved catalogues of auctions held in Brussels, with a significant rise from the 1850s onwards (see Figure 5.1). Different factors might have contributed to this growth. It is not implausible that the art catalogue 'democratized' in the sense that more auctions were accompanied by one. After all, printing and distributing catalogues became less expensive. Furthermore, the more catalogues were annotated, the more sense it made to preserve them. However, it is rather implausible that the process of democratization and the increasing habit of preserving catalogues together accounted for this spectacular growth. It is more likely that the explosion of catalogues also points towards an expanding art market.

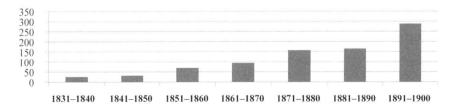

Figure 5.1 Preserved catalogues of painting auctions in Brussels, 1831–1900.

Source: *Art Sales Catalogues Online*.

In terms of format, catalogues did not change much during the nineteenth century. Almost every catalogue consisted of a title page, a survey of the conditions of sale and a list of the items to be sold. The catalogues of sales of paintings found in the Lught repertoire never referred to estate sales. The auction catalogues selected for this research were published on the occasion of

[9] Whiteley, 'The Language of Sale Catalogues', pp. 35–45; and Lyna, *The Cultural Construction of Value*, pp. 9–11 and 151–163.

either specialized auctions for paintings or general art auctions, where paintings were combined with other artistic objects or antiques. Sometimes a sale could consist of one specific type of art object, but this type of auction never became the standard. If, as was often the case, several objects were sold together, they were usually organized by type. Paintings were mainly listed alphabetically. The length of descriptions could vary anywhere between a simple denomination of the subject and a lengthy analysis. As printing became cheaper, illustrations or photographical reproductions became increasingly common. The style of the title page followed the fashion of the day, but became more structured and neatly organized with time.

Every now and then a catalogue would start with a preface. The length of those prefaces varied greatly. Sometimes a preface consisted of a few cliché sentences, but it could also fill over ten pages.[10] Prefaces were common in the 1840s, 1850s and 1860s, but became increasingly rare afterwards. Apparently the genre had passed its prime or had become redundant. As they decreased in number, their average length nevertheless increased. At the same time, the number of trivial introductory texts decreased, which could indicate that the medium was only used when it added value. Similar to its length, the content of a preface could take on different forms. Most often, if not platitudinous, a preface formed an introduction to the collection that was to be auctioned off. Sometimes it was seized upon as an opportunity to philosophize about the true nature of the amateur existence. When the collections of deceased painters were sold, the preface usually took the shape of a eulogy.

Strategies of Location and Artistic Expertise

While in eighteenth-century Paris, London and Antwerp the public auctioning of artistic goods mainly took place in auction rooms, the house of mourning had remained the dominant location in Brussels. If an auction took place in an auction room, those rooms were mostly only temporarily fixed up as such. This changed during the nineteenth century. In the 1830s, the semi-permanent auction room or auction house had already outgrown the house of mourning as the most common sales location. Both were, however, still well matched. As the century progressed, the gap between them grew larger until almost 90 per cent of all auctions of paintings took place in auction houses (see Figure 5.2). Also, the number of sales for which the nature of the location was unclear decreased. Likewise, alternative locations such as bookshops, theatres or courthouses were only very rarely used as auction venues.

[10] Of the 711 catalogues that I was able to consult, 149 started with a preface.

The Culture of Auctions of Paintings in Brussels, 1830–1900 109

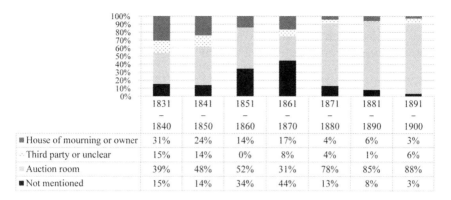

Figure 5.2 Auctions of paintings per type of location in Brussels, 1831–1900.
Source: Art Sales Catalogues Online.

There were already a couple of auction rooms in the centre of town during the 1830s. In order to reconstruct their location patterns, we can contrast the addresses listed in the commercial directories with the locations most commonly mentioned in catalogues, which refer to the more prestigious sales events.[11] In the 1830s, auction rooms had already distanced themselves spatially from the trade in old and used goods, perceived as socially inferior.[12] According to the addresses in the directories, the greater part of the Brussels auction rooms were located on and around the Grand Place, the geographical and commercial heart of the city (see Figure 5.3). More interesting was the group of auction rooms settled on and around the Place de la Monnaie. The area around this square, housing the royal Monnaie theatre, was an important centre of entertainment. According to the catalogues, the geographical alliance between auction houses and the spectacular culture of the lower city had already been formed in the 1830s – while the directories only listed a group of auction houses there in 1854 (see Figure 5.4). They remained there until the end of

[11] In an earlier study of the location patterns of art and antique dealers and auctioneers, I reconstructed the location patterns of auction houses, dealers in paintings, art objects, antiques, drawings and prints using four sample years (1832, 1854, 1885 and 1914). For this chapter those sample years were contrasted with the auction houses that recurred most often in the catalogues in the corresponding decades.

[12] Bruno Blondé and Ilja Van Damme, 'Fashioning Old and New or Moulding the Material Culture of Europe (Late Seventeenth–Early Nineteenth Centuries)', in Blondé et al. (eds), *Fashioning Old and New*, pp. 1–13; and Ilja Van Damme, 'Second-Hand Dealing in Bruges and the Rise of an "Antiquarian Culture", c. 1750–1870', in Jon Stobart and Ilja Van Damme (eds), *Modernity and the Second Hand Trade: European Consumption Cultures and Practices 1700–1900* (Basingstoke, 2010), pp. 73–92.

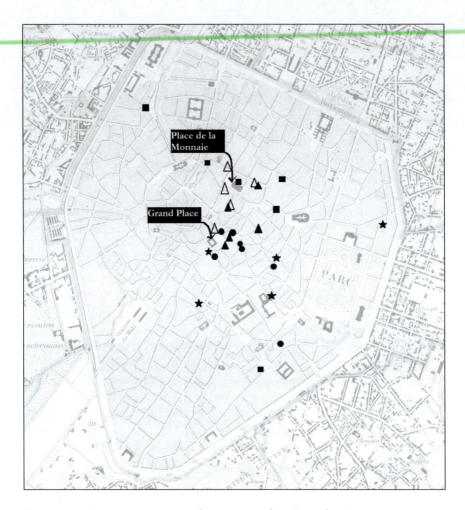

Figure 5.3 Auction rooms, art and antiquity trade in Brussels, 1830s.

Locations mentioned in the 1832 commercial directory: ★ *Antiquités, curiosités, objets d'art*; ■ *Tableaux*; ● *Estampes*; ▲ *Ventes publiques*; ∆ most common locations mentioned in the preserved auction catalogues of the 1830s. Source: Almanach de commerce, 1832 and Brussels auction catalogues, 1831–1840, *Art Sales Catalogues Online* (map, Huvenne, *Bruxelles*, 1858).

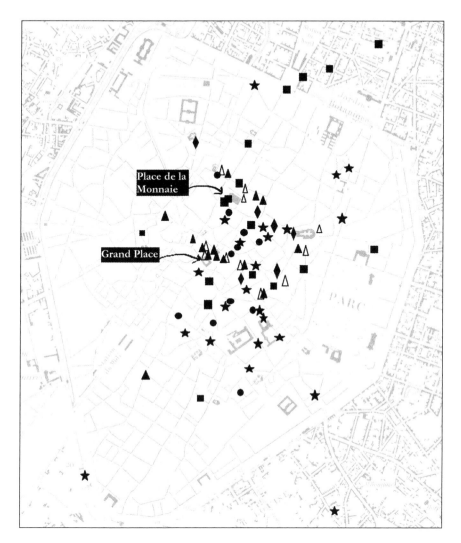

Figure 5.4 Auction rooms, art and antiquity trade in Brussels, 1850s.

Locations mentioned in the 1854 commercial directory: ★ *Antiquités, curiosités, objets d'art*; ■ *Tableaux*; ● *Estampes*; ▲ *Ventes publiques*; Δ most common locations mentioned in the preserved auction catalogues of the 1850s. Source: *Almanach de commerce*, 1854 and Brussels auction catalogues, 1851–1860, *Art Sales Catalogues Online* (map, Huvenne, *Bruxelles*, 1858).

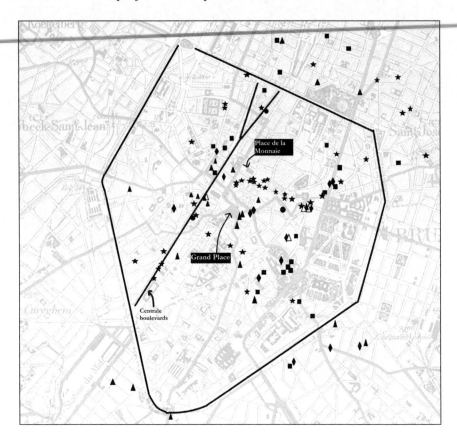

Figure 5.5 Auction rooms, art and antiquity trade in Brussels, 1880s.

Locations mentioned in the 1885 commercial directory: ★ *Antiquités, curiosités, objets d'art*; ■ *Tableaux*; ● *Estampes*; ▲ *Ventes publiques*; ∆ most common locations mentioned in the preserved auction catalogues of the 1850s. Source: *Almanach de commerce*, 1885 and Brussels auction catalogues, 1881–1890, *Art Sales Catalogues Online* (map, *Bruxelles*, 1930).

the century. According to the directory of 1885, the vast majority of Brussels auction houses were settled near this Parisian-style boulevard, constructed in the 1860s (see Figure 5.5). In the meantime, the upper city had also grown into an exquisite location for the more prestigious auctions of paintings – at least as far as the catalogues' information goes. Home to the royal art museums and the academy of fine arts, the upper city was an elitist and artistic neighbourhood. Whilst in Paris prestigious auction houses became prominent near broad avenues, department stores, theatres and other entertainment venues, shaping

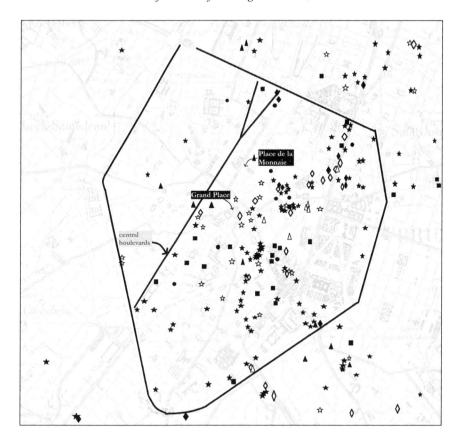

Figure 5.6 Auction rooms, art and antiquity trade in Brussels, 1914.

Locations mentioned in the 1914 commercial directory: ■ *Tableaux*; ● *Estampes*; ▲ *Ventes publiques*; ★ *Antiquités & curiosités*; ☆ *Objets d'art*; ♦ *Antiquités & curiosités + Objets d'art*; ◊ Multiple categories: *Antiquités & curiosités en/of objets d'art + tableaux, estampes en/of ventes publiques*; Δ most common locations mentioned in the preserved auction catalogues of the 1890s. Source: *Almanach de commerce*, 1914 and Brussels auction catalogues, 1891–1900, *Art Sales Catalogues Online* (map, *Bruxelles*, 1930).

'Paris spectaculaire', Brussels' artistic auctioneers progressively preferred the more luxurious and artistic area of the upper city (see Figure 5.6).[13]

When comparing the patterns of settlement of auction houses with the location of shopkeepers dealing in art and antiquities (such as dealers in paintings, drawings, prints, antiques and art objects), it becomes clear that auction houses

[13] Guichard, 'From Social Event to Urban Spectacle'; and Charpy, 'The Auction House and its Surroundings'.

were at the geographical core of the trade in art and antiques for most of the century. From the 1880s onwards, auctioneers nevertheless increasingly relinquished this central spot in favour of the explosively blossoming group of antiquity dealers (see Figures 5.5 and 5.6). They simultaneously decreased in numbers. Indeed, during the 1890s, the Brussels auction business was past its peak and had lost its geographical coherence. By 1914 every geographical pattern in the location of auction houses listed in the directories had evaporated, whilst the shopkeepers of art and antiques were grouped closely together (see Figure 5.6). Whereas the auction houses downtown had been the poles of attraction for art and antiquity dealers, it seems to have been the other way round in the upper city. Not only were art and antiquity dealers growing dramatically in numbers, but they had also been situated there for a longer time. At the turn of the century, the auction houses for which the most catalogues have been preserved settled within a clear stream of art and antiquity dealers. Furthermore, the directors that ran those thriving, high-end art auction houses operated as specialized dealers too. A couple of them even switched business from public sales to antiquities retailing. Apparently, at that time, a geographical connection with the small-scale luxury shops in the elitist and artistic upper city seemed more advantageous than the earlier connection with the nightlife and spectacular leisurely culture downtown.

The discourse of auctioneers about themselves, their auctions for paintings, their intended audience and their auction houses underwent a similar evolution. In the prefaces of their catalogues, auctioneers strengthened the ties between their own auctions and a broader elitist and artistic culture both implicitly and explicitly. In an auction catalogue published in 1868, it was literally argued that the taste for the art of painting was the privilege of a social and artistic elite: 'La capitale de la Belgique, comme toutes les métropoles du monde civilisé, prouvera dans cette circonstance que le goût raisonné de la grande et belle peinture est toujours à l'apanage des classes éclairées et opulentes de la société.'[14] The world of art clearly encompassed more than wealth alone. Art lovers were particularly 'enlightened'. The ideal of artistic civilization was elaborately described in the catalogues. When private art galleries were auctioned, it was their disappearance as meeting places for the Brussels artistic and fashionable society that was most particularly deplored. The end of the salon of the former British minister Sanford in Brussels was portrayed as the loss of an artistic sanctuary. Many a collection was described as too well known among amateurs to even need praise. Auctions for paintings thus seem to have been part of a distinctive world of art lovers, artists and collectors.[15] In 1886, the sense of community

[14] L30452: *Catalogue de tableaux anciens des écoles* ... (Brussels, 1868), p. 6.
[15] L35357: *Catalogue des tableaux modernes et dessins des écoles* ... (Brussels, 1875), p. vi.

within the art world was explicitly called upon when an auction of paintings was organized for the benefit of the family of the deceased Brussels artist Gustave de Jonghe.[16]

In their prefaces, the organizers of art auctions usually addressed their intended audience in a direct manner. They seem to have written for a mostly specialized audience of 'amateurs', 'connoisseurs' and collectors – expert art lovers with the right amount of capital to sponsor their activities.[17] In the discourse of the authors of catalogue prefaces, art dealers and speculators were distinguished from that audience as a different type of specialist.[18] Their motivations were considered dissimilar, as if they belonged to two very different worlds, or as it was eloquently put in an 1835 catalogue preface, speculators were only interested in the thrill of the sale, whilst amateurs longed to be acquainted with the art of painting in its most qualitative and exceptional emanations.[19] This differentiated category of specialists was sometimes put up against a more vaguely and less frequently addressed general public: 'le monde artistique' or 'le public'. This general public was always mentioned in combination with or in opposition to the more specialized audience of experts or artists and only popped up in prefaces when the sale was held at an auction house.

It is not clear whether this discursive differentiation of the audience found a parallel in the spatial organization of auction rooms. The only relevant clue was found in an 1894 auction catalogue, in which it was announced that visitors in possession of tickets could make use of the reserved seats.[20] Possibly this practice was related to the specific space in which this auction was held: an unspecified house where the number of seats might have been limited. However, it is just as likely that this is the only explicit reference to a widespread practice. In any case, distinctions within the audience were very common in the practice of viewing days preceding most of the art auctions. Although exhibitions were free and open to everyone interested, it was nevertheless also customary to combine public and private exhibitions. The private exhibition was intended for potential buyers and provided an occasion for connoisseurs to converse with kindred spirits, while newcomers to the business of collecting could get to know the ropes. The public exhibition offered a broader audience the opportunity of gazing at paintings that were usually locked up in private collections. While the auctions themselves – with the exception of a couple of 'night-shows' – were mainly held around

[16] L45449: *Oeuvre de Gustave de Jonghe. Tableaux, aquarelles ...* (Brussels, 1886), pp. xiii–xiv.

[17] Guichard, 'From Social Event to Urban Spectacle', pp. 203–204.

[18] Buyers at Antwerp auctions during the second half of the nineteenth century were indeed often art experts and dealers: Heuvelman, *De Antwerpse kunstveilingen*, pp. 161–169; and Van de Vel, *De Antwerpse kunstveilingen*, pp. 96–113 and 132–142.

[19] L13983: *Catalogue d'une belle et rare collection de tableaux ...* (Brussels, 1835), p. 4.

[20] L52487: *Catalogue des objets d'art, antiquités, tableaux ...* (Brussels, 1894).

noon, the preceding exhibitions were mostly opened in the afternoon and the early evening. In this way they linked up with the matinees in theatres and other venues of bourgeois leisure. The popularity of the auction exhibition is furthermore proven by its continuous existence throughout the century.

Like their preferred audience, organizers of art auctions belonged to the artistic scene of Brussels. They came from artistic families or worked as art dealers or restorers. This had not always been the case. Estate sales were historically the terrain of 'crieurs jurés', sworn criers. These 'crieurs' were clerks who did not necessarily have expertise in the goods they were selling. In the course of the eighteenth century, their role in auctioning art was gradually assumed by specialized dealers.[21] Sworn criers were still officially required to assist at auction, but their importance decreased.[22] While all professional categories in the 1832 commercial directory were organized alphabetically, the 'crieurs jurés' were classified as a sub-category of the 'directeurs de ventes'. This discursive association did not reappear later in the century, possibly indicating a decreased role for the criers in the auction business. The sales information gathered from catalogues further suggests that official, judicial representation was gradually taken over by notaries. However, only after 1895 did the 'crieurs jurés' disappear from the directories for good.[23]

According to the directories, the function of a sworn crier was never cumulated with that of an auctioneer, but they were sometimes listed at the same address in the 1830s. Every once in a while namesakes were active in both professions. At least half of the sworn criers or auctioneers had a namesake active in the auction business. For example, the name Lalieux appears in at least ten variations throughout the period, with different first names, at different addresses or in varying formations or partnerships.[24] The Le Roy family was also numerously represented: Etienne, Henri, Victor and Frédéric Le Roy were active as auctioneers or experts and Jules de Brauwere, director of the prosperous auction house Galerie Saint Luc, was married to a female descendant of the Le Roy family.

Apart from a legal representative and an auctioneer, it became increasingly common to call in experts to assist with the sale as well. Auctioneers and experts often switched hats depending on the auction and the location. Artists or other

[21] Lyna, *The Cultural Construction of Value*, pp. 63–95; and Van Damme, 'Second-Hand Dealing in Bruges', pp. 73–92.

[22] Etablissement géographique de Bruxelles (ed.), *Annuaire industriel et administratif de la Belgique* (Brussels, 1832).

[23] For this part of the research I studied the categories concerning auctions and sworn criers in the directories every two years – when possible – between 1832 and 1914: Several editors, *Annuaire industriel et administratif de la Belgique* (Brussels, 1832–1914).

[24] Ibid.

figures deemed important in artistic terms performed as experts too.[25] The rise of the expert assisting the auctioneer points to the growing importance of expertise and knowledge in the auction business. The word 'expert' alone is revealing. Moreover, the artistic expertise of the auctioneers came to the fore as the century progressed. Auctioneers added information to their name on the title pages of catalogues. Even if those additions were rather limited or empty and blank, the urge to give context nevertheless points to the importance of reputation. Furthermore, in those specifications, auctioneers often hinted at their connections or reputation within the artistic world. For example, when Etienne Le Roy was auctioneer or expert for an auction, it was always mentioned that he was a restorer of paintings and an expert at the Royal Museum of Fine Arts. Underlining the expertise and reliability of the organizers of the sales added to the positive image of the auction house as an institution of impeccable repute.

In any case, the most important person in the auction house was the director or the auctioneer. Directors often actively searched for potential collections to put up for auction. The artistically knowledgeable auctioneers seem to have gained more elbow room towards the end of the century. Sometimes sales consisted of one or more pre-existing collections. Sometimes, however, there was no sign that the objects at auction belonged to an existing collection. Leaving the rather incomplete 1830s out of the scope of this research, the amount of sales without reference to a collection grew from 14 per cent in the 1840s to almost 50 per cent during the 1890s (see Figure 5.7). If in those cases there

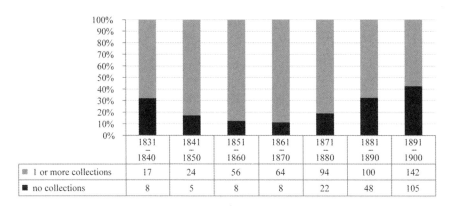

Figure 5.7 Brussels auctions of paintings with collections mentioned in catalogues, 1831–1900.

Source: *Art Sales Catalogues Online*.

[25] It should be mentioned that sometimes even more people were involved with the auctions: the person holding the mallet was not necessarily the director of the auction house, the auctioneer or the expert.

truly was no existing collection, the auctioneer had assembled one, as a dealer would assemble his stock. If there had been a collection, the fact that it was kept completely secret might point to the prevalent use of the auction house as a marker of value over the collection and its owner. Two related evolutions can thus be discerned. While the auction moved from the house of mourning to the 'hôtel de ventes', the owner of the collection was gradually shunted in favour of the organizers of the sale. The position of the collector as quality marker thus seems to have decreased in favour of the established auctioneer.

Considering the preceding viewing days and the artistic experts hammering on stage, auctions for paintings were an integral part of the cultural infrastructure of the city. At the same time when other cultural institutions were provided with purpose-built accommodation, auctioneers, too, constructed new buildings for their auction business. In the 1830s several auction rooms fulfilled multiple functions. Because of their central location on the Grand Place, it is, for example, unlikely that those auction rooms were reserved solely for the public sale of goods. It could even be possible that auctioning took place on the public square in front of the buildings. Furthermore, if auctions were held inside, those rooms had (most probably) not been designed as auction rooms. This changed with time. Indeed, the number of auction rooms that were specialized venues did continue to grow, and auctioneers started to establish their own buildings in which they designed their auction rooms and fitted them out to their liking. For example, in 1892 G. Cambier asked permission of the Brussels city council to start demolishing three adjoining properties which he wanted to transform into one vast sales room.[26] Later on he constructed stables, which was especially useful for his rich clients arriving at the auction house by carriage. Other reconstruction work was aimed at bringing as much natural light into the auction rooms as possible. An auction house could also be built from scratch, which was the case with the Galerie Saint Luc, the auction house that features most often in the collection of catalogues studied. This complex of auction rooms was constructed in 1870, in the rue des Finances 10 and 12, under the authority of Jules de Brauwere.[27] According to an advertisement in an 1882 auction catalogue, the complex consisted of four exhibition or sales rooms with adjoining depots. They were specifically fitted out for auctions of paintings and art.[28]

The blossoming of auction houses as cultural and commercial institutes is furthermore reflected in the evolution of their (self-re)presentation. The

[26] City Archives Brussels, *Openbare werken*, 9093: letter from Cambier to the city council (2 August 1892).

[27] City Archives Brussels, *Openbare werken*, 11 134 (building file Financiënstraat 8-10-12).

[28] L42465: *Tableaux, aquarelles, marbres italiens délaissés par ...* (Brussels, 1882).

name of the category devoted to auctions in the directories changed from 'directeurs de ventes' in the 1830s to 'directeurs et salles de ventes' and finally 'salles de ventes' in the 1850s. A change in name can be mere coincidence. Indeed, auctioneers did not necessarily have any control over the category name they were listed under. Nevertheless, there is reason to suspect there was more to the nomenclature. In the 1830s, 1840s and 1850s an auction room was clearly connected with the personal name of the auctioneer. In the 1860s it was occasionally specified that this person was the 'director', implying that he had something to direct. In 1868 the term 'salles de ventes' was first cited in order to distinguish between a book shop – 'J. Sacré librairie' – and an auction room – 'J. Sacré salles de ventes'. In the years that followed, auction houses started to be advertised with a non-personal name, functioning like a brand. From the 1870s onwards, names such as Galerie Ghémar, Galerie Saint Luc, Hôtel de ventes de Bruxelles and Salle Sainte Boniface appeared. This shift was probably related to changes in the business structure, but it is also important from a marketing perspective. The person in charge was still mentioned, but often only at a later stage than the company name, which was now used as a front and hallmark.

With similar timing, a shift in marketing strategies marked the auction catalogues. In the early years it was announced as being held 'à l'établissement de Louis de Man' or 'dans les salons et sous la direction de Henri Le Roy'. With time, the family name was combined with the prefix 'salles de ventes'. From the 1870s company names started to appear. The typographical development is even more significant. In the 1830s the location was mentioned in one small paragraph, printed together with all the other sales information. From the 1840s onwards, all this information was increasingly spread out over the whole of the title page. Gradually, the information was more neatly structured and the sales location became more prominent. Initially it was the address that stood out, but from the 1870s onwards it was the name of the auction house that was printed mostly in capitals, on a separate line and higher up than the names of the auctioneers or the responsible organizers. By the end of the century, title pages had become emptier, but the name of the auction house remained prevalent. For example, it is surprising to find that the auction house was more prominently present on the title pages of the catalogues of the Galerie du Congrès than the content of the sale.[29] Combining this rhetorical shift with the spatial prominence of the auction house instead of the house of mourning, and their establishment amongst dealers in art and antiques with the growing assertiveness of the auctioneer in compiling collections, one could suggest that auction houses climbed to their high point while building and living up to their reputation as professional commercial institutes.

[29] For example, ibid.

A Dangerous Expedition

While the organizational practices demonstrate the agility of the Brussels auctioneers to transform their businesses into the most functional configuration, the prefaces of auction catalogues hold more explicit discursive strategies in attributing value to the art on sale. In order to present the sale as valuable, the author of the preface of nearly every catalogue studied turned to the objects themselves: the works of art. The same range of adjectives was used throughout the century: 'famous', 'beautiful', 'valuable', 'rare' and 'precious'. They were of unseen perfection, merit and pure conservation. Apart from these descriptions, the quality of the works on sale was argued using three other strategies. Value was connected to the collection put up for sale, to the persona of the auctioneer and to the moment of sale.

Everyone organizing an art auction tried to present their collection as the most important being sold in a long time. The laudatory adjectives deployed were the same used to praise the works of art themselves. Value was apparently connected with rarity. Indeed, auctioneers presented their collection as the most exceptional to be presented at auction in ages. This singularity was contrasted with the mediocrity of 'every other' collection. In an 1856 auction catalogue, the well thought-out collection strategy of this collection's owner was contrasted with the compulsive urge to agglomerate every possible painting which characterized so many other collections. According to one author, this so-called 'agglomeration mania' transformed so many cabinets of paintings into 'de vastes bazars de médiocrité'.[30] In 1882, a catalogue was published in which the author of the preface ranted even more explicitly against mediocrity: 'Si souvent on s'est efforcé de nous illusionner sur des rebuts de collections banales qu'il y aura pour nous, cette fois, une intime satisfaction, à nous laisser aller aux élans de notre admiration, sans craindre, d'être déçus.'[31]

The curiosity of a collection was also argued by lauding its collector or owner. With the royal family, the nobility, the haute bourgeoisie and wealthy entrepreneurs among its citizens, Brussels had a mass of potential and rich clients. Even though a literal reference to the social position or the riches of a collector was rare, it was always implied that the collections belonged to a wealthy elite. Typical of those playing the cultural field, social distinction was subtly articulated in terms of enlightenment, civilization, artistry and

[30] L23131: *Catalogue de la belle et riche collection de tableaux anciens* ... (Brussels, 1856).

[31] 'Because we have to force ourselves to get excited over the leftover scraps of trivial collections so often, we will now find sweet satisfaction in letting our imagination get us carried away, without having to fear any disappointment.' L42454: *Catalogue de tableaux modernes de l'école française* ... (Brussels, 1882).

knowledge of artistic business.[32] Collectors were consistently portrayed as distinguished 'hommes de goût', having insightfully assembled their collection in a distinguished manner and informed by an enlightened spirit. Especially in the second half of the nineteenth century, the preface of an auction catalogue took on the form of a biography of merits, when the collection to be sold had belonged to a deceased painter. As with the collectors, the artist's moral accomplishments were emphasized, but they were also complemented with the argument of the brilliance of his artistic talent. Fame was also put forth as indicating value, while others applied the opposite approach of playing with the excitement that anonymity produced. It was sometimes argued that it made little sense to give away the name of the owner of the collection put up for auction. Since his or her salon was a meeting place for the artistic world, everybody already knew the collector anyway. In the 1850s the prominence of several collections was lauded because of the 'urbanité' with which their owners had welcomed highly honoured visitors.[33] In 1858 another 'amateur' was admired for the civility in his speech. On one occasion, the collector whose collection was sold at auction was contrasted with the so-called 'amateur de convention'. The conventional amateur disguised himself as a true art lover and patronized the arts with a hidden agenda and an inclination for paternalism.[34] Buying art thus turned into a socially and culturally constructed activity.

Social distinction was called into play, yet ever so subtly in terms of artistry and knowledge of artistic matters. Apart from the courtesy and distinction of the collector, his insightfulness and knowledge of the artistic world was also used in the argumentation. Collectors were considered to be visionaries. In an age of cultural eclecticism, making the right choice had turned into an art of its own.[35] Prefaces were thus full of words such as 'goût' and 'choix', referring to the ability to produce order in the chaos of possibilities. Both words were never fully defined, but clearly referred to a combination of innovation and convention. Around the mid-century, the concept of a golden age for collectors appeared in the prefaces. The late eighteenth and early nineteenth centuries were portrayed as having been prehistoric times, characterized by a lack of interest in artistic matters. Great masterpieces had been undervalued and as a consequence, visionaries had been able to assemble extremely valuable collections for next to

[32] On social and cultural distinction, see Pierre Bourdieu, *La distinction. Critique social du jugement* (Paris, 1979); and, for example, Nick Prior, 'A Question of Perception: Bourdieu, Art and the Postmodern', *The British Journal of Sociology*, 56 (2005): pp. 123–139.

[33] L23131.

[34] L24230: *Catalogue de la riche et nombreuse collection de tableaux modernes ...* (Brussels, 1858).

[35] Yves Schoonjans, '"Intérieur d'un employé aux magasins du Louvre Rue St Jacques". Een negentiende-eeuws burgerlijk interieur', *Dietsche warande & Belfort*, 97 (1997): pp. 2–23.

nothing.[36] Contrary to these golden ages, the mid-nineteenth century was put forth as one in which a decreasing number of available masterpieces and famous collections was accompanied by an increasing number of 'amateurs' and bidders.[37]

This golden-age theory intertwined with a nationalistic discourse lamenting the loss of the national art reserves to foreigners. The dispersal of collections was described as utterly deplorable. Local and national governments, as well as foreign amateurs and museums, were pointed to as being the guilty parties.[38] This discourse fitted perfectly with the blossoming interest in the (national) past so typical of the nineteenth century. It is nevertheless at least ironic that auctioneers were the ones to recuperate this nationalistic and historicist discourse and point their finger at others. After all, the auction business was the ultimate commercial circuit that facilitated the exodus of art works to foreign bidders with bulging purses. This dubiety beautifully demonstrates how auctioneers incorporated existing cultural and political discourses as a rhetorical strategy to underline and argue the exceptional value of the collections they put up for sale and to lure in native buyers.

As the golden ages were passing and competition grew fierce, the diligent efforts one had to make to form a collection were increasingly lauded. From the 1850s onwards, it was increasingly emphasized in the prefaces how much capital and time had been sacrificed to assemble the collection put up for auction. As the authors of the prefaces could not think of a better and more honourable way of spending leisurely time and fortunes, the difficulties that 'their' amateurs had encountered were always emphasized with admiration.[39] In a more subtle way the value of a collection was sometimes argued by means of contemplations about the difficult existence of the collector. Louis Lampe, who was the auctioneer of the collection assembled by Ruelens in 1882, wrote the most poetic of these contemplations. He described the love of paintings as a dangerous expedition undertaken by 'amateurs', whom he called explorers: 'La peinture est une vaste pays qui, depuis des siècles battu en tous sens, ménage encore aux explorateurs sagaces et circonspects bien des émotions, bien des surprises, mais réserve aux voyageurs novices de décourageants mécomptes et de dures déceptions.'[40] Because of the dangers of this vast land of painting, a decent guide was of the

[36] The eighteenth century was indeed characterized by an overload of available paintings and a clearance sale to foreign collectors: Lyna, *The Cultural Construction of Value*, pp. 251–267.

[37] L26461: *Catalogue de la collection de tableaux anciens et modernes* ... (Brussels, 1861).

[38] L23598: *Catalogue de la belle et riche collection de tableaux anciens* ... (Brussels, 1857).

[39] For example, L18734: *Catalogue d'une belle collection de tableaux des écoles* ... (Brussels, 1847); and L24230.

[40] 'The art of painting is a vast territory that, even though it has been tamed and conquered in every possible sense for a long time, still elicits many emotions and plenty of

utmost importance. Of course, Lampe himself had the honour of presenting the collection of one of the most exceptional of these guides. However sweet the adventure might turn out to be, when an explorer failed in his mission, the world of auctions could be trying. For example, in 1856 an anonymous collection was auctioned. According to the author of the preface of the catalogue of this auction, the man in question had collapsed under the disastrous consequences of the mania that was typical of a passionate collector. According to the rather dramatic description, the explorer was now deeply offended and his self-esteem was seriously damaged. Betrayed by everyone he had trusted, he would now get rid of everything that had ever given him pleasure and comfort. The collection consisted of a conglomerate of both ordinary and exceptional pieces of art. Expert art lovers were encouraged to take advantage of the opportunity.[41]

Apart from their provenance, collections were also attributed value by discussing their possible or preferred destinations. At the end of the 1840s the museum appeared for the first time as a place where auctioneers wanted the works on sale to end up in. However, it was only from the 1870s onwards that public museums were actively deployed in the construction of value, when collections were regularly described as 'digne de figurer dans une collection publique'.[42] Museums had come to be perceived as temples of quality, as leading institutions in the construction of a canon. Therefore, it was no coincidence that the more prestigious art auction houses settled in the neighbourhood of museums during the later nineteenth century. Indeed, judgement on the quality of the art works presented shifted from the collection and its owner to an external institution. Because the role of private artistic cabinets as artistic sanctuaries weakened in the wake of the rise of public museums, this shift in the auctioneers' discourse was not illogical. With an elegant flexibility, auction house directors seem to have capitalized on changing circumstances. This adaptability also showed in the unstable treatment of museums in auctioneers' discourse. Either they were addressed positively as desired clients or negatively as fearsome competitors for the amateurs. Foreign collectors were treated in a similar way. At first, foreign interest was only phrased in a positive way. The 'undeniable' interest shown by foreign amateurs was emphasized several times during the 1840s in order to enhance the international allure and importance of the auction. However, when nationalistic discourse took root in the 1850s, foreign amateurs were increasingly portrayed in a negative light.

surprises for the shrewd and cautious explorers, but reserves daunting miscalculations and grim disappointments for inexperienced travellers.' L42899.

[41] L 23115: *Catalogue de la belle et nombreuse collection de tableaux* ... (Brussels, 1856).

[42] Quote: L32622: *Catalogue de tableaux, esquisses, études etc. délaissés* ... (Brussels, 1871); and, for example, L18738: *Catalogue de tableaux des écoles anciennes* ... (Brussels, 1847); L32622 and L41963: *Catalogue de deux portraits de Franz Hals* ... (Brussels, 1882).

Praising a beautiful collection was not sufficient. The assessment of quality and value was always amenable to discussion. As was written in the *Journal de Bruxelles* in 1878 following an art auction held in London: 'Cet art est souvent une affaire de fantaisie, d'écus et de convention.'[43] This remark marks the negative reputation that the auction business often had. For example, Henri Rochfort, French dissident author and political journalist, wrote a satire on the Parisian auction circuit, *Les petits mystères de l'hôtel de ventes*, in which every party involved, from the auctioneer to the shrewd amateur, got it in the neck. He characterized auction houses as 'tours de Nesle'. In popular imagination this concept was used to represent a place of ruin and deteriorating morals.[44] That the Brussels auction business aroused less controversy than the Parisian scene is easily conceivable. It is nevertheless clear that a concern with reputation was very much present.

This concern was mostly concentrated on the issue of credibility. The last generation of eighteenth-century auctioneers had cashed in on the potential of the auction catalogue as a marketing tool. The specific language as it had developed in the early catalogues thus eroded into pompous eulogies with little substance, while many art works had wrongfully been attributed to specific artists.[45] Up until the 1870s the effects of this blatant marketing technique remained visible. In over half of the prefaces it was explicitly guaranteed that the auction catalogue would refrain from praising the objects listed. Etienne Le Roy explicitly indicated that all of his auction catalogues were consequently edited with the premise of avoiding all praise.[46] A couple of times the link between the practice of avoiding puff and prejudices against the auction business were made explicit. In 1841 it was argued in an auction catalogue preface that every sort of praise should be avoided, because eulogies were only deployed by quacks:

> Il est complètement inutile d'employer de grands mots ou des phrases emplantiques, pour appeler l'attention publique sur cette Vente. [...] tout les amateurs et connaisseurs pourront suffisamment se convaincre de la rareté et de la richesse des articles [...] sans qu'il soit nécessaire de se jeter dans la voie malheureusement trop commune, du charlatanisme ou de la camaraderie.[47]

[43] 'The arts are most often a matter of fancy, money and convention.' Untitled news report in *Journal de Bruxelles*, 58/537 (23 December 1878).

[44] Henri Rochfort, *Les petits mystères de l'hôtel de ventes* (Paris, 1862).

[45] Whiteley, 'The Language of Sale Catalogues', pp. 35–45; and Lyna, *The Cultural Construction of Value*, pp. 9–11 and 151–163.

[46] L24140: *Catalogue du cabinet de tableaux anciens, des écoles ...* (Brussels, 1858).

[47] 'It is completely useless to use big words or inflated language in an attempt to draw public attention to that Sale. [...] all amateurs and connoisseurs will be able to convince themselves sufficiently of the rarity and richness of the objects [...] without it being necessary

Condemning quacks was thus a way of emphasizing one's own dignity, reliability and honour. This rhetorical trick was used rather often.

Obviously, the rhetorical strategy of denouncing malpractices did not withhold auctioneers from simultaneously puffing up their auctions with enthusiasm. In the preface of an 1844 catalogue, the author boldly stated that a preface was only of use to swindlers: 'Un avant propos! en vérité nous devrions nous en dispenser en cette circonstance, comme d'une chose superflue. Le charlatanisme seul a besoin de prôner ses oeuvres éphémères!'[48] In the meantime, he nevertheless made eager use of the medium, justifying himself by the proclamation that being able to present a collection of exceptional beauty constituted for him the most intimate pleasure. The combination of promising to avoid praise while writing a text full of laudatory adjectives was typical of almost every catalogue.

The reasons given for refraining from laudatory remarks – beyond the fact that the practice smelled of charlatanism – varied. Some authors argued that it was inspired by the wish of the owner of the collection, for practical reasons, such as lack of time or space. Some argued that the fame of the collection or the owner outdid the necessity of describing its merits. Most often it was put forth that the professed public of 'amateurs' had inspired the decision, because they were deemed to form their own opinions. Any attempt to influence those opinions was both a waste of effort and an insult to their taste. This reasoning was balanced somewhere between buttering up the 'ever so competent amateurs' and emphasizing the amateurs' own responsibility for knowing their business.

A similar ambiguity could be traced in the discussion of the issue of guaranteeing the authenticity of the works on sale. Initially authors of catalogues asserted that the works of art and their attributions were believed to be authentic, until proven otherwise. Amateurs had to call upon their own knowledge to discover the possible mistakes. In this way, the organizers of the auction cleared themselves of any responsibility. In practice, it was a safeguard to list unfunded attributions in the catalogue, even if this was something they discursively frowned upon. This again proves how much the discourse against quacks was first and foremost a strategy to recommend oneself as a reliable tradesman, rather than an honest concern that something was wrong with the trade. Quality was actively construed in the old-fashioned way by means of some sort of professional code of honour. In the second half of the nineteenth century, auctioneers had the habit of boasting that they had specifically been

to take the road of charlatanism or camaraderie, unfortunately so commonly travelled.' L16152: *Catalogue de tableaux des anciennes écoles* ... (Brussels, 1841).

[48] 'A preface! Really, we should dispense with it on this occasion as if it were something superfluous. Charlatanism alone finds itself in need of extolling its fleeting works!' L17477: *Catalogue d'une belle et riche collection de tableaux* ... (Brussels, 1844).

requested to organize a specific auction.[49] The faith that the collection's owner had in them was testimony to their professional reputation. The respectability of the auctioneer was emphasized, rather than the good breeding of the owner of the collection.[50]

While the problem of eulogies was less often addressed in prefaces of the later nineteenth century, auctioneers progressively guaranteed the authenticity of the lots without any reserves. Works of art were now provided with a stamp of provenance, so that its pedigree could easily be reconstructed. The use of such a stamp also fitted with a growing scholarly culture invading the auction room. From the 1850s onwards auctioneers called in scholarly authorities to substantiate their arguments. They spoke of the reliability of their sources. The adjective 'scientific' surfaced and the language used in the prefaces became scholarly. One of the collections was even described as having been collected 'with science' – not taste. To the memory of a deceased artist who had left behind another collection, put up for auction in 1885, 'aucune atome de célébrité' could be added.[51] Instead of the anti-praise rhetoric, auctioneers promised to describe their lots using terms such as 'technical', 'accurate', 'scientific' and 'exact' as much as possible. Unsurprisingly, the number of signed prefaces increased from the 1850s onwards. Especially in the later years of the nineteenth century prefaces were often written by outsiders instead of auctioneers in order to add a sense of objectivity. The rise of the humanities as academic disciplines and the increased reference to science in popular culture was thus incorporated in efforts to build up a professional reputation.[52] Once more, auctioneers demonstrated their flexibility and their ability to adapt to wider, 'external' changes.

Finally, the moments of sale became a guarantee of quality as well. Initially a condescending attitude towards commercial motives seems to have prevailed. The sublime artistic qualities of both collections and owners were stressed, while commercial circumstances were ignored. It is no coincidence that in 1835 the author of a preface of an auction catalogue felt the need to openly distinguish between the 'amateur' – the true lover of everything that was art and art cabinets – and the speculator, getting a thrill from the excitement a sale produced.[53] In

[49] This had been a common strategy amongst early modern shopkeepers: Ilja Van Damme, *Verleiden en verkopen. Antwerpse kleinhandelaars en hun klanten in tijden van crisis (ca. 1648–1748)* (Amsterdam, 2007), pp. 160–169.

[50] For example, L23598; L28389: *Catalogue de la collection de tableaux anciens & modernes* ... (Brussels, 1865); and L42899.

[51] 'not a single atom of fame'. L24707: *Catalogue de la belle et riche collection de tableaux* ... (Brussels, 1859); and L44632: *Catalogue de tableaux et aquarelles dépendant de la succession* ... (Brussels, 1885).

[52] Rens Bod, *De vergeten wetenschappen. Een geschiedenis van de humaniora* (Amsterdam, 2010), pp. 313–429.

[53] L13983.

the prefaces of the 1840s and 1850s every association with trade had a negative ring to it. Inversely, it was stressed that the works of art were indeed excellently conserved because they had not circulated in trade, or amateurs were called on to buy the objects at auction, in order to protect them from the dangers of deterioration in commercial surroundings. In one of the prefaces it was explicitly stated that the collection was assembled without any sign of mercantilism. In this case, it was proudly argued, commerce had not prevailed, as it so often did.[54] One could thus be sure that the paintings presented were of an exceptional artistic nature. When a commercial collection was sold, it was always added that the art dealers putting their stock up for sale were no charlatans but honourable merchants. For example, in 1850, one author of a preface thought it necessary to stress that he was selling a collection belonging to one of those very rare speculators distinguishing himself by propagating true art.[55] Auctioneers thus deployed an artistic discourse in order to attune to an artistic audience.

Even if the anxious and condescending attitude towards speculation and lucre never fully disappeared, the 1860s nevertheless marked the beginning of an opposite and complementary discourse. Conversely, now and then the commercial aspect of auctions became a positive point of reference. Paintings were argued to be valuable, using the argument that trade stocks ran out of them. High sales prices were cited as a sign of quality. 'Amateurs' were believed to be in dire need of great fortune and investing in art was a wise way to spend it. Even though the owner of the collection was still mentioned when a pre-existing collection was auctioned, the auction as a medium increasingly functioned as a point of reference. In the 1860s it became more and more common to cite auctions that the works of art had previously figured in, instead of referring to their pedigree, a subtle but important shift in the discourse from the collection to the moment of sale. Since prefaces in the later nineteenth century were written mostly for auctions in which a pre-existing collection was sold, this shift is all the more significant. The prefaces of auction catalogues in the early and mid-nineteenth century described the rareness of the collection in hand as the most remarkable collection having been auctioned in a very long time. Gradually, a variation on the following formula became customary: 'La collection que nous offrons aux enchères des amateurs forme une des ventes les plus considérables et les plus remarquables qui se soient présentées depuis quelques années …'[56]

Even though the geographical alliance of auction houses with the theatrical and spectacular culture was weaker in Brussels than in Paris, from the 1850s

[54] L20655: *Catalogue d'une belle et nombreuse collection de tableaux* … (Brussels, 1852).
[55] L19765: *Catalogue d'une belle collection de tableaux anciens* … (Brussels, 1850).
[56] 'The collection we are offering to the highest bidders among the art lovers constitutes one of the most important and most remarkable auctions that have taken place in several years …' L38824: *Catalogue de tableaux modernes & anciens* … (Brussels, 1878).

onwards, Brussels auctioneers nevertheless did describe their auctions as thrilling events. Collections were sold 'au feu des enchères'.[57] Amateurs were predicted to fight fiercely and passionately over the works of art on auction.[58] At the very least this suggests that auctions were indeed exciting social events. One does not need a lot of imagination to picture the auction space as a place where kindred spirits engaged in a ritual battle. The auction as a commercial medium was therefore increasingly positively perceived to be an artistic event. A beautiful illustration of this artistic recuperation of the auction as a commercial institute is found in the preface of the catalogue accompanying the 1870 auction hosted by Etienne Le Roy. For this auction three separate collections were brought together. In his preface, Le Roy argued that the owner of the second collection need not be mentioned. Indeed, this collection had been carved into the collective artistic memory of artists and experts alike: 'C'est là un des signes distinctifs de notre temps où chaque vente aux enchères publiques met en relief les pages dont s'honorent les Ecoles soit anciennes, soit contemporaines.'[59] The circuit of public art auctions fed, as it were, the artistic memory. In an 1865 catalogue of an auction selling the well-known collection of paintings gathered by Gustave Couteaux, a famous Brussels banker, amateur and art dealer, positive appreciation for the commercial medium of the auction became most eloquently clear. Auctioneer Etienne Le Roy most explicitly argued the auction to be the standard of value within the artistic world. After having praised the collection from a number of perspectives, he expressed his faith in the high prices these paintings would receive, 'car les ventes publiques ressemblent à la pierre de touche qui constate la valeur d'or.'[60] Auctions were considered golden touchstones or Lydian stones within the art world. This remark is illustrative of the way in which commerce and culture became intertwined in the discourse shaping the auctions of paintings in Brussels.

Conclusion

Although the economic principle behind the auction has not changed, different times, places and societies witnessed different auction cultures, and art was attributed value in different ways because of it. Miscellaneous, subtle, yet

[57] 'in a heated bidding battle'. L28389.

[58] For example, L24230; L31988: *Catalogue de tableaux modernes des écoles* ... (Brussels, 1870); and L48996: *Catalogue. Tableaux anciens et modernes* ... (Brussels, 1890).

[59] 'There is to be found one of the distinctive traits of our times, when every public auction brings into prominence those pages in history on which either the old or contemporary schools congratulate themselves.' L31988.

[60] 'because public auctions are much like the Lydian stone assessing the value of gold'. L28389.

meaningful shifts in location, organization and culture marked the nineteenth-century auction scene in Brussels. Even if very few trails of the theatre and spectacle associated with the Parisian auction scene have been found, it is clear that Brussels auctions of paintings were thrilling and stylish events. The viewing days, the well-chosen locations of imposing auction houses, as well as the subtle construction of an artistic and elitist world in them, testify to that. Auctioneers tried to create added value by immersing their auctions in an artistic culture. Their commercial interests and actions were strategically and rhetorically wrapped in artful packaging. Auctioneers gave their events an exclusive air by making use of a culture and language that were typical of both their suppliers and their audience. They articulated social status in terms of (subtle) cultural distinction. They tried to locate value in the artistic scene of the art auction.

In their attempts to add value, auctioneers demonstrated an elegant flexibility in responding to changing cultural circumstances and recuperating existing discourses. Grown out of the public sale of existing collections, auctioneers had long invested in underlining the exceptional qualities of individual collections. In a context in which semi-public artistic cabinets fulfilled the function of a meeting place for the artistic community, this was a very smart strategy. When nineteenth-century public museums took over this role of trendsetter, auctioneers were quick to respond. They settled near the art museum and the academy in the elitist upper city. Auctioneers organized viewing days and lauded the artistic qualities of their collections. In the second half of the nineteenth century, they brought their own artistic expertise to the foreground, recuperated the taste for science in the process of building their reputations and connected the value of their art works to their potential as museum pieces.

However, connecting the evolution of auctions of paintings in nineteenth-century Brussels in one teleological line with today's high-profile auction houses will not do. Right before the turn of the twentieth century, the number of Brussels auction houses decreased and auctioneers lost their geographical gravitas in the trade for art. Furthermore, the most prestigious auction houses at that time were also active as retailers, and some of them even switched business, becoming full-time shopkeepers for art. In a way, the increasingly explicit emphasis on artistic expertise carried within itself the seeds of later decay. By bringing themselves, their expertise and the moment of sale into the spotlight, next to or instead of the collections they sold, the discursive attention for what made an auction an auction – the collection – diminished. Without wanting to undervalue the continued function of auctions as price and value setters, a permanent shop offered rather more opportunities to exploit artistic expertise and build durable client relations based on mutual trust. It should not be surprising, then, that the better auction houses followed the art and antique shops to their neighbourhoods. Individual clients chose to invest in art proposed to them by dealers with whom they could build a personal relationship

– someone they could trust. Tired from their expedition within the land of the golden touchstones, the explorers probably returned to their old and familiar dealer. As a result, value was now, once again, guaranteed and construed through the mechanism of personalized trust.

PART II
Conventions, Material Culture and Institutions

Chapter 6

The Justness of *Aestimatio* and the Justice of Transactions: Defining Real Estate Values in Early Modern Milan

Michela Barbot

Prices and Values in the Early Modern Milanese Real Estate Market

In January 1632, the Chapter of the Venerable Factory of the Dome, one of the biggest property owners in Milan, decided to put up for sale a property with two apartments and five workshops.[1] To establish the value of the property, situated in one of the most important marketplaces of the city,[2] the Chapter consulted Carlo Buzzi, a member of the College of Engineers, Architects and Land Surveyors in Milan (hereafter referred to as 'the College'), an institution founded in 1563 following the forced closure of a *Universitas*, in existence since the Middle Ages.[3] Carlo Buzzi paid a visit to the property and prepared a report in which he used only one evaluation criterion: the capitalization at 5 per cent of the sum of the rents from the apartments and workshops.[4]

Two months later, the same engineer[5] was called to evaluate a house in the parish of San Primo, in a residential area of the city. In this case, Carlo

[1] On the real estate of the Venerable Factory of the Dome of Milan, see Michela Barbot, *Le architetture della vita quotidiana. Pratiche abitative e scambi immobiliari a Milano in età moderna* (Venice, 2008), pp. 2–80; Michela Barbot and Luca Mocarelli, 'Quand s'allonge l'ombre de cathédrale: l'impact du chantier du Dôme de Milan sur l'espace urbain (XVIe–XVIIIe siècles)', in Patrick Boucheron and Marco Folin (eds), *Les grands chantiers de la renovation urbaine: les expériences italiennes dans le contexte européen* (Rome, 2012), pp. 255–261.

[2] It was the Piazza del Carrobbio at Porta Ticinese, where one of the biggest weekly food markets in the city was held: Stefano D'Amico, *Le contrade e la città. Sistema produttivo e spazio urbano a Milano fra Cinque e Seicento* (Milan, 1994).

[3] On the history of the College, see Giorgio Bigatti and Maria Canella (eds), *Il Collegio degli Ingegneri e Architetti di Milano. Gli archivi e la storia* (Milan, 2008).

[4] Archive of the Veneranda Fabbrica del Duomo di Milano (hereafter AVFD), Capo XXIV, Cartella (hereafter Cart.) 258, foglio (hereafter f.) 3.

[5] Here I will use the term 'engineer' as it is the one which most frequently appears in the sources. However, it should be borne in mind that in modern Italy, this term is used to indicate a professional person with composite functions, who at the same time carries

Buzzi took into consideration only the intrinsic value of the property. In other words, he calculated the building costs, splitting up rooms, corridors, stairs and porches into their separate elements (stones, bricks, tiles, beams, nails, locks, frames, and so on). Subsequently, he measured them in *tavole, trabucchi* and *quadretti*.[6] Finally, to each of these parts he gave a value in the local currency (the Milanese imperial *lira*)[7] and fixed according to two variables: the type of materials employed (wood – the most fragile; clay, stone – the strongest)[8] and their state of preservation (new, in good condition, repaired, damaged, old, very old).[9]

Some years previously (1601), the Venerable Factory of the Dome had purchased a three-storey building. In this case, too, the estimate was entrusted to an engineer from the College. On the basis of its intrinsic value, the engineer established that the property was worth 4,700 imperial *lire*.[10] However, the engineer decided to deduct 700 imperial *lire* from this sum due to the fact that for 22 years there had been a dispute over the building between neighbouring owners.[11]

In all three of the cases considered, the notarial deeds state that the estimated value coincided with the price at which the property was sold. In the three cases, therefore, the market price was the outcome of processes which involved different kinds of evaluation. Extending the analysis to a more significant number of cases and to a longer period, the result does

out engineering and architectural activities: see G. Mazzi and S. Zaggia (eds), *Architetto sia l'ingegniero che discorre. Ingegneri, architetti e proti nell'età della Repubblica* (Venice, 2004); Alessandra Ferraresi and Monica Visioli (eds), *Formare alle professioni. Architetti, ingegneri, artisti (secoli XV–XIX)* (Milan, 2012).

[6] The uniformity of the systems of measurement in Italy dates from the unification of the country in 1861. Prior to that, each regional state and each city-state was characterized by local systems of measurement. In the state of Milan, the main square measures were precisely the *tavola* (27.3 square metres), the *trabucco* (6.8 sq. m.) and the *quadretto* (0.35 sq. m.): see Angelo Martini, *Manuale di metrologia, ossia misure, pesi e monete in uso attualmente e anticamente presso tutti i popoli* (Torino, 1883), pp. 351–352.

[7] On the *lira imperiale milanese*, see Carlo Maria Cipolla, *Mouvements monetaries dans l'Etat de Milan: 1580–1700* (Paris, 1952).

[8] In Milan, these three kinds of building materials were those most in use because they could be easily obtained locally: see Laura Giacomini, 'Organizzazione e costi dei cantieri privati delle élites Milanese tra 1550 e 1650: manodopera, materiali e tecnologie', in Simonetta Cavaciocchi (ed.), *L'edilizia prima della Rivoluzione Industriale* (Florence, 2005), pp. 739–758.

[9] AVFD, Capo XXIV, Cart. 279, f. Castelletti Angela e Francesco.

[10] It was a house in the Piazza del Duomo, owned by the noblewoman Samaritana Inzaghi: AVFD, Capo XXIV, Cart. 247, f. 92.

[11] Ibid.

not change. My examination of a set of 300 estimates made between 1565[12] and 1796[13] confirms that a large number of evaluation criteria were used to evaluate property, often applied within the same estimate. Moreover, the percentage of transactions in which the value set by the engineers and the sale price registered by the notaries coincided is established on extremely high thresholds, equal to 90.2 per cent of the cases considered. These two aspects – the presence of evaluation criteria, which differ from time to time, and of a market price largely depending on the opinion of an expert – are difficult to interpret using the standard tools of neo-classical economic theory. This hardly comes as a surprise: many scholars have shown that this problem is largely due to the characteristics of the house in so far as it is an object of trade.[14] House, in fact, is an 'impossible'[15] commodity as it is an economic asset which embodies a large number of extra-economic meanings: symbolic meanings (it is one of the places in which social differences are most apparent),[16] political meanings (it is an essential asset protected by the

[12] I chose 1565 for the beginning of this study because of its importance in the urban history of Milan: the walls circling Milan (the so-called Spanish Walls) were completed in that year, while two years previously the College of Milan was founded. The final date of the study (1796) coincides with the end of the Habsburg's domination of Milan (begun in 1535) and with the closure of the College and the urban guilds. On the closure of the Milanese guilds, see Luca Mocarelli, 'Le attività manifatturiere a Milano tra continuità dell'apparato corporativo e il suo superamento (1713–1787)', in Alberto Guenzi, Paola Massa and Angelo Moioli (eds), *Corporazioni e gruppi professionali nell'Italia moderna* (Milan, 1999), pp. 131–170.

[13] This research is based on the study of three archives: as well as the archive of the Veneranda Fabbrica del Duomo (AVFD), I consulted the Archive of the State of Milan (ASM) and the Archive of the Civic History of Milan (ASCM). From them I obtained altogether a set of 300 estimates pertaining to 300 purchases (and their notarial documents) divided as follows: 100 on residential real estate units (called 'houses' – 'case' – or 'apartments' – 'appartamenti' – by the sources), 100 on productive and commercial units ('workshops' – 'botteghe') and 100 on units with a mixed function (the so-called 'houses with workshop' – 'case con bottega': see later). A part of these estimates is also analysed in Michela Barbot, 'A ogni casa il suo prezzo. Le stime degli immobili della Fabbrica del Duomo di Milano fra Cinque e Settecento', *Mélanges de l'École Française de Rome, Italie et Méditerranée*, 119 (2007): pp. 1251–1262.

[14] On this, see the views of Maurice Halbwachs, *Les expropriations et le prix des terrains à Paris* (Paris, 1909), pp. 277–280; Pierre Bourdieu, *Les structures sociales de l'économie* (Paris, 2000); and the more recent Lucien Karpik, *L'économie des singularités* (Paris, 2007).

[15] This is a definition borrowed from Christian Topalov, *Le logement en France: historie d'une marchandise impossibile* (Paris, 1987).

[16] See Michel De Certeau, *L'invention du quotidien. Habiter, cuisiner* (Paris, 1990); and Pierre Bourdieu, *Esquisse d'une théorie de la pratique précédé de trois études d'ethnologie kabyle* (Paris, 2000), pp. 61–82.

public authorities as it allows access to citizenship via residence)[17] and, last but not least, affective and anthropological meanings (it is the place where domestic intimacy is best expressed).[18] What is more, houses are unique objects, neither standardized nor totally replaceable. This set of factors means that the real estate market eludes the theory of the competitive market,[19] making the traditional tools of price history largely unserviceable too.[20] As has been seen for other forms of trading,[21] in the analysis of markets where goods are not homogeneous and transactions are profoundly conditioned by extra-economic variables, the knowledge of conventions[22] that influence the process of the formation of value turns out to be more relevant than the mere construction of series of prices over a long period. From this point of view, architectural estimates are a historical source of extraordinary interest for an analysis of the evolution of the conventions of real estate values. It is

[17] On the relationship between residence and belonging to the urban community, see Michela Barbot, 'La résidence comme appartenance. Les catégories spatiales et juridiques de l'inclusion et de l'exclusion dans les villes italiennes d'Ancien Régime', *Histoire urbaine*, 27 (2013): pp. 29–48.

[18] See Philippe Ariès and Georges Duby (eds), *Historie de la vie privée. De la Renaissance aux Lumières* (Paris, 1986).

[19] As observed by Bradford Case and John M. Quigley, 'The Dynamics of Real Estate Prices', *Review of Economics and Statistics*, 73 (1991): pp. 50–58; and John M. Quigley, 'The Economics of Housing', *The International Library of Critical Writings in Economics*, 85 (1997): pp. 365–372.

[20] On the characteristics of price history, see the classic works of William Beveridge (ed.), *Prices and Wages in England from the Twelfth to the Nineteenth Century* (London, 1939); and Earl J. Hamilton, 'Use and Misuse of Price History', *Journal of Economic History*, 4 (1944): pp. 47–60. On the connection between the theories of price history and neo-classical economic theory, see Guido Guerzoni, 'The Social World of Price Formation: Prices and Consumption in Sixteenth Century Ferrara', in Evelyn Welch and Michelle O'Malley (eds), *The Material Renaissance: Costs and Consumption in Italy, 1350–1650* (Manchester, 2007), pp. 85–105.

[21] The history of the art markets is the field of analysis which has most contributed to demonstrating the limits of price history. Within a now extensive bibliography, see the references in De Munck and Lyna's introduction to this volume.

[22] Here I use the term 'convention' in the meaning given to it by the French Economics of Convention, as 'a system of reciprocal expectations concerning the behavior and competences of others': Robert Salais and Michael Storper, *Les mondes de production: enquête sur l'identité économique de la France* (Paris, 1993), p. 31. For a discussion about this approach in a historical perspective, see again De Munck and Lyna's critical comments made in their introduction, as well as Rainer Diaz-Bone and Robert Salais, 'Economics of Convention and the History of Economies: Towards a Transdisciplinary Approach in Economic History', *Historical Social Research*, 36/4 (2011): pp. 7–39.

precisely this type of analysis that I have made in the case of Milan between the sixteenth and eighteenth centuries.[23]

Constellations of Conventions

As in many other centres of the pre-industrial era, in Milan, too, the urban building sector was one of great importance, coming third after the textile and food sectors.[24] The Milanese real estate market was an extremely active and lively one, characterized by a large volume of transactions in the fields of both sales and rents.[25] It was, moreover, one of the markets most severely controlled by urban authorities. Even though a real 'right to housing' did not exist in pre-industrial times,[26] the sale of real estate, involving basic necessities, was very much at the centre of public governance, in which recourse to the procedures of *aestimatio* played a key role.[27] No real estate transaction could

[23] Interest in this analysis also depends on the fact that a conventional analysis of the prices on real estate markets has never been made up to now. Moreover, it is necessary to underline that traditional price history has also shown little interest in this field of study. The only studies in this field deal more with the analysis of the wages of labourers in the building trade, rather than the study of the prices of urban manufactured articles: see, for instance, Luca Mocarelli, 'Wages and Labour Market in the Building Trade in 18th Century Milan', *Jahrbuch für Wirtschaftsgeschichte*, 23 (2004): pp. 61–81; Gregory Clark, 'Work, Wages and Living Conditions: Building Workers in England from the Magna Carta to Tony Blair', in Cavaciocchi (ed.), *L'edilizia prima della Rivoluzione Industriale*, pp. 889–932. The exceptions are Michel Dorban and Paul Servais (eds), *Les mouvements longs des marchés immobiliers ruraux et urbains en Europe (XVI–XIX siècles)* (Louvaine-le-Neuve, 1994); and Gérard Béaur, *L'immobilier et la Révolution. Marché de la pierre et mutations urbains 1770–1810* (Paris, 1994). An analysis of market prices in the rental markets in early modern Milan has been made using the method called 'hedonic prices' in Michela Barbot and Marco Percoco, 'Real Estate Markets and Rental Contracts in the Early Modern Age: Milan, 1570–1670', paper presented at the European Real Estate Society Conference, Bocconi University, Milan (June 2010).

[24] See Carlo Maria Cipolla, *Storia economica dell'Europa preindustriale* (Bologna, 1974), p. 53.

[25] For the sixteenth and seventeenth centuries, see Barbot, *Le architetture della vita quotidiana*. On the eighteenth century, see Luca Mocarelli, *Costruire la città. Edilizia e vita economica nella Milano del secondo Settecento* (Milan, 2008).

[26] It is well known that the right to housing was the outcome of the struggles arising from the 'social question' at the end of the nineteenth century. See Robert Castel, *Les métamorphoses de la question sociale. Un chronique du salariat* (Paris, 1995).

[27] The widespread recourse to the *aestimatio* in medieval and modern economies is stressed by Giacomo Todeschini, *Ricchezza francescana. Dalla povertà volontaria alla società di mercato* (Bologna, 2004); in the same vein, Michela Barbot, Jean-François Chauvard and

take place in Milan without recourse to an expert. It was, in fact, the city's constitutional charter (the so-called 'New Constitutions') which invested the College members with the delicate task of attributing the 'right' value to property considered civic par excellence.[28]

However, as we have seen in the first examples, the estimate operations carried out by these experts did not correspond to one particular assessment procedure. They did not mechanically apply a system with strict rules or a previously fully defined protocol.[29] Rather, from one transaction to another, the engineers decided according to the circumstances which factors were to be considered relevant in order to determine the value of the real estate. In turn, these factors, although numerous, always refered to two principal repertoires of assessment: an objective one, based on the quality of the objects of the transaction, and a subjective one, related to the subjects of the transaction. In each single estimate, these two repertoires were then expressed in a multitude of criteria. This, as we will see, gave rise to distinct constellations of valuational conventions.

Rental Value and Intrinsic Value

With regard to the characteristics of the objects of the transaction, the criterion that the engineers mainly took into consideration was whether the property to be estimated was to be used for residential or professional purposes or had a mixed function.[30] In the urban area, three different kinds of buildings

Luca Mocarelli (eds), 'Premessa a Questioni di Stima', *Quaderni Storici*, 135 (2010): pp. 643–650.

[28] Milan's New Constitutions, promulgated by the Spanish emperor Charles V, are dated 1541: *Constitutionum Dominii Mediolani*, ASCM, Arch. C92. As already mentioned, they considered houses in the same way as civic assets, because, via the mechanism of residence, they could give access to urban citizenship. See Barbot, 'La résidence comme appartenance'.

[29] From the seventeenth century, two manuals of estimates are known to have circulated in Milan. Both were written by jurists: Nicola Festasio, *Tractatus de aestimo, et collectis* (Mutina, 1569, followed by the Venetian editions in 1571 and 1584); and Giulio Cesare Glusiano, *Tractatus de precio et estimatione secundum ius civile* (Milan, 1615). These manuals do not envisage strict methods of calculations, but set out a mainly practical formation, as shown by Alberto Gabba, *L'opera di stima nella formazione e nel rinnovo della città in età moderna* (Pavia, 1984); and Marica Forni, 'The Negotiations for the Palazzo that Belonged to the Deceased Tomaso Marino: Palazzo Marino and its Real Estate Evaluations and Use from the Sixteenth to the Eighteenth Centuries', in Michela Barbot, Luigi Lorenzetti and Luca Mocarelli (eds), *Property Rights and their Violations: Expropriation, Seizure and Confiscation, 16th–20th Centuries* (Bern, 2012), pp. 37–63. In any case, it is important to emphasize that none of the estimates analysed here makes an explicit reference to these or any other manual.

[30] Examples are the two estimates made by Carlo Buzzi in 1632: see above.

corresponded to these functions: houses (perhaps divided into apartments or rooms),[31] workshops, and finally, houses with a workshop.[32]

In the case of property used for work purposes (the workshops), the main criterion of evaluation was that of capitalization (usually at 5 per cent) of the revenue from rents. This convention createed a close interdependency between the markets dealing with rents and sales, making both markets very sensitive to sudden changes in economic and demographic trends.[33] A brief shock (for example, the plague of 1630) was sufficient to cause a drastic contraction in rent price – and therefore sale prices. The opposite occured in periods of economic prosperity and urban population growth.[34]

The case of property used for habitations was different. In this situation, the prevailing valuational convention was the calculation of the intrinsic value, regardless of the existence of any revenue from rents. As a result of the combination of the assessment of the quality of the materials and of their state of preservation,[35] the intrinsic value was never univocally defined, but it was always established and calculated by experts 'in the context of the circumstances'. As we saw in the first example, for Milanese engineers, determining the intrinsic value meant classifying, counting, measuring and weighing the individual components of which the houses were composed. Qualifying made it possible to quantify: the measuring procedures introduced a quantitative dimension within a valuational procedure which would otherwise only be qualitative.[36] Finally, in the mixed case of the house with workshop, the benchmark of the rental value and the intrinsic value, according

[31] Barbot, *Le architetture della vita quotidiana*, pp. 105–114.

[32] According to the 1636 census and the land register of 1748, this third typology was the prevalent one in the Milanese urban area: ibid., p. 40.

[33] On the way in which the rental market reacted to demographic movement, see the classic work of Emmanuel Le Roy Ladurie and Pierre Couperie, 'Le mouvement des loyers parisiens de la fin du Moyen Age au XVIII siècle', *Annales ESC*, 25 (1970): pp. 1002–1023.

[34] Michela Barbot, *Opposite Trends: The Real Estate Market's Dynamics in Milan from Growth to Recession (16th–17th Centuries)*, paper presented at the XIV World Economic History Congress, Helsinki (August 2006).

[35] It is interesting to observe that the surface area of the houses was not a feature that engineers took into account. In fact, this information was usually omitted: Barbot, 'A ogni casa il suo prezzo'.

[36] Already in the medieval period, the state of preservation of materials and buildings was one of the principal criteria in the estimate of real estate: for the case of France, see Jean-Pierre Leguay, 'La propriété et le marché de l'immobilier à la fin du Moyen Age dans le Royaume de France et dans les grands fiefs périphériques', in Jean-Claude Maire Vigueur (ed), *D'une ville à l'autre: structures matérielles et organisation de l'espace dans les villes européennes (XIII–XVI siècles)* (Rome, 1989), pp. 135–199.

to the case, prevailed one over the other, or were combined within the same estimate. This contributed to making the range of possible results even richer.

The Locational Rent and the Legal Context

In turn, the rental value and the intrinsic value (used separately or concurrently) did not, on their own, totally cover the whole objective repertoires of evaluation. Besides these two conventions, a further criterion often came into play, on a geographical basis: consideration of the location of the real estate within the urban space. Applying *ante litteram* the theory of locational rent,[37] the engineers of Milan showed that they were perfectly aware of the existence of a hierarchy in the value of urban land. In the case of workshops, proximity to the nerve centres of business and trade was an important factor in increasing their value.[38] The opposite was true for habitations, when the proximity of traffic and the confusion of a marketplace converted it into a markdown in value.[39] Within this 'geographical' convention, other elements could also play an important role, such as the position of rooms, the noise or tranquillity of the area or street where the property was located and, last but not least, the architectural features of neighbouring buildings. When, for example, in 1669 the engineer Gerolomo Quadrio was asked to give an estimate of the value of a mixed property (a house with a workshop and three cellars in the square of the most important market in the city), having calculated the rental value of the workshops and the intrinsic value of the dwellings, he corrected these figures, adding a mark-up on account of its central location and the architectural quality of the neighbouring buildings.[40]

As well as geographical impact, the legal context in which the transaction took place was equally important.[41] As we have seen, engineers were very careful

[37] The father of this theory was the geographer Johann-Heinrich Von Tünen, *Der Isolierte Staat in Beziehung auf Landwirtschaft und Nationalokonomie* (Hamburg, 1826).
[38] See various examples in Barbot, *Le architetture della vita quotidiana*, pp. 226–245.
[39] Ibid.
[40] AVFD, Capo XXIV, Cart. 279, f. Corio Conte Filippo.
[41] I have included the legal context among the 'objective' repertoires of evaluation as the system of property rights existing in the cities of the *ancien régime* was based on the primacy of the objective dimension – of the *res* – over the subjective aspect of appropriation. Property, in other words, was not considered as a quality of the individual person, but as an attribute of things: see Paolo Grossi, *Il dominio e le cose: percezioni medievali e moderne dei diritti reali* (Milan, 1992); John Brewer and Susan Staves (eds), *Early Modern Conceptions of Property* (New York, 1996); Michela Barbot, 'When the History of Property Rights Encounters the Economics of Convention: Some Open Questions Starting from European History', *Historical Social Research*, 40/1 (2015): pp. 78–93.

to indicate both the state of ownership and whether there were any disputes or legal obligations on the property. In Milan, as in many other cities of the *ancien régime*, the most common form of occupation of houses was the so-called 'dissociated property'.[42] This legal system entailed the possibility of selling, dividing or sharing between individuals the right of ownership on the same property in the medium to long term, more than nine years and often permanently.[43] The fact that this form of ownership was widespread meant that the transactions might concern real estate or single perpetual rights on it, making the real estate market a place of transactions of material and immaterial assets, depending on the case. Even the sales made in a system of full ownership (with more of a tendency to concern workshops and buildings with a mixed use) did not conform to just one type of contract. In fact they fell into four categories:[44] free transfers; terminations *causa transactionis*, stipulated to put an end to disagreements and disputes; sales for *datum in solutum*, aimed at paying off a debt; and 'masked loans', that is, transactions that hid mortgages behind a sale and simultaneous lease.[45] The legal context in which these transactions took place greatly influenced, in turn, the way in which the value of the real estate was determined. In the case of sales made in a system of dissociated ownership, the presence – or even only the possibility – of disputes which made the transfer of property rights slower or more difficult, increasing transaction costs, usually ended up generating a disvalue.[46] We have seen an example in the case of the

[42] On this property regime, see Olivier Faron and Etienne Hubert (eds), *Le sol et l'immeuble: les formes dissociées de proprieté immobilière dans les villes de France e d'Italie* (Rome, 1993); Michela Barbot, 'What the Dominia Could Do: Enfiteusi and Other Forms of Divided Property Rights in Lombardy from the 14th to the 20th Century', in Gérard Béaur, Rosa Congost and Pablo F. Luna (eds), *Les pratiques emphytéotiques en Europe* (Turnhout, forthcoming, 2016).

[43] For example, in Rome in the sixteenth century, two thirds of real estate transactions were carried out under the system of dissociated property: Renata Ago, *Economia barocca. Mercato e istituzioni nella Roma del '600* (Rome, 1998).

[44] On the frequency of these contracts in Milan, see Barbot, *Le architetture della vita quotidiana*, pp. 203–220.

[45] These hidden loans were famously aimed at getting round the ban on usury, which started at a higher rate than 5 per cent: Gigi Corazzol, *Fitti e livelli a grano. Una forma di credito rurale nel Veneto del '500* (Milan, 1979); Luigi Faccini, *La Lombardia fra Seicento e Settecento. Riconversione economica e mutamenti sociali* (Milan, 1988); Marco Cattini, *I contadini di San Felice. Metamorfosi di un mondo rurale nell'Emilia dell'età moderna* (Turin, 1984).

[46] On transaction costs, see Oliver E. Williamson, 'The Economics of Organization: The Transaction Cost Approach', *American Journal of Sociology*, 87 (1981): pp. 548–577. I have discussed the link between the dissociated property system and transaction costs in Michela Barbot, 'Incertitude ou pluralité? Les conflits sur les droits fonciers et immobiliers dans la Lombardie d'Ancien Régime', in Julien Dubouloz and Alice Ingold (eds), *Faire la*

house bought by the Factory of the Dome in 1601: its intrinsic value was docked by a sum that quantified the inconvenience caused by the presence of a dispute between the previous owners.

Status and Relations: The Social Embeddedness of Property Values

The presence of potential disputes between the actors also prompts us to consider the second great repertoire adopted by the engineers: the appraisal of those involved in the exchange. The subjective repertoire, too, contained numerous variations. Throughout the period under consideration, there were two major criteria for assessing the 'quality' of the participants in the exchange: the analysis of their social status and a consideration of the kind of relationship existing between them. However, even these two criteria – which we might define respectively as 'statutory' and 'relational' – were pertinent in different ways and variously combined, depending on specific situations.

In general, it was the criterion of status that prevailed whenever there was a distinct difference in prestige between buyers and sellers. Since society in early modern Milan was stratified, that is, arranged according to class, there was the idea that the value of things should, first of all, reflect the value of the people they were intended for.[47] In actual situations, the application of this equivalence may have led to completely opposite results. If the socially stronger party was the seller, the value of the property, generally speaking, was increased in his favour; but if instead he was the purchaser, the opposite occured. However, such a linear correlation between economic value and social status was only detectable when the transaction involved outstanding public figures, in the case of some members of the town's 'elite of elite': the patriciate. In the case of transactions which, although socially asymmetrical, involved lower ranking nobility or non-nobility, the criterion of status could be mitigated by other factors, including, in fact, the pre-eminence of the objective repertoires or consideration of any possible links between the subjects of the exchange. More often than not, in fact, the quality of those involved was included in the calculation of property value, not in general

preuve de la proprietà. Droits et savoirs en Méditerranée (Antiquité–Temps modernes) (Rome, 2011), pp. 275–301.

[47] On the correspondence that the society of the *ancien régime* tended to establish between the 'nature of things' and the 'quality of people', see Bartolomé Clavero, *Antidora, Antropología Católica de la Economía Moderna* (Milan, 1991); and Simona Cerutti, *Giustizia sommaria. Pratiche e ideali di giustizia in una società di Ancien Régime (Torino XVIII secolo)* (Milan, 2003), pp. 81–109. In property evaluations, the importance of the 'quality of people' was explicitly called into question whenever the transaction dealt with the so-called 'noble houses': see the examples given in Barbot, *Le architetture della vita quotidiana*, pp. 124–127; and Forni, 'The Negotiations for the Palazzo'.

terms of abstract belonging to certain social and professional categories, but rather in specific terms of the relationship that bound buyers to sellers 'in the situation'. In not infrequent cases in which transactions were conducted between people who had a previous connection with each other (relationships of family, patronage, past professional relations or previous debt/credit relations), the estimate was accompanied by explicit accounting calculations that made it quite clear that the value attributed to the property was, first of all, the economic sanction of this specific connection.[48]

The Estimate of Estimators

Ultimately, the analysis of real estate valuations shows how, in pre-industrial Milan, property exchanges were influenced by a marked conventional pluralism. This pluralism, in turn, was mostly derived from the combined action of the objective and subjective valuation repertoires. When observed under the valuation microscope, real estate values turned out to be, in fact, the outcome of remarkable alchemies between the legal property system, the building's intended use, its intrinsic characteristics, its urban location, the identity of the participants in the transaction and, last but not least, the nature of the relationship existing between them. Even though in some cases it was possible to determine the economic weight carried by each of these factors with a degree of precision, in the majority of cases this operation was impossible. Inevitably, all this created a halo of opaqueness around the valuation procedure. Not answering to any formal set of rules or abstract procedure, the valuations, apparently at least, were always at risk of being seen as lacking transparency and being arbitrary or even unlawful. Nevertheless, as we have already mentioned, in over 90 per cent of the transactions analysed, the valuation made by the experts was never challenged and was taken as the selling price.

This phenomenon raises two major issues, then. The first is the mode of co-ordination of the actors interacting within a market characterized by the co-existence of a variety of judgement criteria, only partly hierarchical *ex ante*.[49] How was it that this multitude of evaluation criteria did not lead to an intolerable conflict between the parties involved, or, worse still, give rise to such uncertainty as to undermine the very possibility of the existence of a market? The second question is that concerning the justice of the transactions: given the

[48] See the examples given in Barbot, *Le architetture della vita quotidiana*, pp. 226–245.

[49] As highlighted by François Eymard-Duvernay, Olivier Favereau, André Orléan, Robert Salais and Laurent Thévenot, 'Valeurs, coordination et rationalité: trois thèmes mis en relation par l'économie des conventions', in François Eymard-Duvernay (ed.), *L'économie des conventions: méthodes et résultats*, 2 vols (Paris, 2006), vol. 1, pp. 23–44.

high degree of discretion enjoyed by the estimators, how was it that the legitimacy of their valuations was so rarely questioned? We have just mentioned that very few of the architects' assessments were challenged, that is to say, 9.8 per cent of the total. This means that in the vast majority of cases the valuations of these experts became a kind of *communis aestimatio* accepted by all parties involved in the exchange. In order to understand how this phenomenon is possible, we need to examine another mainstay of the valuation procedure: the esteem (in the sense of reputation) of the experts who carried out the valuation. What do we know of the engineers who drew up the 300 assessments examined? First of all, we know that they were the most renowned professionals working in the Milanese area and Lombardy region at that time.[50] As previously mentioned, they all practised their profession within the College of Milan. Since its beginnings in 1563 until the mid-eighteenth century, this guild-like organization gradually became ever more closed and elitist in nature, adopting increasingly severe criteria of selection and co-option.[51] From the beginning of the seventeenth century, to be accepted as a member it was necessary to meet the following requirements: to have completed at least four years of practical experience in the employment of an architect belonging to the College; to be a citizen of Milan; to belong to a family of the so-called 'negative nobility' (namely a family that, for the past 50 years, had not exercised commercial or artisan professions);[52] and finally, to be 'honoured people, born of a good father and a good mother'.[53] The application of these selection criteria, with the reputation of the family playing a central role, helped to create real dynasties of engineers, with the profession being handed down from generation to generation.[54]

As well as inheritance of the profession, an examination of the recruitment area for members of the College also signalled the existence of a close link with another prominent group of city professionals: the notaries. In the sixteenth, seventeenth and eighteenth centuries, between 35 and 50 per cent of the College engineers proved to be, in fact, either the son or the brother of a notary.[55] Both

[50] For their architectural achievements, see Paolo Mezzanotte, 'L'architettura da Francesco Maria Ricchino al Ruggeri', *Storia di Milano*, X (1959): pp. 441–478.

[51] See Giovanni Liva, 'Il Collegio degli ingegneri architetti e agrimensori di Milano', in Bigatti and Canella (eds), *Il Collegio degli Ingegneri e Architetti di Milano*, pp. 9–26.

[52] The 'negative nobility' requirement was introduced in 1658: ASM, Culto, old part, f. 57, *Ordines Novi ingenieriorum et architectorum collegiat. Mediol., nec non et agrimensorum pub. A Senatu excellen. Approbati*.

[53] In fact, it reads like this in a College statute dated 1603: ASM, Amministrazione Fondo di Religione, f. 2100/2.

[54] This transmission occured for even as many as five or six successive generations: see the examples cited by Liva, 'Il Collegio degli ingegneri architetti e agrimensori di Milano'.

[55] See Francesca Giardino, 'Gli ingegneri a Milano in età teresiana e giuseppina: strategie familiari, estrazioni sociali, patrimoni', in Bigatti and Canella (eds), *Il Collegio degli Ingegneri e Architetti di Milano*, pp. 27–82 (especially pp. 70–72).

these professions were regarded as 'property-related civil occupations'[56] belonging to a professional aristocracy closer to the patriciate than to the bourgeois world of commerce and business.[57] The contiguity of the two professions explained the engineers' great familiarity with legal issues. What is more, it strengthened their role as connectors between worlds of different people and stressed the eclectic nature of their skills. One of the characteristic features of the members of the College was, in fact, their multiple activities. In early modern Milan and the Lombardy region, they were to be found performing engineering, plumbing, surveying and architecture tasks simultaneously. They worked in the countryside as well as in the city, designed cathedrals and palaces, repaired roads and built bridges, determined the value of land and houses and stipulated water rights, settled minor disputes over property rights and oversaw important land register operations.[58] This marked multiplicity of activities made this group a sort of storehouse of non-specialised experience, which, in its turn, strengthened the prestige and authority that the group enjoyed in urban society.

The Localization of Real Estate Value

Although the reputation of both the College and its engineers doubtless played a fundamental role in vouching for the legitimacy of their valuation, nevertheless it was not enough to ensure the co-ordination of the actors on the real estate market. In order to ensure that the experts' assessment was not a cause of conflict, another indispensable element had to be included: the correctness of the empirical procedures employed in the evaluation process. Throughout most of the modern age, the College of Milan encouraged its members to accumulate implicit knowledge, with a clear preference for practice rather than theory.[59] During their four years of apprenticeship, and then throughout their entire career, the engineers were called upon to perform extremely practical tasks

[56] Elena Brambilla, 'Il sistema letterario di Milano: professioni nobili e professioni borghesi dall'età spagnola alle riforme teresiane', in Aldo De Maddalena, Franco Rotelli and Gennaro Barbarisi (eds), *Economia, istituzioni, cultura in Lombardia nell'età di Maria Teresa* (Bologna, 1982), pp. 79–160.

[57] Ibid.

[58] For the role of Milanese architects and surveyors in carrying out the lengthy process of the Lombard land register, begun in the sixteenth century and only completed in 1758, see Michela Barbot, 'Stima, stime ed estimi. La valutazione di beni e persone nella Milano d'Antico Regime', in Guido Alfani and Michela Barbot (eds), *Ricchezza, valore e proprietà in età preindustriale (1450–1800)* (Venice, 2009), pp. 31–41.

[59] Giovanni Liva, 'La formazione professionale degli ingegneri e agrimensori in Lombardia dal '500 al primo decennio dell'800', in *L'immagine interessata. Territorio e cartografia in Lombardia tra Cinque e Ottocento* (Como, 1984), pp. 83–93.

such as taking land measurements, feeling beams, weighing bricks and covering distances. The downside of the materiality of the experts' activities was the local nature of their knowledge, given that the justness of their assessments was based largely on respect for the systems of measurement in use locally where the task was actually performed. This aspect was so important that the College Statutes stated 'know how to measure well' – even before 'know how to draw well' – as the essential condition to practise the profession of engineer or architect.[60] In effect, ability in measuring was so important that all cases in which estimates were challenged concerned accusations that the experts had failed to abide by the measurement systems used in Milan (and therefore there was a lack of correctness in their measurements). In this sense, one can understand better the reason why admittance to the College was reserved exclusively for Milanese citizens: their geographic origin was considered to be not just a guarantee of reputation, but also the best attestation to their knowledge of local monetary and measurement systems.

Towards a New Conventional System

Throughout most of the early modern age, thanks to the architects' reputation on the one hand, and the justness of their procedure on the other, the numerous evaluation criteria succeeded in working in such a way that bitter disputes were avoided. This system, in fact, continued unaltered until the mid-eighteenth century, even though an important change started to appear in the second decade. From this period on, as regards house valuations, the intrinsic value was gradually replaced by rentable value, previously used only for workshops.[61] Certainly this change simplified matters and reduced the estimate criteria, but did not cancel the conventional character of the valuation process. As has been demonstrated in other works,[62] the rentable value, besides the apparent objectivity due to its arithmetical calculation, was also actually the result of conventional mechanisms in which joint consideration of the 'nature of things' and the 'quality of the people' played an important role.[63]

[60] Liva, 'Il Collegio degli ingegneri architetti e agrimensori di Milano'.

[61] In any case, this was a decidedly gradual change; in many house evaluations the two criteria continued to operate side by side: see the example cited by Forni, 'The Negotiations for the Palazzo'.

[62] Barbot, *Le architetture della vita quotidiana*, pp. 230–240.

[63] In particular, among the variables that, in Milan, affected the formulation of the rentable value, there were elements of home comfort such as the presence of toilets, glass windows, cellars and stables, or even elements of social distinction such as the presence of drawing rooms, courtyards and areas for private use. And all these elements strengthened one

Apart from that, what is interesting to note is that the gradual fading out of the criterion of intrinsic value was to be found, in the same period, in other economic sectors too, regarding other professional groups and in other urban areas in Europe.[64] It therefore becomes crucial to get an understanding of this change in convention, which would seem to have been very general. As far as our case study is concerned, it is not yet possible to form a precise hypothesis on the motives behind the engineers' adoption of this change. For the moment we can only note how the disappearance of intrinsic value from property evaluations went hand in hand with other important changes that took place in political, intellectual and legal contexts in the Milan of that period.

In the first place, actually beginning from the second decade of the eighteenth century, the College of Milan underwent a series of radical transformations, which in turn were affected by the changed political climate in the city. The autonomy that the city had enjoyed since medieval times began to be seriously threatened by the reforms that the Habsburgs introduced, bringing in their centralistic policy limiting urban powers, starting with the operations involved in the general land register. The long story of the Austrian land register (1714–1751) had a decisive effect on the fate of the College engineers. From the beginning, the Viennese government engaged them to work on operations concerning the land register, obliging them to abandon their local methods of measurement in favour of a uniform instrument, the 'plane table' (*tavoletta pretoriana*: see Figure 6.1), invented by the German mathematician Johannes Praetorius in the sixteenth century.[65]

The adoption of this instrument, alien to their culture, obliged the engineers of Milan to acquire a series of items of abstract knowledge that clashed with their own traditional empirical and practical training. This process, then, gradually paved the way for the introduction (made official from 1767) of theoretical subjects into the apprenticeship course required by the College.[66] At the same time, the elitist character of this institution weakened in connection with a series of reforms that culminated in the *Regulations* of

another, establishing a close correspondence between the physical features of the buildings and the social characteristics of their occupants (actual or potential): ibid.

[64] See, in particular, Bert De Munck, 'Guilds, Product Quality and Intrinsic Value: Towards a History of Conventions?', *Historical Social Research*, 36/4 (2011): pp. 103–124; and De Munck and Lyna's introduction to this volume.

[65] The *tavoletta pretoriana* was introduced into Italy by the Italian mathematician Marinoni, who worked at the court in Vienna: see Alberto Gabba, 'Strumenti e metodi di rilevamento e di stima usati per il censimento milanese nel sec. XVIII: fonti e formazione', *Annali di Storia Pavese*, 4–5 (1980): pp. 56–73.

[66] Among which were geometry, algebra and hydrostatics: ASM, Amministrazione fondo di religione, cart. 2100/2, 1767, *Raccolta degli ordini e statuti del venerando Collegio de signori ingegneri ed architetti di Milano e degli ordini per gli agrimensori pubblici*.

Figure 6.1 Giuseppe Antonio Alberti, *Istruzioni pratiche per l'Ingegnere civile. Sezione Prima, Tavola I, Tavoletta pretoriana e accessori* (Venezia: Stamperia di Venezia di Pietro Savioni, 1798). Source: http://www.capurromrc.it/ingegnere/primauno.html

1775. These *Regulations* were a crucial turning point for two reasons. On the one hand, they officially put an end to the eclecticism of the College members, setting up distinctly separate courses for architects, engineers, building surveyors and land surveyors, and creating an implicit hierarchy of prestige among them (with a predominance of engineering over architecture, and the latter over surveying).[67] On the other hand, the *Regulations* replaced the criterion for membership based on citizenship and family background with a criterion based on income (that is, the possession of yearly revenues of at least 700 imperial *lire*) and scientific merit.[68] This brought about a radical change in the characteristics and status of the College members, reducing the 'family' aspect of the institute while increasing the weight carried within the College by the new men from the urban bourgeoisie.[69] In parallel with these transformations, an important change occured in the legal context of the real estate market. In notarial contracts from the mid-eighteenth century on, there was a gradual decline in dissociated property, with a consequent increase in the quantity of houses sold in freehold or with short-term rather than long-term leasehold contracts.[70] While the College saw its characteristics altered – and was then abolished in 1796[71] – houses, civic assets which for a long period had been immune from competitive mechanisms, became commodities whose value was primarily measured by their ability to yield revenue. This paved the way for the gradual creation of a capitalist market of urban housing: a market that did not deprive the house of its unique character as goods *sui generis* and did not lessen the conventional nature of its real estate value, but at the same time triggered important changes in these conventions.

[67] Liva, 'Il Collegio degli ingegneri architetti e agrimensori di Milano'.

[68] ASM, Studi parte antica, cart. 150, *Regolamento generale per gli ingegneri nello Stato di Milano*, 1775.

[69] See Giardino, 'Gli ingegneri a Milano'.

[70] First introduced into the contract procedure, this process would be subsequently formalized when the Napoleonic Code was adopted in 1804.

[71] Liva, 'Il Collegio degli ingegneri architetti e agrimensori di Milano'. The city guilds met the same fate: see Luca Mocarelli, 'Le attività manifatturiere a Milano tra continuità dell'apparato corporativo e il suo superamento (1713–1787)', in Guenzi, Massa and Moioli (eds), *Corporazioni e gruppi professionali nell'Italia moderna*.

Chapter 7

Vehicles of Disinterested Pleasure: French Painting and Non-Remunerative Value in the Eighteenth Century*

Tomas Macsotay

Introduction

> It seems a strange whim of history that all those denunciations – trade, not art; compulsion, not freedom; routine, not genius – which the first academicians and their forerunners had poured out over the guilds were now heaped upon academies. For the second time in the history of European art, the artist condemned his ancestors and his native soil in order to obtain full emancipation.[1]

The assumptions behind these terse lines, taken from Nikolaus Pevsner's seminal *Academies of Art Past and Present* (1940), are a good complement to the project outlined in this book's introduction, seeking to conceive of shifts in the thinking about value while resisting the centripetal force of what De Munck and Lyna call historical 'teleologies'. Pevsner fights assumptions revolving around notions of artistic autonomy that emerge in the day-to-day practice of art history, as they do in those strands of historical analysis of material culture analysed by De Munck and Lyna.

As he looked back on the emergence of the autonomous artist, Pevsner felt discomfort at the compulsory, excessive nature of claims for artistic emancipation. The first disruption came along with claims that informed Italian sixteenth-century humanist, theoretical appraisal of fine arts. Here, academies, and in particular the institution that will occupy me today, the Paris *Académie royale de peinture et de sculpture*, played a key role in disparaging a 'servile' practice of painting policed by guild privileges and regulations. The second fracture took

* This chapter was made possible by the generosity of the Henry Moore Foundation. I owe particular debt to my mentor Christian Michel, to whom it is dedicated. In my title he will most likely recognize the pun, via Shaftesbury and Kant, to his own thoughtful article, 'Le goût pour le dessin en France aux XVIIe et XVIIIe siècles: De l'utilisation à l'étude désintéressée', *Revue de l'art*, 143 (2004): pp. 27–34. I also want to thank Bert De Munck, both for inviting me to write this chapter and for his valuable suggestions over the past years.

[1] Nikolaus Pevsner, *Academies of Art Past and Present* (New York, 1974; orig. 1940), p. 204.

place around 1800. Credited with having freed artists, at least symbolically, from the yoke of the state, its demands were truly promethean. Art was now to be amputated from all structural impositions, social as well as political and even economic. Thus, not one, but two ideological fractures had accompanied the surge of the modern outsider-artist. What seems strange even now is that the former rebellion had a clear object and goal – to break the monopoly of guilds and authorize a new artistic persona, taking its principal characteristics from the model of European men of letters and nobility. By comparison, the latter upheaval offered no social anchorage point, just a stance of sheer individualistic defiance that proclaims the work of the artist to be unlike any other brand of human enterprise. Moreover, those attacking the academies had themselves been educated in academies, so that the words of the 1800 'revolution' – inflamed with immaterial entities of art, freedom and genius – were at odds with the position of those who spoke them.

Pevsner's suspended belief in a historical trajectory of continuous emancipation contains a subtle warning against art history's periodizations, questioning their ability to 'speak the truth' about art's evolution.[2] From the time of Jakob Burkchardt (1818–1897), art historians have pursued such trajectories by examining the dramatic change of attitude towards artists in evidence in fifteenth- and sixteenth-century poetry and philosophy. These primary sources proclaim the superiority of painting, sculpture and architecture to mere 'mechanical arts'. Academies of fine arts enter the stage of art history in sixteenth-century Italy, just at the moment that a new genre of the art treatise exposed what it claimed to be the latent nobility of the 'sister arts'. Since the first academic writings were intimately bound up with this mobilization of the language of classical humanism, and as humanist theorists such as Leonardo (1452–1519), Benedetto Varchi (1502/1503–1565) and Giorgio Vasari (1510–1574) were themselves involved in (proto-)academic collectives, it made sense to view academization in Italy as an expression of the first break – the one with a late medieval system of urban guilds. The opposition to 'mechanical' labour was a shared characteristic of academism and humanist art theory, in particular in the so-called paragone, which belittled sculpture for its association with 'ignoble', insular workshops driven by hardened physical labour. The Academies of Florence, Rome and Paris were adamant about bringing artistic practices into

[2] I wish to stress that Pevsner aims to expose a paradox rather than endorse a teleology vindicating modern autonomy. Other writers have, in my view, missed this important point: to them, sixteenth-century liberal ideals arrived, as it were, too soon to find favour in a society entrenched in hierarchic thought. According to this logic, *ancien régime* academies exist in a space of compromise, evincing an unstable image of the artist between courtier and tradesman. See, as an example of this line of argument, Anthony Hughes, '"An Academy for Doing" II: Academies, Status and Power in Early Modern Europe', *The Oxford Art Journal*, 9/2 (1986): pp. 50–62.

conformity with the directives of ancient, classical poetics. They ranked painting according to subject matter, preferring history painting – whose subject matter emerges from a *historia*, a story or account – for its proximity to literary culture and for the demands it made upon the intellectual predispositions of the painter.[3]

For all the evidence of a 'new climate' around 1500, there are some objections to be raised against the idea that what we can observe parallel to the inception of academies is a transformation of the socio-economic world that artistic labourers inhabited. The first indication of this is historiographical. Primary sources have for too long been read in a way that confused rhetorical liberation with modern emancipation. Keith Moxley, Martin Warnke – and in the Low Countries, we could add Hessel Miedema – have scorned this demiurgic art history which is, ideologically speaking, a refuge for Hegelian views of history where '(it was) a kind of self-determination of the Spirit that produced claims of artistic autonomy'.[4]

A commonly held view of the second rupture, around 1800, sees autonomy as a result of art's entry into the bourgeois public sphere. This reading, which supposes that academies are in essence aristocratic institutions ill at ease with the demands of modern, emancipated artists, is in part predicated on a new theoretical calibration of art at the dawn of Romanticism. Famously, in 1790 the *Kritik der Urteilskraft* by Immanuel Kant (1724–1804) provided a philosophical justification of the free, autonomous individual by acknowledging the unique position of art as a domain of selfless aesthetic judgement.[5] By enlisting artists to a new political ideal of personal autonomy, the bourgeois public would have 'freed' the high arts from their prior captivity as tools of aristocratic and religious representation. Recently, John Brewer has alerted us to the role played by mass audiences and commodity culture in bringing about a transformation in the self-

[3] The most informative volume on the impact of art academies on early modern art production is Peter M. Lukehart, *The Accademia Seminars: The Accademia Di San Luca in Rome, c. 1590–1635* (New Haven, 2009). On the subsequent development of the institution, see the encyclopaedic overview in Anton W.A. Boschloo (ed.), *Academies of Art between Renaissance and Romanticism* (The Hague, 1989).

[4] Martin Warnke, *Hofkünstler. Zur Vorgeschichte des Modernen Künstlers* (Hannover, 1985), p. 53; Keith Moxley, 'Art History's Hegelian Unconscious', in Mark A. Cheetam, Michael Ann Holly and Keith Moxey (eds), *The Subjects of Art History: Historical Objects in Contemporary Perspective* (Cambridge, 1998), chapter 2; and Hessel Miedema, 'Kunstschilders, gilde en academie, Over het probleem van de emancipatie van de kunstschilders in de Noordelijke Nederlanden van de 16de en 17de eeuw', *Oud Holland*, 101 (1987): pp. 1–34.

[5] One may point to the origins of the influential critique of Kant as 'bourgeois ideology' in the post-war Marxist thinking of Theodor Adorno. See the recent translation of T.W. Adorno and Max Horkheimer, *Dialectic of Enlightenment*, trans. Edmund Jephcott (Stanford, 2002).

definition of artistic practice, again to the detriment of academies. Eighteenth-century publics increasingly confounded an interest in high art produced in academies with a predilection for tradeable goods (such as prints and lustrous furniture, but also imported Italian paintings and restored antiquities), feeding the expanding transnational trade in cultural objects and informing the material culture of aristocratic estates and country houses. Whilst most artists attended to the constantly shifting preferences of a heterogenous public, some chose a stance that corresponded with the heroic artist of inherited humanist theory, with its transcendental investment in the non-materialistic acquisition of 'glory'. This laid the groundwork for the 1800 'rebellion', which, next to a theoretical breakthrough, represents a symptom of a much slower, structural transformation of the way painting and trade interacted in modernizing European societies.[6]

As some of the revisions of art's transition from heteronomy to autonomy have shown, what lay behind the liberalization of the fine arts was not so much a rupture with the past as a project of hierarchical differentiation. Theorizing and academizing were ways of bringing coherence to a complex, dynamic reality. In the 1980s, after a long period of neglect, the interstitial presence of the academic movement between medieval craft and modern individuality began to be re-examined. In her *Du peintre à l'artiste*, Nathalie Heinich credited the Paris *Académie* with having wrought decisive steps towards the creation of a modern condition of autonomy, thus contradicting the then current belief that academism was much more an impediment to such progress.[7] At the same time, Heinich explored a new way of thinking about autonomy that had nothing of the Hegelian predilection for the emancipated individual and was

[6] Good introductions to the British commercial painter and designer are John Brewer, *The Pleasures of the Imagination: English Culture in the Eighteenth Century* (New York, 1997); idem, '"The Most Polite Age and the Most Vicious": Attitudes towards Culture as a Commodity, 1660–1800', in Ann Bermingham and John Brewer (eds), *The Consumption of Culture 1600–1800* (London, 1995), pp. 1–20; idem, 'Positioning the Market: Art, Goods and Commodities in Early Modern Europe', in Simonetta Cavaciocchi (ed.), *Economia e arte Sec. XIII–XVIII* (Florence, 2002), pp. 139–148. Special mention must be made of Peter De Bolla, who explores the expanding culture of consumerism against the backdrop of a pedestrian and democratic aesthetics. De Bolla is extremely valuable as a guide to the changing horizons of audiences in eighteenth-century Britain, explaining how they navigated the wide availability of public art and culture, both antique and modern. He adopts a slightly outmoded stance on academic theory, which he equates with a strict focus on 'elevated' subject matter, and I will not follow him in this particularly widespread definition of academism. However, he articulates a shifting understanding of the cultural artefact in a way that has informed my own expositions. See Peter De Bolla, *The Education of the Eye: Painting, Landscape, and Architecture in Eighteenth-Century Britain* (Stanford, 2003).

[7] Nathalie Heinich, *Du peintre à l'artiste. Artisans et Académiciens à l'âge classique* (Paris, 1991).

also sceptical of Kantian advocacy of free contemplation of beauty accorded to self-contained works of art. What resulted were stunning conclusions on the seventeenth-century state of 'liberty' of French painting, and in general on the process of gentrification by which artists separated themselves from the sphere of manufacturing. Heinich did not credit humanist theory alone with having wrought this liberalization, but saw another powerful motor for change in the emergence of the art market for paintings. It was by virtue of the removal of altarpieces and decorative canvases from their consecrated spaces of viewing in chapels and palaces, followed by their subsequent trading and collecting, that it became possible to subject them to an 'aesthetic' mode of contemplation. In keeping with this view, the autonomy of art was a result of the collaboration of two different mechanisms of liberalization: on the one hand, the academic insistence on noble habits of unremunerative occupation; and on the other, the renewal of meaning that happened when the artwork is laicized and converted into a commodified *image* – less an object proper encoded with meanings and values for specific communities than an opportunity for 'disinterested pleasure' for the beauty-seeking individual.

The following pages will delve into problems emerging from this somewhat reorganized picture of historical development.[8] Returning to the methodological expositions in this book's introduction, there is good reason to rethink the 'shift' to a modern economic era by allowing for a 'sited' analysis of value, taking note of competing agents and institutions, but also the conflicted definitions of the characteristics of the objects at the interface between interacting historical forces. Painting appears too entrenched between different possible forms of establishing value to allow for a reading in terms of a clean shift to its modern economic condition. If the academic movement does not mark the conclusion of an era of corporate and workshop economies, but existed at its side, then it is necessary to ask how it mediated between trade and the unremunerative investment in art that it proposed. I will discuss the role of the Paris Academy

[8] The co-existence and entanglement of artistic labour and polite experimental culture in the Paris Academy is a subject I have embarked on before. I argue for the notion of the demonstrative and performative 'academic method' in Tomas Macsotay, *The Profession of Sculpture in the Paris Académie* (Oxford, 2014). A fundamental reading, particularly for the relationship between the symbols and languages of Paris aristocratic distinction and the form and labour divisions of the Paris decorative trades market, is Katie Scott, *The Rococo Interior: Decoration and Social Spaces in Early Modern Paris* (New Haven, 1996). Crucial recent studies on the *Académie*'s intellectual culture and the importance of considering non-dogmatic aspects of life in and around the *Académie* are Christian Michel's books, in particular *Le Célèbre Watteau* (Geneva, 2008), *L'Académie royale de Peinture et de Sculpture (1648–1793): La naissance de l'école française* (Geneva, 2012), and, together with Carl Magnusson (eds), *Penser l'art dans la seconde moitié du XVIIIe siècle: théorie, critique, philosophie, histoire* (Rome, 2013).

in perpetuating an anti-corporate stance in an age where inherited hierarchies were losing their validity, but before anything resembling a hegemonic notion of individuality had taken its hold on artistic life. There is a shift in economic practices of painting, but in eighteenth-century Paris the nature of painting was established by a synchronic, not a diachronic, difference between values, so that the Academy's role is one of arbiter.

Towards the end of this chapter, I also want to address Pevsner's difficulty in giving a place to the academic model with regards to the modern self-standing artist. As the present volume tackles complex issues of value indexing and the valorization of objects, there is no escaping this problem of a cultural predilection for the uniqueness of the self, which marks the limits of value because it maintains that art, as culture, is like no other human enterprise.

Vile Artisanship

Let us now turn to the vilification of artisanship, and start by remarking that already in the eighteenth century, the conventional boundaries between the physical artwork and the person of the maker were seen in a new light. How did this come about? A series of three academic lectures delivered in Paris between 1749 and 1750 by the elderly painter Jean-Baptiste Massé (1687–1767) shed some light on this. Massé does not shy away from attacking the craftsman, whereby his target is not so much the artisan's social condition as the mentality that is forged in the mind of the craftsman who does not desire to be, or be turned into, something more socially dignified. In his 1750 lecture, 'On the Need to Establish One's Dispositions', the artisan is cast in a distinctively negative role, as 'vulgar' and full of 'lowly inclinations':

> Ceux, au contraire qui n'ont embrassé l'art que par la volonté de leurs supérieurs, *machinalement ou comme un état mercenaire* dont ils n'estiment les avantages qu'en proportion du bénéfice qu'il procure, n'éprouvent qu'ennui, difficultés et infortunes; *l'appât pernicieux d'un gain présent* étant leur object le plus chéri et ne pouvant jamais par sa modicité dédommager l'homme sans valeur du poids insupportable attaché aux *études faites sans goût*, il ferait infiniment mieux de la quitter et de prendre tout autre parti plus convenable à sa *stupidité*. [My emphasis added][9]

[9] 'Those who, on the contrary, have embraced their art only following the wishes of their superiors, doing so mechanically or in a mercenary state where only the measure of gain that it procures offers them a sense of benefit, will experience nothing but boredom, difficulties and misery; the harmful lure of immediate gain being the object they cherish most, and never able for their lowness to make up for the unbearable man without significance ['valeur du poids'], author of studies done without taste, they should be far better advised to leave [the

In the theme of artistic identity, this dejection of simple craft is an interesting phenomenon, for the simple fact that artisan painters and sculptors who thrived outside of the Louvre no longer behaved as an amorphous class of bakers and joiners, toiling in their sweaty workshops, hidden from the delicate eyes of the educated. The new phenomenon of the Paris luxury trades implied not only that workers trained as artisans could acquire considerable wealth and privilege, but also that it had become a matter of course for them to interact with the educated classes.[10] As demonstrated by Sonenscher in his 1989 *Work and Wages* and Scott in her 1996 *The Rococo Interior*, the Paris luxury tradesman was directly employed by the refined inhabitants of Parisian hotels, receiving commissions from patrons as distant as the courts of Naples, Stockholm and St Petersburg. Measured in the ever growing membership lists of the *Académie de Saint Luc*, the actuality of the Parisian luxury trades hardly called for the harsh adjectives we find in these writings by Royal Academicians when engaged in painting a picture of artisan life.

Massé, attentive to contemporary reality, did not care to revive one of the dichotomies of early modern anti-corporatism – he does not discredit craftsmen for their sweaty manual labour, but neither does he exalt the high-flung subject matter of history painting as the natural domain of theoretical knowledge. In its place, we find a dichotomy that sounds familiar to scholars of the eighteenth-century luxury debates: that between the 'mercenary' tradesmen haunted by 'the poisonous lure of immediate profit' and the now more inconspicuous nobility of the academic painters. Massé's remarks were of a pedagogical nature: they were intended for the young apprentices, most of them still in their teens, who visited the Louvre *école du modèle*. He wanted to make the advantages of drawing school both more specific in the framework of a diversified art market and more adequate as a vehicle for social advancement. He continues by alerting students to personal vocation:

> Ainsi après les épreuves des grands prix qu'il est toujours avantageux de tenter, s'ils ne se sentent pas les sortes de qualités brillantes et nécessaires pour tenir le premier rang dans l'histoire, ils doivent alors sans hésiter choisir, entre tant

career] and to follow some entirely different path better suited to their stupidity.' J.-B. Massé, *Examen qu'il faut faire pour connaître ses dispositions* (1750), Paris, ENSBA Archives, mss 190.

[10] On the pejorative use of *manière* to disparage the practices of trading painters, see Christian Michel, *Charles-Nicolas Cochin et l'art des lumières* (Rome, 1993), pp. 253–291; and idem, 'Manière, Goût, Faire, Style; les mutations du vocabulaire de la critique d'art en France au XVIIIe siècle', in F. Soublin (ed.), *Rhétorique et Discours critique* (Paris, 1989), pp. 153–159. See also Émile Passignat, *La réception du maniérisme dans les théories de l'art en France aux XVIIe et XVIIIe siècles: histoire d'une dévalorisation* (Paris, 2003).

de talents différents que renferme la peinture, celui qui les touche davantage, le cultiver et le regarder comme aussi honorable qu utile quand il est bien rendu.[11]

This is by all means a remarkable text: Massé left students free to try their hands at pastel, to become adroit in portraiture in the Flemish manner or even to resort to animal painting, as had Dutch seventeenth-century landscape painters not so long ago. The central plank of Massé's argument is a double warning: if students should resist the lure of exercising a genre that is not tailored to their personal proclivities (history painting), nor should they follow the artisan into a commercially profitable niche from which they might not be able to escape. Moreover, the recurrence of the image of vile artisanship was kept in check by warnings directed at the students not to overestimate their true potential for greatness. Written by a specialist in the highly skilled disciplines of miniature painting and engraving, 'On the Need to Establish One's Dispositions' moderates the strain to compete, the emulation among drawing school students. Massé reminds students that few will ever win the *prix*. Others must prepare to part ways with that very select company that will be encouraged to pursue a career as history painters. An important implication of such a stance is that the overt goal of the figure drawing school – to create the emulative circumstances adequate for the training of history painters – was no longer regarded as the general advantage had by the numerous young draughtsmen that visited it. Students came to the Academy to learn their inward proclivity to exercise particular techniques and represent particular natural objects.

The challenge, in other words, was to lift up humble 'contentless' painting to social dignity by shedding the mentality of trade. Exactly what kind of artist did Massé have in mind in order to rise to the challenge? More importantly, could this new artist be regarded as autonomous? There are two arguments to contradict the idea that Massé had anything like a self-supporting artist in mind: the first is the nature of space in academic ideas about artistic achievement; the second is the historical role of *amateurs*.

Space of Making and Sociability

Fears that, once artists were no longer tied to the Academy's system of *prix* and constant regulatory supervision by the Academy's professors, they would quickly

[11] 'So if after the tests of the annual contests ['grands prix'], which it is always profitable to engage in, they do not feel the type of brilliant and necessary qualities for obtaining first rank in history painting, they should not hestitate to choose, among so many different talents that exists in the field of painting, that which touches them most, and to cultivate it and regard it as honourable and useful in equal measure, provided it is carried well.' Massé, *Examen*.

deteriorate into entrepreneurial masters were repeatedly expressed throughout the Paris Academy's history. A case in point is the establishment of a French Academy in Rome, where painters and sculptors who had won the *prix* spent anywhere from three to five years in a spacious retreat under the supervision of a painter appointed directly from among members of the Academy by one of the King's ministers, the *Surintendant des Bâtiments*.[12] The purpose of the Italian journey was to introduce painters and sculptors to the daily habits of drawing after great works and inventing works of their own, much in terms of the humanist scholar dividing his time between reading and writing, or of the disciplined grand tourist visiting great monuments and writing elaborate letters to describe them. The idea was to relocate young men of talent in an environment alien to the Parisian workshops. Going abroad was leaving behind national prejudice: young artists were obliged, as it were, to think outside the box. As early as 1665, it was determined in the Academy's *Statuts* that students were to be barred from the dual temptations of leading a dissipated life and bread-winning.[13]

As I remarked earlier, monetary reward was seen by academicians to undermine the quest for dignity and spoil the education of the academic artist. The problem was not just theoretical: in the day-to-day conduct of affairs, artists found that self-perfection usually entailed reclusion from the market, or, if you prefer, the life of the merchant. The sculptor Etienne-Maurice Falconet told his close friend and admirer Diderot how he saw the work of sculptors decay over the course of their lives as independent artists. According to Falconet, sculptors 'need to use models over even longer periods than painters

[12] The French Roman journey has been described extensively: the key study is H. Lapauze, *Histoire de l'Académie de France à Rome I (1666–1801)* (Paris, 1924). For accounts of French artistic practices during the Roman journey, see M. Roland-Michel, *Die französische Zeichnung im 18. Jahrhundert* (Fribourg, 1987), pp. 74–86; and Macsotay, *The Profession of Sculpture*, pp. 147–266.

[13] '(...) l'expérience fait connoistre que la plupart de ceux qui vont à Rome n'en reviennent pas plus sçavants qu'ils y sont allés, ce qui provient de leurs desbauches ou de ce qu'au lieu d'estudier d'après les bonnes choses qui devroient former leur génie, ils s'amusent à travailler pour les uns et pour les autres et perdent absolument leur temps et leur fortune pour un gain de rien qui ne leur fait aucun profit ...': *Statuts et Règlement* (1665), in Jacques Guiffrey (ed.), *Correspondance des Directeurs de l'Académie de France à Rome avec le Surintendant des Bâtiments du roi de 1663 à 1793*, 18 vols (Paris, 1887–1912), vol. I, 10 (Article XI). In a similar vein, the 1737 *Instruction* warns: 'Le Directeur ne permettra et n'employera aucuns des pensionnaires qui montreront quelques talent à faire des tableaux de vierges et de saints pour des églises ou des particuliers, à dessein d'en retirer rétribution ou d'orner les apartemens du palais de l'Académie; toutes productions de ceux qui sont à la pension du Roy doivent appartenir à S.M., et il n'en doit disposer que suivant l'ordre qu'il recevra de nous, sur le compte qu'il nous en rendra': Guiffrey, *Correspondance des Directeurs*, vol. IX, 316.

and, whether due to laziness, avarice, or poverty, the greater number dispense with them after their forty-fifth year'. Those who do dispense with nude models lose the 'vigor of expression', the 'grandeur' and 'nobility' that Diderot admired in 'these works produced by the hands of youths between nineteen and twenty years old' – works judged by artists who were themselves no longer in possession of such elevated vision.[14] Massé, Diderot, Falconet and other artists and critics conversant in academic principles claimed to perceive these elusive marks of nobility in a piece of painting or sculpture with utmost precision. To them, knowing the work meant knowing the man behind the work in a social, intellectual and moral dimension. The centrality of psychological terms like *goût*, *génie*, *perfection*, *sentiment* and *enthousiasme*, but also *médiocrité* and *stupidité* (to include abusive jargon), in the Paris academic vocabulary reflects the fact that the mark of quality was seen to arise from features that continued to be named after properties of the mind. Diderot was expanding on this capacity for metonymic displacement when he wrote that 'la *manière* est dans les beaux arts, ce que l'hypocrisie est dans les mœurs'.[15]

Christian Michel and other scholars have demonstrated that the Paris Academy was far from discharging practical life from its discourse. On the contrary, it devoted ever more of its time to examining procedural problems. Proponents of *coloris* moved towards a more comprehensive image of the elusive qualities of paint to forge, in the theories of Roger De Piles, a belief in the power of painting that can be seen to operate entirely on the level of pictorial (and sculptural) surface.[16] The Academy set the rules of engagement for a more material conception of artistic practice by formulating a cluster of semi-material notions that continued to establish correspondences between traces of craft and mental activity. Anne-Claude-Philippe de Tubières, Comte de Caylus coined the wonderful expression *opérations de la main et de l'esprit* to account for the sense of inspecting a crafted object whose surfaces bear testimony to the vital, embodied technique of its production. We are back to the problem of distinguishing the 'mercenaire' (hireling) from the 'habile peintre' (capable painter). If we can no longer tell the nobility of a painter by concentrating on subject matter, then marks of quality appear in criticism, in examining the relationship of the painter to the practice of painting *itself*.

[14] John Goodman and Thomas Crow, *Diderot on Art, Volume I: The Salon of 1765 and Notes on Painting* (New Haven, 1995), p. 162.

[15] 'the manner in fine arts, like hypocrisy in costumes'. See 'Du naïf et de la flatterie' in Diderot's 'Pensées détachées sur la peinture'. I am quoting from Robert Ganzo, *Diderot, Traité du Beau et autres essais* (Verviers, 1973), p. 180.

[16] Roger De Piles is best known for his *Cours de Peinture par Principes* (Paris, 1708). De Piles has received sustained attention for his defence of *coloris*. See, above all, Jacqueline Lichtenstein, *The Eloquence of Color: Rhetoric and Painting in the French Classical Age*, trans. Emily McVarish (Berkeley, Los Angeles, 1993; orig. Paris, 1989).

One can use this important shift towards applying discipline on the painters, rather than on their subject matter, to explain some of the discontinuities in the Paris Academy's theoretic output. In its early and most productive stage, before about 1680, academic theory was dedicated to the analysis of famous works: classical statues and Renaissance and baroque painting. The repertory consisted, without exception, of difficult and complex subject matter, and therefore of the problems of pictorial technique in dealing with *historia*. The object-anchored 'explanation' of specific works all but ceased to be composed after 1700. Later developments, particularly after 1720, saw a marked increase in the pragmatic-biographical exposition. Some of these lectures had titles like 'On the Advantages of the Virtues of Society'. Others were accounts of specific artists' lives, paying special attention to the circumstances of training in familial workshops, the cities where they worked, the men's 'manners' (we suddenly see a preoccupation with questions such as: did Watteau drink too much? Did the sculptor Simon Guillain fancy himself a soldier and sway his swords excessively? Did the painter François De Troy creep into bed with his benefactor's wife?) and, crucially, whether bad living habits or personal weaknesses had consumed an artist's capacity to bring his talents to full fruition. There are different ways to interpret the shift towards morality-tainted life stories of French masters, few of them canonic names, most of them forerunners or middle-range members of the Academy. One is that new generations of academicians had grown sceptical towards the academic society's capacity to manage artistic quality – a more positive attitude to progress had certainly driven the artefact-specific discourses in the early years of the Academy. A second possibility is that academic theory was no longer a source of principles for its active members, and that the biographies would at least teach lessons to young, impressionable drawing students. However, whether it sprang from a disbelief that academicians would care for 'rules' that had no bearing on patrons' tastes, or whether it had to do with Massé's desire to see the ennobling of students even when they chose lower genres, there is a strong case to be made for reading these new discourses as a new academic project about personal discipline. In this reading, academicians forsook statements of doctrine: the point was instead to touch, through vivid tale and verifiable experience, the real souls and active spaces of great men of genius.

Unlike in seventeenth-century rules, metaphysical pathways to the 'ideal' art, tools and technique appeared as a truly universal force inside the studio, equal for all talents. Academicians of many callings in Paris assumed a positivist, empirical attitude that looked at how artists actually co-inhabited their tools and understood their peers and models. As Roger Hahn pointed out in his eloquent study of the Paris *Académie des sciences*, academicians began to step back from practice, thinking of themselves as a tribunal, the better to

guide practice.[17] Tribunal activity was less guided by absolute thresholds – the guild's certificates and trademarks – than by continuous efforts at translation, which had to bring to the fore an inherent merit, and make comprehensible a mute knowledge of inventions, tools and techniques. Academicians embraced practical truths, the better to bring the incommensurable values of different practices and talents for painting under a common denominator. Possibly, this was the only way to save the belief in theoretic 'principles' of art and science, without which there was little justification for the body of the Academy to continue to exist.

Academic excellence pended on a strategic retreat into a new space: a space more socially exposed than the studio's self-enclosure inside labour and monetary reward. The Paris Academy began to pursue a reflexion on the studio environment around 1740 and by far the most sophisticated contribution is that of a brilliant non-practising member, the antiquarian Comte de Caylus.[18] The chronology overlaps not just with the expansion of the Paris luxury trades, but also with developments in learned bodies elsewhere, such as the new, anti-dynastic assessment of 'expertise' in distant Milan's College of Engineers, as Michela Barbot demonstrates. Like other academicians, Caylus cast a suspicious eye on the studio as the controlled environment of the trading master. Painters seldom separated the functions of production and display, indiscriminately using their 'laboratory', where they were immersed in the 'perfection' of the art form, as an advertising shop-front to woo commissioners and lead the public along. Caylus found no solace in the formal opportunities for academic arbitrage, as he observed that artists were prone to jealousy and expressed dishonest opinions on their peers' work. Crushing the philistine spirit of the entrepreneur was, as far as Caylus was concerned, going to depend on the measure by which artists perfected themselves as *social* beings.

Drawing on a Ciceronian model of intellectual friendship with a long ancestry in humanist literature, Caylus hoped to resolve the studio-laboratory conundrum by invoking the aid of an ideal of sociability carried on in the form of an amicable conversation between gentlemen and artists about the means and goals of art-making. As we can read in Charlotte Guichard's recent study on Parisian *ancien régime amateurs*, the person of the unimposing artist-friend, for which Caylus himself attempted to become a model, was art history's first

[17] Roger Hahn, *The Anatomy of a Scientific Institution: The Paris Academy of Sciences, 1666–1803* (London, 1971), especially his remarks on the first statutes from 1699 on pages 19–34.

[18] On Caylus, see Joachim Rees, *Die Kultur des Amateurs. Studien zu leben und Werk von Anne Claude Philippe de Thubières, Comte de Caylus (1692–1765)* (Weimar, 2007); and Nicholas Cronk and K. Peeters (eds), *Le comte de Caylus. Les Arts et les Lettres. Actes du colloque international Oxford* (Amsterdam and New York, 2004).

(and by no means last) middleman between artist and public.[19] In Paris, the new sociability was such a success that painters and sculptors greedily vacated their working spaces in order to join poets, intellectuals and the new financial elites attending the fashionable weekly literary Salons. Many Salons were simply habitual occasions for dinner and polite conversation. They were also, at times, performative spaces, where participants engaged in displays of improvisational bravura or stood by to watch a fellow diner compose and recite bawdy poems, sketch pithy caricatures or perform a series of actors' postures and expressions. It was in these polite excesses that we can find the antecedents of nineteenth-century bohemian banquet, where self-declared social misfits engaged in a sociability marked by utopian dreaming, eccentricity and casual hedonism.[20]

The Disinterested Artist-Friend

Caylus wrote about the *amateur* in terms of a practitioner whose abilities are insufficient for the production of work of any value.[21] The key to his relationship to the painter consists in the fact that, in it, procedural knowledge is made explicit without allegiance to a hierarchy of 'intellect' over 'technique'. The *amateur*, who has taken up the practice of drawing and painting, is consecrated the moment he becomes aware of his own technical shortcomings: in his conversations with the artist, he has a sublimated sense of the skills required to make a successful painting. It is clear from Caylus' assessment that the type of man he had in mind outgrew the seventeenth-century *dilettante*. At stake was not just the translation of elite expectations to the painter, but also, in the inverse direction, the representation of the nature of painterly practice to ignorant commissioners. The goal was to obtain an impartial, encouraging conversation with academic artists about their work, in ways that are beyond the scope of jealous, sectarian and competitive fellow artists. The *amateur* thus comes to

[19] See Charlotte Guichard, *Les amateurs d'Art à Paris au XVIIIe siècle* (Seyssel, 2008).

[20] On the polite Paris Salon, see Jacqueline Hellegouarc'h, *L'Esprit de Société. Cercles et 'Salons' Parisiens au XVIIIe siècle* (Paris, 2000). The impact of Salon life on literary production is the subject of Elena Russo, *Styles of Enlightenment: Taste, Politics and Authorship in Eighteenth-Century France* (Baltimore, 2008). Artistic bohemia is generally associated with Romanticism, but there have been attempts to show its origins in the Enlightenment circles of literary figures, adventurers and fine artists. See, for instance, George Levitine, *The Barbu Rebellion: The Dawn of Bohemianism and Primitivism in Neo-Classical France* (New York, 1982), and more recently Ann Bermingham, *Learning to Draw: Studies in the Cultural History of a Polite and Useful Art* (New Haven, 2000) on the British 'practical dilettanti' and the use of drawing as a practice of polite sociability.

[21] Caylus, 'De l'amateur', in André Fontaine (ed.), *Vies d'Artistes du XVIIIe siècle* (Paris, 1910), pp. 119–129.

impersonate the autonomous artist that the eighteenth-century painter cannot dream to become. It is for this reason that their balanced assessments are valuable to the artist, in ways that the opinions omitted by the public at large, and by the commissioning party in particular, are not. The sociability between *amateurs* and painters thus emerges as a new means to retain distinctions between trade and art as autonomous activity. It does so, however, without recourse to our 'modern' belief in individuality.

A clue to understanding the new identity procured for painters by friendships is provided by a fascinating article by Svetlana Alpers on approximations of painters' studios to sites of epistemological investigation. Alpers suggests that the changing nature of the studio between the seventeenth and nineteenth centuries was in part determined by the ambition on the part of painters to mirror varieties of spaces devoted to empiricism and experimentation. While in the seventeenth century painters used the interior space as a 'lightbox', an enclosed space which, fitted with 'real' things seen in enclosed space and set in a well-controlled light, was made to anticipate the overall space of perspectivistic painted image, later practices displayed an increasingly experimental use of space where it was the work-in-progress, rather than a natural object represented, that furnished an object of study. This shift had great repercussions for the position of the audience which, from a seduced, deceived observer, is introduced into the problems of technique. Since in this instrumentalized studio individual works are seen in the process of their production, they can become a rich source for new observations, even before the artist completes them. Technique became an object of expert interest, rather than a reproductive method or lifeless tool.[22] All of this upsets modernist art histories, which have tended to see private sketching and its growing critical acclaim towards the end of the eighteenth century as a sign that artistic production was beginning to resist societal intervention as alien to pure art-making.[23] It seems appropriate to challenge this interpretation with one that underscores that showing technique implied presuppositions of some sort about the audience's capacity for perceiving the import of gesture such as we find in 'unfinished' canvases and preliminary studies.

To understand the role of French *amateurs* in the transition from the vilified artisan to the seemingly modern position of relentless autonomy, one should consider, among other factors, the importance of gift-giving. French *amateurs* stood in the tradition of the Italian baroque collector, acquiring many works as personal gifts from artists in exchange for access to their networks

[22] Svetlana Alpers, 'The View from the Studio', in M.J. Jacob (ed.), *The Studio Reader: On the Space of Artists* (Chicago, 2010), pp. 126–149. For the early modern development of the studio, see Michael Cole and M. Pardo, *Inventions of the Studio: Renaissance to Romanticism* (Chapel Hill and London, 2005).

[23] See, for instance, Alfrend Boime, *The Academy and French Painting in the Nineteenth Century* (London, 1971).

of noblemen and financial elites. The influence of collectors and *amateurs* in Paris was both sought after and feared, as they could play crucial roles in the choice of artists for royal decorative projects. Drawings and models were ideally fit for establishing the basic terms for a lifelong relationship to an art-loving nobleman. One may be reminded of someone like Antoine Watteau or indeed Edmé Bouchardon, Parisian artists who became noted for their reluctance to settle for large commissions and their preference for 'purposeless' drawing and sketching.[24] Unlike the heavier, more context-bound pictorial, sculptural and decorative projects, lighter fare – designs, drawings, sketches and maquettes – passed from workshop to Salon and on to the collector's cabinet, traversing a public forum and being evaluated by actors entirely divorced from the system of patronage. Mariette recalled in his *Abécédario* that Bouchardon had made a habit of giving his drawings away, and that with the passage of time they had become so desired that they were turning out to be literally worth their weight in gold.[25] In this respect, Mariette's friendship with Bouchardon could be seen in terms of Bourdieu's analysis of distinguished publishing houses, which hide their highly profitable business plan behind a mask of disinterested devotion to literary classics and great authors' *oeuvres*.[26] The loose leafs and models received by the *ancien régime* collectors as gifts from their artist friends may appear to be acquired in a spirit of disinterested aesthetic self-indulgence, were it not that these works could yet become cherished items sold at high auction prices once the makers enjoyed established reputations. Moreover, there was money to be made from engraving Bouchardon's drawings. The Mariette–Bouchardon friendship reveals that the predilection for *oeuvres* above monumental works can be explained by means of Caylus' model of artistic sociability rather than a modern ideal of individuality.[27]

[24] Antoine Watteau is the more famous of the two, although in the eighteenth century admiration for Bouchardon, particularly among collectors, was unrivalled. An insightful contribution on Watteau's appeal to the *dilettante* is Michel, *Le Célèbre Watteau*. Bouchardon's relationship to Caylus via the activity of writing and drawing was the subject of a long chapter in Rees' excellent *Die Kultur des Amateurs*. On Bouchardon as a draughtsman, see also K.T. Parker, 'Bouchardon's "Cries of Paris"', *Old Master Drawings*, 5 (1930): pp. 45–48; Marc Jordan, 'Edmé Bouchardon: A Sculptor, Draughtsman and his Reputation in Eighteenth-Century France', *Apollo*, 121 (1985): pp. 388–394; and Katie Scott, 'Edme Bouchardon's "Cris de Paris": Crying Food in Early Modern Paris', *Word and Image*, 29/1 (2013): pp. 69–89.

[25] Pierre-Jean Mariette, *Abécédario de Pierre-Jean Mariette et autres notes inédites de cet amateur sur les arts et les artistes*, ed. Antoine De Montaiglon (Paris, 1851–1860), vol. I, p. 164.

[26] See Frank De Glas, 'Authors' *Oeuvres* as the Backbone of Publishers' Lists: Studying the Literary Publishing House after Bourdieu', *Poetics*, 25/6 (June 1998): pp. 379–397.

[27] On Mariette, see Kristel Smentek, 'The Collector's Cut: Why Pierre-Jean Mariette Tore Up his Drawings and Put Them Back Together Again', *Master Drawings*, 46/1 (2008):

It is important to note that the activity of collecting was not impervious to trade – it depended, by and large, on the measure by which artworks had lost their role as topographic markers and become tradable goods. Along these lines, Geneviève Warwick has insisted on the radical nature of collecting as a compromise between two seemingly incompatible audience positions: a disinterested love for the arts and a desire for personal possession, arising from the logics of trade. Discussing Sebastiano Resta, one of the best documented collectors of old master drawings in the late early modern period, Warwick argues that the specialized collecting of drawings, not unlike the serial production of engravings, presupposed the waning of an eye-to-eye personal relationship between masters and patrons. The ways in which artworks changed hands were quickly shifting, subject to the pressures of a transnational network of collectors that was draining Italy of important works of art.[28] While northern collectors and their agents purchased artworks wholesale and in large amounts (quantity in this case representing the investor's perspicuity), Resta acted by a principle of concentration, combining drawings into larger, instructive image sequences. To make up for a waning topography of autograph paintings, Resta composed informative albums of designs. He visited artists' studios, placed his drawings in carefully composed volumes and amended these with notes reporting information collected verbally from other artists, scholars and witnesses. Then the annotated albums containing *oeuvres* of important masters themselves entered a nexus of noble habits of scrutiny and sociability. They were shown and offered, as gifts, to friends and the powerful. In this way, connoisseurial care for the object, a care that proclaimed itself in good humanist tradition as free of personal gain, managed to reframe the commercial transaction of paintings, paradoxically derailing the process by which the market reduced autographs to commodified goods.

Well before Resta, Bouchardon and the Caylus artist-friend, the seventeenth-century French painter Nicolas Poussin had circumscribed his practice by a closed circuit of relationships, exposing his pictures to interconnected activities of designing, inviting comments from collectors and using these exchanges to fuel further ruminations on the nature of painting. Poussin worked for most of his life in Rome, where he created for himself a position of relative autonomy, keeping his distance from both the Parisian machinery of royal representation and the Roman art market. The collectors who obtained paintings by Poussin established a relationship with the painter

pp. 36–60; Krzysztof Pomian, 'Mariette et Winckelmann', *Revue germanique internationale*, 13 (2000): pp. 7–38.

[28] See Geneviève Warwick, *The Arts of Collecting: Padre Sebastiano Resta and the Market for Drawings in Early Modern Europe* (Cambridge, 1985); and Krzysztof Pomian, *Collectionneurs, amateurs et curieux. Paris, Venise: XVIe–XVIIIe siècle* (Paris, 1987).

defined by codes of friendship, personal protection and gift exchanges. By the very nature of the understanding existing between Poussin and his select audience, the paintings looked humble and simple, much like other portable easel paintings produced for a more 'superficial' audience in the growing market. One of the marks of Poussin's fame is that, from the beginning, it was articulated in a highly self-critical practice, which earned the painter the epithet *peintre philosophe*. Poussin underscored this in his use of stratified and enigmatic elements of landscape, his scattered figures, his petrified architectural settings and frozen gestures, to complicate the perception, on the part of the beholder, of subject matter. Even to modern observers, Poussin seems to open up the space for a demanding lecture of images, creating with his balanced compositions a type of visual enigma to be unravelled only by the initiated.[29] Charles Dempsey and Elizabeth Cropper have taken the provocative position of crediting Poussin with having invented the 'tableau' as an object with separate status from the simple painted image. A 'tableau' was a self-conscious translation of principles of poetics to painting. Unlike the commissioned painting, the 'tableau' consecrated a *personal* bond, sealed by a shared love for painting, between the maker and the beholder.[30] Poussin, a painter who declined to return to Paris to head the faction of artists launching France's first fine arts academy, provided an instance of a painting already positioned as the reverse of trade.

Diderot, as is well known, loved the dense atmosphere provided by Chardin's still lifes and Vernet's landscapes. Still, his confrontation with these paintings is unlikely to have been a solitary one. Diderot was keen on visiting the Salons in the company of artists, above all academicians, with whom he carried on conversations that inform his written accounts. There is little that connects such a practice of viewing with the individualized parcours that the modern museum environment has in store for today's audiences. The aptitude for amicable dialogue is a complement to a number of the emerging forms of eighteenth-century image production. The mid-eighteenth century, for instance, sealed the success of a serially produced form: the high-quality reproductive engraving which, in the hands of a German migrant artist like Johann Georg Wille, reached its commercial and critical apogee. As Stephen Bann has shown, much of Wille's popularity sprang from the subtle waves and clean patterns of his engraved lines, creating an interpretative distance between the original picture

[29] The unresolved tensions in Poussin's paintings are discussed at length by post-structural and neo-Marxist art historians. See Louis Marin, *Sublime Poussin* (Seuil, 1998); and the fascinating materialist and 'experimental' account in T.J. Clark, *The Sight of Death* (New Haven, 2005).

[30] Elizabeth Cropper and Charles Dempsey, *Nicolas Poussin: Friendship and the Love of Painting* (Princeton, 1996).

and its reproductive image.[31] Engravings like Wille's appear as the opposite of the sketch: one will look in vain for the characteristic traits of the romantic, self-standing individual. Rather, they organize the field of painting according to criteria that sit well with the image's new condition of having lost a locality: produced for the market, they nevertheless harbour a polite commerce between refined eyes that double, then go on to dismiss the entrepreneurial.

Epilogue

At the end of the *ancien régime*, anti-corporate ideology derailed from its original purpose, arming the opponents of academies against academic institutions, perhaps even the way of life of academicians. This course of events has no doubt muddled our reading of academies, which became degraded to 'yet another' system of control, putting the artists in shackles. I have wanted to offer a critique of this narrative by revising the role of the artist, so central to Pevsner's book. For all of Pevsner's exposure of a double bind, his study of academies saw anti-corporatism as the inexact expression of a more abstract, spiritual entity, full-fledged individualism. I think recent scholarship allows for a different reading. According to this reading, the identity of the artist was given its contours by the very nature of the relationship of the painter to the practice of painting as an abstract entity – it was created under specific circumstances in the studio and deposited its marks on the works that left it.

I have argued that the eighteenth-century French fine arts Academy tailored a new image of a fine arts practice, not by playing on hierarchies of the mental and manual, the theoretical and the 'mechanical', but by a series of devices that implied a community of viewers, connecting empiricism and deliberation, inspection and introspection. To the punitive prohibitions of guilds, the Academy opposed a social discipline that was to make academic artists stand out from and resist the lure of commodity trading in eighteenth-century Paris. Although rivalling the entrepreneur and luxury manufacturer gave painters some measure of notional autonomy, this was true less by virtue of claims to individuality than through their ability to activate a new dichotomy that contrasted types of spaces and social exchanges. One can see this polite era anti-corporatism deriding not the sweaty labour, but the false polish and penny-pinching morale of work in the promontory domain of a trading master's shop. Academic discourse exalted the worthiness, the public *importance*, of a series of exceptional, restricted spaces and social conditions, not incompatible with those of market-driven practices, yet of a type that is

[31] Stephen Bann, *Parallel Lines: Printmakers, Painters and Photographers in Nineteenth-Century France* (New Haven, 2001).

more adequate to the concerns of an experiential subject. Such a shift, I have argued, depended on a subtle transformation in the status of the artwork.

There remains much to be done to bring to light the mechanisms for attributing value to individual artists, as well as particular groups of *objets d'art*, in the sphere of the Paris Academy. As this work is carried on, the challenge may consist in taking at face value Pevsner's apprehensions towards histories of emancipation. In the complex languages of the Paris Academy, the autonomous artist is as much of a 'useful' fiction as the vile artisan.

Chapter 8

Usefulness, Ornamental Function and Novelty: Debates on Quality in Button and Buckle Manufacturing in Northern Italy (Eighteenth to Nineteenth Centuries)

Barbara Bettoni

Introduction

During the eighteenth century, metal objects for domestic and personal use played a special role in the European novelty market. The advances in techniques for working metal alloys, improvement of design and inventive abilities of the artisans all contributed to the establishment of these products as 'fashionable' items for the decoration of houses and people. By making small variations in the products and in the techniques for working materials which could now imitate precious ones, European entrepreneurs in the sectors of fancy goods, utensils and small metal objects for personal use proposed a range of items which were able to satisfy vanity and the craving for novelty products among men and women from different social classes.[1]

[1] On metal things and their role in the European novelty market during the eighteenth century, see Maxine Berg, 'New Commodities, Luxuries and their Consumers in Eighteenth-Century England', in Maxine Berg and Helen Clifford (eds), *Consumer and Luxury: Consumer Culture in Europe 1650–1850* (Manchester and New York, 1999), pp. 73–85; idem, *Luxury and Pleasure in Eighteenth-Century Britain* (Oxford, 2005), pp. 154–192; Helen Clifford, 'A Commerce with Things: The Value of Precious Metalwork in Early Modern England', in Berg and Clifford (eds), *Consumer and Luxury*, pp. 147–167; and Neil McKendrick, John Brewer and J.H. Plumb, *The Birth of a Consumer Society: The Commercialization of Eighteenth Century England* (London, 1982), pp. 68–73. Particularly on locating novel goods in domestic spaces, see Amy Barnett, 'In with the New: Novel Goods in Domestic Provincial England, c. 1700– 1790', in Bruno Blondé, Natacha Coquery, John Stobart and Ilja Van Damme (eds), *Fashioning Old and New: Changing Consumer Patterns in Western Europe (1650–1900)* (Turnhout, 2009), pp. 81–94.

Recent literature on the birth of a consumer society in the West has included this typology of objects, in eighteenth-century discourses called 'toys',[2] in the wider sector of 'new luxury items'. 'Old luxury objects', which were made using materials with a high intrinsic value (gold, silver, precious stones), were distinguished by their exclusivity, luxury, excess and the fact that they could be shared only in elitist environments, like the courts. 'New luxury items' were characterized by their functionality, comfort, decorative value, variety, elegance, taste, affordability and the strongly innovative material content. Metal alloys could look very similar to precious metals in brightness and colour, depending on the treatment they underwent, but they had the advantage of being more practical, flexible and easier to handle.[3]

Studies on the success of 'new luxury items' on the European market have led to the observation that this gradual, complex process had been accompanied by a new way of perceiving the value of things. Products were now beginning to be appreciated, on the consumption side, not just because of their intrinsic value and the quality of the materials used, but also thanks to their fine design, the enjoyment in their use, visibility, novelty and the fact that they could be replaced easily. On the production side, this passage was accompanied by the gradual definition of new values and who to turn to when the product had to undergo quality checks.[4]

In the case of 'old luxury objects', attention was mainly given to the purity of materials. The value of a precious object was strongly determined by its intrinsic value. This tendency was particularly heightened in goldsmiths' and jewellers' guilds. These craftsmen were authorized to work metals, like gold and silver, which played a very special role in an economic and political climate that was heavily conditioned by the mercantilist ideology. Quality control tended to appear as an 'ex-ante' evaluation of the product and this took place inside the guild system. Consequently the consumer was excluded from this process, because he usually had the possibility of choosing the object in a later and different selling and buying phase. The good quality of an object depended on the purity of its ingredients and also on the fact that it had been made according to the rules set out by the guild system. These rules stated which craftsmen were authorized to create certain products and use certain materials. Apprenticeship had a formative value, but at the same time it was used to identify who would

[2] The word 'toy' referred not only to children's playthings or games, but also, and more generally, to fashionable luxury or semi-luxury items; see Ariane Fennetaux, 'Toying with Novelty: Toys, Consumption and Novelty in Eighteenth-Century Britain', in Blondé, Coquery, Stobart and Van Damme (eds), *Fashioning Old and New*, pp. 17–28.

[3] For a definition of the concepts of 'old luxury' and 'new luxury', see Jan De Vries, *The Industrious Revolution: Consumer Behavior and the Household Economy, 1650 to the Present* (New York, 2008), pp. 40–70.

[4] On this theme, see Berg, *Luxury and Pleasure*, pp. 154–192.

receive the privileges of the craft and who would be excluded from the guild. Contributing to the identification of places and instruments through which both product quality and value could be established, guild rules also gave indications about the tools to be used and the characteristics of the premises where the craft was to be practised (dimensions, location, placement of signs). Through the use of hallmarks, which were functional for communicating both the intrinsic value of the item and the honesty of the producer, guilds sanctioned the moral and political superiority of their members with respect to non-guild artisans.[5]

In the case of 'new luxury items', the moment of product evaluation was deferred to a phase which was closer to the actual sale (and to its display) than to production. Checks were directed at observing the ways in which the product had been worked, shaped, designed and decorated, rather than at the purity of ingredients. Various subjects (not necessarily members of the guild) could be interested in the production of 'new luxury objects'. They were selected on the basis of their ability to make an innovative contribution to the productive process, especially through their drawing and designing skills, creative talent and good taste.[6] Consumers were invited to take into consideration the characteristics of new products thanks to the intermediation of sellers. Product catalogues, fashion magazines and shop windows showed the quality of articles for sale, suggested their possible uses, created a buying atmosphere and raised the expectation of the latest novelties offered on the market.[7]

Changes in taste and function affecting clothing and its accessories in the European panorama, which led consumers towards new forms of luxury (scaled down, but more comfortable), were also seen in many cities on the Italian peninsula.[8] In this context the transformation that occurred in lifestyles and

[5] On the shift from intrinsic value to design and decoration as important ingredients of product quality, see Bert De Munck, 'Guilds, Product Quality and Intrinsic Value: Towards a History of Conventions?', *Historical Social Research*, 36/4 (2011): pp. 103–124; and idem, 'Skill, Trust, and Changing Consumer Preferences: The Decline of Antwerp's Craft Guilds from the Perspective of the Product Market, c. 1500–c. 1800', *International Review of Social History*, 53 (2008): pp. 197–233. On apprenticeship requirements understood from the perspective of 'distributional conflicts', see idem, 'Gilding Golden Ages: Perspectives from Early Modern Antwerp on the Guild Debate, c. 1450–c. 1650', *European Review of Economic History*, 15 (2011): pp. 221–253.

[6] Ibid.

[7] On quality controls, marketing and advertising referring to metal items, see Berg, *Luxury and Pleasure*, particularly pp. 179–192.

[8] On the diffusion of comfort and new forms of luxury among Italian people belonging not only to the aristocracy during the seventeenth and eighteenth centuries, see Paolo Malanima, *Il lusso dei contadini. Consumi e industrie nelle campagne toscane del Sei e Settecento* (Bologna, 1990); Renata Ago, *Il gusto delle cose* (Rome, 2006); and Barbara Bettoni, *I beni dell'agiatezza. Stili di vita nelle famiglie bresciane dell'età moderna* (Milan, 2005).

consumer patterns was the result of a long process, which started during the Renaissance under the influence of the court milieu, and gradually became more accentuated and similar to the European taste during the seventeenth and eighteenth centuries.[9] Recent studies on guild institutions in Italy have taken into consideration the modalities through which professional groups operating in the territory of the peninsula met the new needs that markets were expressing. The reconstructions of the varied, even fragmented, panorama of guild institutions in Italy have led to a re-evaluation of the role they had in various regional contexts regarding sensitivity and openness to innovation.[10] The immobility and rigidity concerning innovation, traditionally attributed to guilds, have been re-evaluated by more recent studies.[11] They have affirmed that some guilds, especially the ones whose business was the production of luxury items (textiles, clothing, metal-working), played a clear role in the definition of the quality standard of products, in the transmission of know-how and in the elaboration of innovative production processes. In such a context, apprenticeship guaranteed a high degree of technical innovation: it had actually been conceived for the production of luxury objects where the purity of materials was enhanced through the use of manual and creative skills. Some studies have furthermore underlined how the apparent rigidity of the Italian guild system had been mitigated and made more flexible by the patent system and the granting of privileges. The latter were operative inside the same institutional frame and were regulated by local government authorities, who were put under pressure by craftsmen, merchants and entrepreneurs with different interests.[12]

This chapter deals with buckle and button manufacture in Italy in the eighteenth and the beginning of the nineteenth centuries. As mentioned above, in the Italian context, the gradual transformation in lifestyles, consumer practices and, consequently, ways of dressing had deep roots. However, the

[9] On the deep roots of the phenomenon that we define as 'consumerism', in particular with respect to the Italian panorama which was conditioned by the presence of court circles in the urban context, see Richard A. Goldthwaite, *Ricchezza e domanda nel mercato dell'arte in Italia dal Trecento al Seicento*, trans. Maria Colombo (Milan, 1995).

[10] See the issues contained in Alberto Guenzi, Paola Massa and Angelo Moioli (eds), *Corporazioni e gruppi professionali nell'Italia Moderna* (Milan, 1999); and Paola Massa and Angelo Moioli (eds), *Dalla corporazione al mutuo soccorso. Organizzazione e tutela del lavoro tra XVI e XX secolo* (Milan, 2004).

[11] On this theme, see Luca Mocarelli, 'The Guilds Reappraised: Italy in the Early Modern Period', *International Review of Social History*, 53/16 (2009): pp. 159–178.

[12] On the spread of innovation during the early modern period, see Carlo Marco Belfanti, 'Between Mercantilism and Market: Privileges for Invention in Early Modern Europe', *Journal of Institutional Economics*, 2/3 (2006): pp. 319–338; and idem, 'Guilds, Patents and the Circulation of Technical Knowledge: Northern Italy during the Early Modern Age', *Technology and Culture*, 45/3 (2004): pp. 569–589.

sources analysed only from the central decades of the eighteenth century allow us to identify a sort of informal debate on product quality among artisans and entrepreneurs, whose prevalent activity was buckle and button manufacturing in Italy. Metal button-makers were particularly involved in this comparison between different ideas about 'locating value'. Italian button manufacturing in the period under examination was influenced by many innovations in products and processes, which had already been started in France and England in the previous decades. Fashion accessories promoted by English and French entrepreneurs had been very successful on the Italian market. Changes in demand induced Italian governments to stimulate, even at a local level, the production of buttons and small fashionable objects for personal use, following working procedures which had been tried by English and French craftsmen. The latter had created a series of products which could easily be considered as part of the category of so-called 'new luxury items'. Efforts directed at adjusting clothes fastenings to a more specific function with respect to the garment and its user had already occurred in Italy during the previous centuries. However, the success enjoyed by French and English toys on the European novelty market during the eighteenth century particularly stimulated the updating of metal button and buckle manufacturing in northern Italy. English and French products were the result of working procedures based on the use of machinery which was able to produce huge quantities of metal alloy buttons and buckles. The range of innovative models and materials was wide and easily renewable. My objective, therefore, is the observation of the way in which Italian craftsmen interested in button (especially metal button) manufacture evaluated, accepted or criticized the new type of accessories. Through the analysis of this informal debate, in which local governments and guilds also participated, I would like to reconstruct the 'value framework' that the craftsmen involved usually referred to when defining their product quality.

Craftsmen interested in Italian metal button manufacture were, for a long period of time in the early modern age, goldsmiths and jewellers.[13] They were used to producing a type of buckle or button whose characteristics were initially more similar to those of a precious object ('old luxury') than to a 'fashionable' accessory ('new luxury'). This type of manufacture had rather deep roots in Italy, dating back to the late Middle Ages. Italian buttons were mainly small jewels, handmade and requiring the use of small tools. Their evaluation was mainly determined by the intrinsic value of materials. However, material modelling skills affected the final result in these products of fine goldsmith art. Precious buttons were for a long time limited to a restricted number of customers, mainly males. There were also other forms of buttons, which were of different qualities,

[13] On this theme, see Rosita Levi Pisetzky, *Storia del costume in Italia*, 4 vols (Milan, 1964), vol. 2, pp. 136–140.

less conspicuous and less precious. However, the idea that buttons were mainly objects of distinction, on a social and gender level, had been very strong between the late Middle Ages and the Renaissance.[14]

In the first section, I intend to describe the change from a kind of manufacture which was mainly oriented towards the production of old-style luxury items to one which progressively tended to include new-style products. It was not really a sudden change, but a phase during which the traditional and new types of production started to co-exist. The phenomenon was slow and gradual, and there was a high degree of overlap. On the market, it created the availability of a mixture of products, in which new-type buckles and buttons gradually emerged and overcame the old-type products; however, this did not spell the disappearance of traditional manufactures.

In this context, 'old luxury' buttons became one of the many different types of buttons available on the market. Since the early phases of their introduction they had been characterized by the following features: usefulness, ornamental function and variety (of shapes and materials). Later these characteristics would also become typical, even more prominently, of 'new luxury' products. The latter, however, can be contrasted with the former because, as we have already observed, they were the fruit of different production techniques. The materials being used were innovative metal alloys. Design and decorations, moreover, played a very strong role in the satisfactory outcome of these products. The working procedures adopted had to compensate for the lesser intrinsic value of materials. This was particularly true in the case of models where the intention to reproduce the brightness of the old gold or silver buttons was particularly evident. Sometimes an effect of illusion was created: old-type buttons were reproduced using new techniques and materials and they could even, at first glance, be taken for an original piece. Cast production was able to reproduce decorative shapes and motifs which had previously been created by hand through metal thread-weaving and intricate knitting.

'New luxury' buttons were designed more for the garment than a person. As it would frequently be changed, it had a high degree of 'quality as accessory'; that is, it was very specific in relation to the garment, and the gender and age of its user. This meant that special attention was given to the ornamental and functional aspects of the product. A design phase preceded the actual moment of production with the use of casts and machinery. The new product was also affordable and consequently led to a wider circulation among people who did not necessarily belong to restricted social sectors. It is my belief that this gradual intersection of 'old luxury' and 'new luxury' products can be interpreted as a

[14] On the role acquired by clothing and personal accessories during the Renaissance, see Bella Mirabella, 'Introduction', in Bella Mirabella (ed.), *Ornamentalism: The Art of Renaissance Accessories* (Ann Arbor, 2011), pp. 1–10.

growing tendency of the new-type products towards 'the quality as accessory' which was already present in the older ones. Regarding the evaluation of product quality, attention therefore also moved more towards working procedures in this case (for example, design, decoration and, above all, new metal alloys and their novelty effect) than towards the intrinsic value of materials.

The second section presents the protagonists of this gradual change. On the one hand, they were the goldsmiths, jewellers and embroiderers, who were craftsmen mainly employed in manual, 'traditional' working procedures which were oriented towards the production of old-type precious buttons. On the other hand, craftsmen from the Mint were emerging; they had better skills in cast engraving techniques and metal fusion and therefore able to produce a greater quantity of items. These workers, together with the new entrepreneurs who were interested in experimenting with French and English fashionable products, were the protagonists of what I can define as an informal debate on the quality of old and new products. They attracted attention in local governments which granted privileges (at the specific request of different parties), hoping to facilitate a nationwide production of goods which had until then been imported from other countries. The documents I have analysed show that, in this case too, the granting of privileges had the function of counter-balancing the rigid rules of the guild system.

The third section explores the central part of the debate. Through source analysis, I try to emphasize the way in which craftsmen working on traditional-type products tended to evaluate their production. Goldsmiths, jewellers and button-makers who used gold and silver threads defended their primacy. Their products were the genuine result of honest work that was performed by respecting the rules of the guild of which they were members. One of the craftsmen's tasks was to guarantee the coincidence between form and substance of their products; they felt they had an ethical responsibility when compared to other categories of craftsmen, as they enjoyed the 'trust' of the public. In this comparison with other professional groups, goldsmiths and jewellers seemed to fear, above all, the artisans who specialized in new metal alloy working techniques and cast engraving. They were more indulgent towards embroiderers and button-makers who employed fibres other than golden and silver threads (especially camel hair, goat hair and horse hair) and fabrics in their works. These handmade manufactures, in fact, required a lengthy period of production. Their aspect was different from that of golden and silver buttons and there was no possibility of confusion between the two types of products. As a consequence, thread and fabric buttons could not be as competitive on the market as those obtained by the use of cast techniques.

Product quality control in the old style was entrusted to guild officials, called *sindaci* (auditors). Checks had the purpose of verifying the purity of materials. However, in the case of fine goldsmith crafts they were also meant

to ascertain the existence of further requisites, most important of which was a specific period of apprenticeship for that particular kind of work. New-type products were criticized because they were highly effective at reproducing precious objects. Their external form could be misleading as regards both the intrinsic value of materials and the working procedures which had been used. Fusion techniques, when casts were engraved by craftsmen highly skilled in drawing, created products which looked exactly like handmade ones. Because of this, the traditional craftsmen felt as if they had been hit twice. In reality, though, this process of imitation had led to a new product, not to plain counterfeiting of the traditional ones. Consumers were perfectly aware of the characteristics of the new products, and the shift between external appearance and substance, as criticized by goldsmiths and jewellers, was one of the reasons for their appreciation.

The artisans and entrepreneurs who manufactured new products were honest and the quality of their fashionable accessories was transparent. Their manufacturing came under different regulations from those followed by the goldsmiths' art. These rules could be more flexible than those regulating goldsmiths and jewellers, but on the other hand, the craftsmen were not completely free in their working processes. New products, as will be observed in the fourth section, were manufactured following a set of rules which entailed the characteristics of the privilege that had been granted. The good quality of new products was examined by experts appointed by government authorities. While analysing case studies, I noticed that these experts were chosen from Mint craftsmen. They belonged to a different guild from that of the goldsmiths. As we have already seen, they were particularly skilled in cast engraving techniques and the fusion of materials. This category had a strategic role, alongside groups of craftsmen skilled in metallurgy techniques originating from France, in the introduction and production in Italy of new-type metal alloy buttons and buckles. Product quality control could also be entrusted to people in the sales sector. They were often fancy goods sellers and they were heavily criticized by goldsmiths and jewellers, as they were seen as plain sellers (not creators) of objects of various quality. These sellers, in their capacity as intermediaries between producers and consumers, controlled products 'ex-post' and observed the presence of those characteristics which would attract consumers interested in fashionable products.

Checks were performed on the quality of material fusion and on the permanence of the 'illusion' effect in new products. The resistance of paints applied to covers to reproduce the chromatic effect of silk, gold and silver was also checked. Design and decorations were fundamental ingredients in enhancing the 'quality as accessory' of the product in relation to the garment, and therefore the good result of the final product. In some cases, craftsmen who worked in the traditional sector were also appointed. They usually belonged to

the goldsmiths' guild and their task was to verify if competing craftsmen had done their job by respecting the limitations in product categories granted by the privilege.

The fifth section describes the classification of products within tariff tables. I think this could provide a picture of the variety of products available on the Italian market at the end of the eighteenth century. The sources I quoted in the first sections do not contain images, diagrams, catalogues of the products or detailed descriptions of button design and decorations. The analysed tariff tables make reference both to the intrinsic value of materials and to the working procedures used, and instead give a more detailed description of design, decorations and the chromatic effects of these accessories. Tariff tables, in fact, offer a summary of the characteristics that these product categories possessed. These sources give us an idea of the general information which was considered necessary, by producers and consumers alike, to define quality and determine the final price of the items. The sixth section examines the descriptions of these products given by almanacs and fashion magazines between the end of the eighteenth and beginning of the nineteenth centuries. These sources are closer to the sale phase, and they emphasize some product characteristics which were probably considered extremely important in the context of checks on new-type articles. Consumers learned the characteristics of materials as regards both their intrinsic value and the processing method. Moreover, these sources gave recommendations for the future use of the product and so induced consumers to buy it.

From 'Old' to 'New Luxury' Items: Traditional Products and New-Type Accessories in the Eighteenth-Century Italian Market

Usefulness and ornamental function, in variable mutual relationships, were features of buttons dating back to their early introduction in European clothing at the end of the Middle Ages. Usefulness was connected to the function of fastening. Buttons were an innovation which was closely linked to the use of tight clothes. In the beginning they were mainly used for the fastening of long, tight sleeves. In the following decades, rows of buttons, along with button-holes, began to appear all along the front length of clothes. Buttons could also acquire a decorative function, whose importance would vary depending on their shape and on the effect produced by the use of different materials.[15]

[15] On the origins of buttons and their use in clothes fastening, see Stella Mary Newton, *Fashion in the Age of the Black Prince: A Study of the Years 1340–1365* (Woodbridge, 1980), pp. 6–30; Luic Allio, *Boutons* (Paris, 2001), pp. 14–19; and Chiara Frugoni, *Medioevo sul naso: occhiali, bottoni e altre invenzioni medievali* (Bari, 2001), pp. 102–103.

Archaeological investigations have shown how buttons had already become available in a rather wide range of shapes and materials since the early phases of their introduction.[16] Sources relating to the Italian context of the fourteenth and fifteenth centuries confirm the existence of such a variety. In sumptuary legislation, which treated buttons in a rather benevolent way, considering them as useful jewels, different terms were used for buttons. These varied depending on shape (spheres, drops, little pears, lentils), type of fastening (button-holes, hooks, pins) and material (gold, silver, other metal alloys, precious stones, glass).[17]

The usefulness, ornamental function and variety which were typical of these items increased over the following centuries. During the Renaissance this tendency was enhanced by the growing complexity and luxuriousness of clothing. Recent studies on material culture in Renaissance courts have emphasized the importance that clothing accessories had in social relations. Buttons, like gloves, feathers and hats, were often used as a vehicle to convey evolving social, political and cultural values because they were easily replaceable and renewable.[18] In this context, buttons were often seen as little jewels: they were 'old luxury' items destined for high-ranking people. A garment enriched by rows of precious buttons was a way to exhibit one's social status. As they decorated the external side of garments, they were particularly visible, and as such, they were also more easily worn out. Buttons were easily lost and easily stolen. Loss or wear were used as an excuse to justify a new fastening which was often combined with the wish to surprise other people with new accessories.[19] Buttons, especially when conspicuous, were used as clothes accessories more suitable for men than

[16] See J.L. Nevinson, 'Buttons and Buttonholes in the Fourteenth Century', *Costume*, 11 (1977): pp. 38–44; Brian Read, *Metal Buttons c. 900 BC–c. AD 1700* (2nd edn, Somerset, 2010); and Geoff Egan and Frances Pritchard, *Dress Accessories 1150–1450* (London, 2002), pp. 272–280.

[17] Buttons were mostly seen as little jewels with a dual purpose: they were an ornament but also joined the two parts of a garment. Regulations were limited to establishing the number, the use of noble metals and button distribution on the garment. On this theme, see Levi Pisetzky, *Storia del costume in Italia*, vol. 2, pp. 77–82, 136–140, 395–396; vol. 3, pp. 203–207; vol. 4, pp. 263–264; idem, *Il costume e la moda nella società italiana* (Turin, 1995), pp. 146, 169; and Marzia Cataldi Gallo, 'Storia del costume, storia dell'arte e norme suntuarie', in Maria Giuseppina Muzzarelli (ed.), *Disciplinare il lusso. La legislazione suntuaria in Italia e in Europa tra Medioevo ed Età Moderna* (Rome, 2008), pp. 181–189.

[18] On this theme, see Evelyn Welch, 'Art on the Edge: Hair and Hands in Renaissance Italy', *Renaissance Studies*, 23/3 (2008): pp. 241–243; and idem, 'Scented Buttons and Perfumed Gloves: Smelling Things in Renaissance Italy', in Mirabella (ed.), *Ornamentalism*, pp. 13–39.

[19] On the button as a precious and functional jewel, see Paola Venturelli, 'I gioielli e l'abito tra Medioevo e Liberty', in Carlo Marco Belfanti and Fabio Giusberti (eds), *La Moda, Storia d'Italia, Annali 19* (Turin, 2003), pp. 94–99. See also Vittoria De Buzzaccarini and

for women. They also characterized the complex way of dressing among the rich compared to the simple clothes of the poor. Button fastenings were for quite a long time a typical feature of menswear. On clothing destined for women, or the poor, it was much more common to find knots, ribbons and drawstrings. Precious buttons often appeared in post-mortem inventories, in the list of valuable objects, destined to pass from one generation to the next. In these inventories, furthermore, precious buttons were frequently described as separate from the garment. This habit emphasized the fact that in such a case the product was considered as oriented to the person rather than to the garment.[20]

A further increase in the variety and novelty of models was recorded during the seventeenth and eighteenth centuries.[21] This process was stimulated by the use of a wider range of materials in manufactures. Under the influence of French fashion, the use of fabric and thread buttons had become established.[22] Progress in glass and metal-working techniques made a wide range of metal

Isabella Zotti Minici, *Bottoni & Bottoni* (Modena, 1995), pp. 9–13; and Terese Gandouet, *Boutons* (Paris, 1984), pp. 15–20.

[20] See Venturelli, 'I gioielli e l'abito', pp. 94–99; Levi Pisetzky, *Il costume e la moda*, pp. 32–33; idem, *Storia del costume in Italia*, vol. 2, pp. 139–140; vol. 4, p. 263; Paola Zanieri, 'Splendide illusioni: il fascino dei bottoni gioiello', in Dora Liscia Bemporad and Caterina Chiarelli (eds), *Appesi a un filo. Bottoni alla Galleria del Costume di Palazzo Pitti* (Livorno, 2007), p. 126; Isabella Bigazzi, 'Il giardino dei bottoni', in Bemporad and Chiarelli (eds), *Appesi a un filo*, p. 19; Dora Liscia Bemporad, 'Bottoni senza casa', in Bemporad and Chiarelli (eds), *Appesi a un filo*, p. 14.

[21] Descriptions of buttons that can be found in eighteenth-century technical dictionaries help us understand this variety. For example, see Francesco Griselini, *Dizionario delle arti e de' mestieri*, 18 vols (Venice, 1768–1778), vol. 3, *ad vocem* 'bottonajo', pp. 11–26. Interesting information about 'button-makers' and types of buttons in the second half of the eighteenth century can be found in Denise Diderot and Jean Baptiste D'Alembert, *Encyclopédie, ou Dictionnaire raisonné des sciences, des arts et des métiers*, 28 vols (Geneva [Paris and Neufchatel], 1754–1772), vol. 1, pp. 369–372, *ad vocem* 'bouton', according to which buttons could be sub-divided into three main categories: stone, metal and cloth; and in Jacques Savary de Bruslons, *Dictionnaire universel de commerce*, 3 vols (Paris, 1723–1730), vol. 1, pp. 459–462, *ad vocem* 'bouton' and 'boutonnier'; and in idem, *Dictionnaire universel de commerce*, new edn, 3 vols (Paris, 1741), vol. 1, pp. 1091–1094, *ad vocem* 'bouton', 'boutonnerie' and 'boutonnier', where the variety of buttons is confirmed (precious stones, cloth, gold and silver threads, silk, goat hair).

[22] On the production of cloth, embroidered fabric and gold and silver thread buttons, see Levi Pisetzky, *Storia del costume in Italia*, vol. 2, pp. 136–139; Bigazzi, 'Il giardino dei bottoni', pp. 18–22; 'L'art du brodeur et du boutonnier', *L'homme paré, Connaisance des Arts*, 262 (October 2005): p. 13; and 'Les plaisirs de l'étoffe', *L'homme paré, Connaisance des Arts*, 262 (October 2005): pp. 14–16. See also Isa Tarchi, 'Fili e intrecci', in Bemporad and Chiarelli (eds), *Appesi a un filo*, pp. 26–31.

alloys and coloured vitreous paste available.[23] These results were an incentive for the production of a button catalogue which was characterized by cheaper prices when compared to jewel buttons, while retaining a strong decorative presence. The patterns included in this catalogue referred to a new concept of luxury.

Precious buttons were still in demand. At the same time, however, a rise in the production of various kinds of buttons could be observed. The vast range of materials encouraged, on the one hand, the imitation of jewel buttons and, on the other, experimentation with new products. The increase in the variety of models was actually also stimulated by the need to produce buttons which were characterized as being more functional for garments and their owners. The need also arose to extend the use of buttons to items of clothing which were hidden under the visible side of garments. It was also necessary to modify shapes and choose materials which were more suited to the needs of consumers belonging to different social classes, genders and ages (women, men, children).[24]

Various studies on the birth of the consumer society in the West have recently outlined the role that metal alloy buttons played in the European novelty market in the eighteenth century. Alongside other 'toys' for personal use (stick knobs, snuffboxes, watches, buckles, combs, toilet accessories), they were part of the category of so-called 'new luxury items'.[25] These articles, according to Jan De Vries' studies, offered a contrast between comfort and balance and an idea of luxury based on excess and exclusivity.[26]

Thanks to the introduction of casting techniques, metal buttons could be offered in an incredible variety of solutions. It was the stylish finish for a garment. Models were surprisingly and continuously updated. Small variations in cast engravings, which were the result of an accurate design plan, were sufficient to renew a wide catalogue of products and guarantee remarkable profits for button entrepreneurs.[27] The frequent reference to the old and the exotic increased the effects of surprise and novelty. The twinkling and colour of some metal alloys

[23] On the use of glass and metal alloys in button manufacturing, see Dora Liscia Bemporad, 'Bottoni staccati', in Bemporad and Chiarelli (eds), *Appesi a un filo*, pp. 32–37; and Donata Grossoni, 'Gemme e vetro per i bottoni', in Bemporad and Chiarelli (eds), *Appesi a un filo*, pp. 114–123.

[24] See Avril Hart and Susan North, *Seventeenth and Eighteenth-Century Fashion in Detail* (London, 2009), pp. 112–121, 127, 139, 147, 155. On the Italian case, see Griselini, *Dizionario*, vol. 3, pp. 11–26; and Giuseppe Morazzoni, *La moda a Venezia nel secolo XVIII* (Milan, 1931), pp. 47–48.

[25] See, among others, Berg, *Luxury and Pleasure*, pp. 154–192; and Clifford, 'A Commerce with Things', pp. 147–167.

[26] For a definition of 'new luxury' and 'old luxury', see De Vries, *The Industrious Revolution*, especially pp. 40–72.

[27] On this theme, see David S. Landes, *The Wealth and the Poverty of Nations: Why Some Are So Rich and Some So Poor* (New York, 1998), pp. 276–278.

reminded one of the depth and brightness of precious metals. Darker and more opaque materials were used to create an antique effect on some articles.[28]

Changes in taste and function which characterized clothing and its accessories in the European panorama in the last centuries of the early modern period had their effects on different areas of the Italian peninsula. In this context the button *par excellence* had long been the metal variety produced by goldsmiths.[29] These craftsmen had been entrusted with the production of precious buttons since the end of the Middle Ages. During the Renaissance Italian button manufacturing stood out especially for precious products which had been made by goldsmiths. The skills of these craftsmen, especially when they were involved in art workshops located in urban contexts and influenced by court milieu, were improved by the frequent interaction of technical knowledge between 'fine' and 'applied' arts. Cases regarding collaboration between painters and goldsmiths are well known in the literature. The former were usually involved in drawing the shape and ornamental part of the product, whereas the latter created the object.[30]

Benvenuto Cellini, in his treatise on goldsmith art,[31] listed buttons as small jewellery products, since their covers were produced with precious metal threads and refined materials. He described them as 'very gracious' (*vaghissime*) and 'ingenious' (*ingegnosissime*) creations because, in order to create them, a great ability in drawing and reproducing plant (*fogliami*) and natural (*trafori*) elements was fundamental. The object was shaped only after a design phase during which a 'well-studied drawing' (*disegno bene studiato e considerato*) was pre-set. Buttons described by Tommaso Garzoni at the end of the sixteenth century were refined products.[32] They could be little jewels, especially when produced with precious stones and metals. In other cases they could be made with cheaper materials, but were clearly inspired by the old-style precious version, because of their shape and ornamental patterns. Precious buttons were prevalently directed at the

[28] On the use of metal alloys and their role in both the imitation and invention process, see Maxine Berg, 'From Imitation to Invention: Creating Commodities in Eighteenth-Century Britain', *Economic History Review*, 55/1 (2002): pp. 4–14; Helen Clifford, 'Concepts of Invention, Identity and Imitation in the London and Provincial Metal-Working Trades, 1750–1800', *Journal of Design History*, 12/3 (1999): pp. 241–243, 250–253; Reed Benhamou, 'Imitation in the Decorative Arts of the Eighteenth Century', *Journal of Design History*, 4/1 (1991): pp. 7–9; and Bemporad, 'Bottoni senza casa', pp. 13–15.

[29] See Levi Pisetzky, *Storia del costume in Italia*, vol. 2, pp. 136–139.

[30] See Paola Venturelli, *Gioielli e gioiellieri milanesi. Storia, arte, moda (1450–1630)* (Milan, 1996), pp. 22–25.

[31] See Benvenuto Cellini, 'Dell'arte del lavorare di filo, del modo di far la granaglia e del saldare', in Benvenuto Cellini, *Due trattati, uno intorno alle otto principali arti dell'oreficeria, l'altro in materia dell'arte della scultura* (Florence, 1568).

[32] See Tommaso Garzoni, *La piazza universale di tutte le professioni del mondo* (Venice, 1589), pp. 481, 485, 490, 541, 550, 909.

elite. However, because of their characteristics, they would act as a model for a wide range of products, which were very different both for their materials and quality. This new wide range of products would involve artisans coming from different sectors and encouraged the production of a 'new object'. This one was competitive with respect to the old-style version not only because of its price, but also because of its usefulness and ornamental function. The catalogue of products made by goldsmiths would later include fake jewel buttons as well: in this case, vitreous paste and metal alloys were used as a replacement for precious stones and materials.[33]

Embroiderers and tailors, glass-makers, brass-makers and engravers, and, finally, rosary-makers gradually became involved in button manufacture.[34] The former group of craftsmen produced thread and fabric buttons, while the latter specialized in a wide range of beads, called *paternostri*. They were made using coloured or transparent glass and could be elegantly employed as a replacement for crystal and precious stone buttons (rubies, lapis lazuli, agates).[35] The third group of craftsmen entered button manufacturing proposing a range of products to compete with those generally made by goldsmiths, jewellers and those embroiderers authorized to work with gold and silver threads. The items they proposed were substantially new luxury accessories. Brass-makers and engravers were among the first craftsmen in Italy to adopt casting techniques and gilding procedures which had been tried out by French and English manufactories at the end of the seventeenth and during the eighteenth centuries. Rosary-makers were involved in the manufacture of button moulds; the latter were wooden

[33] It is a curious observation that in Etienne Boileau's book, button-making has, among various categories, goldsmiths who worked with precious metals and glass: see René De Laspinasse and François Bonnardot (eds), *Les Métiers et corporations de la ville de Paris, XII siècle, le livre des metiers d'Etienne Boileau* (Paris, 1879), pp. 57–61, 151–154. On this theme, see particularly De Buzzaccarini and Zotti Minici, *Bottoni & Bottoni*, p. 11; Bemporad, 'Bottoni senza casa', p. 14; Frugoni, *Medioevo sul naso*, pp. 102–103; and Zanieri, 'Splendide illusioni', pp. 126–129.

[34] On button-makers and types of buttons, see Griselini, *Dizionario*, pp. 11–26. See also Doretta Davanzo Poli, *I mestieri della moda a Venezia nei secoli XIII–XVIII, Documenti: Parte II* (Mestre, 1986), p. 149; and data illustrated in Lavinia Parziale (ed.), *Istituzioni corporative, gruppi professionali e forme associative del lavoro nell'Italia moderna e contemporanea, archivio informatizzato-schede dati*, cd-rom attached to both Guenzi, Massa and Moioli (eds), *Corporazioni* and Massa and Moioli (eds), *Dalla corporazione*.

[35] Glass button work was mainly entrusted to *perleri*, who represented one of the branches of the ancient Venetian glass guild. On the variety of Venetian glass art production, see Luigi Zecchin, *Vetro e vetrai di Murano*, 3 vols (Venice, 1987, 1989, 1990). Especially on glass colours, see also Carlo Neumann Rizzi, *Memoria storica, tecnica, scientifica dell'Arte del vetro* (1811), pp. 49–68 (I consulted this unpublished volume at the Biblioteca del Museo Correr, Venezia, cod. Cicogna 2599); and Luigi Zecchin, *Il ricettario Darduin: un codice vetrario* (Venice, 1986).

or bone semi-finished products. They were the internal part of a button which would later be covered. Button moulds were a fundamental part of printed metal, fabric and thread buttons.[36]

During the eighteenth century the demand for buttons coming from Italian markets was rather diversified; demand for precious ('old luxury') buttons still existed. Glass, enamel, brass and thread buttons were also in demand. However, the highest share on the local markets was clearly taken by the 'new luxury' products in printed metal alloy, created by French and English entrepreneurs.[37] Geographically, local production was characterized by a higher number of manufactories in the northern regions of the peninsula. A few exceptions existed among the more typical manufactures in the Italian territory. Jewellery and silk button production, which was clearly prevalent in the north, could also be found in other Italian urban centres.[38]

The typology of buttons produced in Italy made an effort to meet new tastes and fashions. Alongside 'traditional' products, manufactures of a 'new' type started to appear. The objective was the creation of a product with a strong 'quality as accessory' in relation to the garment, but also sold at a reasonable price. For 'quality as accessory', I mean a product 'specific' to a certain garment and, for example, a button whose shape, material, hook, design, decorations and colour made it difficult to transfer from one garment to another. In the Italian context, which was very tied to the production of old luxury items, this process was particularly encouraged during the eighteenth century as a consequence of the success obtained by French and English 'toys' in the European novelty market. The shift from an 'old' to a 'new luxury' way of valuating and offering

[36] Griselini, *Dizionario*, pp. 11–26.

[37] Customs tariffs (*tariffari di dogana* in Italian) often illustrated the vast range of products available on the Italian markets. For example, see *Tariffa delle gabelle toscane* (Florence, 1781), pp. 134, 140–143, 225; *Tariffa delle gabelle toscane* (Florence, 1791), pp. 22–23; *Capitoli di dogana, entranea di Grassina, Tratta, Foranea, e Transito …* (Turin, 1721), pp. 30, 32, 45–46, 84; *Dato del dazio della mercanzia della città di Milano ed altre dello Stato con le loro rispettive province …* (Milan, 1725), pp. 32–33; *Tariffa e stima delle merci per l'esigenza delle Gabelle delle dogane di Roma* (Rome, 1750), pp. 87, 132. Many details about fashionable accessories requested on the Italian market were described in the statutes of rosary-makers and other button-makers. For the Milan case, see, for example, Atti di governo, Commercio, p.a. (b. 263, chincaglieri, coronari università, 1741), Archivio di Stato di Milano, Milan. For the Venetian market, see also Morazzoni, *La moda a Venezia*, pp. 47–48.

[38] For an overview of the professional group distribution on the Italian peninsula, see data contained in the cd-rom Parziale (ed.), *Istituzioni corporative*. See also Cellini, 'Dell'arte del lavorare di filo'; and Garzoni, *La piazza universale*, pp. 481, 485, 490, 541, 550, 909. On the production of silk buttons in Italy, see Edoardo Demo, '"Una compagnia per attender al traffico di Bolgiano, Vienna et altre fiere solite". I Carminati dalla Luna, mercanti veronesi nell'Europa centro orientale del secondo Cinquecento', *Studi Storici Luigi Simeoni*, 59 (2009): p. 45.

products was in this case more gradual than in other European countries.[39] However, more spontaneous efforts directed at modifying traditional products according to fashion changes could also be identified in the Italian peninsula in the previous centuries. Anyway, these first timid signs of change on the supply side are worthy of being mentioned.

The production of Venetian coloured glass buttons and Milanese brass buttons, in fact, was already going in that direction. In the second half of the fifteenth century Venice exported huge quantities of yellow and coral glass buttons to the Alexandrine markets, while in the same period Milan specialized in the production of round brass buttons, which were particularly requested by the Constantinople markets.[40] Thread button manufacture produced objects which, by their very nature, were characterized by quite a high degree of specificity in relation to the garment. The thread and weaving which were used in these kinds of buttons were usually chosen so as to match the garment's fabric. However, thread button production was still based on manual methods which required long production times. As a consequence, this product was not competitive in terms of market prices.[41] Probably for the same reason, this manufacture, in the early phase of its introduction, was less of a contrast with the traditional monopoly of the goldsmiths' art. Embroiderers, who used golden and silver threads in their work, often came from the goldsmiths' guild and followed working techniques similar to the traditional type. Garzoni, at the end of the sixteenth century, mentioned two types of artisans involved in precious thread button manufacturing: the first was represented by *ricamatrici* (the women who were used to creating a vast range of button covers with the help of a needle and a very complex and creative intertwining technique); the second was represented by *bottonanti mechanici* (men whose prevalent activity was oriented to the production of thread button covers, probably using mechanical instruments that the author did not describe in his treatise). The catalogue of this faster way of button-making was already various and complex, but more simplified than the women's totally handmade creations. Women were in fact able to intertwine an infinite variety of stitches on button covers, whereas men specialized only in a determinate number of patterns.[42]

[39] See, for example, the Dutch case, in which, in the second half of the sixteenth century, a significant shift from old luxury-style products to a more standardized way of producing metal buttons took place: J.M. Baart, 'Knopen aan het Hollandse kostuum uit de zestiende en zeventiende eeuw', *Antiek*, 9/1 (1974): pp. 17–49.

[40] See *Tariffa de i pesi e misure corrispondenti dal Levante al Ponente e da una terra, e luogo all'altro, quasi per tutte le parti del mondo: con la dichiarazione e notificazione di tutte le robbe che si tragono di uno paese per l'altro composta per M. Bartholomeo di Pasi da Vinetia* (Venice, 1540), pp. 76–77.

[41] See Griselini, *Dizionario*, vol. 3, pp. 11–26.

[42] See Garzoni, *La piazza universale*, p. 481.

Later, during the eighteenth century, some innovations in the product are recorded in the Naples area, which had been the home of white twist thread buttons for shirts and vests in the eighteenth century.[43] In the same period, among the most innovative manufactures we can find metal alloy button production in French and English fashion. French and English new metal-working techniques finally allowed the production of a huge quantity of fashionable buttons and buckles. This kind of innovation satisfied customer demand. Starting from the last decades of the seventeenth century, in fact, the diffusion of military uniforms and, especially in court circles, button-fastened liveries increased the demand for metal buttons both for military and civil use.[44] Finally, ceramic button manufacturing, which was oriented to the use of ceramic as an imitation of porcelain, started in Veneto and the Naples area towards the end of the eighteenth and beginning of the nineteenth centuries.[45]

The interaction between the new working procedures and the manufactures which were already rooted in the Italian territory was often enlivened by contrasts. 'Traditional' products were often regulated by strict rules typical of the guild system. As we have already observed, button manufacture in Italy was often in the hands of goldsmiths. The introduction of new-type manufactures followed patterns which were freer, relatively speaking.[46]

[43] See *Notiziario delle produzioni particolari del regno di Napoli e delle Cacce riserbate al Real divertimento ricercate ed esaminate da Frà Vincenzo Corrado* (Naples, 1792), p. 165.

[44] See Dora Liscia Bemporad, 'Uniformi senza esercito', in Bemporad and Chiarelli (eds), *Appesi a un filo*, pp. 144–149.

[45] The documents we analysed underline the concentration of metal alloy button production in the northern regions of the peninsula, especially in Turin, Milan and the Venetian mainland. For Turin, see Materie economiche, Commercio, Professioni Arti Manifatture (categoria IV: orefici, m. 5; ottonai; porcellane e maioliche, m. 6; dorerie, m. 2, bottonai; dorerie [orefici], m. 19 [mazzo d'addizione], donne bottonaie; orefici, m. 19 [mazzo d'addizione], statuti e cataloghi; dorerie, m. 19 [mazzo d'addizione], Stefano Pacalet), Archivio di Stato di Torino, Turin. For the Venetian mainland, see V Savi (b. 378, 22 dicembre 1772), Archivio di Stato di Venezia, Venice. For Milan, see Atti di governo, Commercio, p.a. (b. 222, 1781–1791), Archivio di Stato di Milano, Milan.

The documents contained in Camerale II, Arti e Mestieri (b. 27), Archivio di Stato di Roma, Rome, illustrate how buttons made with materials less valuable than gold and silver were usually imported into Rome from the northern areas of the peninsula. For ceramic button production, see Morazzoni, *La moda a Venezia*, p. 48; Levi Pisetzky, *Storia del costume in Italia*, vol. 4, pp. 263–264; and Giuseppe Novi, 'La fabbricazione della porcellana in Napoli e dei prodotti ceramici affini', in Giuseppe Novi, *Storia delle porcellane a Napoli e sue vicende* (Sala Bolognese, 1980), pp. 278–279.

[46] To support the establishment of the new manufactures, governments used instruments that came mainly under the category of privilege. This kind of regulation, which took the form of patents, tax exemptions and concessions of privileged manufactories, could be used to favour the introduction of innovations in a strictly regulated context, at least from a formal point of

The first attempts to integrate 'old' and 'new' products – particularly evident in Italian metal button production during the second half of the eighteenth century – were therefore followed by what we could define as a debate on the quality of manufactures which saw, among its protagonists, both the guild system and local governments. At the same time the quality of traditional and new products was under examination in fashion magazines, inventories, technical dictionaries and customs tariffs.[47]

The Protagonists of the Debate

Towards the end of the early modern period, button manufacture in Italy still retained the 'crossover' characteristics which had been one of its features in previous centuries. As outlined above, in the Italian context 'real' buttons had long been of the metal variety, produced by goldsmiths. Over time, however, a number of manufacturers had progressively entered the market, and with them glass-makers, tailors, embroiderers, engravers and brass-makers. Only rarely did this process lead to the creation of autonomous button-makers' guilds.[48]

The Turin button-makers' guild (which produced gold, silver and silk buttons) was an isolated case. It was created in 1736, after a split in the goldsmiths' guild, and it specialized in the production of precious buttons using high intrinsic value materials (especially gold and silver threads).[49] The formal acknowledgment, in a few guild branches, of specialization in working processes connected with button manufacture was also rare. One exception was represented by the Venetian 'anemeri', that is, the wooden rosary-makers.[50] During the seventeenth and eighteenth centuries they had specialized in the production of button moulds. This was the semi-finished product that brass-makers, engravers, goldsmiths and embroiderers would then complete with metal covers, or, in other cases, with intertwined threads or fabric.[51]

view, of guild discipline. On this theme, see Belfanti, 'Between Mercantilism and Market', pp. 319–338; and Belfanti, 'Guilds, Patents and the Circulation of Technical Knowledge', pp. 569–589. See also Massa and Moioli (eds), *Dalla corporazione*, pp. 275–442.

[47] *Tariffari di dogana* in Italian.

[48] See data contained in the cd-rom Parziale (ed.), *Istituzioni corporative*.

[49] See Materie economiche, Commercio, Professioni Arti Manifatture (categoria IV: orefici, m. 5; ottonai; porcellane e maioliche, m. 6; dorerie, m. 2, bottonai; dorerie [orefici], m. 19 [mazzo d'addizione], donne bottonaie; orefici, m. 19 [mazzo d'addizione], statuti e cataloghi, Archivio di Stato di Torino, Turin.

[50] Savi alla Mercanzia, prima serie diversorum (b. 393, foglio n. 222, importazione proibita di bottoni in modo particolare di anime, 7/06//1780), Archivio di Stato di Venezia, Venice.

[51] See Griselini, *Dizionario*, vol. 3, pp. 11–26.

Goldsmiths, embroiderers, tailors, engravers and brass-makers who produced buttons were often also involved in manufacturing other small objects.[52] The task of making certain products was usually given to craftsmen, depending on their ability to work on a certain kind of material and possession of the tools suitable for working on buttons. It was the guild system which decided what tools and materials the craftsmen could use. There was, therefore, a tendency to entrust the manufacture of precious buttons to goldsmiths and jewellers, and thread or fabric buttons to embroiderers and tailors. However, goldsmiths often handled other kinds of materials, like cheap metals, glass and fake stones. Gold or silver threads, in a pure or mixed form, could be used both by goldsmiths and embroiderers.[53]

Brass-makers and engravers, the latter particularly skilled both in drawing and carving techniques, had tried their hand at the production of buttons obtained by casting techniques, exploiting the versatility of the tools which were used for the production of a vast range of metal objects and toys.[54] During the eighteenth century, then, the tendency to increase button variety, for decoration and functional reasons, often clashed with the guild system's desire to establish an ordered and lasting sub-division of products. On the one hand, we can observe formal rigidity; on the other, a clear tendency towards the juxtaposition of competence.[55]

During the eighteenth century the most intense conflicts concerned metal button manufacture. The diffusion on the Italian market of metal alloy buttons following French or English fashion greatly complicated the situation. French and English fashion products were offered on the market as elegant replacements for precious metal buttons which had long been

[52] Work on the new types of buttons was usually associated with traditional products as well as with manufacturing of fancy goods, furnishings, fireplace tools, portable heating sources, gaskets, handles, and door and window parts. See, for example, Materie economiche, Commercio, Professioni Arti Manifatture (categoria IV: dorerie, m. 19 [mazzo d'addizione], Stefano Pacalet, 1780–1797), Archivio di Stato di Torino, Turin.

[53] See Garzoni, *La piazza universale*, pp. 481, 485, 490, 541, 550, 909; and Griselini, *Dizionario*, pp. 11–26.

[54] See, for example, the Milanese case in which a few engravers from the Mint were involved in button production: Atti di governo, Commercio, p.a. (b. 222, 1781–1791), Archivio di Stato di Milano, Milan.

[55] This phenomenon was particularly evident in Turin. In this case, button production involved both goldsmiths and button-makers belonging to different guilds. See Materie economiche, Commercio, Professioni Arti Manifatture (categoria IV: orefici, m. 5; ottonai; porcellane e maioliche, m. 6; dorerie, m. 2, bottonai; dorerie [orefici], m. 19 [mazzo d'addizione], donne bottonaie; orefici, m. 19 [mazzo d'addizione], statuti e cataloghi, Archivio di Stato di Torino, Turin.

typical of goldsmiths' manufacture in the Italian context.[56] Over the centuries, goldsmiths had sometimes experimented with the production of counterfeit buttons, using glass and fake stones as a replacement for crystal and precious stones. English and French manufactures could be mistaken for goldsmiths' products. This 'illusion' effect was often due to the brightness of the metal alloy as well as decorations and design. Cast production was able to reproduce the visual effect of the original handmade product. However, French and English creations were not simple imitations of precious products. They were actually manufactures whose antique and exotic aura made the product new and particularly desirable. Furthermore, the production process mainly based on casting techniques allowed a rapid updating of product catalogues.[57]

Governments in various northern Italian cities tried to facilitate the introduction of manufactures similar to English and French ones by granting privileges. Local government authorities were perfectly aware of the potential of these products. Their manufacture could be associated with the production of a vast catalogue of fashionable objects destined for personal and domestic use.[58] The interest shown by local governments in the introduction of these

[56] Buckles and buttons sold on the Milan market in the mid-eighteenth century were used for shoes and shirts, and were made of tin, brass, steel, gilded or silver-plated iron. Other versions, whose decorative and chromatic effect was stronger, were completely manufactured in glass or metal, with the addition of stones and mother-of-pearl. These products were in great demand on local markets and mainly came from abroad, especially from France, Flanders, and Genoa and Venice harbours. See Atti di governo, Commercio, p.a. (b. 263, chincaglieri, coronari università, 1741), Archivio di Stato di Milano, Milan. On the Venetian market, see Morazzoni, *La moda a Venezia*, pp. 47–48. In Turin there was a great demand for pinchbeck shirt buttons; for shoe and trouser buckles with steel borders and damascening; for pinchbeck and 'fine' and 'common' metal thimbles; for pinchbeck and common metal watch keys; for every kind of pinchbeck snuffboxes, made of enamel decorated with animal figures, or of fine and common quality tombac; for pinchbeck, silver and steel watch chains for men and women; and for enamel dials for clocks and watches. See Materie economiche, Commercio, Professioni Arti Manifatture (categoria IV: porcellane e maioliche, m. 6, 1755–1765), Archivio di Stato di Torino, Turin.

[57] See, among others, Bemporad, 'Bottoni staccati', pp. 32–37; and Berg, *Luxury and Pleasure*, pp. 154–192.

[58] Metal alloy and steel button manufacturing, in the English and French style, were mainly located in the northern regions of the peninsula. In all these cases, characterized by different political and economic backgrounds, interest in the introduction of new manufactures had been kindled by the success that foreign products in the sector of fashion goods had obtained on the local markets. Materie economiche, Commercio, Professioni Arti Manifatture (categoria IV: orefici, m. 5; ottonai; porcellane e maioliche, m. 6; dorerie, m. 2, bottonai; dorerie [orefici], m. 19 [mazzo d'addizione], donne bottonaie; orefici, m. 19 [mazzo d'addizione], statuti e cataloghi; dorerie, m. 19 [mazzo d'addizione], Stefano Pacalet), Archivio di Stato di Torino, Turin. For the Venetian mainland, see V Savi (b. 378,

new types of products encouraged competition in the production of objects following English and French fashion[59] and contributed to a stronger feeling of instability inside the goldsmiths' guild. They were afraid that their market would be eroded by the new products. They also believed that English and French fashion manufactures, being imitations of precious products, could harm the reputation of the high quality that goldsmiths' buttons had earned over time.[60] In pleas presented to local government authorities and magistrates dealing with economic and trade matters, goldsmiths and other craftsmen employed in the production of 'traditional'-type buttons expressed their fears concerning the introduction of new manufactures. In these documents, in an attempt to defend their manufactures, these craftsmen often insisted on the difference between traditional jewel buttons and new fashionable accessories.[61]

The analysis of these documents has allowed us to follow the route of what can be defined as a 'debate' on the quality of these products. From the second half of the eighteenth century, the informal debate about product quality, involving artisans devoted to both the old- and new-style products, became more explicit. Goldsmiths were often the authors of these observations. These artisans tried to update their old-style products, but were often unable to completely abandon ideas about the intrinsic value of raw materials and the 'rules of the art' as fundamental ingredients of their creations. Their counterpart could be identified, depending on circumstances, in local governments or in the craftsmen who were introducing the new-type manufactures. The latter could be brass-makers or engravers who had been given a licence to try the new type of production in the workshops where they habitually worked.[62] In other cases,

22 dicembre 1772), Archivio di Stato di Venezia, Venice. For Milan, see Atti di governo, Commercio, p.a. (b. 222, 1781–1791), Archivio di Stato di Milano, Milan.

[59] Between the seventeenth and eighteenth centuries the imitation of fashionable objects, whose 'standardization' was kept in evidence by the expressions 'all'uso di …', 'façon de …', '… style', was usually encouraged by local governments as a competition form: on this dynamic, see Carlo Marco Belfanti, 'Imitare, copiare e contraffare per competere nell'Europa preindustriale', in Carlo Marco Belfanti (ed.), *Contraffazione e cambiamento economico. Marchi, imprese, consumatori* (Milan, 2013), pp. xxii–xxiv.

[60] Particularly on this theme, see Materie economiche, Commercio, Professioni Arti Manifatture (categoria IV: orefici, m. 5; ottonai; porcellane e maioliche, m. 6; dorerie, m. 2, bottonai; dorerie [orefici], m. 19 [mazzo d'addizione], donne bottonaie; orefici, m. 19 [mazzo d'addizione], statuti e cataloghi), Archivio di Stato di Torino, Turin.

[61] See Materie economiche, Commercio, Professioni Arti Manifatture (categoria IV: dorerie, m. 2, bottonai, 1753), Archivio di Stato di Torino, Turin.

[62] In Milan, for example, the production of metal alloy buttons in the French and English style was introduced by Mint engravers: see Atti di governo, Commercio, p.a. (b. 222, 1781–1791), Archivio di Stato di Milano, Milan.

enterprising businessmen tried their hand at the production of buttons and similar objects inside privileged manufactories, with the help of foreign artisans.[63]

Excellence of Products and the Rules of the Art

When expressing their opinions about the quality of traditional products, which were mainly in the hands of the goldsmiths' guild, craftsmen gave particular emphasis to the theme of the 'excellence' (*bontà*) of manufactures.[64] The term 'excellence', when used to describe a product, meant the correspondence between what one was thinking of buying and what was being sold. This criterion, then, was used to measure the authenticity of a product, in reference both to materials and procedures which had concurred during its creation.[65] In particular goldsmiths felt they had an ethical responsibility, since they enjoyed the 'trust' of the public in managing precious materials like gold and silver.[66]

Turin button-makers, who were used to working on gold and silver thread buttons, believed that the excellence of their products was based on respect for the guild system rules. These consisted of very precise regulations concerning materials, tools, the distribution of tasks among craftsmen, the verification of product provenance and the possible stamping of marks. They thought that gold and silver thread buttons were the typology that had been damaged more than other fibres' (silk, wool, horse hair, camel hair thread) button categories, because of the arrival of French and English products on the Italian market. Material used in new fashionable buttons looked like precious metal, but was neither gold nor silver. The non-existing correspondence between the first-sight

[63] See Materie economiche, Commercio, Professioni Arti Manifatture (categoria IV: dorerie, m. 19 [mazzo d'addizione], Stefano Pacalet, 1780–1797), Archivio di Stato di Torino, Turin. These documents illustrate the opening of a privileged manufactory in Turin on behalf of Stefano Pacalet, a French producer of buttons and fancy goods. Foreign artisans were also involved in the opening of a similar manufactory in Bergamo on the Venetian mainland. For this case, see: V Savi (b. 378, 22 dicembre 1772), Archivio di Stato di Venezia, Venice.

[64] See Materie economiche, Commercio, Professioni Arti Manifatture (categoria IV: dorerie, m. 2, bottonai, 1753), Archivio di Stato di Torino, Turin.

[65] On the term *bontà* (in this chapter translated into English as the term 'excellence') relating to arts and manufactures, see also Giovanbatista Pini and Francesco Giacometti, *Memorie coronate dalla Società Patria delle Arti e Manifatture sul programma 'Quale manifattura nazionale possa e debba essere preferita ...'* (Genoa, 1790), p. 49.

[66] See, for instance, the Turin and Milanese case studies: Materie economiche, Commercio, Professioni Arti Manifatture (categoria IV: dorerie, m. 2, bottonai, 1753), Archivio di Stato di Torino, Turin; Atti di governo, Commercio, p.a. (b. 222, 1781–1791), Archivio di Stato di Milano, Milan.

effect caused by metal alloy buttons and the intrinsic value of materials was seen by Turin button-makers as the main flaw of foreign manufactures. At the same time, foreign production was feared because it could easily be mistaken for the product it was imitating. This was actually an acknowledgment of the potential of the new creations and the threat they posed to the precious buttons market.[67]

Turin button-maker guild rules prescribed the exclusive use of gold and silver threads, in determined proportions, for the production of buttons. It was mainly 'spun gold' (*oro tirato*) or gilded silver which had been reduced to an extremely thin thread. Regulations on the possible use of gold and silver threads mixed with different fabrics were very strict. Yarns had to be composed of three gold or silver threads. Guild rules condemned the use of 'mixed' yarns, obtained from the mixture of two gold or silver threads with a silk one. Products which were made using gold and silver threads mixed with different fabrics were considered to be unlawful and flawed.[68]

In the documents I have analysed, Turin button-makers were either called 'gold and silver button-makers' or 'gold, silver and silk button-makers'. The latter denomination mainly appears in later documents.[69] Trade dictionaries in the 1770s acknowledged the use of medium-quality silks in gold button production. Medium-quality silk was used to create a bottom layer which would be the background of gold threads. Dictionaries also mention the production of buttons in all-silk threads. They were very prestigious and required the use of Piedmontese silk. Among the silks known to button-makers, this kind was the most suitable for use with gold, thanks to its brightness. The reference to silk in the denomination of Turin button-makers might lead us to think that all-silk buttons were included in their catalogues of products.[70] However, from the quality hierarchy perspective described previously, in the early phase of this kind of production, even the best quality silk was considered inferior and incompatible when compared with gold and silver thread purity. The value attributed to the quality of these materials was probably reviewed in the following decades.

The 'excellence' of Turin buttons, produced with gold and silver threads, was defended, as we have already seen, citing the purity of the materials being used. The tendency to emphasize the intrinsic value of materials, considered as the basic component for the good outcome of final products, was also common inside the

[67] See Materie economiche, Commercio, Professioni Arti Manifatture (categoria IV: dorerie, m. 2, bottonai, 1753), Archivio di Stato di Torino, Turin.

[68] See Materie economiche, Commercio, Professioni Arti Manifatture (categoria IV: dorerie, m. 2, bottonai, 1740, 1753, 1766), Archivio di Stato di Torino, Turin.

[69] Ibid.

[70] See *Dizionario di commercio dei signori fratelli Savary che comprende la cognizione delle merci di ogni Paese (…) accresciuto di vary importantissimi articoli tratti dall'Enciclopedia e dalle Memorie dell'accuratissimo Mr. Garcin, ec …*, 4 vols (1st Italian edn, Venice, 1770–1771), vol. 1, *ad vocem* 'bottone', p. 206.

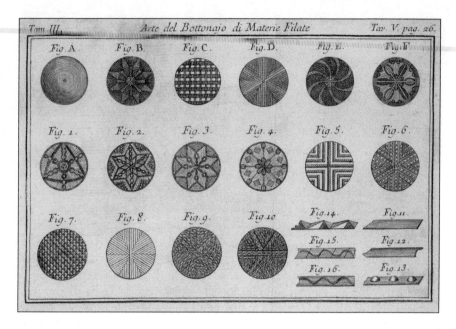

Figure 8.1 Buttons covered with fabric and spun materials. Source: Francesco Griselini, *Dizionario delle arti e de' mestieri*, 18 vols (Venice, 1768–1778), vol. 3, table 5 (courtesy of the Civica Biblioteca Queriniana, Brescia).

Turin goldsmiths', jewellers' and silversmiths' guilds. The latter produced buttons, among other wares. Around the 1750s they had considered the opportunity to update their catalogues to include products closer to new fashionable tastes. A few craftsmen had proposed directing production towards two specific categories: the first would include luxury goods, characterized by a high weight in carats of materials; the second would include small ornaments destined for a lower category of consumers ('peasants and the poor'). Weight in carats was supposed to be lower in this case than it was in products from the first category. However, it could not fall below a certain limit. In the goldsmiths' view, an excessively low weighing could have damaged the general image of their products.[71]

The 'excellence' of gold and silver thread buttons was also defended in reference to the kind of work they required. They were mainly handmade. Skill in the handling of needles and the patience needed to sit in front of a desk for

[71] See Materie economiche, Commercio, Professioni Arti Manifatture (categoria IV: orefici, m. 5, Università degli orefici e dei gioiellieri, suppliche e statuti dell'Arte, 1708; orefici, m. 19 [mazzo d'addizione], statuti e cataloghi, 1815), Archivio di Stato di Torino, Turin.

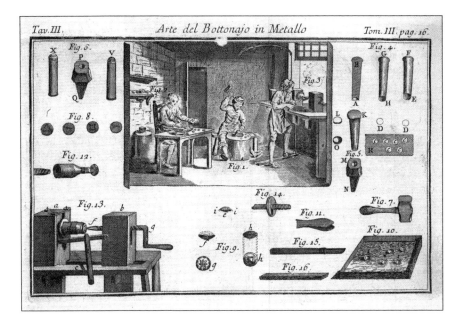

Figure 8.2 Metal button-makers in their workshop. Source: Francesco Griselini, *Dizionario delle arti e de' mestieri*, 18 vols (Venice, 1768–1778), vol. 3, table 3 (courtesy of the Civica Biblioteca Queriniana, Brescia).

many hours were requirements of the job. This was the reason why the female workforce was preferred to the male one in thread button production. A few documents stress the importance of a specific apprenticeship. The apprenticeship necessary to learn the skill of button-making using hair threads, for example, was actually different from the one required for dealing with gold and silver thread buttons. This difference was in some cases emphasized, particularly in the Turin case study, by the fact that embroiderers working with gold and silver threads derived from the goldsmiths' guild.[72]

One of the qualities of gold and silver thread buttons was the fact that they coupled a high intrinsic value with variety in patterns. This kind of button therefore had a high degree of 'quality as accessory' in relation to the garment. Technical dictionaries in the second half of the eighteenth century stressed how patterns never actually changed 'except in relation to shape', and how the base of thread buttons was usually the same. These dictionaries, however, also reminded their readers that high doses of 'taste' and 'imagination' were among

[72] See Materie economiche, Commercio, Professioni Arti Manifatture (categoria IV: dorerie, m. 2, bottonai, 1740, 1753, 1766), Archivio di Stato di Torino, Turin.

the fundamental ingredients needed to practise this sophisticated craft.[73] Piedmontese craftsmen mistrusted French and English fashion products because they gave an impression, at first sight, of having been produced by hand-matching of precious threads. This impression involved materials as well as decorations: metal alloys were bright and cast engravings were various and well designed. The relief patterns which appeared on the covers of French and English fashion buttons, however, were the product of casting. This technique guaranteed fast production and, at the same time, a rapid updating of the product catalogue. For these reasons it was greatly feared by gold and silver thread button-makers.[74]

Gold and silver button-makers pleaded with the authorities to enforce regulations concerning the marking and checking of products.[75] Marks should indicate the origin of products; they should bear the name of the producer and so make identification easier. They also guaranteed the regularity of production. The guarantee of 'excellence' was also given by the stamping of a visa on parcels for the shipment and sale of buttons by guild officials. These officials, called *sindaci*, had the task of checking products in order to establish 'how high or low the quality was'. Regulations also stated that merchants, shopkeepers and other buyers could only sell buttons if they were duly marked.[76]

'New' Products and Privileges

During the eighteenth century the governments of several northern Italian cities granted privileges to facilitate the start-up of manufactures of new-type metal alloy buttons. However, their attitude was rather ambiguous. On the one hand, they defended traditional-type products; on the other, they encouraged the start-up of businesses whose button production would be highly competitive with the former.[77] Local authorities gave incentives to these manufactures in order to limit the importation of similar products from abroad. This policy, which encouraged internal competition, was not exclusively directed at buttons but also at other fashion goods.[78] The production of new-type buttons looked particularly convenient as it was

[73] See Griselini, *Dizionario*, vol. 3, p. 18.

[74] See Materie economiche, Commercio, Professioni Arti Manifatture (categoria IV: dorerie, m. 2, bottonai, 1753), Archivio di Stato di Torino, Turin.

[75] See Materie economiche, Commercio, Professioni Arti Manifatture (categoria IV: dorerie, m. 2, bottonai, 1740, 1753, 1766), Archivio di Stato di Torino, Turin.

[76] Ibid.

[77] Ibid.

[78] See Belfanti, 'Imitare, copiare e contraffare', pp. xxii–xxiv.

easily associated with the production of other goods for personal or domestic use (cutlery, candelabra, trays, tea and coffee sets, fireplace tools, snuffboxes, toiletries, buckles). All of these products, as previously introduced, belonged in the category of so-called 'new luxury items' which had been very successful in Italian markets during the eighteenth century.[79]

The rules set by guilds and the privilege system were complementary. The privilege allowed craftsmen or entrepreneurs who were not necessarily members of guilds traditionally active in the button-making sector to introduce manufactures of the new type. In a few cases they were foreign craftsmen, especially from France; they were experts in metal-working, particularly in gilding techniques. The privilege worked as a double track, making the guild system more elastic when its rules were too strict.[80]

The size of the privilege defined, in turn, the choice of tools to be bought, the training to be followed and the place where business could be done. Privilege could consist of tax exemptions or the anticipation of capital to start a business. These amounts were variable. The size of incentives was not always sufficient to cover start-up expenses. In some cases it was necessary to move one's business from a small workshop to a larger laboratory, which could be sub-divided into departments for fusion, turnery, wire-drawing and cleaning of products.[81] It was then often necessary to renovate buildings and build a new infrastructure; in particular, canals were needed to facilitate the use of water as a source of energy. Furthermore, it was necessary to replace old trade tools with more complex machinery.[82]

Craftsmen and entrepreneurs who competed to obtain privileges emphasized the characteristics of the items they were proposing in the pleas that they sent to authorities. They particularly stressed the potential of the materials (new metal alloys) that they used, the working processes (cast engraving and the use of machinery) and the novelty of their products (pattern variety).[83] The material they used was neither gold nor silver, but new metal alloys which were not always easy to distinguish from precious metals. These innovative metal alloys helped to emphasize the novelty aspect of the new products.

[79] See Materie economiche, Commercio, Professioni Arti Manifatture (categoria IV: dorerie, m. 19 [mazzo d'addizione], Stefano Pacalet, 1780–1797), Archivio di Stato di Torino, Turin.
[80] Ibid.; and V Savi (b. 378, 22 dicembre 1772), Archivio di Stato di Venezia, Venice.
[81] See Materie economiche, Commercio, Professioni Arti Manifatture (categoria IV: dorerie, m. 19 [mazzo d'addizione], Stefano Pacalet, 1780–1797), Archivio di Stato di Torino, Turin.
[82] See V Savi (b. 378, 22 dicembre 1772), Archivio di Stato di Venezia, Venice.
[83] See Materie economiche, Commercio, Professioni Arti Manifatture (categoria IV: dorerie, m. 2, bottonai, 1740, 1753, 1766), Archivio di Stato di Torino, Turin.

In the early stages, materials like pinchbeck, tombac and ormolu were introduced.[84] Later, especially in the Milan area, there were attempts to reproduce English platen, and steel buckle and button production also began. The secret of these materials, which were often the result of various gilding procedures, was that they reminded one of the brightness of gold and silver. Sometimes this illusion was not limited to the reproduction of metallic glitter. It could create an antique effect or give depth to the surfaces of objects. This illusion effect, which Piedmontese gold and silver button producers criticized but also feared, was considered among the strengths of these new manufactures. The excellence of metal alloy depended then on the power it had to create an illusion effect, and the latter was what made the product new.[85] The good outcome of this illusion effect also depended on the skills of the artisans in cast engraving. This ability was fundamental for modelling the item, decorating its surface and making it similar to the handmade version.

We should mention the case of steel button production, which was the field that some Milan *bijouterie* workshops specialized in during the eighteenth and nineteenth centuries.[86] In the last decades of the eighteenth century steel was also used for the production of buckles, watches, objects for personal use and especially toiletries. This material was well suited to the simple lines which characterized and added a touch of novelty to the most recent objects for personal use to be found on the market. The price of these articles was rather high, as they were requested in court circles. Steel was resistant, easy to clean and pleasant to handle. In addition, it was particularly appreciated because of the extraordinary way in which it reflected candlelight.[87]

The illusion effect could also be produced by colour. Metal alloy buttons were often painted. At first sight painted buttons could look like buttons made

[84] Akin to brass, both tombac and pinchbeck were used to imitate gold. Their colours were characterized by different hues. Tombac tended towards a reddish yellow. When polished, pinchbeck acquired a warm golden colour. The ormolu was a gilding technique in which gold – as a leaf or in ground form – was used to plate bronze or copper through a mercury-based procedure. *Platina* was introduced in England in the eighteenth century. This was a technique in which a copper mould was covered by a thin silver layer. See Luigi Grassi, Mario Pepe and Giancarlo Sestieri, *Dizionario di antiquariato* (Milan, 1992), pp. 894, 1018–1019, 1103.

[85] On *platina*, the difficulties of discovering its secret and the first attempts to reproduce it in Milan, see Mario Pessina (ed.), *Relazioni di Marsilio Landriani sui progressi delle manifatture in Europa alla fine del Settecento* (Milan, 1981), pp. 235–240.

[86] Atti di governo, Commercio, p.m. (b. 97, 1802–1822), Archivio di Stato di Milano, Milan.

[87] On the success of steel button and buckle production, see Maria Cristina Bergesio, 'Scintillio metallico. I diamanti di Woodstock', in Bemporad and Chiarelli (eds), *Appesi a un filo*, pp. 136–143.

of silk threads or precious buttons. Quality checks on products, which were provided for in privileges, could be verified by the grip of paints. The duration of the illusion effect depended on the paint's wear resistance. A good colour, furthermore, increased the button's 'quality as accessory' in relation to the garment.[88]

In privileged manufactures, printed metal buttons were the final result of procedures in which the use of new machinery and tools replaced old ones, like the round burin and the hammer used for carving. The new working procedures saw the use of machinery which could also be used for similar products (combs, blades, knick-knacks and other toys). They could easily be converted and directed towards the diversification of production.[89]

The new products were distinguished by the regularity of their shape and the precision of their contour. These factors increased the wearability, replacement and practicality of buttons. The machine working process, being simple and fast, guaranteed the rapid updating of the catalogue of products. This phase was preceded by cast engraving, work which required a high level of competence in drawing the ornamental pattern of the object. Metal alloy buttons were generally less expensive than buttons produced with high intrinsic value materials and the embroidered ones where precious threads were used. The latter, as we have already seen, were the product of hand work and required long production times.[90]

New-type buttons were also characterized by their strong 'quality as accessory' in relation to the garment. This was also true of thread buttons, thanks to their variety in patterns and the characteristics of materials (from gold, silver and silk to camel hair and goat hair). In the case of printed metal alloy buttons, however, the level of 'quality as accessory' was increased by the rapidity with which products could be updated in relation to changing fashions. To guarantee rapid product updating, it was necessary to have a variety of patterns to engrave on casts. The variety of patterns (both in decoration and shape) heightened the novelty factor of products and the effect of surprise that they created. Their variety and quality depended on the craftsmen's ability to combine good taste and drawing skills.[91]

In the second half of the eighteenth century, Milanese craftsmen working in the field of buckle and button production fully understood the importance of pattern and good taste in determining the quality of a product. In this case the engraving of casts to be used in button manufacture in the English

[88] See Materie economiche, Commercio, Professioni Arti Manifatture (categoria IV: dorerie, m. 2, bottonai, 1740, 1753, 1766), Archivio di Stato di Torino, Turin; and V Savi (b. 378, 22 dicembre 1772), Archivio di Stato di Venezia, Venice.
[89] Pessina (ed.), *Relazioni di Marsilio Landriani*, pp. 235–240.
[90] See Griselini, *Dizionario*, vol. 3, pp. 11–26.
[91] Ibid.

and French fashion had initially been entrusted to Mint engravers. They had special skills in the drawing of decorative patterns and cast engraving: the work inside the Mint required the continuous practice of carving, engraving and decoration. Their example prompted the emulation of Milanese goldsmiths and silversmiths who tried to improve their own skills. During the last decades of the eighteenth century, Milanese goldsmiths and silversmiths began to realize the need to update their drawings. It was clear that, in order to obtain products which could compete with French and English manufactures, especially in the *bijouterie* sector, innovations in drawings and design patterns were fundamental. In mechanical working the use of casting techniques required craftsmen to be highly competent in drawing and carving. Attendance and certification at drawing courses in the local art academies then became a fundamental prerequisite for both obtaining 'gallant, good taste manufactures' and entering the guild.[92] A new institution – the local art academy, founded in 1776 – was appointed to teach drawing techniques and verify the effective abilities of the craftsmen. These efforts were successful and from the beginning of the nineteenth century would help to make Milanese buckle, button and *bijouterie* production the most appreciated on the European novelty market.[93]

When a privilege was granted, deadlines were also set for quality checks to be performed on new products. In the new quality hierarchy perspective described above, attention was clearly more focused on the way in which the material was shaped and decorated than on its intrinsic value. Quality controls on new-type products were often carried out by experts appointed by government authorities. The provenance of these officials varied. However, the documents that I analysed reveal a shift from an 'ex ante' quality check, entirely controlled by officials belonging to the same guild in which the products were made, to a product quality control in which people from the sales sector were involved. The officials, in fact, could be not only Mint craftsmen but also fancy goods sellers. In some cases goldsmiths who worked in the traditional sector were involved, in order to verify if competing manufacturing had been

[92] See Atti di governo, Commercio, p.a. (b. 222, 1781–1791), Archivio di Stato di Milano, Milan.

[93] See *Almanacco del commercio di Milano: Guida per l'anno bisestile 1836* ... (Milan, 1836), issue 'dicembre', p. 178, 'bottoni dorati e altri oggetti di metallo'; *L'interprete milanese o sia Guida generale del commercio e dei recapiti di Milano per l'anno 1823* (Milan, 1823), issue 'dicembre', p. 320; *L'interprete milanese o sia Guida generale del commercio e dei recapiti di Milano per l'anno 1825* (Milan, 1825), issue 'dicembre', p. 42; *L'interprete milanese o sia Guida generale del commercio e dei recapiti di Milano per l'anno 1826* (Milan, 1826), issue 'dicembre', p. 235; *L'interprete milanese o sia Guida generale del commercio e dei recapiti di Milano per l'anno bisestile 1828* (Milan, 1828), issue 'dicembre', p. 43.

carried out while respecting the limitations in product categories granted by the privilege.[94]

Committees would verify the correct stamping of marks and, above all, the resistance of paint and gilding to wear. The correct stamping of marks was considered to be one of the most important requirements of the product in the early phase of the introduction of these import-substituted manufactures. This procedure, in fact, made local production in the French and English style distinguishable from that manufactured abroad.[95] The quality of products was also measured in relation to the Italian manufactures' success in the reproduction of the original French or English product, and therefore in relation to the possibility of replacing it on the local market. Italian craftsmen found it easier to begin by imitating French products. They believed English manufactures were superior and had a more direct knowledge of French production. French buttons were in demand on the Italian market, and contacts with French craftsmen were frequent. As regards gilding procedures, French production had actually reached the same level as that in England, judging by contemporary trade dictionaries. Perhaps the opinions expressed by Italian craftsmen mainly concerned plated products: this was the English manufacturers' latest discovery and it was difficult to unlock their secret.[96]

Classification of Buttons in Customs Tariffs

Lists of products which were subject to customs tariffs published in various Italian cities during the eighteenth century usually presented a meticulous description of items.[97] In their descriptive notes it was possible to find information on the dimensions, weight, price, materials, provenance and specific function of articles. These sources are therefore useful if we want to reconstruct the range of fastening accessories then available on local markets. There was very often a mixture of new- and old-type products. Buckles and buttons appeared in the lists, sub-divided into categories. Attempts at classification were the result of

[94] See, for example, V Savi (b. 378, 22 dicembre 1772), Archivio di Stato di Venezia, Venice; and Materie economiche, Commercio, Professioni Arti Manifatture (categoria IV: dorerie, m. 2, bottonai, 1740, 1753, 1766), Archivio di Stato di Torino, Turin.

[95] Ibid.

[96] See V Savi (b. 378, 22 dicembre 1772), Archivio di Stato di Venezia, Venice. See also *Dizionario di commercio dei signori fratelli Savary*, vol. 1, *ad vocem* 'bottone', p. 206.

[97] See *Tariffa delle gabelle toscane* (1781), pp. 134, 140–143, 225; *Tariffa delle gabelle toscane* (1791), pp. 22–23; *Capitoli di dogana, entranea di Grassina, Tratta, Foranea, e Transito ...*, pp. 30, 32, 45–46, 84; *Dato del dazio della mercanzia della città di Milano*, pp. 32–33; *Tariffa e stima delle merci per l'esigenza delle Gabelle delle dogane di Roma*, pp. 87, 132.

careful evaluation of product characteristics. Classes of items were defined on the basis of the definition of a quality hierarchy which paid special attention to materials. The kind of working procedures on products, their shape and their destination were also important when classifying products.

This hierarchy of qualities was analytically applied to the Tuscan tax tariff published in 1781.[98] As regards metal buttons, a macro-category included gold, silver and brass buttons (or any other metal) which were ordered 'according to their respective quality'. Solid gold buttons were part of a different category from gold and silver buttons, 'good or fake, spun or drawn, in the shape of blades, pallets, plates and tinsel'. Silver and gold buttons, 'good or fake, spun or drawn', had their own list and were excluded from the category of buttons which could be produced with materials suitable for spinning, weaving or 'felting'. The category of fabric or thread buttons was clearly distinguished from buttons which were part of the macro-category of small fancy articles. This included six classes of buttons.

The first included horn, wooden, bone or 'jet' (burnt amber) buttons. They could be 'simple' (without any workings) or enriched with decorations, inlays and applications made of any material, except solid gold or silver. The second class comprised buttons made of ivory, crystal, mother-of-pearl, enamel, tortoiseshell or any other material. These products could be simple or decorated as well, but like the previous class they could not be enriched with solid gold or silver parts. In the third class we can find, once again, horn, burnt amber, wooden or bone buttons, which, in this case, could be worked with solid silver inlays and applications. In this class solid silver could be mixed with any other material, except solid gold. In the fourth class, once again ivory, crystal, mother-of-pearl, fake stones, enamel and tortoiseshell buttons are included; these products were decorated, inlaid and enriched with applications of solid silver mixed with other materials, except solid gold. The fifth and sixth classes included the products we have already seen in the third and fourth respectively. However, in these case applications, decorations and inlays were made of solid gold mixed with any other material.

In the Tuscan tax tariff for 1791, gold and silver buttons, 'good' or 'fake', 'drawn or spun' were included in a different class from metal buttons 'of any kind'.[99] There were four further categories which included thread or fabric buttons. The first category included buttons made of hemp, cotton, 'floss silk', wool, linen, hair, hair and silk, joined or mixed with gold or silver, good or fake. The second category included buttons of hemp, cotton, wool, linen and hair, both in a pure or mixed form. In the third, buttons of hemp, cotton, wool, linen or cloth, joined or mixed with floss silk, could be found. The fourth included

[98] See *Tariffa delle gabelle toscane* (1781), pp. 134, 140–143, 225.
[99] See *Tariffa delle gabelle toscane* (1791), pp. 22–23.

silk, silk floss or silk and silk floss mixed. A final category had been established for buttons 'of any other material not mentioned here'.

Similar criteria for categorization had characterized the customs chapters published in Turin in 1721.[100] In this case as well, the difference was represented by the material which was used. Enamel 'and similar' buttons were included in the category of haberdashery and small fancy articles. Thread and fabric buttons belonged to different classes, depending on the material they were made of (silk, twist or horse hair).

In some tariffs the indication of materials was accompanied by a note concerning the kind of work or the shape which characterized the button. The button could be made of gilded iron or iron which had been worked with *gemina*; it could be of the 'Turkish' type. The tariff for items available on the Roman market in 1750 contained a list of buttons distinguished by material.[101] The city or country of production was indicated for every type of button. The description of products also contained information on the degree of functional specialization of items in relation to garments, the characteristics of 'fastening' (in 'fine' or 'fake') and the quality of 'button moulds'. The list mentioned Venetian thread buttons with bone moulds, French brass buttons – defined as 'ordinary' with wooden moulds, and gilded to be used on jackets – German mother-of-pearl buttons with fake stones, and buttons for shirts, bodices or umbrellas.

The Representation of Buttons in Fashion Magazines and Almanacs

Magazines which presented the latest products of English and French fashion to Italian consumers accurately described clothing accessories.[102] Buckles and buttons played an important role among the protagonists of this collection of samples. They were often matched, and they contributed a finishing stylish touch to clothing and its accessories, from hats to shoes.

These fashion magazines gave ample space to the presentation of metal alloy products placed on the market by French and English entrepreneurs. Pictures illustrated the vast range of available models. Products were characterized by an incredible variety of shapes and materials. Metal alloy buttons and buckles were distinguished by their strong 'quality as accessory' in relation to garments and the people who would wear them.

[100] See *Capitoli di dogana, entranea di Grassina, Tratta, Foranea, e Transito ...*, pp. 30, 32, 45–46, 84.

[101] See *Tariffa e stima delle merci per l'esigenza delle Gabelle delle dogane di Roma*, pp. 87, 132.

[102] See Grazietta Buttazzi and Daniel Roche (eds), *Giornale delle nuove mode di Francia e di Inghilterra* (Turin, 1991).

In pictures, buttons and buckles were normally presented having already been matched to clothing and accessories. Sometimes the illustration of the fashion plate was accompanied by a bigger image of buttons and buckles used on garments.[103] Only more rarely were buttons and buckles illustrated separately from the garment.[104] In this case, buttons had special decorative motifs on their covers (portraits). In other cases metal buttons and buckles were presented on pages in the same sections where other metal alloy objects destined for personal and domestic use were illustrated. The latter were distinguished by the elegance of their shape, the chromatic effects of their materials and the particular visibility they would acquire once they had become part of domestic furniture.[105]

In the descriptions of products alongside illustrations, particular attention was given, once again, to the characteristics of materials. The fact that materials were able to create particular effects was given importance. Metal alloys that could be as similar as possible in brightness to gold and silver were particularly successful. Texts dealt with the widespread use of glass and coloured enamels as a replacement for crystal, diamonds and precious stones. Metal could be silver-plated, steel 'bronzed' or polished; enamel was painted in various colours. The key element in the novelty of these products was the evocation of antique, exotic or precious products; often it was a free interpretation of the old precious buttons. In this version, the use of new metal alloys guaranteed a better lightness and wearability when compared to old buttons.[106]

Shapes, patterns and the addition of applications (rhinestone, beads, braiding) of buttons and buckles were also scrupulously described.[107] Some notes described the way in which these accessories could be applied and distributed on the various parts of a garment. Buttons could be distributed in one or more rows. The functionality and decorative side of buckles and buttons largely depended on the way they were applied and distributed on garments.[108]

Illustrations and captions had the task of conveying an idea of the garment's comfort. They were supposed to underline the wearability and functionality of its accessories. More generally, the presentation of products was meant to convey images of elegant living, which would be refined and dynamic at the same time. One particularly significant series of fashion plates represented men and women wearing clothes suitable for horse-riding promenades.[109]

Almanacs published in the early decades of the nineteenth century witness the presence of a deep-rooted production of steel and metal alloy buttons in

[103] Ibid., plate 214 (1789).
[104] Ibid., plate 73 (1787).
[105] Ibid., plates 52, 63, 64 (1787).
[106] Ibid., plates 4, 12, 15, 16, 23, 24 (1786).
[107] Ibid., plate 56 (1787).
[108] Ibid., plates 29, 30 (1786).
[109] Ibid., plates 4, 15 (1786).

the English fashion in a few northern Italian urban centres, among which Milan stands out. Milanese almanacs contained the list of makers and traders of buttons and other gilded, silver-plated and painted metal objects. This kind of manufacture was often associated, both in production and sale, with brass knobs, metal curtain rails, candelabra, knick-knacks for domestic use, cutting weapons, engraved medals and *bijouterie*. In a smaller number of cases it was associated with the production and sale of ribbons and braiding. When dealing with button production, almanacs stressed the variety within the range of items for sale. 'Metal and fabric buttons of all qualities', 'metal buttons with coats of arms', 'buttons of any metal', 'painted, gilded and silver-plated buttons' were produced and sold.[110]

Conclusion

The debate regarding quality in Italian button manufacturing during the eighteenth century was, in the beginning, stimulated by the will to revalue national products, which were generally part of the goldsmith art, in comparison with metal alloy buttons which were becoming remarkably popular on the European novelty market. When defining the quality of traditional products, particular importance was given to the high intrinsic value of materials, to respect for the guild system rules, and to the technical skills (manual ability, drawing, taste, imagination) which craftsmen had acquired over time. These elements were believed to be fundamental in order to guarantee the 'excellence' of products – that is to say, the correlation between what customers thought they were buying and what was being sold. In the case of traditional products, purity of materials was especially appreciated. Gold and silver buttons also represented a small capital.

The ideas expressed by craftsmen in defence of traditional products were later on used to underline the potential and reasons behind the success of new-type products. New-type products, as we have already observed, were considered by precious button craftsmen to be 'flawed', especially because of the non-existing correlation between the effect produced by materials – as bright as, or even more so than, gold – and their intrinsic value. This had actually been the key element in the success of the new products. New metal alloys increased the brightness

[110] See *Almanacco del commercio di Milano: Guida per l'anno bisestile 1836* ..., issue 'dicembre', p. 178, 'bottoni dorati e altri oggetti di metallo'; *L'interprete milanese o sia Guida generale del commercio e dei recapiti di Milano per l'anno 1823*, issue 'dicembre', p. 320; *L'interprete milanese o sia Guida generale del commercio e dei recapiti di Milano per l'anno 1825*, issue 'dicembre', p. 42; *L'interprete milanese o sia Guida generale del commercio e dei recapiti di Milano per l'anno 1826*, issue 'dicembre', p. 235; *L'interprete milanese o sia Guida generale del commercio e dei recapiti di Milano per l'anno bisestile 1828*, issue 'dicembre', p. 43.

and visibility of products. The free interpretation of precious antique models gave the new product a symbolic value. The 'excellence' of the product was in this case mainly identified with the power that metal alloys had to resemble the brightness of precious materials. At the same time metal alloys made products cheaper, lighter and more wearable. Particular care in drawing and a careful study of shapes compensated for the lesser intrinsic value of materials, and contributed to the increased functional and decorative specificity of products in relation to the garment and the person who would wear it. Finally, the casting technique guaranteed a rapid updating of the catalogue of models, enhancing the effects of novelty and surprise of the final product.

What we have been saying shows that, in both cases, debate led to the definition of a hierarchy based mainly on the characteristics of materials, even if from partially different points of view. On the one hand, attention was focused above all on the intrinsic value of the material; on the other hand, emphasis was put on the novelty content of the new metal alloys and on the modalities in which the material was shaped and decorated. In this context guilds were able to guarantee market transparency for old-type, but not new-type, items. These, in fact, involved different forms of expertise, and a need for new institutions to improve craftsmen's abilities was recognized. Finally, analysis of the sources has let us see how the effects of this kind of quality hierarchy also influenced the classification criteria of products listed in contemporary tariffs and the illustration of products in fashion magazines and almanacs.

PART III
The Old and the New

Chapter 9

Façon de Venise: Determining the Value of Glass in Early Modern Europe*

Corine Maitte

Introduction

Classical economics has tended to identify value and price, the latter resulting from the free market trade of depersonalized supply and demand. Such a purely theoretical model can quickly become ideological; yet, it has strongly influenced historical reconstructions of price series through the ages. In recent years, this conception has been thoroughly upended. Whether it be the prices of consumer goods or works of art, pricing has revealed itself to be infinitely more complex than was long assumed.[1] Pre-classical economists, for whom 'the understanding of price formation presupposes a fragmented approach that relies on the multiplicity of places of determination',[2] are therefore, from this point of view, certainly more useful heuristically to modernist historians. This re-reading once again raises the question of the value of goods, which simultaneously appears as an economic, social, cultural and anthropological construct. This construction clearly intersects with the creation of luxury and the progressive change in how it was defined. Jan De Vries in particular emphasized the twinned birth of new consumers and a 'new luxury' in seventeenth-century Europe, a luxury no longer linked to the intrinsic value of raw materials, but to new *values* such as convenience and constantly renewed *design*.[3] This revolution would have meant a fundamental change in Western civilization between the late Middle Ages and the end of the seventeenth century. However, as suggested in the introduction to this volume, breaks were certainly never so abrupt. Different value systems for old and new luxury

* Translation by Ly Lan Dill.
[1] For food prices, see, for example, Michelle O'Malley and Evelyn Welch (eds), *The Material Renaissance: Studies in Design and Material Culture* (Manchester, 2007); Monica Martinat, *Le juste marché: le système annonaire romain aux XVIe et XVIIe siècles* (Rome, 2004).
[2] Jean Yves Grenier, *L'économie d'Ancien Régime* (Paris, 1996), chapter 1.
[3] Jan De Vries, *The Industrious Revolution: Consumer Behavior and the Household Economy, 1650 to the Present* (Cambridge, 2008).

goods have long co-existed in non-linear evolutionary processes,[4] preventing us from succumbing to teleological temptation. Furthermore, exchanges are far too often superficial between the historiography of the Italian Renaissance and that of northwestern Europe. To simplify, some place the birth of the consumer revolution in Renaissance Italy, while others point to the United Provinces and England during the seventeenth century.[5] For many, social emulation was the major reason behind the consumer desires of the new social classes as they sought to imitate the courts and aristocracies. For others, new bottom-up forms of consumption were emerging. This is where supply meets demand and production meets consumption. Stimulated by these new social demands, new production techniques created more affordable imitations of the traditional luxury enjoyed by the socially dominant – the former eventually exceeding the latter, before finally subverting it.

To address these issues, glass is a near textbook case. Raw materials could hardly be any more humble than gravel, sand and a few plants, albeit sometimes exotic ones. Yet glass products were certainly considered luxury items: 'objects

[4] Bruno Blondé, 'Conflicting Consumption Models? The Symbolic Meaning of Possessions and Consumption amongst the Antwerp Nobility at the End of the Eighteenth Century', in Bruno Blondé, Natacha Coquery, Jon Stobart and Ilja Van Damme (eds), *Fashioning Old and New: Changing Consumer Preferences in Europe (Seventeenth–Nineteenth Centuries)* (Turnhout, 2009), pp. 61–79.

[5] While there is abundant literature on the subject, we will focus on the multiple meanings of consumption in Venice, with notably Patricia Allerston, 'Consuming Problems: Wordly Goods in Renaissance Venice', in O'Malley and Welch (eds), *The Material Renaissance*, pp. 11–46. For a more general view of consumption in Renaissance Italy, see the special issue of *Renaissance Quarterly* (1989) dealing with new approaches in the economic history of the Renaissance; Richard Goldthwaite, 'The Empire of Things: Consumer Demand in Renaissance Italy', in Francis William Kent, Patricia Simons and John Christopher Eade (eds), *Patronage, Art, and Society in Renaissance Italy* (Oxford, 1987), pp. 153–175; idem, *Wealth and Demand for Art in Italy: 1300–1600* (Baltimore, 1993); Lauro Martines, 'The Renaissance and the Birth of Consumer Society', *Renaissance Quarterly*, 51 (1998): pp. 193–203; Luke Syson and Dora Thornton, *Objects of Virtue: Art in Renaissance Italy* (London, 2001); Lisa Jardine, *Wordly Goods: A New History of the Renaissance* (London and Basingstoke, 1997); Evelyn Welch, *Shopping in the Renaissance: Consumer Cultures in Italy, 1400–1600* (New Haven and London, 2005). For England, see: Neil McKendrick, John Brewer and John H. Plumb, *The Birth of a Consumer Society: The Commercialization of Eighteenth Century England* (London, 1982); John Brewer and Roy Porter (eds), *Consumption and the World of Goods* (London, 1993); Maxine Berg and Helen Clifford (eds), *Consumers and Luxury: Consumer Culture in Europe 1650–1850* (Manchester and New York, 1999); Maxine Berg and Elisabeth Eger (eds), *Luxury in the Eighteenth Century: Debates, Desires and Delectable Goods* (Basingstoke and New York, 2003); Maxine Berg, *Luxury and Pleasure in Eighteenth-Century Britain* (Oxford, 2005). For France, see Daniel Roche, *Histoire des choses banales* (Paris, 1997).

of pleasure and enjoyment only, without any necessity',[6] said the aldermen of Macon in 1583 and those of Nantes a few years later.[7] How, then was the value of the different glass objects created? Though the problem must be considered over the long term, it does take on a very particular meaning during the fifteenth century when innovations in both the composition and the final manufactured products multiplied within the Venetian guild and gave rise to *façon de Venise* glass.[8] They were the answer to social demands that would raise these objects to the level of ostentatious luxury. In parallel, the same producers created multiple variations (some would say deteriorations) of a product with different levels of quality. There were no strictly defined regulations, nor any guaranteed brand, which is rather surprising in the universe of techniques and trade of the time.

As suggested in the general introduction, the question of value will be addressed as broadly as possible. Only by tying together findings from cultural anthropology, economy of conventions and the social history of culture can we interpret the emergence of new values for a number of glass objects.[9] The more specific question of the price and costs of production will not be squarely at the heart of our investigation. The focus here is on how fifteenth-century Venetian innovations promoted a certain number of hollowed glass objects as ingenious imitations of nature, and by doing so, acquired a new cultural and social value

[6] Quoted by Léonce Lex, 'Projet d'établissement d'une fabrique de verre de Venise à Mâcon en 1583', *Annales de l'Académie de Mâcon*, 3/5 (1900): pp. 250–254.

[7] For 1596–1598, see Henri Schuermans, 'Verres "façon de Venise" fabriqué aux Pays-Bas', *Bulletin des Commissions royales d'Art et d'Archéologie*, 1892: p. 67; Corine Maitte, *Les chemins de verre. Les migrations des verriers d'Altare et de Venise, XVI–XIXe siècles* (Rennes, 2009), p. 72.

[8] Much work has been published on the subject: see Maitte, *Les chemins de verre*. Here, I will mainly discuss the theses of Patrick McCray, *Glassmaking in Renaissance Venice: The Fragile Craft* (Ashgate, 1999) who used extensively the three volumes of Luigi Zecchin's writings: *Vetro e Vetrai di Murano* (Venice, vol. 1, 1987, vol. 2, 1989, vol. 3, 1990). These documents had originally been published in many obscure journals and were collected after Zecchin's death. Concerning Venetian guilds, see Francesca Trivellato's fundamental work, *Fondamenta dei vetrai. Lavoro, tecnologia e mercato a Venezia tra Sei e Settecento* (Rome, 2000).

[9] David Graeber, *Toward an Anthropological Theory of Value: The False Coin of Our Own Dreams* (New York, 2001); Arjun Appadurai (ed.), *The Social Life of Things: Commodities in Cultural Perspective* (Cambridge, 1986), pp. 3–63; André Orléan (ed.), *Analyse économique des conventions* (Paris, 1994); François Eymard-Duvernay, 'Conventions de qualité et formes de coordination', *Revue Économique*, 40 (1989): pp. 329–359; idem, 'Coordination des échanges par l'entreprise et qualité des biens', in Orléan (ed.), *Analyse économique*, pp. 331–358; Daniel Miller (ed.), *Material Culture and Mass Consumption* (Oxford, 1987); idem (ed.), *Material Culture: Why Things Matter* (London, 1989); Isabelle Garabuau-Moussauoi and Dominique Desjeux (eds), *Objet banal, objet social. Les objets quotidiens comme révélateurs des relations sociales* (Paris, 2000).

built through humanist recognition, which valorized the objects but not those who produced them, or if so, only very briefly. However, these 'new luxury objects', far from being requested by the 'urban middle classes', remained a part of the distinctive range of the socially dominant categories. The marketing of such products within the Venetian corporation is based on the producers re-appropriating at least a portion of their sales, notably in fairs and interpersonal relationships with clients and important merchants. Despite this, a specific brand was not established, any more than price constraints. On the contrary, it would take the expansion of new, privileged production centres in Europe for public authorities to start establishing price rates based on the market's 'common price', which referenced the price of Venetian objects.

Façon de Venise Glass: Imitations of Nature in Answer to Social Demands

The reputation acquired by the Venetian glass industry during the Renaissance has long distorted the representation of glass production on the peninsula. Since the Middle Ages, production was already present, though discontinuous, in at least 52 centres.[10] During the early fifteenth century, the Tuscan and Ligurian centres appear as busy, if not more so, than Murano, which showed certain signs suggesting a relative lull in creation and production.[11] The sluggishness of one centre was perhaps linked to the energy of the others. These centres mainly produced drinking glasses and bottles of basic, standardized quality – a good example being the *gambassini*, decorated stemware blown into various shapes and produced in relatively large series.[12] This proves that, in a certain number of regions at least, glass tableware had become more widespread than was previously believed.

The phenomenon is also not specific to Italy. In his *Discours admirables*, Bernard Palissy recalls the plight of all the 'nice inventions' now scorned for having become too common:

> I pray you consider glasses, which having become too common amongst men have now been valued at such a vile price that those who make them live more mechanically than the porters of Paris. Is this not the misfortune that has befallen the glassmakers in Périgord, Limousin, Saintonge, Angoulmois, Gascony, Bearn, and Bigorre? Countries where glasses are so mechanized that they are hawked in

[10] Marja Mendera (ed.), *Archeologia e storia della produzione del vetro preindustriale* (Florence, 1991).

[11] McCray, *Glassmaking*, p. 62: wood consumption in Murano glassworks dropped by 45 per cent. The number of boutiques went from 24 to 12.

[12] For the forms, see Daniela Stiaffini, *Il vetro nel medioevo. Techniche, strutture, manufatti* (Rome, 1999).

the villages by those selling old linens and scrap metal, so much so that those who make them and those who sell them must both work hard for a living.[13]

The proliferation of products lowers prices and abases the men who make them. The quote dates not from the eighteenth century, but from the sixteenth century. This calls into question the linear trends that are too often drawn in broadly sketched historical frescoes.

Regardless, the progressive affirmation throughout the fifteenth century of what would soon be called *façon de Venise* glass seems on the contrary to be a case of the progressive development of products related to constantly evolving techniques, whose main characteristics should first be outlined.[14] *Cristallo* is probably one of Murano's first innovations during the fifteenth century. The name of the highly transparent glass that Venetian masters had developed is very significant in this valorization; imitation is one of the intrinsic legacies of glass. Laws were introduced protecting consumers against such practices, with, in 1326, Venetian crystal producers being prohibited to make falsified gemstones out of glass. This aspect was then lauded and certainly re-developed during the fifteenth century, especially at a time when glass-makers developed a technique for purifying soda, which allowed them to obtain glass that was much clearer than ever before. Without listing all the innovations in glass composition, a long chain of experiments initially linked these advances to a desire to produce counterfeit gems. Knowledge of the reaction of metal oxides was crucial to the success of these compositions and explains the links that may have been forged between glass art and alchemy.[15] Other innovations developed in what might be called the decoration of glass and often involved new compositions and methods.[16] This was certainly not the case with enamels, though, a technique mastered well before and partially renewed in the mid-fifteenth century, notably with the development of new colours. Until the 1530s, enamelled glass was highly prized.[17] Meanwhile, gilded glass

[13] Bernard Palissy, *Oeuvres complètes* (Paris, 1844, reprint), p. 307.

[14] Many have already compiled such summaries. See, in particular, Rosa Barovier Mentasti, Attilia Dorigato, Astone Gasparetto and Tullio Toninato, *Mille anni di arte del vetro a Venezia* (Venice, 1982); and, in English, Hughe Tait, *The Golden Age of Venetian Glass* (London, 1979); Syson and Thornton, *Objects of Virtue*.

[15] This is especially underlined by Vanuccio Biringuccio, *De la pirotecnia* (1540; reprint Milan, 1977). See also Detlef Heikamp, *Studien zur Medicieschen Glaskunst* (Florence, 1986), p. 354.

[16] Some resulted from the combination of types of glass with different compositions to produce patterns, most notably filigree, lattice and *a retortoli* glass that used the contrast between opaque and clear glass to create decorative effects. Others involved new procedures such as crackle or *a piume* glass from the sixteenth century.

[17] Attilia Dorigato, *Le verre de Murano* (Paris, 2003), pp. 53–54.

emerged as a new trend, imitating the precious metal, presumably under the dual influence of ties with the Islamic world and the rediscovery of Antiquity.[18] Similarly, imitation of the Ancients led to the rediscovery of glass engraving around the middle of the sixteenth century, at a time when the technique of cold painting on glass was developing, which allowed glass masters to compete with *maiolica*, whose development was concomitant.[19] In fact, *maiolica*, enamelling and glass painting must all be considered together: their parallel revivals allowed notably for the reproduction of the Renaissance's most well-known paintings and themes, thus contributing to their spread and probably their reputation.[20] In all three cases, Venice played a fundamental role and technical transfers between the various branches have been proven.[21] In all these decoration techniques (enamelling, painting, etching), copying and reproducing prestigious models ensured the success of the product.[22] All three maintained contiguous ties with paper engraving, by which they were often directly inspired.

Meanwhile, the particularly malleable composition of *cristallo* and its longer cooling times were used to the benefit of formal innovations, as the resulting glass could be worked with more finesse than many other glass substances. The virtuosity in creating intricate shapes and designs became a recognized and valued characteristic of Venetian glass-makers, especially in the 1520s and 1530s:[23] the glass fins, snakes or fantasies are merely some

[18] Concerning the renewal of gilding in the Western world under the influence of the rediscovery of the Antique world and ties with the Islamic world, see Anthony Hobson, *Humanists and Bookbinders: The Origins and Diffusion of the Humanistic Bookbinding, 1459–1559* (Cambridge, 1989).

[19] Richard Goldthwaite, 'The Economic and Social World of Renaissance Maiolica', *Renaissance Quarterly*, 42/1 (1989): pp. 1–32.

[20] Even though Timothy Wilson, *Ceramic Art of the Italian Renaissance* (London, 1987), p. 11, notes that ceramics often used models from the previous generation, popularized through etchings.

[21] This was also noted by Giuliana Gardelli, *Italika. Maiolica italiana del Rinascimento* (Faenza, 1999), p. 10 concerning Venetian *maiolica*. There has been much scholarship on the importance of transfers and loans between branches in terms of innovations; see especially the remarks of Liliane Hilaire-Pérez, 'Pratiques inventives, cheminements innovants, crédits et légitimations', in Liliane Hilaire-Pérez and Anne-Françoise Garçon (eds), *Les chemins de la nouveauté: innover, inventer au regard de l'histoire* (Paris, 2003), pp. 35–39.

[22] Jutta-Annette Page, 'Introduction', in Jutta-Annette Page (ed.), *Beyond Venice* (New York, 2004), pp. 10–11. Thus, through both paper and glass engraving, models inspired by Raphael can be found here.

[23] Syson and Thornton, *Objects of Virtue*, p. 197. For the very interesting case of scale-model ships made of glass, see Patricia Fortini Brown, *Private Lives in Renaissance Venice: Art, Architecture and the Family* (New Haven and London, 2004), p. 147.

of the best-known examples of a production able to fulfil all requests, even those for prestigious armour, horse saddles, miniature vessels or musical instruments made entirely of glass.[24] Thus in the sixteenth century, part of Venetian production relied on the innovation and formal invention offered by this substance. Glass masters went from imitating objects made of more precious materials to formal prowess permitted by the substance. This was the result of a development process that also included two major innovations, pearls and glass mirrors, which ensured the reputation of *façon de Venise* glass throughout Europe. In 1540, Biringuccio, from Sienna, author of one of the first major texts explaining the techniques of the fire arts (*De la pirotecnia*), stated: 'Art has surpassed nature, although crystal and all other species have produced jewels more beautiful than this – glass – we have yet to find a way to transform them as we do glass.'[25] The game of skill between man and nature was thus recognized and praised.[26]

Figure 9.1 Bertrand Clavez, sketch of a furnace in Altare, based on a painting by San Rocco.

A Complex Process of Valorization

The value of glass certainly did not wait for the Renaissance for affirmation. Starting in the thirteenth century, the glass arts were regarded in Venice as 'a mystery of such use for our land' that neither the raw materials, nor the tools,

[24] Page, *Beyond Venice*, pp. 21–22, notes that in Ferdinand II's collection, some of these glass instruments were placed with the musical instruments (and not with the glassware), which would suggest they could be played, or were at least considered capable of being so.

[25] Biringuccio, *De la pirotecnia*, p. 42. See Zecchin, *Vetro*, vol. 2, pp. 278–283. See also McCray, *Glassmaking*, p. 66.

[26] See corroborating remarks by Roberto Mancini, 'Il principe e l'artigiano. Proposti di emarginazione sociale nella Firenze del '500', in Franco Franceschi and Gloria Fossi (eds), *Arti fiorentine. La grande storia dell'artigianato*, vol. 3: *Il Cinquecento* (Florence, 2000), p. 34.

nor the men needed for its creation could leave the city.[27] Its development clearly accelerated during the fifteenth century, alongside the previously mentioned technical innovations.[28] It appears in the writings of a number of humanists. Thus, in his treatise on architecture, *Trattato di architettura*, published in Milan between 1458 and 1464, the Florentine Antonio Averlino, nicknamed Filarete, explained to his master the organization and characteristics of the ideal future city, *Sforzinda*. In the form of a dialogue characteristic of many neo-platonic treaties, the description of the ideal city came to life. Questioned by his master on the person capable of carrying out such beautiful glass and mosaic objects included in the project, he answered: 'A great friend of mine will do it; his name is Master Angelo of Murano and it is he who makes such beautiful crystal glass objects.'[29] This passage has often been cited because it connects a man to an innovation: Angelo Murano, whom Filarete had probably met in Milan during his stay in the city in 1455, and crystalline glass. He is not the only one: between 1455 and 1460, the humanist Ferrara Ludovico Carbone bestowed upon him the epigram of *optimum artificem crystallinorum vasorum*, while a 1460 household account book describes him as *ab alchymizis crystallized*.[30] Literary and humanistic circles thus singled out this glass master who seemed capable of testifying to the alliance between theory and practice. Testimony from the early sixteenth century relates that Angelo attended courses given by the 'philosopher' Paolo da Pergola Rialto between 1445 and 1455. This would have allowed him to learn about processing matter and the properties of metals from which would arise the 'special colours and certain mixtures which were used by the glassmakers of Murano'.[31] Though this personalization of inventions died away, it demonstrates how Venetian glass innovations were promoted: identification of *ingenious* men, praise and acknowledgement in scholarly writing, in connection with projects of the princely courts.[32]

In fact, both name and object appeared relatively quickly beyond the confines of Venice. *Cristallo* appeared in France in 1467, Constantinople in 1473 and England in 1481. Testimonies abound on the qualifications of Venetian glassworks, which were in large part penned by pilgrims publishing

[27] The expression can be found in a text of 1384; see Zecchin, *Vetro*, vol. 2, p. 14.

[28] For a quick overview of these innovations, see Maitte, *Les chemins de verre*, chapter 2; McCray, *Glassmaking*.

[29] Antonio Averlino detto il Filarete, *Trattato di architettura*, ed. A.M. Finoli and L. Grassi (Milan, 1972), vol. 1, pp. 257–258 ('Gli farà uno mio amicissimo, il quale si chiama mestr'Angelo da Murano, il quale è quello che fa quelli belli lavori di vetri cristallini').

[30] Zecchin, *Vetro*, vol. 1, p. 238, and vol. 3, p. 146.

[31] The handwritten sheet was found in 1819 in a volume of Hartman Schedel, *Chronicorum sive de historiis aetatum mundi opus* (Nuremberg, 1493), conserved in Venice; see Zecchin, *Vetro*, vol. 3, p. 378.

[32] See also McCray, *Glassmaking*, especially chapter 4.

tales of their journey. Thus, Brother Felix Fabri of Ulm, returning from the Holy Land in 1484, stated that there could be no glass more precious than that of Venice.[33] Travellers, accompanied by their Venetian hosts, acquired the habit of going to admire glass furnaces. From 1493, Marin Sanudo's notebooks indicate that 'Murano, where they make the glasses' is 'one of the key sights shown to the lords in Venice', notably the Treasure of San Marco and the arsenal.[34] Visits by sovereigns or high-ranking figures would increase, including trips by the Queen of France in 1502 and Henry III returning from Poland in 1574. The glass masters did not hesitate to light their furnaces for very important guests. This fostered knowledge and information about Murano's production, established the prestige of its glass masters, contributed to the reputation of Venice and activated trade.

In his description of Italy published in Bologna in 1550, the Dominican Leandro Alberti (1479–1553) seemed to confirm a well-established reputation; one of its highly important, even essential, aspects was the renewal of products:

> In such a great land, they make glass vases whose variety and skill exceed those of all the other vases in this material throughout the world. And the *artefici*, aside from the preciousness of the material, consistently find new ways to make them more elegant and ornate with each other's various accomplishments ... Throughout Europe, the art of the Muranese is manifest ...[35]

The major technical texts of the mid-sixteenth century – Biringuccio's text quoted above, but also that of Agricola[36] and Fioravanti[37] – all began to highlight technical genius that surpasses nature. Moreover, this was also the reason behind the presence of Venetian glass in the collection of Francesco 1 de' Medici, whose goal was precisely 'to illustrate the effects of genius and art applied to elements of

[33] Zecchin, *Vetro*, vol. 2, p. 274. He also cites Pietro Casola, a Milanese canon travelling to Jerusalem. Harff Arnolf of Cologne equally undertook a pilgrimage in 1497.

[34] 'Muran dove si fa veri è fra le cose notabili che si mostrano a'Signori in Veniexia', quoted in Zecchin, *Vetro*, vol. 2, p. 275; and McCray, *Glassmaking*, p. 86.

[35] Leandro Alberti, *Descrittione di tutta l'Italia e isole pertinenti ad essa* (Bologna, 1550), quoted by Zecchin, *Vetro*, vol. 2, p. 283 ('In questa terra tanto eccellentemente si fanno vasi di vetro, che la varietà et eziandio l'arteficio d'essi superano tutti gli altri vasi fatti in simile materia, di tutto il mondo. Et sempre gli artefici, oltre la preziosità della materia, di continuo ritrovano nuovi modi da farli più eleganti et ornati con diversi lavori l'uno dell'altro ... Hormai per tutta l'Europa è manifesta l'arte di quei Muranesi ...')

[36] Georges Agricola, *De re metallica* (1556; reprint Thionville, 1987).

[37] Leonardo Fioravanti, *Lo specchio di scientia Universale*, 1564–1588. See Zecchin, vol. 2, pp. 283–290. He states that Murano is 'a site that seems to have been made by God and Nature to make this glass' ('un sito che pare sia stato fatto da Dio e dalla Natura per fare essi vetri' ...)

nature'.[38] Consistent with this programme, a glass furnace was painted by Butteri in the prince's *studiolo*, certainly modelled after the one that functioned in the *fonderia* of the *Palazzo Vecchio* which was used in part to supply the court.[39]

In this valorization process, the association between glass masters and painters known to patrons may also have played an important role. In fact, in the sixteenth century, certain famous painters did not balk at working with the glass masters of Murano.[40] Giovanni da Udine, one of Raphael's pupils, provided the boutique *La Serena* with glass models copied from Ancient Rome and Greece. Pietro Aretino did the same and the success of his glassware was such that they were known as *Aretini*.[41] The name had a double meaning as it evoked both the name of the painter and the antique vases produced near Arezzo, of which Pliny extolled the merits. Aretino even stated that if Pliny had seen the modern glass vases, he would have enjoyed them just as much. The participation of famous painters who offered copies of Ancient models became an important element of these objects' aesthetic value, which allowed for a direct and concrete relationship to Antiquity.[42] The *ingegno* of well-known painters was also used by the Florentine court that called on Bernardo Buontalenti (1536–1608), for example, to propose models that the glass masters then started producing.[43] It was again for the Tuscan court that Giovanni Moggi, the Roman painter (1566–1618), composed in 1604 a *bicchierografia* in four volumes, detailing more than 1,600 kinds of drinking glasses.[44] This trend further developed when the Veronese painter Iacopo Liguozzi produced, in 1617, at the request of Cosimo II, his first album of drawings of drinking glasses for the Tuscan court whose

[38] For the Germanic period, see Cristina De Benedictis, *Per la storia del collezionismo italiano, Fonti e documenti* (Florence, 1991), pp. 62–63. For 'scientific' collections, see Paula Findlen, *Possessing Nature: Museums, Collecting, and Scientific Culture in Early Modern Italy* (Berkeley, 1994). Ferdinand seems to have reserved an entire room for his glasses in the *Kunstkammer* in his Ambras Castle. Cf. Jutta-Annette Page, 'Venetian Glass in Austria', in Page (ed.), *Beyond Venice*, p. 21.

[39] De Benedictis, *Per la storia del collezionismo italiano*, pp. 36–37 and 64–67.

[40] A similar phenomenon took place in the silk sector: 'Venice used its most famous artists like Jacopo Bellini to establish a fruitful relationship between painting and silk manufacturing, Bellini providing drawings to Venice's silk weavers': Salvatore Ciriacono, 'Les manufactures de luxe à Venise: contraintes géographiques, goût méditerranéen et compétition internationale (XIV–XVIe siècle)', in *La ville et la transmission des valeurs culturelles au bas Moyen Age et aux temps modernes* (Spa, 1994), p. 236, quoting Pompeo Molmenti, *La storia di Venezia nella vita privata* (Trieste, 1973), p. 157.

[41] Zecchin, *Vetro*, vol. 1, p. 235–236: Giovanni da Udine also provided templates to Domenico Ballarin.

[42] Syson and Thornton, *Objects of Virtue*, p. 199.

[43] Stiaffini, *Il vetro nel medioevo*, p. 161. For stained glass, things had long been so. See Sophie Lagabrielle, *Pinceaux de lumières. Les vitraux et leurs modèles* (Paris, 2006).

[44] Stiaffini, *Il vetro nel medioevo*, pp. 166–171; Zecchin, *Vetro*, vol. 1, pp. 148–152.

forms broke with the established tradition of *façon de Venise*. The list continues with such figures as Jacques Callot, Baccio del Bianco and Stefano Della Bella,[45] who are some of the most well-known artists that the Tuscan court called upon to draw glassware.[46]

Façon de Venise glass established itself during the fifteenth and sixteenth centuries as a new product of ostentatious luxury whose cultural and social value was independent of the materials that composed it. This example shows that the dissociation between the value of materials and the social value of a product can be dated to much earlier than the eighteenth, and certainly the nineteenth, centuries.[47] However, it remains unclear which social classes participated the most in the development of this luxury.

A New Luxury for the Reaffirmation of Social Distinctions?

Patrick McCray, along the lines of Richard Goldthwaite's work on *maiolica* and on consumption in Italy's Renaissance cities, emphasizes the role of the 'new' urban middle class who, 'though they might not buy crystal or jasper tableware, could aspire to a glass replica of these materials'.[48] Considering the current state of research, it seems that this is more of a statement of principle than a well-supported assertion. Indeed, Isabella Palumbo-Fossati's study, one of the few focusing on the homes of artisans and artists in Venice during the sixteenth century, shows that in the capital of glass production, the homes of artisans possessed very few glass objects; at most, a lamp, a vase or two, a bowl. Palumbo-Fossati concludes that the bulk of production was exported and that:

> The fragility of this material explains that it was rarely to be found in a working class, merchant household. It was only in patrician homes, even if they were not particularly rich, in which there was an accrued concern over ornamentation, that the Murano glass arts were often mentioned.[49]

[45] Heikamp, *Studien*; Page, *Beyond Venice*, pp. 9–11. Starting in 1549, the Ambassador of Como I indicated that he had placed orders with Murano glass-makers by providing them with drawings by Pier Riccio, the Majordomo of the *Duomo* in Florence. Isabella d'Este had already done so in the late fifteenth and early sixteenth centuries.

[46] Heikamp, *Studien*, completed a very thorough study of all these drawings conserved mainly in Florence; unfortunately for me, it is in German. I am quoting from the Italian summary.

[47] Contrary to what Gilles Lipovetsky seems to affirm occasionally: 'Luxe éternel, luxe émotionnel', in Gilles Lipovetsky and Elyette Roux, *Le luxe éternel. De l'âge du sacré au temps des marques* (Paris, 2003), pp. 46–71.

[48] McCray, *Glassmaking*, p. 78.

[49] Isabella Palumbo-Fossati, 'L'interno della casa dell'artigiano e dell'artista nella Venezia del Cinquecento', *Studi Veneziani*, 8 (1984): pp. 123–124. Concerning exports, one

Moreover, the examples cited by Patrick McCray actually corroborate this. Who are the main admirers of Venetian glass products? Francesco Sforza; Alfonso of Aragon before Isabella and Ferdinand of Aragon; Isabella d'Este, the Medici; Philip II or the Count of Altamira in Spain; Frederik of Denmark ... The valorization process seems to have transited through humanist circles allied to the courts, perhaps even to the highest urban orders of patricians,[50] rather than through representatives of a middle class, who used these glass substitutes in the absence of luxury products they could not afford.

Venetian glass therefore managed to occupy a place vacated by the gradual disappearance of what had until then been the most prestigious glass, imported from the Orient, and this just as the new table arts were being established. The sixteenth century saw the rise of the ritualized act of drinking during banquets that were above all else opportunities for ostentation and the enhancement of the host's prestige, be he prince or high-ranked patrician.[51] This ritual grew thanks to new intermediaries: there was a servant who, at the request of guests, would take a glass from the sideboard, fill it, bring it on a saucer to the guest and finally replace it on the sideboard, which was very aptly named the *mostra*. The proper manner to hold one's glass was developed in the context of table manners.[52] This imbued the glass with profound meaning, 'from a drinking glass, it became a symbol to be exhibited at court banquets'.[53] It was no longer simply a utilitarian object, but a product made to be displayed and even offered. The Medici, after the Serenissima, also used these precious chalices as instruments of their policies and diplomacy. They offered the objects,[54] which naturally contributed to

of the only estimates we have on destinations of Venetian glass indicates that 14 per cent of production was consumed in Venice proper: see Gino Corti, 'L'industria del vetro di Murano alla fine del secolo XVI in una relazione al granduca di Toscana', *Studi Veneziani*, 13 (1971): pp. 649–654. For Palumbo-Fossati, the real discovery about interiors that was revealed by the Venetian inventories was the frames of paintings, books, musical instruments and ceramics, which proved to be one of the most widespread cultural goods. See also William David Kingery, 'Painterly Majolica in Italian Renaissance', *Technology and Culture*, 34/1 (1993): pp. 28–48; and Goldthwaite, 'The Economic and Social World'.

[50] See Page, *Beyond Venice*; and Syson and Thornton, *Objects of Virtue*.

[51] Stiaffini, *Il vetro nel medioevo*, pp. 151–186. Concerning the court of Mantua, see Giancarlo Malacarne, *Sulla mensa del principe: alimentazione e banchetti alla corte di Gonzaga* (Modena, 2000), pp. 51 ff, on dining rituals and 'tools'.

[52] Alexandra Gaban-Van Dongen, 'Longing for Luxury: Some Social Routes of Venetian-Style Glassware in the Netherlands during the 17th Century', in Page (ed.), *Beyond Venice*, pp. 192–225. She reproduces (p. 196) a treatise published by Gerard De Lairesse, *Groot Schilderboek*, in Amsterdam in 1707 distinguishing the ways to hold glasses according to the placement of the hand and fingers; the text was illustrated with diagrams.

[53] Stiaffini, *Il vetro nel medioevo*, p. 175.

[54] Ibid. On giving, see notably Nathalie Zemon Davis, *The Gift in Sixteenth-Century France* (Madison, 2000); Sharon Kettering, *Patronage in 16th and 17th Century France*

consolidating the international reputation of the production, although certain examples show that the adoption of these new criteria of valorization was neither automatic nor immediate. When Emperor Frederik III traveled to the city in 1468, the Republic offered the Holy Roman Emperor one of their prized glass creations. The Emperor dropped it on the ground to clearly illustrate the inconsistency of the gift.[55] He clearly had not yet been exposed to the new social conventions that assigned a value to objects that surpassed the cost of their raw materials.

Nevertheless, the delicacy of glass also added to its value and uses. Indeed, the intrinsic fragility of the material makes handling it that much more delicate, in that any breakage is irreversible and leads to the pure and simple destruction of the object's value; controlled gestures, a recognized element of social distinction, was therefore essential.[56] Meanwhile, the refined *façon de Venise* glasses became symbols of the *vanity* of wealth and human existence; thus they were fairly systematically represented in the *Vanitas* paintings of the seventeenth century.[57] Breakage was also ritualized, notably to magnify the sumptuousness of a meal. This is obviously what happened at the banquet celebrating the marriage between Margherita Farnese and the future Duke of Mantua, Vincenzo Gonzaga, in May 1581. In 1593, Cervio, author and chef at the banquet, wrote an account:

> In addition to the very rich credenzas and ordinary bottles, there was also a display of various glasses, decanters, jars and other beautiful crystal vases from Venice, such that I believe all the shops of Murano had participated, and it was necessary as all the invited ladies, after drinking, broke the glasses they held in their hands to signify their great joy …[58]

(Aldershot, 2002). For examples of glass manufactured in the ducal glassworks and glassware donated by the Grand Duke, see Heikamp, *Studien*, especially pp. 354, 355, 373, 375.

[55] Heikamp, *Studien*, p. 44. Similarly, at the end of the fifteenth century, Brother Felix Faber still stated: 'only the fragility of these vases makes them cheap and of low reputation, although they are most elegant in appearance, most beautiful to see': see Creighton Gilbert, *Italian Art, 1400–1500: Sources and Documents* (Evanston, 1980), p. 154.

[56] Norbert Elias, *La Civilisation des mœurs* (Paris, 1973).

[57] Hugh Willmott, 'English Sixteenth and Early Seventeenth Century Vessel Glass in the Context of Dining', in Guy De Boe and Frans Verhaeghe (eds), *Material Culture in Medieval Europe* (Brussels, 1997), pp. 187–188; and idem, *Early Post-Medieval Vessel Glass in England c. 1500–1670* (York, 2002), p. 196. The use of glass in *Vanitas* paintings is quite systematic; see, for example, Gaban-Van Dongen, 'Longing for Luxury', p. 207. However, it does not seem that their use by the aristocratic elites is a sign of their conversion to asceticism, as McCray has stated in *Glassmaking*.

[58] Vincenzo Cervio, *Il rinciante* (Venice, 1581, and Rome, 1593), quoted in Giancarlo Malacarne, *Sulla mensa*, p. 60 ('vi erano poi oltre le richissime credenze e

In the footsteps of the Italian elite, European aristocracy eventually adopted these new values, if we are to believe the example of English noblemen mentioned by William Harrison in 1587:

> ... it is a world to see in our days, wherein gold and silver most aboundeth, how our gentility, as loathing those metals – because of the plenty – do now generally choose rather the Venice glasses, both for our wine and beer ... and such is the estimation of this stuff that many become rich only with their new trade unto Murano ... from whence the very best are daily to be had. And as this is seen in the gentility, so in the wealthy community the like desire of glass is not neglected.[59]

Harrison therefore underlines the fact that it is the very abundance of precious metals, characteristic of the sixteenth century and which has been much discussed by historians, that triggered this cultural novelty amongst the former elite. We would therefore need to practically reverse the statements initially quoted by McCray: it was those who had always been able to buy gold and silver tableware who sought to differentiate themselves from the growing numbers of people that were capable of imitating them. To do so, the former created the social value of goods whose price remained very reasonable compared to the jewels of traditional luxury.

Price, Marketing Methods and Brands

Price and the creation of value are clearly related. However, analyzing prices and their creation is very difficult and we have not yet had an opportunity to conduct extensive research on the question. Two key points can nevertheless be asserted. First, the prices of *façon de Venise* glasses reflect the valorization process that was also underway in marketing methods and can therefore be distinguished from other types of glass. Second, however, the prices of the finest glassware never equaled those of precious stones or metals. Economic

bottigliarie ordinarie, una prospettiva di diversi bicchieri, carafe, giarre, et altri bellissimi vasi di cristallo di Venezia, che credo vi fossero concorse tutte le botteghe di Morano; e di ciò ve n'era bisogno, poichè tutte le signore convitate, doppo che avevano bevuto, rompevano il bicchiere che tenevano in mano per segno di grande allegrezza, e si sentiva alle volte si fatto strepito che occupava tutta l'armonia della perfetta musica che si udiva dali quattro cantoni della gran sala ...')

[59] William Harrison, *Description of England*, 1587, reprint by George Edelen (New York and Ithaca, 1968), p. 128; Willmott, *Early Post-Medieval Vessel Glass*, p. 196. Also quoted in Robert J. Charleston, *English Glass and the Glass Used in England c. 400–1940* (London, 1984), p. 50, and re-quoted in Berg, *Luxury and Pleasure*, p. 118.

value was separate from social and cultural value, as was also the case with ceramic-ware.[60] Objects of modest value (relative to those using precious raw materials) can acquire immeasurable social value, even if the work and *art* embodied in these objects confer upon them a price that distinguishes them from more common objects. The inventories published by Luigi Zecchin show that *cristallo* glassware during the fifteenth century cost nearly a hundred times more than ordinary stemware (0.7 lire against 0.005).[61] The very formulation of prices is an indication of the quality of the stemware. Very few objects were estimated singly, which of course distinguished them from those sold by weight or by the dozen. Prices thus varied depending on the size, complexity of models, decorations, colour and components; much like the valorization of paintings.[62] Prices probably also varied according to the social level of buyers and the manner in which the goods were sold, the two being inseparable.[63] The price of these objects, however, was not commensurate with their counterparts in other materials. Thus, the most expensive object in the Dragano boutique inventory in 1508 was an enamelled blue bowl valued at 31 lire. The rock crystal vases ordered by Isabella d'Este during roughly the same period were worth between 300 and 400 ducats, or 1,900 to 2,500 lire.[64] Yet Isabella d'Este paid almost as much attention to obtaining the former as the latter. This confirms that, though glassware was ostentatious, it was not due to the economic value of the goods.[65]

The marketing itself was very diverse. For high-end products, orders of specific models placed directly with the workshops, sometimes with additional drawings, clearly prevailed. Commission letters sent from other Italian states, Germany or England help illustrate the types of orders that were placed;[66]

[60] Syson and Thornton, *Objects of Virtue*, p. 201, concerning historiated ceramics, state: 'whatever its actual economic worth, its aesthetic value (admittedly within a very restrictive élite) was disproportionately high'.

[61] Zecchin, *Vetro*, vol. 3, pp. 58–62.

[62] McCray, *Glassmaking*, p. 142. For examples of prices in England in the eighteenth century, see Berg, *Luxury and Pleasure*, pp. 125–126.

[63] O'Malley and Welch (eds), *The Material Renaissance*.

[64] McCray, *Glassmaking*, p. 144; and Clifford Brown, *Isabella d'Este e Lorenzo da Pavia* (Genova, 1982), pp. 219–221.

[65] The culture of Ancient Greece and Rome was perhaps also important in this valorization; see Syson and Thornton, *Objects of Virtue*, pp. 182–183, who state that, for Pliny, hard to obtain metal alloys were perhaps worth more than 'raw' precious metals.

[66] For Italian orders, see Zecchin, *Vetro*; Brown, *Isabella d'Este*; and Dwight Lanmon, *Glass* (New York, 1993) for the Medici. For England, see especially Charleston, *English Glass*, pp. 104–108, who discusses the many letters sent during the late seventeenth century by John Greene to Alvise Morelli, containing hundreds of drawings of the requested stemware. There were also specific requests from Germany; see Barovier Mentasti et al., *Mille anni*, pp. 67–75.

many were similar to those placed with painters and other 'artists'. It is indeed a case of dedicated products in a world of interpersonal production.[67]

However, alongside this production on demand, the workshops also created a yearly production that included new models introduced at the annual Ascension Fair, a collection that was one of the fair's main attractions. Collectors and enthusiasts sent their clerks or agents to the fair to make purchases. Some, such as Isabella d'Este, specifically sought out the year's newest pieces.[68] Thus in 1529, she requested that Iacopo Malatesta, *oratore* in Venice for the Marquis of Mantua, go shopping for her at the fair: '... I am persuaded that beautiful new vases will appear in the glassmakers' shops at the Ascension fair, simply find up to X or XII drinking glasses of different kinds, cups and glasses, and with white threads and no gold.'[69]

This valorization of products at the fair seems to have been a trade innovation linked to that of *cristallo*. Since 1436, glassware produced in Murano was retailed in Venice by a specific guild, the *stazionieri*, who were purely resellers. As early as 1463, the glass masters opposed the system because it could potentially cost them a significant portion of expected profits from innovations, as well as combine productions that they were eager to differentiate in quality and value.[70] From then on, the sale of crystalline glassware was permitted only on Saturdays, and once a year at the Piazza San Marco during the feast of the Ascension. Of course, many disputes would arise as certain furnace owners continued to supply the city's mercers, or general merchants, who could then vaunt the production to their foreign customers.[71] In 1482, it was therefore decided, in the name of equity between all of Murano's 'shops', to prohibit the practice by restricting sales

[67] Robert Salais and Michael Storper, *Les mondes de production: enquête sur l'identité économique de la France* (Paris, 1993).

[68] This aspect is also underlined in the case of ceramics by Syson and Thornton, *Objects of Virtue*, p. 215. They quote, in particular, a letter from Lorenzo de Medici who thanks Vasari for sending ceramics: 'I value these as if they were made of silver, on account of their excellence and rarity, as I say, and the fact that they are a novelty to us here.'

[69] Malacarne, *Sulla mensa*, p. 60 ('Persuadendome che alle Apoteche delli vitrarii di questa Ascensa appariranno qualche belli vasi novi, siate contenti di ritrovarmi sino a X o XII vasi da bevere che siino varii di foggie; taze e bicchieri, et che habbino li fili bianchi schietti, senza oro'). This is surely referring to *a retortoli* glasses, for which a privilege was sought and obtained in 1527 by two brothers, Filippo and Bernardo Catanei.

[70] Zecchin, *Vetro*, vol. 2, p. 102. They complained in particular in 1463 to the 'Proveditori of Comun' and to the 'Justieri vecchi' that 'our crystal trade, that was so useful to the city of Venice, would lead to ruin and destruction' ('che 'el mestier nostro del lavoro del christallo, tanto utile alla città di Venezia, fosse per andar in roina et in destrution') due to undifferentiated sales of ordinary and crystal glass stemware.

[71] This led to a new decision in 1482 that prohibited such practices. See Zecchin, *Vetro*, vol. 2, p. 103.

to only in the island's workshops or at the annual fair.[72] The terms are important: the measure must allow 'for Murano to be ennobled'. Despite everything, the stakes encouraged infractions. Glass masters therefore requested the intervention of the Council of Ten which continued and furthered legislation in the same vein in 1510, and again in 1523. A three-person committee (a government appointee, a master and a furnace owner) was now in charge, 'to see and examine which glasses the *compravendi*[73] buy to sell here in Venice and not allow them to take anything other than common glasses and not *cristallini*'.[74] The Council of Ten justified these measures through the coincidence between the private good of furnace owners and the public good, 'per esser tal arteficio uno de gli Nobili ornamenti di questa città' ('for such an artefact to be one of this city's noble ornaments'). This clearly fulfils the goal of distinguishing between objects and the payment of their creators, even if infractions were certainly as abundant as the repetitive legislation. However, the guild never set prices, nor did they request that trademarks be created.

This absence, with only a handful of exceptions during the eighteenth century,[75] persisted until very recently and has rarely been remarked upon. It is surprising, however, that neither the Venetian state nor the shop owners thought to valorize their production through product certification. In a branded world, here is a luxury product that was not.[76] This deserves investigation. We

[72] It is therefore the glass masters who extended their activities to include trade, and not vice versa, as was the case in Antwerp; see Bert De Munck, 'Skills, Trust and Changing Consumer Preferences: The Decline of Antwerp's Craft Guilds from the Perspective of the Product Market, ca. 1500–ca. 1800', *International Review of Social History*, 53/2 (2008): pp. 197–233; and idem, 'One Counter and Your Own Account: Redefining Illicit Labor in Early Modern Antwerp', *Urban History*, 37/1 (2010): pp. 26–44.

[73] Literally buyers/sellers.

[74] Zecchin, *Vetro*, vol. 2, p. 42. Each time, the Council of Ten made the decision 'to see and examine closely ... which are and will be the glasses that the *compravendi* buy to later sell in Venice and not to allow these *compravendi* to take from here (Murano) anything other than commonplace glasses and not the *cristallini* ...' ('veder et ben examinar ... che veri sono et saranno quelli che ditti Compravendi compraranno per vender qui in Venetia et ... non lasciar che essi Compravendi possano portar de qui altro che veri comuni et non cristallini ...')

[75] Dorigato, *Le verre de Murano*. This is particularly the case as regards Daniel Miotti, who was then marking at least a portion of his production; see Carolus Hartmann, *Glasmarken Lexicon, 1600–1945. Signaturen, fabrik und handelsmarken. Europa und Nordamerika* (Stuttgart, 1997): marks 194, 2306, 2307, 2308, 4747, 7749.

[76] Research on brands is over-abundant for the contemporary period; see, for example, Eymard-Duvernay, 'Conventions'; Jean-Noël Kapferer and Jean-Claude Thoening (eds), *La marque. Moteur de la compétitivité des entreprises et de la croissance de l'économie* (Paris, 1989); Alain Semprini, *La Marque* (Paris, 1995). See Alessandro Stanziani's assessment, 'marques, marques collectives', in Alessandro Stanziani (ed.), *Dictionnaire de l'économie-*

know that a collective brand could allow for at least two things under the *ancien régime*: the certification of a product's quality and its origin, two essential pieces of information in the exchange of goods.[77] Requests came from different sources. There were local producers looking to counteract counterfeits by their counterparts, especially imitations manufactured elsewhere that could thus become counterfeit objects. There were also buyers (retailers or consumers) who thus obtained guarantees for purchased products. Finally, the states themselves guaranteed fair trade while safeguarding their financial interests from imitations.[78] In fact, very early on, the Venetian state required certain producers to label their products, notably goldsmiths for obvious issues of value and possible fraud over the precious metals used. However, such a requirement was never imposed on glass-makers, who did not request any such branding either. It is unclear whether the question was even ever raised. This was not due to an incapacity to accomplish it. The enormous corps of glassworkers brought together by Carolus Hartmann demonstrates their existence and relative variety, including during the modern era.[79] Ignorance and technical impossibility are therefore not explanations for the absence of brands.

Hypotheses are needed. One possible reason for the absence of a collective brand, which would signal the authenticity of Venetian manufacturing, could be the inability to attach a quality certification to the name due to the highly varied processes, some of which were secret, and to the changing levels of quality. However, during the *ancien régime*, the appellation of origin was almost always related to the possibility of identifying a number of stable, reliable and easily verifiable technical components using the certifying authority. This is easily understood by observing what was happening in textiles where brands

droit, XVIII–XXe siècles (Paris, 2007), pp. 229–238. It is less developed, however, for the modern era. See especially Corine Maitte, 'Labels, Brands and Market Integration in the Modern Era', *Business and Economic History online*, 2009: www.thebhc.org/publications/BEHonline/2009/maitte.pdf; Bert De Munck, 'The Agency of Branding and the Location of Value: Hallmarks and Monograms in Early Modern Tableware Industries', *Business History*, 54/7 (2012): pp. 1–22.

[77] For textiles, see notably Gérard Gayot, *Les draps de Sedan, 1646–1870* (Paris, 1998); Philippe Minard, 'Réputation, normes et qualité dans l'industrie textile française au XVIIIe siècle', in Stanziani, *Dictionnaire*, pp. 69–92.

[78] See Philippe Minard, *La fortune du colbertisme* (Paris, 1998).

[79] Hartmann, *Glasmarken*, identified 11,211 glass-maker marks from the sixteenth to the twentieth centuries throughout the majority of European and American museums. His catalogue is not adapted to historians' needs. As a result, only three brands date from the sixteenth century, 180 from the seventeenth century (1.8 per cent), and nearly 580 for the eighteenth century (around 5 per cent maximum). The vast majority is made up of German or Dutch glass-makers, followed by the English. There is only one Italian in the entire catalogue: Daniel Miotti. See Trivellato, *Fondamenta*.

were widespread. The brand is the certification of controlled quality.[80] Such specifications and examinations are hardly conceivable in the glass sector where compositions are by nature changing and secret, where processes are variable, and where, ultimately, each product is different from one another. Though the division of labour had started early on and the codification of gestures was indeed established, products were perhaps not yet sufficiently standardized for certification to be considered necessary by a legitimate state authority. Moreover, producers were certainly unwilling for outsiders to pierce the secret of their formulas.

In this, glass work is comparable to dyes, where the 'secret of brews' was expected and necessary. However, unlike glass, controls and certifications did exist for dyes. Requirements and verifications existed at the beginning of the process for specific raw dyes and further controls were carried out on the resulting dyed products. Manufacturers, who were not dyers, and merchants often imposed certifications on producers, with the assistance of states. Nothing like this existed for glass. Was this due to an utter incapacity to do so? In fact, beautiful Venetian glass was the result of a selection of raw materials – Ticino gravel, soda from Syria or Alicante, types of wood – certain lengths of fusion time, and specific technical processes. These aspects were only very partially codified in the regulations.[81] However, no controls were performed before production and no subsequent examination certified them. Thus, for all these reasons, the idea of a collective brand certified by the Venetian state was probably impossible at the time.[82] Perhaps the Murano glass-makers were also quite confident that their cohesive strength would not tolerate internal counterfeits? Perhaps, too, merchants were sufficiently knowledgeable concerning their suppliers?

Brands for individual shops were possible, however. Roughly equivalent to an artist's signature at the time, individual brands did exist in similar crafts, including that of *maiolica*.[83] This route was not chosen by Venetian glass masters either. None of them branded their production directly, although it is possible that markings were affixed to the packaging of the glasses, none of which has survived. This would be similar to the markings of certain blocks of raw glass from the eighteenth century. Whatever the case, this would have been a 'marketing' brand that in no way certified the product's quality.

[80] Minard, 'Réputation'.

[81] Trivellato, *Fondamenta*, notes that, contrary to widespread belief, there were very few productive regulations imposed by the guild, leaving ample leeway to glass-makers.

[82] Even in the field of ceramics, where branding was not an issue, not all centres required this certification, which makes it difficult to attribute their production; this is notably the case as regards Ferrara: see Wilson, *Ceramic Art*, p. 11.

[83] Goldthwaite, 'The Economic and Social World', p. 4. However, only a minority of master ceramists signed their production. Furthermore, the name on the piece was sometimes the recipient, or the shop owner, rather than the painter. See Wilson, *Ceramic Art*, p. 11.

This approach would have a multitude of consequences outside the confines of Venice, when *façon de Venise* glasses were on the rise throughout Europe. Often imitations were of such calibre that they were indistinguishable from the original, as demonstrated by contemporary testimonies: how, then, were imitations to be discovered? How could something be qualified as a fraud if no brand existed?[84] Above all, how do trust and veracity play themselves out in this non-branded production which, despite all the regulations, certainly constituted a significant share of products traded under the *ancien régime*? This very real problem arose quickly – and continues to exist, since the attribution of discovered objects and the identification of particular styles is obviously very difficult in the absence of any manufacturing marks.[85]

Façon de Venise Products beyond Venice: Privileges, Trademarks, Quality and Price Certification

The fame of *façon de Venise* glassware quickly led other Italian states to want to imitate production, eventually extending throughout Europe. Two major migratory flows encouraged the establishment in Europe of the manufacture of this type of glassware. The first was of Venetian glass masters, of course, in defiance of all legal prohibitions to leave the city. The second entailed glass masters from Altare who had long been organizing their businesses as mobile entities and who possessed, probably as early as the second half of the fifteenth century, at least a portion of the secrets of Venetian glass production. All the glass masters promptly requested privileges from the governing authorities of the countries where they settled – privileges that would allow them to manufacture and market this glassware.[86] The economic aspect was, of course, at the heart of their requests. The goal was to enter the market without harassment by local glass-makers and, more especially, without being threatened by competitors with the same skills. The argument constantly used was that they wanted to be assured of covering the major expenses required to install a new glassworks and to ensure the availability of a work team. Certain examples show that investments

[84] For problems of counterfeiting and fraud, see notably Alessandro Stanziani (ed.), *La qualité des produits en France (XVIIIe–XXe siècles)* (Paris, 2003); idem, *Histoire de la qualité alimentaire, XIX–XXe siècle* (Paris, 2005); Gérard Béaur, Hubert Bonin and Claire Lemercier (eds), *Fraude, contrefaçon et contrebande de l'Antiquité à nos jours* (Geneva, 2006).

[85] This is why chemical analyses often appear as the only means to identify compositions and therefore different origins. Numerous studies have been performed and are generally presented at the yearly Congress of the International Association for the History of Glass (AIHV). Nevertheless, interpretations of chemical analyses are extremely difficult, given the many factors involved.

[86] Maitte, *Les chemins de verre*.

needed for glassware were relatively high, but so too were the expected profits.[87] However, commercial and social aspects are not to be overlooked. The allocation of privileges also reflects a process of distinguishing their products from those of local producers, and simultaneously bestowing accrued value on their production through a sort of recognition of their status as 'certified true copies' of Venetian glass.

Like their model, these copies did not bear markings; however, this did not prevent unprivileged producers from being accused of forgery. Imitation of what the privileged artisans produced was considered counterfeit and punished by the public power, guaranteeing exclusivity.[88] This is clear in the privileges granted to De Lame in 1549 (Antwerp), as well as those for Mutio in 1551 (France), Centurini in 1572 (Cork) and Bertoluzzi in 1603 (Mantua) where it was forbidden to 'infringe/violate the said concession'.[89] From then on, there were two kinds of imitations of Venetian products: one that was authorized and valued, created by the privileged; and another, forbidden, created by the others. Obviously only the latter were considered counterfeits, which could therefore be seized and destroyed at any moment. It is not certain, however,

[87] It is impossible to detail production costs here. An idea can be fleshed out through the inventories published by Zecchin, *Vetro*, vol. 3, especially pp. 35–37, 48–62, 89–90, and used by McCray, *Glassmaking*, p. 133. It appears that in the early sixteenth century, at the Dragani 'boutique', the investment totalled 100 ducats for tools (of which only a little over five ducats was for a furnace) and 450 ducats for raw materials (150 for wood, 100 for soda, 170 for the frit, the cullet and stones), for a grand total of 550 ducats, which did not include labour costs that seem very generous (at Barovier's in 1460, a master's exceptional salary was 100 ducats per year; however, at Cappa's, it was 22 to 26 soldi a day in 1450, or 42 ducats for 200 working days). For comparison, a Tuscan document from the early seventeenth century, written by Guasparre di Simone Parigini, exposes the costs of investment and operation of a common glass furnace for a month. He indicates a profit of 330 lire 7 soldi per month for an initial investment of 1,200 lire. He concludes: 'and it seems that were we to earn the third, it would be a good deal': Archivio di Stato di Firenze, Miscellanea Medicea 27, cc. R 1001 v-1105, quoted in Heikamp, *Studien*, pp. 351–354.

[88] Current legislation has directly inherited the definitions of this right: 'counterfeiting can be defined as the theft of a private right', states a modern-day lawyer; see Veronique de Chantérac, 'La marque à travers le droit', in Kapferer and Thoening (eds), *La marque*, p. 65.

[89] Archivio di Stato di Mantova, Decreti Ducali (who would counterfeit said concession). In the privilege granted by Charles V to De Lame in 1549, it is stated that 'nulz aultres ouvriers que lui puissent faire iceulx voires de cristal ny les contrefaire ne faire vendre' ('no other workers than he can make these crystal glasses nor counterfeit them, nor sell them'). In 1551, Mutio also expressed his fear that it was possible to 'contre faire son dict ouvrage à ladicte façon de Venise' ('counterfeit his *façon de Venise* production'), while in 1572 Centurini was determined to protect himself from those who would work 'in imitation of him'.

whether prices were fundamentally different: it is very interesting to highlight the fact that the prices of these *façon de Venise* artefacts generally seem to be based on Venetian rates. Thus, in Pisa, in the late sixteenth century, prices of locally produced glasses were the same as those of Venice, which certainly offered local producers a distinct advantage by removing transportation costs.[90]

It is for this reason, perhaps, that the authorities were increasingly willing to fix the prices of products manufactured by privileged companies. The first quotes of this kind were found in a privilege granted to the Beltramini brothers in Mantua in 1601, stating that the glasses were to be 'abundant and at current prices'. In 1624, the duchy's government very precisely indicated the prices at which the various items should be sold.[91] Similar measures were taken in the Netherlands as early as 1607, and reaffirmed in 1629 and again in 1642.[92] They could be found in Paris between 1614 and 1625,[93] and in Casale, probably at the end of the century. Prices were also imposed in Spain at the end of the reign of Charles II,[94] and there were traces in Rome in 1731.[95] These rates illustrate the will to prevent holders of privileges from setting any price they chose.[96] It was therefore in Venice, the home of the corporation, that prices were 'freely

[90] Heikamp, *Studien*, p. 350, quoting a letter to Lorenzo Usimbardi from Niccolò Sisti, 16 September 1594, in Archivio di Stato di Firenze, Mediceo, F. 866, c. 378r–379v. This would upset the local merchants who wanted lower prices.

[91] Archivio di Stato di Mantova, Gonzaga, Decreti Ducali, 52, fol. 178 r/v; and Archivio di Stato di Mantova, Gonzaga, Commercio e industria, 3237: Arte dei vetri.

[92] On 26 January 1607, Gridolphi and Jehan Bruyninck – 'livreur des verres de notre hostel' (deliverymen for the glasses of our [royal] residence) – received a special privilege allowing only them to 'faire apporter et amener voires de Venise es pays de leurs Altèzes' ('request the delivery or to bring Venetian glasses to the country of their Highnesses'). Gridolphi was required to manufacture at the same price sufficient goods so as to meet the needs of the inhabitants of the Netherlands. See Jules Houdoy, *Verres à la façon de Venise. La fabrication flamande d'après des documents inédits* (Paris, 1873), pp. 45 ff.

[93] The tariff was imposed in response to conflicts between the holder of the privilege, John Marshal, and Parisian sellers. See Michel Philippe, *Naissance de la verrerie moderne, XIIe–XVIe siècles. Aspects économiques, techniques et humains* (Turnhout, 1998), pp. 40 and 183.

[94] Alice Wilson Frothingham, *Barcelona Glass in Venetian Style* (New York, 1956), p. 69; and Ignasi Domenech, 'Spanish Façon de Venise Glass', in Page (ed.), *Beyond Venice*, p. 107.

[95] Archivio di Stato di Roma, Camerale II, Commercio e Industria, B. 15, Privativa sopra la fabbrica de vetri e cristalli all'uso di Venezia concessa a favore del Sig. Giuseppe Montelli, 06/08/1731.

[96] Such scales were sometimes established early, in association with exclusivity clauses. See Henri Amouric and Danièle Foy, 'Liberté? Contraintes et privilèges. Les artisanats de la terre et du verre dans la Provence médiévale', in *Les libertés au Moyen Age, Actes du Festival d'Histoire de Montbrison, 1–5 oct. 1986* (Montbrison, 1987), p. 261: cullet monopoly with prices set in Marseille at the beginning of the fourteenth century. Price lists of basic necessities existed well before. See Martinat, *Le juste marché*; and Evelyn Welch, 'Making Money: Pricing

established' by supply and demand during the annual fair. In places where it did not exist, it was the public authorities that began to establish a grid of prices for 'the good of the public', to prevent privileged manufacturers from taking advantage of their monopoly.

How were these prices determined? Imported Venetian products established the basic reference. The privilege granted to Gridolphi and Bruninck in the Netherlands in 1607 specified how prices were to be fixed 'at such a price that is equal to that of the real Venetian glasses mixed with local counterfeits'. This amounts to averaging Venetian prices with those established for 'counterfeit' productions elsewhere in the Netherlands. The text goes on to specify that this constitutes 'the current price'. Thus, the advantage was probably less than in Pisa. Presumably, therefore, starting in the seventeenth century, perhaps earlier, a European reference system was established based on the prices of Venetian products sold in each place. This is clearly the case in the eighteenth century. Piedmontese archives contain a number of tables summarizing the prices of imported goods which were then used to set rates for those made locally. Thus, in various European countries, quantity and price were two compensations that became quite common to demand of holders of exclusive privileges, thus ensuring consumers an adequate supply at a 'fair price'.[97]

However, the deposit of samples was never mentioned elsewhere than in the Netherlands, even though this measure, enforced for the first time in 1629 and again in 1642, attempted to solve a crucial problem: the quality of products.[98] Much is known about the role of sampling in the manufacture of textiles where regulations have long existed. 'Sampling is everywhere, from the start to the end of manufacturing operations ... Because through compliance to samples, the compliance to manufacturing regulations is judged, and from compliance to compliance, the mark of perfection is affixed, which is to say the king's coat of arms ...'[99]

and Payments in Renaissance Italy', in O'Malley and Welch (eds), *The Material Renaissance*, p. 73. The first known example dates back to Venice in 1173.

[97] On the right price, see notably Martinat, *Le juste marché*; Guido Guerzoni, 'The Social World of Price Formation: Prices and Consumption in Sixteenth-Century Ferrara', in O'Malley and Welch (eds), *The Material Renaissance*, pp. 85–105. Explicit evaluation measures are present in other texts of the sixteenth century. Cf. Lyon, where it says, for example, that the establishment of Italian manufacturers of ceramics was not especially beneficial to the city since their prices were the same as products imported from Italy. Comte de la Ferrière-Percy, 'Une fabrique de faïence à Lyon sous le règne de H. II (H. III en fait)', *Revue du Lyonnais*, 31/1 (1895).

[98] Eymard-Duvernay, 'Conventions'; Stanziani, *La qualité des produits*; idem, *Histoire de la qualité alimentaire*.

[99] Gérard Gayot, 'Different Uses of Cloth Samples in the Manufactures of Elbeuf, Sedan and Verviers in the 18th Century', unpublished article in *Textile Sample Books*

The sample is a perfect model of the product produced in accordance with manufacturing regulations. In the field of glass production, there was nothing comparable as there were no established manufacturing standards, neither in the Netherlands nor elsewhere. The samples, in these two known cases, existed therefore to assess how well the actual production of the privileged craftsman matched his own promises. This was already an important step because these samples produced quality standards for products. However, contrary to what generally occurred in the textile industry, this standard was established by the two glass masters themselves to establish the quality of 'cristallin' stemware as stated in their contracts.[100] The contracts went on to stipulate that the quality of 'de cristal' glasses (in some cases of windows that were also Venetian imitations) was indeed judged against Venetian production, since it was clearly stated that the production of the privileged craftsman must be of the same 'quality, essence, and goodness of those of Venice'. This assertion was somewhat paradoxical since this 'essence' was never clearly defined, neither in the Netherlands nor even in Venice.[101] This leads us back to the difficulty previously mentioned of establishing precise manufacturing standards for glassware.[102] Quality was thus essentially visual. An imitation had to be imperceptible to the eye. If we are to believe testimonies, the contract was generally respected. It was at any rate a deliberate quality according to the terms used by Philippe Minard. One last problem is whether the valorization process of *façon de Venise* glasses enhanced producers' reputations.

Reassessed: Commerce, Communication and Culture, Conference organized by the University of Southampton and the School of Arts and Design, Winchester, 29–30 June 2000.

[100] The precise definition of what is meant by this term is not necessarily clear-cut, and can vary from one place to another and from one period to another. It seems, however, that this was the term for glasses that resembled Venetian crystal but which were not produced with the same processes, nor with the same raw materials. A notable example is the use of potash as opposed to only soda ash as a flux. Neri, in his work on glass, also makes this distinction between *cristallo* or *bollito*, for which maximal attention is paid to the raw materials used and the preparation, and *cristallino* which is a relatively refined glass.

[101] As has already been noted, guild chapters demanded a number of technical requirements (three workrooms, not four) and the use of certain raw materials (in particular Ticino gravel and Syrian soda), but requirements were still basic, even if they were certainly more extensive than elsewhere. The only known indication to confirm this is Nelio Besci's privilege in Tuscany in 1580 indicating that he would be the only one to use '(the) (white) pebbles of Pietra Santa considered suitable for the above mentioned glass and crystal professions ...': see Archivio di Stato di Firenze, Pratica Segreta, F. 188, fols 120–121.

[102] A very interesting attempt was made by the Trade Council of Turin to impose a definition of the product during the eighteenth century, but glass dealers multiplied arguments to show the impossibility of creating a limiting definition. See Archivio di Stato di Torino, Materie Economiche, IV, M. 12, notably inserto 16.

Developing the Value of Products and Producers?

The complex situation of Venetian glass masters must be distinguished from those of privileged glass masters elsewhere. The Venetian glass masters were members of a powerful corporation and participated in the Republic's political system. The increasing valorization of products resulted in recognition of the workshops that produced them, accompanied by a name that could be that of the owner's family or an identifying symbol.[103] It was mostly the furnace owners that profited from this enhanced recognition, not the masters who worked the glass directly.[104] Parallel to the product's affirmation, a closing process was implemented in 1544 which led, in theory, to the restriction of authorization for producing *cristallo* to only those glass masters who were 'Murano natives'. This belated measure attempted to ensure that the Murano masters would be the first to benefit from the technical innovations developed in the lagoon, which accompanied inefficient measures designed to fight migrations. A certain valorization of furnace owners, and beyond that of the 'local' masters, was at work. Furthermore, this had its political corollary in the introduction to a book describing 'native urban dwellers' in 1604–1605.[105] Nevertheless, though the *façon de Venise* was recognized as a local production method that bestowed a group identity on all producers,[106] the collaboration between glass artists and painters, as discussed above, indicates at the same time the failure of glass masters to be fully recognized as *richi d'ingegno* (artful). The relationship between glass-makers and painters indeed appears quite unbalanced. The latter invented models, while the former then became nothing more than skilled executors of projects elaborated without them (so much so that some of Moggi's glasses seem unfeasible). And if, in fact, they needed to be provided with models, it is because they were deemed *poveri d'invencione* and thus needing the genius of other 'artists', a word whose meaning has vastly changed since.[107] Indeed, no

[103] Zecchin, *Vetro*, vol. 1, pp. 185–195.

[104] In Venice, furnace owners could not also be glass masters. The latter were required to sit examinations whose terms were gradually clarified during the seventeenth century. See Trivellato, *Fondamenta*; and Zecchin, *Vetro*. For processes similar to those discussed here, see Bert De Munck, 'Corpses, Live Models, and Nature: Assessing Skills and Knowledge before the Industrial Revolution (Case: Antwerp)', *Technology and Culture*, 51/2 (2010): pp. 332–356. From a different perspective, see Elizabeth Currie, 'Diversity and Design in the Florentine Tailoring Trade, 1550–1620', in O'Malley and Welch (eds), *The Material Renaissance*, pp. 154 ff. She emphasizes the profound capacity for innovation of these high-end tailors, who were thus '… held in high esteem and could reap the benefit of working for entire families from one generation to the next' (p. 168).

[105] Zecchin, *Vetro*, vol. 1, pp. 217–221.

[106] Syson and Thornton, *Objects of Virtue*, p. 233: 'collective style and local identity'.

[107] Page, *Beyond Venice*, p. 10; Syson and Thornton, *Objects of Virtue*, pp. 183–184.

glass master seems to have given his name to a type of production and, in Italy, not one signed his works.[108] It may be that at a time when the division between craftsmen and artists was being established, glass masters remained anchored in the world of bodily fatigue and manual creation, without access to the coveted rank of the noble arts where genius and intellect dominated matter. They did not attain a socially acknowledged status where individual recognition could take shape.[109] Though their work was admired, they themselves as individuals rarely were, despite certain very rare exceptions.[110]

Abroad, a unique valorization process was taking place in France. It was linked to the recognition, still fragile and yet increasingly accepted in the sixteenth century, of the possible nobility of glass masters. In fact, the privileges obtained by Italian glass-makers all possessed a 'family resemblance', regardless of the European state that issued them; these privileges generally took the form of letter patents granting exclusivity in a given area for a given time. In contrast, the privileges of the Altare glass-makers[111] in France during the sixteenth century relied on the recording of exemptions, generally fiscal, granted by François I (and his successors) in favour of the kingdom's

[108] It is true that one medieval enamelled glass was named after its author, Aldovrandino, but it would seem that this fact remains exceptional. See McCray, *Glassmaking*, pp. 33 ff.

[109] Mancini, 'Il principe', pp. 25–39. It is true that elsewhere there emerged – as stated by Paolo Rossi in *La naissance de la science moderne en Europe* (Paris, 1999), p. 69 – 'a reassessment of manual labour and the cultural function of the mechanical arts', and that survey programmes were established among artisans. However, technicians, engineers and builders who promoted them in the sixteenth century were capable of creating links between high culture and that of the workshops, and it is this capacity for abstraction that they underlined in order to differentiate themselves from the common craftsman. See also Pamela Smith, *The Body of the Artisan: Art and Experience in the Scientific Revolution* (Chicago, 2004); Peter Dear, Lisa Roberts and Simon Schaffer (eds), *The Mindful Hand: Inquiry and Invention from the Late Renaissance to Early Industrialization* (Amsterdam, 2007); Pamela Long, *Artisan/Practitioners and the Rise of the New Science* (Corvallis, 2011).

[110] For example, that of Barovier mentioned above, as well as that of Niccolo dell'Aquila in Murano: 'miraculous and divine master of this art' ('miracoloso divin maestro di tala arte') according to Fioravanti, quoted in Zecchin, *Vetro*, vol. 2, p. 290. Moreover, even if the earthenware potters signed their production, very few achieved elite status by doing so. Goldthwaite, 'The Economic and Social World', pp. 14–15: 'the road to wealth and social status in Renaissance Italy was not paved with maiolica.' They began to consider themselves artists in their own right: on Xanto Avelli, painter of *maiolica*, see Wilson, *Ceramic Art*, p. 10; and Syson and Thorton, *Objects of Virtue*, pp. 250 ff.

[111] The glass-makers of Altare manufactured *façon de Venise* glass, but also *façon d'Altare* glass, and they were the leading manufacturers of this type of glassware in France. See Maitte, *Les chemins de verre*.

gentlemen glass-makers; these personal privileges attributed exemptions from all taxes to glass masters.[112] The two sorts of privileges had nothing in common: different favours were granted, exemptions or exclusivity, and timeframes were specified, either limited or lifetime.[113] However, to qualify, one had to be a 'gentleman glass-maker'. This was how French glass-makers were recognized and the aim of Altare glass-makers. They arrived in France without a title and would gradually acquire one, generally related to a glass furnace with which they were minimally involved. One glass-maker, Jacopo Saroldi, even took the title of 'Sire of Altare'. This was certainly a prerequisite for dealing on an equal footing with French glass-making families with whom the Altare craftsmen sometimes worked and allied themselves. It was above all the prerequisite for obtaining the privileges granted to gentlemen glass-makers and to them alone. These very generous benefits were well worth the invention of a few titles that no one thought to check. As numerous studies have shown, the sixteenth century was particularly conducive to social mobility and the ennoblement of families.[114] In return, there appear in Altare's acts indications that were previously unknown. Nobles apparently appeared in the village at the same time as the emigrants to France returned home. In this case, the social valorization of objects was accompanied by that of the artisans themselves. However, this was quite exceptional, even if in Murano it was also 'probably through the glass masters, whom Colbert

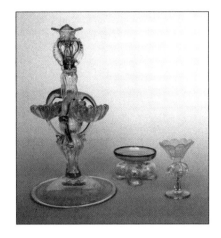

Figure 9.2 Bernard Perrot's workshop, group of objects with red glass decorations. Orléans, France, seventeenth century (courtesy of J. Geyssant).

[112] Archives Départementales de Loire Atlantique, B. 65, fols 290–298. They can also be found in Archives Nationales, R. 985.

[113] The article on 'Privilege' in the Encyclopedia clearly distinguishes between privileges inherent to people and the exclusive privilege that is 'the right that the prince grants to a company or an individual to carry out a trade, or to manufacture & sell a certain kind of goods to the exclusion of all others'.

[114] See Robert Descimon's work, notably 'Chercher de nouvelles voies pour interpréter les phénomènes nobiliaires dans la France moderne. La noblesse, "essence" ou rapport social', *Revue d'Histoire Moderne et Contemporaine*, 46/1 (January–March 1999): pp. 5–21; see also George Huppert, *Bourgeois et gentilshommes, la réussite sociale en France au XVIe siècle* (Paris, 1983).

called to work in Paris, that the concept – of nobility – entered the collective consciousness of Murano craftsmen'.[115]

Conclusion

It would seem that the example of glass studied here demonstrates the extent to which the dialogue between Mediterranean Europe and northwestern Europe deserves to be developed, as mentioned in the introduction. Contrary to claims that link 'new luxury' to a new 'desire to consume' of the emerging social classes of northwestern Europe in the seventeenth century, the case of glass objects (as well as ceramics, for that matter) shows that defining value not on the intrinsic cost of raw materials used, but on a set of aesthetic judgments, dates much further back. The social construction of the ostentatious value of glass is certainly an innovation of the Renaissance, which must be linked to a new respect for human genius.

This desire for novelty, which accompanied the valorization process, was satisfied through constant technical research. Though the economy of conventions can help to better understand the co-existence of different forms of qualitative conventions, we need to question the clear distinction between relatively hermetic production worlds, which are either spread across time or which co-exist without any interpenetration. As we have seen, the social construction of new values for certain glass objects gave rise to a marketing process that was partly based on the return of interpersonal relationships, unlike the previous disconnection. The same glass masters created objects whose modes of production and marketing seem to belong to conventions for different qualities. Changes are far from linear, contrary to a pre-conceived notion that exchanges would switch from an interpersonal mode to an anonymous market. The worlds of production and marketing are not necessarily perfectly separated; different modes of co-ordination can co-exist within the same manufacture.[116]

This also helps us to reconsider the role of various institutions, from guilds to political authorities, especially in terms of setting prices. Because glass artefacts are non-branded luxury goods, they offer an original viewpoint from which to reconsider the issue of brands in trade under the *ancien régime*.

This change in the appraisal process does not call into question social hierarchy. In fact, the main players in this process are not the Italian 'middle classes' who turned to glass replicas of valuable objects that were beyond their economic reach, but rather the elite and the princely courts of the Renaissance.

[115] Trivellato, *Fondamenta*, p. 86. See all of chapter III for social change.
[116] Eymard-Duvernay, 'Conventions', p. 348; Salais and Storper, *Les mondes de production*.

However, the multiplicity of production sites linked to the European migration of glass-makers led to competition and emulation that affected both the price and value of products. Though aristocrats were the first to possess these glasses, as described above, starting in the seventeenth century, such 'Venetian glasses' were to be increasingly found in more varied social circles.[117] These objects were used by the urban middle class as wedding presents, for example. The clergy used them, although Rome banned them from liturgical services because of their fragility.[118] Guilds used the glasses to 'drink together', a prominent part of corporate rituals, whereas merchants apparently used them when signing contracts or as ostentatious decorations during business or social meals. Inns, too, chose amusing glasses of various shapes, which were an important element of the establishment's reputation.[119]

This widespread use, however, did not mean that the differences between social classes were dwindling. As the social value of *façon de Venise* glass diminished, new types of glasses emerged. The development of English flint glass and *façon de Bohème*[120] cut glass was stimulated by the success of *façon de Venise* glass; however, these innovations were clearly different from their ancestor.

Despite this, can we truly state, along with Maxine Berg, that flint glass was 'a New Product for a New Market'?[121] At least two reasons call into question such an assertion. To begin with, this new product occupied the place long held by ostentatious Venetian glass. Furthermore, social demands for glass products were not new and were not initiated by the English innovations. In sum, there is reason to fear that 'the English domination of world glass markets during the eighteenth century' has been proven only by the general lack of comparative studies.

[117] Page, *Beyond Venice*.
[118] Page, 'Introduction', pp. 16–17.
[119] Page, 'Venetian Glass in Austria', pp. 25–28; Domenech, 'Spanish Façon de Venise Glass', pp. 88–89; Gaban-Van Dongen, 'Longing for Luxury', p. 97; Hugh Willmott, 'Venetian and Façon de Venise Glass in England', in Page (ed.), *Beyond Venice*, p. 272; and Heikamp, *Studien*, pp. 264–265 insist precisely on these 'eccentric' glasses as they were called in France in the early seventeenth century; *scherzosi, vessatori, di fantasia* in Italian.
[120] On links with Italian glass, see Olga Drahotova, *Le verre de Bohème* (Prague, 1970).
[121] Berg, *Luxury and Pleasure*, pp. 119–121.

Chapter 10

The Veneer of Age: Valuing the Patina of Silver in Eighteenth-Century Britain*

Helen Clifford

Introduction

In 1992 the British Broadcasting Company produced a television series that presented *Signs of the Times – A Portrait of the Nation's Tastes*, which asked members of the public to volunteer information about aspects of their taste in the home.[1] Attitudes to 'old things' were divided into two camps: those that wanted only new things ('I'm put off real antiques because to me they look old and sort of spooky'); and those that did not ('By and large I would always prefer to go to antique shops and markets rather than to department stores'). When did this dichotomy begin? Can it be traced back to the eighteenth century, a period of fundamental change in manufacture and consumption that heralded the birth of 'modern Britain'?

My exploration of this question first appeared in a much shorter form as a contribution to an edited collection of essays in a book on the ethics of conservation.[2] In it, the authors addressed the issue of how conservators contribute to the social process by which the material and values associated with objects, buildings and sites are transmitted through time. One of the most long-running and impassioned debates in conservation relates to the removal, or not, of patina.[3] Until the 1880s, at the Louvre and elsewhere it was the policy to make the old new; restorers filled in missing pieces, concealed broken edges

* I would like to thank Bert De Munck and Ilja Van Damme for inviting me to give this paper at their 'Location of Value' session at the World Economic History Congress in Utrecht in 2009. Greatest thanks go to Bert De Munck and Bruno Blondé for making me persevere with the paper, and for suggesting so many improvements.

[1] Martin Parr and Nicholas Barker, *Signs of the Times, a Portrait of the Nation's Tastes* (Manchester, 1992).

[2] Helen Clifford, 'The Problem of Patina: Thoughts on Changing Attitudes to Old and New Things', in Alison Lee Bracker and Alison Richmond (eds), *Conservation: Principles, Dilemmas and Uncomfortable Truths* (Amsterdam, Boston and New York, 2009), pp. 125–128.

[3] For example, see Denis Mahon, 'Miscellenea for the Cleaning Controversy', *Burlington Magazine*, 104 (1962): pp. 460–470; Rutherford J. Gettens, 'Patina: Noble and Vile', in Suzannah Doeringer, David Gordon Mitten and Arthur Richard Steinberg (eds), *Art and Technology: A Symposium on Classical Bronzes* (Cambridge, 1970), pp. 57–72.

and repainted old Etruscan vases where the glaze had flaked off. Although few would condone such practices today, debates still rage about the cleaning, or not, of paintings and buildings. An examination of what was understood by the term 'patina' in the eighteenth century, the type of objects to which it was applied, and the change in responses towards it over time, provide a means of investigating attitudes towards 'old' and 'new' objects and the concepts of value that they represented.

The following reworked and extended contribution is written from the perspective of a museum curator, actively involved with issues surrounding the interpretation of material culture, who has a background in eighteenth-century British social and economic history. In it, we will consider how we think about the different values of an object within the culture that made, used, kept and collected it. We will ask if it is possible to identify changes in attitude to objects as they aged. There is a fascinating relationship between objects and words, how things are described, and how their value (in the broadest possible sense, economically, culturally and socially) changes over time. We will take up Arjun Appadurai's idea of 'regimes of value' within which objects circulate in space and time, moving in and out of their status as 'commodities'.[4]

The Surface of Things: Defining Patina

First, what do we mean by 'patina'? Patina can technically be most broadly defined as the weathering or aging of the exposed surface of a material, which can involve colour change: copper turns green, lead goes from silver to grey, and silver acquires a lustrous blueish surface. Patina can be created naturally by the oxidizing effect of the atmosphere or weather, or artificially (a German goldsmith 'aged' coins by shaking them in a mixture of fatty broth and iron filings).[5] However, 'the characteristic mellow lambency' of patinated silver has its origin, in large measure, in its physical 'wear-and-tear'.[6] Patina is 'everything that happens to an object over the course of time. The nick in the leg of a table, a scratch on a table top, the loss of moisture in the paint, the crackling of a finish or a glaze in ceramics, the gentle wear patterns on the edge of a plate' (Figure 10.1).[7] Patina is by definition the mark of use and age.

[4] Arjun Appadurai, 'Introduction: Commodities and the Politics of Value', in Arjun Appadurai (ed.), *The Social Life of Things: Commodities in Cultural Perspective* (Cambridge and New York, 1986), p. 4.

[5] Adolf Rieth, *Archaeological Fakes* (New York, 1970).

[6] Seymour Rabinovitch, 'The Patina of Antique Silver: A Scientific Appraisal', *The Silver Society Journal*, 1 (1990): pp. 13–22.

[7] Israel Sack, http://www.pbs.org/opb/historydetectives/technique/geological-analysis/.

Aesthetic pleasure in the patina of age is first recorded in China from the ninth century. Collectors delighted in the colours of ancient Shang and Chun bronze urns which, via a thousand years or more of burial, had acquired rich patinas. However, in Europe it has been 'only since the sixteenth century [that] ... the look of age became widely appreciated, first as a means of confirming and authenticating historical antiquity, then as attractive in its own right'.[8] At this time the admirers of patina belonged to the elite. 'During most of history men scarcely differentiated past from present more generally, let alone in relation to specific types of object. It was only in the mid-eighteenth century that the wider public, and particularly in Britain, that marks of age were considered attractive', and were admired as part of the broader Picturesque appreciation of nature.[9] 'It is a striking paradox', notes Charles Dellheim, 'that as England became the first industrial nation, it became increasingly fascinated by its pre-industrial past', and by association with the objects which came from it.[10]

Figure 10.1 Detail of the reverse of a silver dinner plate, London, c. 1750.

No hallmarks, showing extensive patina (scratches and wear), centre point and engraved number '30', indicating the position of the plate in the complete dinner service, along with ducal coronet for the Bouverie family. Private collection (photograph courtesy of ScenicView Gallery).

Beyond the Surface of Patina

Deeper examination of the meanings associated with the word 'patina' leads us into more complex and contested territory. Although the word 'patina' relates to the surface of things, whether buildings, paintings, bronze or silverware, its

[8] David Lowenthal, *The Past Is a Foreign Country* (Cambridge and New York, 1985), p. 142.
[9] Lowenthal, *The Past*, p. xvi.
[10] Charles Dellheim, *The Face of the Past: The Preservation of the Medieval Inheritance in Victorian Britain* (Cambridge and New York, 1982), p. 45.

presence undoubtedly 'influences our understanding and appreciation of the object well beyond any actual ... surface change'.[11] The aesthetics of patina reflect a host of chemical and cultural variables. By 'our very association of the word patina with an art or historical object, the object is inflected with an aura giving it greater substance, seriousness and interest'; but what happens when the word is applied to a non-art object?[12]

The word itself has become embedded in our language and acts as a sign of value. The eighteenth-century blue-stocking Lady Mary Wortley Montagu (1689–1762) made a distinction between the patina 'lustre of real worth and mere conspicuousness' in her discussion of the moral standing of women.[13] Patina is the opposite of unsightly tarnish. When Lord William Fitzherbert wrote to Thomas Robinson, 2nd Baron Grantham, in 1782, remarking on the French navy whose glories had been 'so cruelly tarnished by Lord Rodney's Victory', he is clearly communicating their loss of standing.[14] Patina implies the gain of value, tarnish its loss.

Rich in meaning and association, the word 'patina' has been adopted and deployed by historians over the last 20 to 30 years in a variety of ways to articulate attitudes towards the past. They employ the term in two broad ways: one in relation to the concept of the historical past in general; the other in more specific ways concerned with consumption patterns.

The historical geographer David Lowenthal used the word to explore different ideas in connection with the idea of heritage and how it has been valued. In *The Past Is a Foreign Country* (1985), he examined the moment when the 'past ceased to provide comparative lessons [and] ... came to be cherished as a heritage that validated and exalted the present'.[15] Throughout the book he contrasts a more common preference for the new; he observes that 'ageing artifacts are mostly jettisoned without compunction when they have served their use',[16] compared with the minority whose 'affection for certain patinas of age are well attested. But such admiration is the exception'.[17] While Lowenthal adopts the same strategy as *Signs of the Times* in playing the old against the new in direct contrast, he admits that 'These viewpoints shape conflicting but often co-existing perspectives', and the choice between them 'affects not only what we decide to recall and preserve, but how we distinguish past from present'.[18]

[11] Mark Golden, 'Defining the Acrylic Patina', *Just Paint*, 23 (2011): p. 2.
[12] Lowenthal, *The Past*, p. 140.
[13] Ibid., p. 126.
[14] Bedfordshire and Luton Archives, Wrest Park Manuscripts, L 30/14/137/5, 9 December 1782.
[15] Lowenthal, *The Past*, p. xvi.
[16] Ibid., p. 143.
[17] Ibid., p. 127.
[18] Ibid., p. 125.

Writing from a contemporary maker's point of view, David Pye takes it for granted that 'we prefer things not to have been affected by age and wear'. Why, he asks, is this so? Because 'we do not like to think of ourselves aging, and we project this feeling onto our possessions. When we renew them we half imagine we are renewing ourselves'.[19] Pye further suggests that we 'like things new because of what newness symbolizes rather than for any special aesthetic qualities inherent in it'.[20] These observations represent very clearly, although without historical perspective, the 'neophiliac' viewpoint. Where, then, lies this preference for the new, at what time and place does it emerge, and is its triumph over the old such a straightforward trajectory of change?

The historian Grant McCracken used the concept of patina to frame changes in consumption habits. He argues that it was only in the eighteenth century that patina 'ceased to be valued, as it was replaced by "Fashion"'. Patina and fashion, for McCracken, represent old and new systems of consumption. In the past, he argues, objects that had the wear of time 'reassured an observer that ... [they] had been a possession of the family for several generations, and that this family was, therefore, no newcomer to its present social standing'. McCracken explained that as the attraction of age and tradition dwindled, new and fashionable goods became more desirable than those that suggested long-standing wealth and prestige.[21] These could be purchased by anyone with money. As Jan De Vries phrased it: 'purchases became more purely acts of consumption and less acts of "investment"'.[22] De Vries refines the patina versus fashion model by adding the concept of 'breakability' to the equation, whereby European material culture saw 'a broad and complex transformation [with] ... the gradual replacement of expensive, durable products possessing a high secondary market value by cheaper, less durable, more fashion sensitive goods'.[23] In other words, 'Durability, ostentation and intrinsic value declined in importance relative to the rise of new and less durable materials'.[24] Silver was replaced by chinaware, pewter and horn by glass, and tapestry by wallpaper.

[19] David Pye, *The Nature and Art of Workmanship* (London, 1968), p. 65.

[20] Ibid., p. 68.

[21] Grant McCracken, '"Ever Dearer in our Thoughts": Patina and the Representation of Status before and after the Eighteenth Century', in Grant McCracken, *Culture and Consumption: New Approaches to the Symbolic Character of Consumer Goods and Activities* (Bloomington, 1988), p. 37.

[22] Jan De Vries, *The Industrious Revolution: Consumer Behaviour and the Household Economy 1650 to the Present* (Cambridge and New York, 2008), p. 145.

[23] Ibid., pp. 127–128.

[24] Bruno Blondé, Natacha Coquery, Jon Stobart and Ilja Van Damme (eds), *Fashioning Old and New: Changing Consumer Preferences in Europe* (Turnhout, 2009), p. 2.

The Problem with the Patina versus Fashion Model

However, once we start to examine McCracken's model of change more deeply, the strength of its simplicity begins to break down. He admits that the allure of 'patina' did not completely die, but argues that its modern manifestation 'is a pale version of its former self', and is now 'a status strategy used by the very rich alone'.[25] But across what ranks of society did this change take place, was it uniform, and was it such an uncomplicated and total shift in attitude? Since the publication of McCracken's *Culture and Consumption* in 1988, there has been time to test his theory in relation to various social groupings, across geographical and regional areas and amongst a wide range of goods. What emerges is a far more complex, creative and varied consumer response.

Contributors to *Fashioning Old and New: Changing Consumer Preferences in Europe (1650–1850)*, published in 2009, reveal a host of more nuanced strategies of consumption. First, although there has been a tendency to mark out preferences for 'old' and 'new' goods as distinct and oppositional, it is clear from primary evidence such as inventories and accounts, both domestic and commercial, that markets for old and new co-existed, and 'boundaries between the two are never clear'.[26] In his chapter on the Antwerp nobility, Bruno Blondé shows how some households between the 1730s and 1780s shifted to a combined quest for traditional goods that had the 'patina glow of history', with the acquisition of more modern porcelain and glassware.[27] It was not a matter of choosing one or the other types of goods, but selecting from both in a 'hybrid consumer pattern'.[28] These findings are echoed in the activities of the richer households in eighteenth-century Norwich.[29] Here Amy Barnett discovered that 'two apparently distinct types of material culture, new and old were being accessed and utilised concurrently'. Such 'combinative' strategies are easy to find in the historical records. For example, Sir John Hussey Delaval (1728–1808), a Northumberland aristocrat, was quite happy to continue purchasing fine silverware for his table at the same time as ordering the latest novelty, Sheffield plate. Both are carefully noted in his household inventories, both adorned his table, and both were admired by his guests.[30]

[25] McCracken, 'Ever Dearer', p. 35.

[26] Blondé et al. (eds), *Fashioning Old and New*, p. 7.

[27] Bruno Blondé, 'Conflicting Consumption Models? The Symbolic Meaning of Possessions and Consumption amongst Antwerp Nobility at the End of the Eighteenth Century', in Blondé et al. (eds), *Fashioning Old and New*, p. 74.

[28] Ibid., p. 75.

[29] Amy Barnett, '"In with the New": Novel Goods in Domestic Provincial England c. 1700–1790', in Blondé et al. (eds), *Fashioning Old and New*, p. 82.

[30] Helen Clifford, 'Innovation or Emulation? Silverware and Its Imitations in Britain 1750–1800: The Consumers' Point of View', *History of Technology*, 23 (2001):

It is also clear that different goods were part of different cycles of change, reducing or enhancing the contrast between old and new, depending on which commodities are analysed. While the fashion in ribbons shifted monthly, that in hats changed yearly, and furniture styles evolved by decade.[31] Lowenthal suggests another division between goods, where 'appreciation of wear and tear depends on whether the object is used for utility or ornament'. He suggests that 'we expect most functional objects to become less attractive through age', the opposite being true of 'art'. However, as he later comments, it is difficult to sustain these distinctions.

There are also very different cultural attitudes to take into account, across place as well as time. For example, the classical historian and curator Michael Vickers challenges the widely held view that Greek pottery vases were objects of great value in Antiquity, commissioned by rich patrons from the greatest artists of the day. Instead, he suggests that they were simply low-cost versions of tableware originally made in silver and gold.[32] He demonstrates how Greek pottery first came to be regarded as a high-value commodity in the eighteenth century, thanks to clever, if not fraudulent, sales techniques. While arguing his polemical position, he explains that the red on black terracotta wares was imitating tarnished silver, suggesting that the ancient Greeks, like the modern Russians, preferred their silver black to shiny. This runs counter to the English pursuit of well-polished plate.

References to 'old' goods actively increase rather than decrease from the mid-eighteenth century, as evidenced in accounts, inventories, wills and letters. The increasing deployment of the term 'patina' coincided with a wider growth in interest in 'old things', which has been identified in many fields of art and craft. For example, from the 1760s the pages of *The Gentleman's Magazine* reveal a growing number of reports relating to 'old silver', indicative of a new interest in its historical form.[33] Clive Edwards, in his study of the English furniture

p. 75; idem, *Silver in London: The Parker and Wakelin Partnership 1760–1776* (New York, 2004), p. 43.

[31] Neil McKendrick, 'The Commercialization of Fashion', in Neil McKendrick, John Brewer and John Harold Plumb (eds), *The Birth of a Consumer Society: The Commercialization of Eighteenth-Century England* (London, 1982), p. 42.

[32] Michael Vickers, 'Artful Crafts: The Influence of Metalwork on Athenian Painted Pottery', *Journal of Hellenic Studies*, 105 (1985): pp. 108–128; Michael Vickers and David Gill, *Artful Crafts: Ancient Greek Silverware and Pottery* (Oxford, 1994). Black glaze replicates silver, red-figure reflects gold figures applied to a silver background, black-figure imitates silver figures on a bronze or gold ground. Purple translates as copper, white as ivory.

[33] Helen Clifford, 'Revival and Reproduction Attitudes to the Antique', in Helen Clifford, *A Treasured Inheritance: 600 Years of Oxford College Silver* (Oxford, 2004), pp. 112–123.

trade, remarks on 'the growth in interest in old things from the later eighteenth-century',[34] although he notes that 'it is difficult to pinpoint the development of specific antique dealers'.[35] The novelty of these 'old' goods 'did not lie in their taste for vanished forms', argues Manuel Charpy in his work on Parisian auction houses, 'but in that authenticity for items preserved from adulteration'.[36] 'Antiques dealers and interior decorators were useful auxiliaries as they added patina.'[37] Patina, for collectors, increased the value of things; it was a mark of authenticity. It was in this spirit of 'authenticity' that Mr Sewell advised Mr Wickham, in a letter of 1775, that 'the crust or patina' of a Roman coin should 'not be removed [as] it is evidence of the coin's antiquity'.[38] A growing language of discrimination was developing that helped aspiring antiquarians to recognize true from false patinas; as demand grew, so the market responded with the production of 'fakes'. Others, like William Beckford (1760–1844), happily combined 'old' objects with new mounts to create customized antiquities that made the best of both novelty and age.[39] Beckford was as much an 'adapter' as 'adopter' of material culture.

Silverware as a Working Asset

A good way to test these more nuanced and active (rather than passive) ideas of the consumer's relationship with 'the veneer of age' is to apply them to a specific category of goods. For the rest of this chapter we will investigate this rich terrain with a particular focus – wrought silver, made in England in the eighteenth century – as a means of anchoring our investigation in the material world. This material, place and time lie at a point of change, offering a wealth of evidence and opportunity for analysis. Wrought silver, more than any other commodity, reveals the tension between the relative values of design and intrinsic worth. The eighteenth and early nineteenth centuries witnessed major changes in the relationship between labour relations and the location of value. Furthermore, the amount of surviving evidence, both archival and artefactual, relating to

[34] Clive Edwards, 'Perspectives on the Retailing and Acquisition of New and Old Furniture in England 1700–1850', in Blondé et al. (eds), *Fashioning Old and New*, p. 81.

[35] Ibid., p. 51.

[36] Manuel Charpy, 'The Auction House and its Surroundings in the Trade of Antiques and Second-Hand Items in Paris during the Nineteenth Century', in Blondé et al. (eds), *Fashioning Old and New*, p. 217.

[37] Ibid., p. 219.

[38] Lancashire Record Office, Hornby Catholic Mission Papers (St Mary's Church), Correspondence Ref: RCHY 3/7 1775: Draft Letter of N. Sewell at Preston to E. Wickham.

[39] Gervase Jackson-Stops (ed.), *The Treasure Houses of Britain: Five Hundred Years of Private Patronage and Art Collecting* (Washington, 1985), p. 574.

silverware allows us to make a close reading of terms and concepts. There are four specific 'arenas' that will be considered in relation to ideas of value: materials, workmanship, technology and consumption. By looking at ideas surrounding these factors and stemming from our enquiry into patina, new light can be thrown on their complex inter-relationship.

The Changing Equation between Intrinsic Value and Labour Value

Objects made from precious metal provide a particularly appropriate focus for an exploration of ideas about value.[40] Unlike bills for most luxuries, those for silverware, because of the intrinsic value of the material, distinctly state the cost of the metal and the workmanship. The cost of silver was relatively stable in the eighteenth century, and would have been known by maker, retailer and consumer. As one London silversmith explained: 'the market for silver rises and falls the same as corn and other trades; sometimes we can afford to give five shillings and a penny; sometimes five shillings and two-pence, sometimes five shillings'.[41] 'Fashioning' or making was a more fugitive cost to calculate; it was sometimes expressed as a separate figure within the calculation of the price of an object in the customer's bill. Thus the purchase of a soup ladle in 1758 by Brasenose College Oxford is noted as 'To a soup ladle' weighing 9oz 10dwt at 5s 9d per troy ounce of silver which cost a total of £2 14s 7d for the silver, plus a separate £1 4s for 'making'. The total cost of the ladle was therefore £3 18s 7d. The production cost less than half the price of the metal. Labour was cheaper than the material.

The cost of the tureen and cover for which the ladle was supplied is noted in a different way on this same bill. The charge for production is combined with the cost of the metal to give a single sum of £54 7s 6d, charged at 8s per troy ounce. This includes the cost of the 135oz 19 dwt of silver at 5s 9d per troy ounce, plus making at 2s 3d per troy ounce. The latter format obscures the relative costs of production and material. Although the bill implies that the tureen and ladle were made new in 1758, the consumer guarantee of intrinsic value, the hallmarks, reveal that it was assayed in 1750–1751.[42] The bill is made out by the

[40] Helen Clifford, 'A Commerce with Things: The Value of Precious Metalwork in Early Modern England', in Maxine Berg and Helen Clifford (eds), *Consumers and Luxury: Consumer Culture in Europe 1650–1850* (Manchester, 1999), pp. 147–148.

[41] Old Bailey, t17810222-32, Samuel Shelley indicted for receiving stolen silver, 22 February 1781, found guilty, imprisoned with one year's hard labour on the Thames. Cf. Arthur Girling Grimwade, *London Goldsmiths 1697–1837* (London, 1976), p. 657.

[42] Paul de Lamerie died in July 1751. His will of 24 May 1750 ordered all plate in hand to be finished and stock to be auctioned by Langford of Covent Garden. See, further, Grimwade, *London Goldsmiths*, p. 488.

retailers Wickes and Netherton and the hallmark is that of Paul de Lamerie. The survival of both the order and the bill that describes it reveal that the tureen and ladle were purchased second-hand.

The trial at the Old Bailey of the London silversmith Samuel Shelley in 1781 for receiving stolen plate provides a window into the world of the sale of 'old' silver. It reveals in more detail how the decision was made to either melt or sell silver that was received in payment from customers or bought at sale. Calculations about what was in fashion and what was old-fashioned were essential and constant in the silversmith business. When Shelley was asked: 'Is it not very common in your business to buy articles of plate and sell them in the form in which they are as second-hand plate without melting them down?', he replied: 'It is very common where they are serviceable', agreeing that he did 'not of course melt down all that ... [he] buys of old plate'. The interrogation continued: 'When you sell it as second-hand plate do you sell it at 5 s. an ounce?'; 'Very seldom – we sell it for more, if we can get it, if it is tolerable fashionable we sell it at six shillings, and up as high as seven shillings an ounce'. When asked if this was usual, Shelley responded: 'Very seldom; ... [it] depends entirely upon what articles they are, there are a great number of articles though old fashioned, are very expensive in the making', and added that the usual price given was 6s 6d per ounce. So if a shopkeeper had 'it in his power and don't mind laying out of his money to keep the plate in his shop, and wait the chance of a customer', it was worth selling it as second-hand. He further commented that 'the sooner old fashioned table-spoons are in the melting pot the better for the purchaser; it is like locking up money and throwing the key away'.[43] Nearly all surviving eighteenth-century silversmiths' trade cards advertise the purchase of 'old plate', although they seem to be divided between those who state 'Most money for old silver' or 'Utmost value given for old plate', and those who 'Deal in Second-hand plate ... at Reasonable Prices' or 'Buy and Sell Second-hand Plate'. There is also a division in auction catalogues between silver that is sold 'Per Ounce' and that which fetches more than the weight.

Up until the latter half of the eighteenth century, customers who traded in their silverware to help pay their bills received only their bullion and none of the production value back. After this, a growing market for specific types of 'old' silver began to turn the balance between the values of metal and workmanship. As Laurence Fontaine reminds us: 'paying for new objects by getting rid of older ones was common practice' in the luxury trades, and not confined to silverware, although we know less about the precise shift in relative values over time.[44]

[43] Old Bailey, t17810222-32, as above.
[44] Laurence Fontaine, 'The Circulation of Luxury Goods in Eighteenth-Century Paris: Social Redistribution and an Alternative Currency', in Maxine Berg and Elizabeth Eger (eds),

After the foundation of the Bank of England in 1694, the value of silver as a hoardable reserve of convertible currency (where wrought metal could be melted and turned into cash) began to decline, as credit was secured on less tangible assets such as stocks and shares.[45] The decline in interest in the weight of a piece of silverware is reflected in the increasingly unusual practice of scratching the weight of a piece of silver on its base. From the mid-eighteenth century, college, corporation and household inventories reveal that the practice of weighing silver at audit (and comparing against the scratch weight) seems to have declined. The value in weight began to mean less than its 'look', in both certain types of old and most new plate.

The New as Old: The 'Antique' and the Language of Early Modern Retail

Yet the division between 'old' and 'new' silverware is rarely clear-cut, even brand new, novel and fashionable objects borrowed from the symbolic repertoire of the 'old'. In the language of early modern retailing, the 'antique' referred not necessarily to 'old' objects, but more commonly to new commodities that copied shapes and decorative details of 'old' ones, most popularly in the second half of the eighteenth century from Greek and Roman artefacts and architecture. When Thomas Robinson, 2nd Lord Grantham, wrote to his agent in 1776 regarding the procurement of some vases, he used the word 'antique' in this new way: 'In the end I entrust myself to your good taste, to provide a simple, beautiful, and antique shape to these vases which are very precious in themselves. I prefer silver to gilded bronze as they are intended for table'.[46] The 'Antique Tea Urn with a Lamp' which cost the Earl of Coventry £48 1s 6d in 1793 was a thoroughly modern and fashionable object. These 'urns', which began to appear in the mid-1760s, were based on classical vase forms, but incorporated the latest technology in several different ways. They were a hybrid of old and new.

First, these tea urns tended to be made from newly available 'flatted' sheet silver. By the mid-eighteenth century, new machines, like the flatting (or rolling) mill, enabled sheet silver to be rolled quickly, to standard gauges, and very thin.[47] Before then, the metal had to be hand-hammered into sheet, which was both time-consuming and heavy work. The transformation of an ingot of metal into

Luxury in the Eighteenth Century: Debates, Desires and Delectable Goods (Basingstoke and New York, 2003), p. 95.

[45] Helen Clifford, 'Of Consuming Cares: Attitudes to Silver in the Eighteenth Century', *The Silver Society Journal*, 12 (2000): p. 53.

[46] Bedfordshire and Luton Archives and Record Service, L 30/14/229/1, Letter, 17 December 1776, from Thomas Robinson, 2nd Baron Grantham to Monsieur Luig.

[47] Although the first rolling mills had appeared in the 1590s for iron, then later for tinplate and lead, they were not applied to silver until the 1740s.

fine sheet with such speed and consistency had an air of magical performance about it. The use of lighter-weight metal meant that domestic objects could be made from less silver, while adopting the most fashionable forms. The popularity of cylinders, cubes and other polygonal forms in silverware from the late 1760s reflected the ease with which the newly flatted silver could be scored, bent and soldered into shape. Compared with raising (hammering), which took time, and casting, which took proportionately more metal, flatted sheet offered a relatively cheaper and quicker means of fabrication, although its manipulation in this way often required a specialized apprenticeship in its own right.

Second, the tea urns deployed a newly available piece of patented heating technology, the installation of a charcoal brick, which, fitted with a central flue and tap, heated the water and dispensed far more efficiently than the earlier tea kettles, which were heated by rather expensive (and smelly) spirits of wine.[48] The first piece of plate assayed at the newly opened office in Birmingham in 1773–1774 was significantly one of these 'antique' tea urns by Boulton and Fothergill.[49] The trade card of C. Stibbs, a London cutler, jeweller and goldsmith, illustrates one of these new urns, proudly labelled 'patent', clearly a selling point in its own right.

Third, these urns were increasingly decorated with a distinctively different and brand-new type of engraving which appeared in the 1770s, called 'bright cut'. Using the same hand-operated burins used for earlier engraving, bright-cutting involved the cutting out of triangular notches of silver from the surface which reflected the light in a more showy manner than the cursive former type of engraving.[50] These new forms of decoration exploited the advantages of better sources of artificial light within the home. Over the course of the eighteenth century, household inventories reveal a growing number of candles, lanterns and chandeliers, with the added refinement of wax over tallow.[51] The new bright-cut engraving twinkled in this enhanced light.

Not only did these new objects incorporate the idea of the 'old', but they also, as a result of these technological advances, became available to a wider, and growing, lower middle-class market. Their association with an earlier form appears to have given these 'new' objects a credibility, status and familiarity that

[48] See John Wadham's patent of 1774, discussed in Michael Clayton, *The Collectors' Dictionary of Silver and Gold of Great Britain and North America*, Antique Collectors' Club (New York, 1971), p. 424.

[49] Clifford, *Silver in London*, p. 134.

[50] It was not just precious metalware that catered for this new taste for glitter. Cut steel jewellery became the vogue from the 1750s; the tiny facets of metal refracted light with a glare that imitated, and for a time challenged, the popularity of the diamond, either real or paste. However, cut steel was not a cheap alternative; it acquired its own aesthetic and became fashionable in its own right.

[51] De Vries, *The Industrious Revolution*, p. 129.

made them not only acceptable but also desirable. They suggest a 'past freshly made or revived' versus a past 'convincingly scored by time and use' which answered subtly different needs.

The New as Old: Wrought Silver, the Power of Memory and Evocative Value

There is a second arena in which 'new' silver objects sought and acquired the cachet of the old, further blurring the boundary between the two and adding another consumer strategy to the array already considered. As we have seen, it was common practice (and still is, in certain circles) to despatch old 'worn-out items' to the melting pot, rising 'phoenix-like' into 'new, usable pieces'. Sometimes, however, these were engraved with the names, cyphers and attributes of the original donors. 'A nice example of this practice', noted by a college don, 'is that of a fork bearing the inscription D D G Griffith 1652', but 'having a Georgian hallmark'.[52] In such a way 'every generation lives off the largesse of its predecessors' and long-standing symbols of social continuity are transferred. One might dub this 'evocative' value, as it brings to mind a connection with the past.[53] Most silversmiths, like Wickes and Netherton, advertised an engraving service on their trade cards 'in the newest Taste – at the most Reasonable Rates'.

In a similar way, as Bruno Blondé has noted in the households of the newly ennobled Antwerp nobility, new silver was adorned with the sign of 'age' in the form of engraved crests and mottos. 'Silver objects lent themselves for this purpose ... no doubt the family crest was found more often than the inventories led us to suppose'.[54] The ease of engraving silver means that it can be customized and used to anchor the object to a person, place or event (Figure 10.2). In 1756 John Brown's child was willed 'the largest silver waiter which is engraved with the testatrix's late husband's arms'.[55] Mary Viall, spinster of Coventry, left 'six initialled silver spoons to Edward Love'.[56] James Fawcett of Kirkby Stephen, gentleman, left to his wife a 'silver coffee pot and twelve teaspoons and two tablespoons marked AF'.[57] Christopher Buckle of Burgh, esquire, left to his

[52] Magdalen College Oxford Archives, loose sheet, CP2/34.

[53] This term is used by Nicholas Stanley Price, 'The Reconstruction of Ruins: Principles and Practice', in Bracker and Richmond (eds), *Conservation*, p. 37.

[54] Blondé, 'Conflicting Consumption Models?', p. 68.

[55] Coventry Archives, probate will of Ann Pardoe of Lewes, PA/101/7/6, 29 November 1756.

[56] Shakespeare Centre Library and Archives, original will, ER5/1187, 7 June 1762.

[57] Cumbria Record Office, Kendal, copy and office copy will, WD U/Box 59/3/T 22-23, 2 January 1777.

Figure 10.2 Detail of the obverse of a silver dinner plate, London, c. 1750.
No hallmarks, showing extensive patina (scratches and wear), and cypher for the Bouverie family. Private collection (photograph courtesy of ScenicView Gallery).

son a 'large silver waiter, cup and cover with the Hill Arms on them'.[58] Mary Hodgson of Carlisle instructed that her household goods be given to her sons and daughters, 'including her silver teapot and complete set of tea china with the Hodgson arms thereon'.[59]

There was a further level of instruction in wills that could influence the status of the silver; it could be designated as an 'heirloom', along with paintings, books, furniture and small personal objects. In English law, an heirloom was defined as a chattel which by immemorial usage was regarded as annexed by inheritance to a family estate, which could not be bequeathed by will away from the estate. The word subsequently acquired a secondary meaning, applied to goods, like furniture, paintings and silver, vested in trustees to hold on trust for the person for the time being entitled to the possession of a settled house. Heirlooms are a special form of gift, which 'link things to persons and embed the flow of things in the flow of social relations' and as such are withdrawn from Appadurai's 'commodity candidacy'.[60]

[58] North Yorkshire Record Office, Kiplin Hall Archive, copy will, ZBL I/2/1, 14 March 1781.

[59] Cumbria Record Office, Carlisle, probate of the will, D SHEFF 7/13/1, 1795.

[60] Appadurai, 'Introduction', p. 11.

There is an increasing tendency during the eighteenth century to assign objects as heirlooms in wills. Silverware frequently appears as heirlooms with other types of goods that are deemed to have strong connections with people and places. There is often, although not always, an added layer of description that qualifies the 'personal' relationship that these 'old' objects have with their owners in the archival evidence. When Richard Hill of Hawkestone in Shropshire made his will in 1725, he left to his nephew Rowland Hill 'the use not the property of his library at Richmond during his life and for the use of his heirs male after him for their lives', and included 'the library and plate to be heirlooms to his house'.[61] John Mytton left to John Walcot and William Owen 'all [his] gold and silver plate, household goods and furniture, on trust to allow them to descend as heirlooms to the person entitled to the estate'.[62] In 1755 Gervase Gardiner received 'Specified silver, engraved with arms of Winfield and Pole families respectively, as heirlooms'.[63] An inventory was 'made of the silver plate, pictures, and furniture which the late Duchess of Norfolk gave ... and which the testator consigns to his executor as heirlooms'.[64] Charles Turvile of Grays Inn, London, gave to his brother George and son a 'Silver salver presented to him by the Cisaloine Club ... to be passed on as an heirloom'.[65] These instructions appear to have been attempts to protect these personal effects from being cashed in for their bullion value. Those who bequeathed them clearly wanted them to survive as objects, not simply as a reserve of redeemable value, and to evade the more usual fate of eventually old-fashioned silver.

Conclusion

At the very time that McCracken argues that the age of things is becoming less important, we have an expanding vocabulary to identify, describe and analyse it. The 'veneer of age' turns out to be not only a physical property of 'things', but also a means to understand their rich economic, social and cultural context. Our investigation into what was deemed valuable in relation to eighteenth-

[61] Shropshire Archives, will, 112/1/1866, 1726.
[62] Shropshire Archives, The Halston Collections, 2313/123, 21 March 1752.
[63] Nottinghamshire Archives, Fillingham of Syerston, limited administration of goods of Mary Pole, of Parkhill, Barlbrough Derbyshire, spinster, granted to John Fox of Newark, gent., in respect of premises in Syerston held in mortgage assigned to M.P. in 1743, DD/FM/14/39, will: 12 May 1754.
[64] Coventry Archives, Hughes and Masser Solicitors, probate copy 18 June 1783 Will of Rt. Hon. Hugh [III], Lord Clifford, Baron of Chudleigh, PA 202/25/3 m19c.
[65] Leicestershire, Leicester and Rutland Record Office, copy will, DG39/927, 13 January 1836.

century wrought silver reveals a complex interweaving of physical and cultural attributes. While there are strong similarities across European cultures, there are also major differences, yet to be fully explored. In order to understand and appreciate the complexity of 'things', we need far more interdisciplinary discussion. The result would be a far more subtle, if complex, appreciation of the objects that occupy them.

Chapter 11

The Value of a Collection: Collecting Practices in Early Modern Europe[1]

Adriana Turpin

'A man who knows the price of everything and the *value of nothing*.'

Oscar Wilde
Lady Windermere's Fan

Introduction

The question of value as perceived by the collector asks the historian to move from the traditional history of collecting to place the collector within the market, where his role can be described both as consumer and supplier. Because the story of collecting and the role of collectors has been seen primarily from the point of view of the museum curator or cataloguer, and more recently the cultural historian, the collector is not necessarily perceived within the context of economic studies. While art historians have long addressed the importance of patronage and recently there have been studies addressing the motives of patrons in terms of value, this is less true in the study of the history of collecting.[2] Equally there is a growing body of literature on the art market, in which collectors play a

[1] I would like to thank in particular Susan Bracken and Sylvia Davoli for their comments, Humphrey Morison for his advice and criticism, and my students for their interest, comments and useful discussions, both in class and without. I would also like to thank Bert De Munck and Bruno Blondé for their invitation to join this discussion, and for their valuable comments and suggestions.

[2] Important essays where value is considered include Susie Butters, 'Making Art Pay: The Meaning and Value of Art in Late Sixteenth-Century Rome and Florence', in Marcelo Fantoni, Louisa Matthew and Sara Matthews-Grieco (eds), *The Art Market in Italy 15th–17th Centuries* (Modena, 2003), pp. 25–40; Elisabeth Honig, 'Art, Honor, and Excellence in Early Modern Europe', in Michael Hutter and David Throsby (eds), *Beyond Price: Value in Culture, Economics, and the Arts* (Cambridge, 2008), pp. 89–105; Elizabeth Honig, *Painting and the Market in Early Modern Antwerp* (New Haven and London, 1998); see also Koenraad Jonckheere, 'Supply and Demand: Some Notes on the Economy of Seventeenth-Century Connoisseurship', in Anna Tummers and Koenraad Jonckheere (eds), *Art Market and Connoisseurship: A Closer Look at Paintings by Rembrandt, Rubens and Their Contemporaries* (Amsterdam, 2008), pp. 81–89.

role, but their motives for collecting are rarely analysed, thus leaving the question of how the collector valued his collection either unasked or only considered as a subsidiary narrative.³ Collecting research tends to concentrate on particular collectors or collections, resulting in monographs or museum catalogues. The purpose of a collection is seen primarily in cultural and social terms, and, as for Oscar Wilde, is not to be relegated to mere economic considerations. Thus, political prestige, dynastic ambitions, personal or diplomatic gifts have been presented as motives in studies of individual collectors but less often linked to economic considerations. Nonetheless, collectors played an important role in the market for art just as much as dealers.⁴ The market provided a setting for the quantifying of value, and, as Pomian has argued, gained importance with the rise of public auctions and dedicated dealers.⁵ Instead of seeing this as an antagonistic process, with wealth situated at the bottom of the hierarchy of value, it is far more symbiotic. Our view regarding the importance of price as a value for the collector derives largely as the result of regarding the art market as more open and transparent. However, as Olav Velthuis has shown, the art market is still not transparent and the motives of collectors still today place the value of a collection outside market terms.⁶

Historically, the collector, I would argue, has never considered his collection primarily in economic terms or for its economic worth, which does not mean that the works of art were not priced, for example, in inventories, in sales, and later in auctions. For the collector, additional factors, usually not quantifiable in economic terms, set the criteria by which he acquires objects. However, the collector does very often acquire objects within the market, which involves the

[3] Among more recent works on the production of art is Michelle O'Malley and Evelyn Welch (eds), *The Material Renaissance* (Manchester, 2007). For studies on the art market, see, among others, Michael North and David Ormrod (eds), *Art Markets in Europe* (Aldershot, 1998); Neil De Marchi and Hans Van Miegroet, *Mapping Markets for Paintings in Europe 1450–1750* (Turnhout, 2006); for Italy, see Fantoni, Matthew and Matthews-Grieco, *The Art Market in Italy*; for the seventeenth century, see Richard Spear and Philip Sohm, *Painting for Profit: The Economic Lives of Seventeenth-Century Italian Painters* (New Haven and London, 2010); for the Low Countries, see, for example, Filip Vermeylen, *Painting for the Market: Commercialization of Art in Antwerp's Golden Age* (Turnhout, 2003).

[4] Interest in the market has also recently been the subject of several exhibitions, such as *Uylenburgh & Son: Art and Commerce from Rembrandt to De Lairesse, 1625–1675* (Dulwich Gallery, 2006); Jean de Julienne in *Esprit et Vérité: Watteau and His Circle* (Wallace Collection, 2011); *Cézanne to Picasso: Ambroise Vollard, Patron of the Avant-Garde* (Musée d'Orsay, 2007); *Matisse, Cezanne, Picasso and the Stein Family* (Grand Palais, 2012).

[5] Krzysztof Pomian, 'The Collection: Between the Visible and Invisible', in Krzysztof Pomian, *Collectors and Curiosities: Paris and Venice 1500–1800* (Cambridge and Oxford, 1990), pp. 39–41.

[6] Olav Velthuis, *Talking Prices: Symbolic Meanings of Prices on the Market for Contemporary Art* (Princeton, 2005).

related issue of price. Thus the two concepts contained within the definition of the value of an object – its monetary use and its importance or usefulness to the owner – are inextricably interconnected. However, for the purpose of this chapter and in order to evaluate how the collector's notion of value might change or respond within different historical circumstances, a distinction will be made as regards value as a purely economic concept, interpreted often, although not always, by price and non-economic – or, more accurately, non-quantifiable – considerations.[7] These non-quantifiable values have been defined using anthropological, psychological and cultural approaches, which, as discussed in the introduction to this volume, have become part of economic discourse. The second question that this chapter sets out to address is at what points, in what ways and to what effect can these two interpretations of value be said to intersect and diverge in the early modern period?[8] Thus, in order to consider the question of value and its meaning for the collector, it seemed appropriate to take a broad survey over the period from c. 1500 to the late nineteenth century, drawing on research on specific collectors or collections in order to create a narrative in which value is placed at the centre of the discussion, and using a more or less chronological account to exemplify and identify the various ways in which value of the collection was perceived by the collector.[9]

Collecting and Collectors

In her studies on the social phenomenon of collecting, Susan Pearce has shown how many people in Britain would consider themselves collectors of one sort or another.[10] Taking a psychoanalytical approach, others have attempted to understand how the collector today behaves in given circumstances, and why; and what the importance of the collection is to him/her as an individual.[11] Collecting can be said to be fundamental to

[7] For essays on socio-economic value, see Arjo Klamer (ed.), *The Value of Culture* (Amsterdam, 1996); Hutter and Throsby (eds), *Beyond Price*. Krzysztof Pomian goes further and uses semiotic tools to consider the collection as a sign – or, as he calls it, a *semiophore* – for the collector. Pomian, 'The Collection', p. 39.

[8] Michael Hutter and Richard Shusterman, 'Value and the Valuation of Art in Economic and Aesthetic Theory', in Victor Ginsburgh and David Throsby (eds), *Handbook of the Economics of Art and Culture* (Amsterdam, 2006), pp. 171–208.

[9] By the end of the nineteenth century, the rise in the number of public museums, the increasing internationalization of the art market and the growth of investment in it brought new considerations to the question of value, which will not be discussed in this chapter.

[10] Susan Pearce, *Collecting in Contemporary Practice* (London, 1998).

[11] See Jean Baudrillard, *Le système des objets* (Paris, 1968); Werner Muensterberger, *Collecting: An Unruly Passion: Psychological Perspectives* (Princeton, 1994); Frederick

people's nature, whether this is intrinsic or derives from their relationships with each other.[12] Most children collect at some point or another, although not all go on to be collectors,[13] while many people, whether they consider themselves collectors or not, would agree that they appreciate the objects with which they surround themselves as in some way or other reflecting their character or taste.[14] Although it is often dangerous to view the past through the lens of present understandings, the assumption that certain general characteristics transcend historical contingency provides the justification for using specific examples of collecting to develop a broader argument as to how the collector determines values. Each collector, however, must be placed in his particular context, generally social and political, and within the framework of the cultural and intellectual constructs of his day.

In order to understand the criteria by which a collector might establish value, it is useful to consider firstly what is meant by a collector. Frederick Baekeland starts by separating the collector from an accumulator by stressing that the collector has a rationale in acquiring the contents of his collection: there is a purpose and selection in the collecting process; he often displays his collection and the collection gives him pleasure.[15] Joseph Alsop is still seen as providing the most lucid definition of a collector, who he contrasts with the patron. He makes the essential point that a collector 'is concerned only with buying something for the production of which he has been in no way responsible, even if he buys the work of his contemporaries'.[16] Jean Baudrillard would take the concept of ownership and possession further, stating that the collector is more interested in the acquisition and possession of an object,

Baekeland, 'Psychological Aspects of Art Collecting', in Susan Pearce (ed.), *Interpreting Objects and Collections* (London and New York, 1994), pp. 205–219.

[12] This has also been linked to the question of why people want art. See Ernst Fischer, *The Necessity of Art* (New York, 2010).

[13] As Baudrillard states: 'For the child, collecting represents the most rudimentary way to exercise control over the outer world: by laying things out, grouping them, handling them. The active phase of collecting seems to occur between the ages of seven and eleven, during the period of latency prior to puberty.' Jean Baudrillard, 'The System of Collecting', in John Elsner and Roger Cardinal (eds), *The Cultures of Collecting* (London, 1994), pp. 7–24.

[14] In a lecture on the psychology of contemporary collectors given to students on the MA course in the History and Business of Art and Collecting at IESA London, Massimiliano Tedeschi identified four types of collectors: the individualist, the custodian, the traditionalist and the rebel. The creation of these typologies is a possible development for future research into the collecting patterns of historic collectors as well as contemporary ones. I am very grateful to Massimiliano Tedeschi for discussing with me his insights into the psychology of the collector.

[15] Baekeland, 'Psychological Aspects', pp. 205–206.

[16] Joseph Alsop, *The Rare Art Traditions* (New York, 1994), p. 94.

which can lead to obsession and jealousy in the continual search for what is missing from the collection.[17] Another way of understanding the importance of acquisition in the process of collecting is that the collection itself becomes a new work of art, whose nature transcends the individual nature of each object within the collection.

A collection thus becomes in itself a reflection of the values of the owner, and indeed it is possible to argue that, by bringing together a group of objects and displaying them, the collector replaces the original function or purpose of the objects by giving them a new meaning through the selection and display of the work in his collection.[18] The collection can thus be meaningful as an expression of religious belief, dynastic connections, power, taste, investment or any other value given to it by its owner. In Krzysztof Pomian's terms, the collection becomes a *semiophore*; it acts as a form of representation.[19] As part of the act of collecting, the individual uses taste as a criterion to distinguish himself from others. This thesis of Pierre Bourdieu has become one of the cornerstones of contemporary discussion on the role of art for the patron or collector.[20] The hierarchies of taste that are perceived by the collector bring in further conditions of collecting such as connoisseurship and education, exclusivity and rarity, or finance and investment. The collection was an integral element of princely reputation, taste gave prestige to the aristocratic owner of a collection, or the acquisition of works of art represented the wealth of the industrialist collector.

Because the collection plays different roles in the value systems of different collectors, the personality of the collector, as well as the social, economic and cultural significance of the act of collecting, all form part of the process by which value is created. All these associations add to the value of the object, which becomes visible when it is exchanged either through gift-giving, for example, or in a market. The object thus goes through the process that Kopytoff describes when he writes about the singularization of the object.[21] The price of an object becomes part of its history. In addition, collecting becomes part of a culture

[17] Baudrillard, 'The System of Collecting', pp. 9–10.

[18] Pomian, 'The Collection', pp. 27–34.

[19] As a *semiophore*, the type of object has specific associations which, Pomian argues, have no usefulness. Thus, a collection has no economic value, as a collector removes the object from the market. However, he also states that money is the most important 'weapon in the battle for semiophores'; thus the collector can indicate his status by withdrawing 'part of his wealth from the utilitarian circuit through the purchase of semiophores'. Pomian, 'The Collection', pp. 30–34.

[20] Pierre Bourdieu, *Distinction: A Social Critique of the Judgement of Taste* (London, 1984).

[21] Igor Kopytoff, 'The Cultural Biography of Things: Commoditization in Progress', in Arjun Appadurai (ed.), *The Social Life of Things* (Cambridge, 1986), pp. 66–91.

of consumption. And as Goldthwaite writes about the Renaissance consumer: 'The Italians worked out and defined values, attitudes and pleasures in their possession of goods so that these things became the active instruments for the creation of culture, not just an embodiment of culture.'[22]

Because the collector is both the buyer and seller, the objects in the collection may very well be given a quantifiable value. This may be the value given in an inventory, for example, or it may be the price negotiated and paid by a collector. Auctions provide the most visible link between price and value, and for the collector they were often the arena in which value could be given a quantifiable dimension. The public nature of auctions and the widening art markets added new forms of value; for example, symbolic value, where the price itself might become an indication of status, or economic value, as art becomes an investment. Behind the growing importance of an open art market lay the widening circles of those able to take part in the act of collecting, which thus moved from being the preserve of powerful elites, based on family, political and social connections or spectacular wealth, to being available to new groups of collectors, whose main base was that of economic power and the financial ability to spend on luxury goods.

The Value of Status

The establishment of status is arguably one of the primary motives for the collector and indeed for the patron. Resulting from the revival of classical theories of appropriate behaviour during the Renaissance, Aristotle's *Nichomachean Ethics* provided the justification for expenditure on art, while Cicero in *De Officiis* (44BC) stressed the importance of expenditure for the public good.[23] Even when the terms *magnificenza* or *splendori*, its accompanying form of display of luxury, disappeared, the concept that art adds to the status of the owner is found throughout the early modern period.

> The magnificent man is a sort of connoisseur; he has an eye for fitness and can spend large sums with good taste. The motive of the magnificent man in making such outlays will be fine, because this is a feature common to all the virtues. Moreover he will spend gladly and generously because precise reckoning is petty.

[22] Richard Goldthwaite, *Wealth and the Demand for Art in Italy 1300–1600* (Baltimore, 1993), p. 5.

[23] Cicero, *De Officiis*, trans. W. Miller (Cambridge, 1913). Cicero also argued that expenditure above all should follow the rules of decorum, which provides an important part of the argument regarding taste and social position, as, for example, when describing the characteristics of the *honnete homme* in the eighteenth century.

He will consider how he can achieve the finest and most appropriate result rather than how much it will cost and how it can be done most cheaply.[24]

During the Renaissance, the new rulers of the city states used their patronage and collections to define themselves as cultured figures and thus to show *magnificenza*.[25] Treatises such as that by Giovanni Pontano in 1492 represented these concepts in modern terms.[26] As Nelson and Zeckhauser have argued, many examples of patronage can be shown to have accrued benefits for the patron beyond the obvious display of wealth, such as competition and rivalry for status.[27] In the competitive world of the Italian city state, lavish expenditure was a necessity and described as a virtue. In fact, Guerzoni argues, 'it was thus necessary to guarantee a perfect correspondence between the rank of men and the rank of the goods and service in their competence'.[28] Further interests have been argued, such as, for example, that the d'Este family in Ferrara had an additional political motivation for their patronage; they created loyalty to the family based on economic dependency, with networks of artisans, artists and townspeople joined by webs of mutual interests.[29]

Humanist understanding and reverence for the classical past made the collecting of antiquities an essential part of princely display. As such the collection took on the role of signalling the owner's status, in addition to emphasizing his wealth and position.[30] As Panofsky argued in *Renaissance and*

[24] Quoted in James Lindow, *The Renaissance Palace in Florence* (Aldershot, 2007), p. 10.

[25] For a general account of patronage in the early Renaissance, see Alison Cole, *Art of the Italian Renaissance Courts* (London, 1995); Mary Hollingsworth, *Patronage in Renaissance Italy: From 1400 to the Early Sixteenth Century* (London, 1984).

[26] Giovanni Pontano, *I Trattati delle virtù sociali: De Liberalitate, De Beneficientia, De Splendore, De Conviventia* (1498), ed. Francesco Tateo (Rome, 1965). Quoted in Lindow, *The Renaissance Palace*, pp. 1–2 and 139–143.

[27] Jonathan Nelson and Richard Zeckhauser, *The Patron's Payoff: Conspicuous Commissions in Italian Renaissance Art* (Princeton, 2008). The long history of discussion of conspicuous consumption usually begins with Thorstein Veblen, *The Theory of the Leisure Class: An Economic Study of Institutions* (New York, 1899). For a general discussion on forms of communicating culture, see also Peter Burke, *The Historical Anthropology of Early Modern Italy: Essays on Perception and Communication* (Cambridge, 1987).

[28] Guido Guerzoni, 'Liberalitas, Magnificentia, Splendor: The Classic Origins of Italian Renaissance Lifestyles', in Neil De Marchi and Craufurd Goodwin (eds), *Economic Engagements with Art* (Durham and London, 1999), p. 369.

[29] Guido Guerzoni, 'The Social World of Price Formation: Prices and Consumption in Sixteenth-Century Ferrara', in O'Malley and Welch (eds), *The Material Renaissance*, pp. 85–105.

[30] Nelson and Zeckhauser, *The Patron's Payoff*, pp. 3–12 and 67–76. The idea of 'signalling' or the added value given to a commission by a patron is based on the theories of

Renascences in Western Art, antique works of art took on a new value, less to do, perhaps, with material value and as much to do with their appreciation as a commodity that signalled learning and culture.[31] Thus coins, medals and small bronzes became as important to the collector as cameos or jewels. Housed in the study or *studiolo*, the reputation of these collections added to the fame of their owner. Although not princes, the Medici family in Florence, from the outset, placed patronage of the arts as central to showing their status as the richest and most powerful family in the city. Both Piero the Gouty (1416–1469) and his son, Lorenzo the Magnificent (1449–1492), collected on a princely scale: books, antique cameos and hardstones, paintings, Chinese porcelain and Middle Eastern metalwork were listed in the inventory taken after Lorenzo's death in 1493.[32] The collections that successive generations accumulated were the result of personal interest and attention, but at the same time the types of works of art collected were also a means of displaying the importance of the family.[33] When Galeazzo Sforza visited Florence in 1491, a contemporary account stated that he toured the palace with his retinue, especially the noblest parts, 'such as some of the studies, chapels, salons, chambers and gardens'.[34] For collectors, the fame of their collection and the privilege of viewing it were part of the role that the arts played in Renaissance politics and propaganda.

The collecting of antiquities and hardstones by Duke Cosimo I (1519–1574), founding a new Medici dynasty in Florence after years of civil war, was partly a result of his own genuine interest and passion, but equally can be seen as

Michael Spence, *Market Signaling: Informational Transfer in Hiring and Screening Processes* (Cambridge, 1974).

[31] Erwin Panofsky, *Renaissance and Renascences in Western Art* (New York, 1970). Panofsky also makes the point that in medieval collections, the antique cameos or vases were often remounted in contemporary settings, often turning them into reliquaries or objects of religious significance. It should be borne in mind that one of the first collectors of antique coins was not Italian, but Jean duc de Berry. However, he too may have seen his antique medals as a piece of jewellery. See Mark Jones, *The Art of the Medal* (London, 1979), pp. 9–11.

[32] The inventory of Lorenzo de'Medici's objects is transcribed in Laurie Fusco and Gino Corti, *Lorenzo de'Medici: Collector and Antiquarian* (Cambridge, 2006), pp. 378–383. For the complete transcription, see Marco Spallanzani and Giovanna Gaeta Bertelà, *Libro d'inventario del beni di Lorenzo il Magnifico* (Florence, 1992).

[33] See Mario Scalini, 'The Formation of the Fifteenth-Century Collection, its Dispersion and the Return to Florence of the Medici Treasures', in Cristina Acidini Lucinat (ed.), *Treasures of Florence: The Medici Collection 1400–1700* (Munich and New York, 1997), pp. 29–53; Eugene Muntz, *Les Collections des Médicis au XV siècle* (Paris, 1888); Dale Kent, *Cosimo de'Medici and the Florentine Renaissance* (New Haven and London, 2000); Fusco and Corti, *Lorenzo de'Medici*.

[34] Letter from Niccolò de Carissimi, quoted in Rob Hatfield, 'Some Unknown Descriptions of the Medici Palace in 1459', *The Art Bulletin*, 52/3 (1970): p. 70.

a symbol of his political concerns.[35] Having lost most of the previous dynasty's collections of gems, cameos and antique hardstone vases, Cosimo I put together a new collection to equal the former.[36] His collections were placed throughout his palaces: small works of art in the *scrittoio* of Caliope, a study he created in the Palazzo Vecchio in 1556, large-scale sculptures on view in the *Salla delle Niche* in the Palazzo Pitti.[37] In the small study, he could immerse himself in his collection and Cellini describes evenings spent with Cosimo cleaning these new acquisitions late into the night.[38] At the same time, as can be seen in the comments of contemporary writers and critics, the Chimera, discovered in 1553 was seen as an exemplar of the aesthetics of Etruscan art and as showing the glory of ancient Arezzo and the illustrious past of the Tuscan nation.[39]

The collecting of antique sculptures and fragments of antique monuments had particular importance in the ambitions of the Renaissance collector. Cosimo I also aimed to collect antique sculptures, as did his son, Ferdinand.[40] Nonetheless he was frustrated in his attempts while his politics were seen to be at odds with those of the Pope, and it was only after a rapprochement was achieved that he was able to acquire a collection suitable to his ambitions. In addition, the Pope sent gifts of antiquities to Florence in which both the quality of the objects and their source confirmed and enhanced the status of the Medici.[41]

The importance of collections as a means of showing status is well represented in the writings on collectors throughout the early modern period, from Renaissance princes to the display by rulers and their courts of the seventeenth

[35] Among recent studies, see the essays in Konrad Eisenbichler (ed.), *The Cultural Politics of Duke Cosimo I de'Medici* (Aldershot, 2001); and Henk Van Veen, *Cosimo I de'Medici and his Self-Representation in Florentine Art and Culture* (Cambridge, 2006), pp. 8–31.

[36] The collections of the Medici family were dispersed after the expulsion of Lorenzo's son, Piero, and the re-establishment of the republic in the period 1495–1519. Giulio de Medici, Lorenzo's son, as Pope Leo X was able to safeguard some of the cameos and hardstones, which are now to be found in the Museo d'Argenti in Florence.

[37] See Andrea Galdy, *Cosimo I de'Medici as Collector: Antiquities and Archaeology in Sixteenth-Century Florence* (Newcastle on Tyne, 2009).

[38] Cellini, *La Vita*, quoted in Anna Maria Massinelli, 'The "New Medici" as Collectors and Patrons', in Acidini Lucinat (ed.), *Treasures of Florence*, p. 58.

[39] Galdy quotes Vasari and Pietro Aretino as recognizing the important link that Cosimo I made between contemporary Florence and the ancient Etruscan kingdom. Galdy, *Cosimo I de'Medici*, pp. 124–127.

[40] For the collecting of Ferdinand I de' Medici, see Susie Butters, 'Magnifico, non senza eccesso: riflessioni sul mecanatismo del cardinale Ferdinando de' Medici', in Michel Hochman (ed.), *Villa Medici – Il Sogno di un cardinale, Collezioni e artist de Ferdinando de' Medici* (Rome, 1999), pp. 23–45.

[41] Andrea Galdy, 'Lost in Antiquities: Cardinal Giovanni de' Medici', in Mary Hollingsworth and Carol Richardson (eds), *The Possessions of a Cardinal: Art, Piety and Politics, 1450–1700* (Philadelphia, 2009), pp. 163–165.

and eighteenth centuries. It was essential to the prestige of a monarch to own a collection of works of art to display. Jonathan Brown has traced the move from a primary interest in antiquities to the rise in status of paintings in the seventeenth century.[42] Tim Blanning has shown how the display of these collections formed part of the representation of the ruler, both to his own subjects and to a wider audience, both in *ancien régime* France and the German states.[43] By the seventeenth century, the display of collections of paintings had become an accepted part of the magnificence of kingship, as can be seen in the earlier collections of the Barberini in Rome, Philip IV in Spain, Charles I in England, Archduke Leopold Wilhelm, governor of the Netherlands, or his contemporary, Queen Christina of Sweden in Rome. In the case of Louis XIV, he acquired both antiquities and paintings, which he displayed in the case of the former in the *Gallerie des Glaces* at Versailles and the latter in the state apartments. Acquired through his ministers, they formed an important part of his use of the arts as a manifesto of the glory of France and as political messages to his nobility.[44] However, in his private apartments at Versailles, Louis XIV presented his collection of hardstone and rock-crystal vases and works of art on exquisite brackets set against a mirror background.[45]

One additional aspect of showing status is the display of dynastic ambition. Collectors can be seen to be motivated by the desire to show themselves to be part of a previous dynasty, as in the case of Cosimo I. Collections that demonstrated family links or dynastic ties gave value to the works of art and played an important part in the politics of representation and assessing status.[46] Collections were used in this way through gift-giving within the family, or through setting aside certain works of art and declaring them inalienable to the family. In the early modern period, this can be seen with: gifts of portraits or *exotica* from their new domains in the Americas by Hapsburg princes to their family members, in the sixteenth century; the decision of Albrecht V of Bavaria (1528–1579) to declare certain parts of his collection inalienable; or that of Anna Maria Luisa de'Medici (1667–1743) to give the Medici collections to the city of Florence in 1734, so as to prevent the new Austrian dynasty from selling them. With the advent of museums, it was not only princes who could use collecting to make their

[42] Jonathan Brown, *Kings and Connoisseurs: Collecting Art in 17th-Century Europe* (London and Princeton, 1995), pp. 227–230.

[43] Tim Blanning, *The Culture of Power and the Power of Culture* (Oxford, 2002).

[44] Ibid., pp. 44–48.

[45] Nicolas Milovanivic and Alexandre Maral (eds), *Louis XIV: l'homme et le roi* (Versailles, 2010).

[46] Andrea Galdy, Susan Bracken and Adriana Turpin (eds), *Collecting and Dynastic Ambition* (Newcastle upon Tyne, 2009), pp. xv–xxi. For one example of the role of collections in dynastic policy, see Luc Duerloo, *Dynasty and Piety: Archduke Albert (1598–1621) and Habsburg Political Culture in an Age of Religious Wars* (Farnham, 2012).

names endure through perpetuity.[47] Increasingly during the nineteenth century, collecting – and the giving of the collection to city or country – became an important part of the motive for collecting, as evidenced by such benefactors as Henry Tate, Lord Lever, and John and Josephine Bowes in Britain, or John Clay Frick, Andrew Mellon and Isabella Stuart Gardiner in the United States, just to mention some of the earlier collector-donors. Collecting for a public purpose sets up a series of different values for the collector in the choices for his collection and the prices he might be prepared to pay for works of art.

Collecting the Rare: Collecting for Knowledge

A second major impetus in collecting should be collecting for knowledge, where status resides in the value given to the owner by the evidence of his learning, knowledge, connoisseurship or taste. All these terms were used to define the collector and to separate him from those who lacked these qualities. Richard Goldthwaite cites the collecting of *maiolica*, which, as earthenware, had no significance in terms of the cost of production or material, but was given value by its adornment, particularly when that consisted of paintings of historical or mythical subject matter.[48] During the sixteenth century, princely and scholarly collections were created, based on the concept of representing in one space the wonders of the world, whether created by man or nature.[49] In these *kunst* and *wunderkammer* collections, status and princely magnificence remained of value to the collector, but in addition other values came to be of equal, if not greater, importance. Thus objects in the collection were given a new set of criteria for the collector: their creation, where inventiveness and ingenuity were admired; their origins, in the East and the newly discovered Western lands of the Americas; their rarity, as, for example, with the wondrous objects found in nature; or their underlying significance as objects of learning and science. Many objects were made for the collections, commissioned by the princes and owners of these collections. However, the natural works of art or items brought from the New World were at first only exchanged as gifts between collectors. Thus, the objects from the New World, which arrived in Europe on Cortes' boats from Mexico, were exchanged

[47] For example, the collections of John Tradescant were sold to Elias Ashmole, who gave the collection to the University of Oxford, thus removing these objects from the market.

[48] Goldthwaite, *Wealth and the Demand for Art*, pp. 176–196. Goldthwaite argues that it was in the urban environments of the (primarily) Italian city states that value was given to objects that had no material value. The same argument might be extended to coins and medals, although in this case both had some material value as well as rarity.

[49] See Oliver Impey and Arthur Macgregor (eds), *The Origin of Museums* (London, 1985). See also Arthur Macgregor, *Curiosity and Enlightenment: Collectors and Collections from the Sixteenth to the Nineteenth Century* (New Haven and London, 2007).

throughout the Hapsburg family, or to close allies, such as the Medici.[50] Described in terms of awe by Dürer, the exotic quality of these objects, in addition to their rarity, made them works to be displayed in the princely collections of the sixteenth century.[51] They are works that, as Pomian argues, lose their original purpose in order to take on new identities in European collections.[52]

As one moves from the princely *kunst* and *wunderkammern* to the collections formed by the scientists, explorers or natural philosophers of the day, it seems that curiosity was the main driving force of collectors, among whom can be cited Manfredo Settala and Francesco Calceolari, John Tradescant and Sir Hans Soane, or antiquarians such as Montfaucon and the Comte de Caylus, who collected specimens of ancient cultures in order to study them. A collection without any significance in terms of its monetary value is surely that of Cassiano del Pozzo (1588–1657), who created a paper museum representing the knowledge of the world through commissioning contemporary artists to copy the most famous examples in Rome from Antiquity or from nature. Ulysse Aldovrandi (1522–1605) spent his life collecting, categorizing and cataloguing evidence of the natural world in an attempt to create an encyclopaedic collection. Thus the collection as a representation of all the categories of the known world, or, as he called it, his microcosm, meant that completing the collection became an aim in itself.[53] Collections such as those of John Tradescant (d. 1638) were praised as containing 'more Curiosities than might be found in a life of travel'.[54] This changes the relationship between one object and another, perhaps giving greater value to what is new and what is rare than what is easy to acquire or has already been acquired.[55]

[50] The first shipment from Mexico, which arrived in Seville in 1532, was given to Emperor Charles V, who in turn gave presents to other members of the Hapsburg family, such as Archduke Ferdinand of Tyrol, whose collection at Ambras contained feather works and hardstone objects. The Medici collections of New World objects are also thought to have been gifts from the Emperor. See Detlef Heikamp, *Mexico and the Medici* (Florence, 1972).

[51] See Honig, 'Art, Honor, and Excellence', pp. 90–92.

[52] Pomian, 'The Collection', p. 39. These objects took on many and varied meanings, as discussed by Adriana Turpin, 'New World Objects in the Collection of Cosimo I de'Medici', in Robert Evans and Alexander Marr (eds), *Curiosity and Wonder from the Renaissance to the Enlightenment* (Aldershot, 2006), pp. 63–86; Jessica Keating and Lia Markey, '"Indian" Objects in Medici and Austrian-Habsburg Inventories: A Case-Study of the Sixteenth-Century Term', *Journal of the History of Collections*, 23/2 (2011): pp. 283–300; and Isabel Yaya, 'Wonders of America: The Curiosity Cabinet as a Site of Representation and Knowledge', *Journal of the History of Collections*, 20/2 (2008): pp. 173–188.

[53] Claudia Swan, 'From Blowfish to Flower Still-Life Paintings', in Pamela Smith and Paula Findlen (eds), *Merchants and Marvels: Commerce, Science and Art in Early Modern Europe* (London, 2002), p. 110.

[54] Quoted in Macgregor, *Curiosity and Enlightenment*, p. 30.

[55] Kopytoff, 'The Cultural Biography of Things', p. 80.

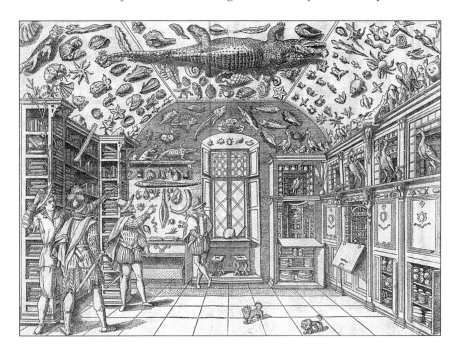

Figure 11.1 Frontispiece of Ferrante Imperato, *Dell' historia naturale* (Naples, 1599). Harvard University, Houghton Library.

To rarity could be added scholarship. Many of the early scientific collections exemplified new discoveries, reflecting discussions between collectors as they attempted to recreate the original context of these objects.[56] For many scientists, the value lay in the knowledge contained within the collection. The exchange of letters and information – and the value that these items had as loaded with meaning as objects of study and learning – can perhaps be best seen in the correspondence between the collector Peiresc and his circle, which included Rubens and Cardinal Francesco Barberini.[57] Such collections of curiosity formed the basis of the British Museum and other scientific collections. Peter

[56] In the history of scientific collections, there are many examples of collections being formed to develop knowledge, to understand the universe as well as to collect its rarities. For the history of the collections that formed the British Museum, see Kim Sloan (ed.), *The Age of Enlightenment* (London, 2003). For a discussion of the development of the scientific collection and its relationship with the museum, see Susan Pearce, *On Collecting: An Investigation into Collecting in the European Tradition* (London and New York, 1999), pp. 113–139.

[57] David Jaffe, 'The Barberini Circle: Some Exchanges between Peiresc, Rubens, and their Contemporaries', *Journal of the History of Collections*, 1/2 (1989), pp. 119–147.

the Great himself considered his collection important for its educative role: 'I want people to look and learn.'[58] For this to happen, the collection had to be available to the public, a far cry from the closed and privileged world normally associated with the *Kunstkammer*.[59] The value attached to the object thus became associated with its educational value to the public, which in turn led to the need for scholarly catalogues and research (Figure 11.1).

Quantifying Status

In the examples of status discussed so far, attention has been focused on the 'non-quantifiable values' placed on the collection as one of the mechanisms by which the collector could differentiate himself, or indeed place himself within a peer group. To a large extent, throughout this period, objects were acquired through negotiations, taking place within what has been described as a 'bargaining' market, a term that can be given to a market in which negotiations were undertaken directly between dealer and agent and in which price is not publically or openly negotiated.[60] Here price was uncertain and negotiable but the object, as a commodity, ultimately had a value which, as Kopytoff argues, could be personal or could have a market value.[61] In addition, the exchange of gifts among collectors meant that a price for the work might not be given or publically considered, but the act of giving brought additional, unquantifiable social and political relationships. Gift-giving acquired a language and literature of its own, placing the act of giving within the discourse of magnificence.[62] Nonetheless, it could also become part of the negotiations in acquiring an object. Isabella d'Este, writing to Andrea Loredan after he acquired a work which she desired at auction, begged that:

> you might out of courtesy and kindness give us this picture as we will willingly repay your money with whatever profit you so wish. In doing this, you will gain, not only the money but also our person, with the obligation to be forever in your debt and prompt you to gratify you in all your needs.[63]

[58] Macgregor, *Curiosity and Enlightenment*, p. 66.

[59] Ibid., pp. 65–69.

[60] I owe the use of the term 'bargaining' market to Giovanni Gasparini, and I am grateful to him for bringing it to my attention and allowing me to use it.

[61] Such mechanisms are discussed, for example, in Kopytoff, 'The Cultural Biography of Things', p. 80.

[62] See Guerzoni, 'Liberalitas, Magnificentia, Splendor', p. 369, where he argues that it was an exact correlation between the rank of the men and the rank of the goods they were given.

[63] Evelyn Welch, *Shopping in the Renaissance: Consumer Cultures in Italy 1400–1600* (New Haven and London, 2005), p. 272.

As was apparently not uncommon, the exchange included payments. In the end Isabella d'Este paid 37 ducats more for her painting than if she had bought it outright at the auction. On another occasion, the exchange was made more explicit. 'But to him say that we have accepted his heads as a gift and that we wish him to accept this money as a gift, for it is as a gift that we offer it.'[64] On the other hand, other instances show that a collection might be sold for less than what was considered its market value, possibly again for the benefits accrued by the links or obligations created. Thus in a contract negotiated with the Capranica in Rome for Cardinal Ferdinand I de' Medici, the heirs accept a price half the value of that which the collection was originally given. Partly, they say, this is because no one else in the time has offered them a higher price. More to the point, perhaps, is that they thought that the connection with the Medici family would stand the family in good stead in the future. What we cannot know, of course, is how much Ferdinand would have been prepared to pay for a collection that was considered the most important in Rome.[65]

Equally, in the search for the rare, objects of curiosity might be exchanged among collectors. Most of the objects would have very little material value, unlike the costly items that sometimes accompanied them in the princely collections; but there were exceptions, and as scientific curiosities and rarities appeared on the market, it is evident that such items also had a market value.[66] Among other examples, seventeenth-century Amsterdam had a thriving market in collections of curiosities, from among which Peter the Great was able to acquire his own extraordinary collection of curious specimens.

Refining Value: Taste and Connoisseurship

One of the important ways in which the collection can give status to the collector is as a means of showing the owner's taste. As Bourdieu argues, if a collector wishes to position himself in a social or cultural hierarchy, then the display of taste, and with it the associated concept of connoisseurship, becomes

[64] Daniela Ferrari (ed.), *Giuio Romano: repetorio di fonti documentie*, vol. 1 (Mantova, 1992), p. 81. Quoted in Welch, *Shopping in the Renaissance*, p. 287.
[65] Susie Butters, 'Making Art Pay: The Meaning and Value of Art in Late Sixteenth-Century Rome and Florence', in Fantoni, Matthew and Matthews-Grieco, *The Art Market in Italy*, pp. 26–28.
[66] See Paula Findlen, 'Inventing Nature: Commerce, Art and Science in the Early Modern Cabinet of Curiosities', in Smith and Findlen (eds), *Merchants and Marvels*, pp. 300–319. She cites several examples of collectors being willing or unwilling to pay large sums of money for a collection, or for a rare item to add to a collection, including a hydra on the market for 10,000 florins in 1720, which the apothecary Albert Seba found so extraordinary that it reawakened his interest in owning a copy.

an important motive for acquiring specific works of art. When Charles I of England began to collect, and in particular to collect paintings, it may have been partly with the intention of raising the reputation of his court to the same level as its European counterparts.[67] At an early age, he is said to have shown an interest in paintings and, as is well known, he rapidly acquired an impressive collection in a short time.[68] His love of painting was commented on by contemporaries including Rubens, while the process of collecting formed a mutual interest with close members of his court circle.[69] As seen in an account by the Papal Nuncio in England to Francesco Barberini on the reception of his gift to Henrietta Maria, Charles' Catholic queen, in 1636, it was important for the purpose of the gift that the status of the paintings was of a suitable quality for an educated collector. The report gives prestige to the paintings by those at the time considered among the most valuable or most renowned artists:

> When the Queen informed the King that the pictures were to be seen he came immediately, accompanied by Inigo Jones 'a great connoisseur', and the Earls of Holland and Pembroke. The very moment Jones saw the pictures, he greatly approved of them, and in order to be able to study them better ... he took a candle, and together with the King, began to examine them very closely. They found them entirely satisfactory ... The King liked particularly those by Leonardo, Andrea del Sarto and Giulio Romano.[70]

The high regard for these paintings reflects a hierarchy of values that was part of the growing literature on art aesthetics. This can be traced to Gianpietro

[67] Charles I's determined and rapid acquisition of an important collection suggests that, as well as being a passionate collector, he saw the importance of collecting as showing status worthy of a monarch. How far this can be linked with his politics has been as much debated as has whether he set out to establish a personal rule based on the divine right of kings. See Christopher Hill, *The English Revolution 1640* (London, 1949) for a Marxist interpretation of the English Civil War; in contrast, see Kenneth Sharpe, *The Personal Rule of Charles I* (New Haven and London, 1992).

[68] Francis Haskell, 'Charles I's Collection of Pictures', in Arthur Macgregor (ed.), *The Late King's Goods* (London and Oxford, 1989), p. 209.

[69] That Charles I was reported as being concerned about the quality of the paintings in his collection is certainly documented, for example, in his personal quest for paintings when he went to the Spanish court. See Jonathan Brown, 'Artistic Relations between Spain and England 1604–1655', in Jonathan Brown and John Elliott, *The Sale of the Century: Artistic Relations between Spain and Great Britain, 1604–1655* (New Haven and London, 2002), pp. 44–50.

[70] Letters of the Roman ambassador, copies of the originals, British Library, quoted in Rudolph Wittkower, 'Inigo Jones: Puritanissimo Fiero', *Burlington Magazine*, 90 (1948): p. 51.

Bellori, whose introduction to his account of the lives of modern painters set out the classicist theories of art criticism that were to be such a seminal influence on later writers.[71] Defined by the end of the seventeenth century, in works such as *Dialogue sur le coloris* by Roger De Piles or his *Cours de peinture par principes avec un balance de peintres* (1708), taken up in England by Jonathan Richardson, a hierarchy of artists was created to form the canon headed by Raphael. The canons of taste were laid out by De Piles and followed by such authorities as Mariette in his catalogue of the collections of the Regent, Philippe duc d'Orleans, where he divided the collection between the different Italian schools in terms of priority: Roman, Venetian, Flemish and French. In England, the canon was confirmed by the discourses of Sir Joshua Reynolds, in which the established hierarchy of painters was listed that collectors could as far as possible follow in their purchases on the Grand Tour. Thus the galleries of the great country houses were filled with works by the artists of the Bolognese school, Reni and Guercino in particular, but also lesser known painters such as Cagnacci, as well as works by Poussin and Claude Lorrain, paintings by Rubens and van Dyck. London houses showcased the taste of the great British aristocrats. To mention only a few, Robert Walpole (1676–1745) displayed a magnificent collection including works by Reni, Poussin, Rubens, Van Dyck and Rembrandt in the drawing rooms of Downing St;[72] John, 1st Earl Spencer (1734–1783) placed two large paintings by Guercino alongside two by Salvator Rosa in his great room at Spencer House;[73] at Northumberland House, the 1st Duke (1714–1786) displayed in his main drawing room the two great Titians inherited from his ancestor.[74] The display of these paintings not only shows the status of the owner in his ability to acquire such works, but also indicates his knowledge and signals his taste. The implication of this is that taste reflects education; the collection thus becomes a sign or *semiophore*, which can act to distinguish its possessor from those without taste.

Taste may be very often informed by contemporary aesthetic judgements – what is seen as good taste at one period in time may not be so at another.

[71] Giovan Pietro Bellori, *The Lives of the Modern Painters, Sculptors and Architects* (1672), trans. and ed. Alice Wohl, Hellmut Wohl and Tomaso Montanari (Cambridge, 2005), pp. 57–65.

[72] Larissa Dukelskaya and Andrew Moore (eds), *A Capital Collection: Houghton Hall and the Hermitage*, with a Modern Version of Aedes Walpolianae, Horace Walpole's Catalogue of Robert Walpole (New Haven and London, 2002).

[73] Joseph Friedman, *Spencer House: A Chronicle of a Great London Mansion* (London, 1993), pp. 41 and 103.

[74] Adriano Aymonino, 'Aristocratic Splendour: Hugh Smithson Percy (1712–1786) and Elizabeth Seymour Percy (1716–1776), 1st Duke and Duchess of Northumberland: A Case Study in Patronage, Collecting and Society in Eighteenth-Century Britain' (unpublished doctoral dissertation, University of Venice, 2010).

Beginning with the writings of the Earl of Shaftesbury (1671–1713) and John Locke (1632–1704) on morality and the arts, the eighteenth century saw a proliferation of treatises and discussions on the description of taste and in particular its value as a moral force in producing the best in society.[75] Taste could differentiate the collector from other acquirers of works of art, who might be in a financial position to buy, but without the aptitude.[76] A man of taste might appreciate an art work for its aesthetic appearance, but if he was to truly show taste, then he needed to differentiate between good and bad versions of a work, copies and originals, works that suited the accepted standards of art historical judgements.[77] Thus connoisseurship became a desirable attribute for the collector and, as the act of connoisseurship signalled his knowledge and judgement, so it gained a social value, which could also be translated into economic terms. The market thus used the idea of taste and the connoisseur in creating a market terminology. As has been observed, in the catalogues of the early eighteenth century, Gersaint introduced the collector in terms of his taste, his connoisseurship and the fame of his collections. The works sold were described in visual terms, to appeal to the aesthetic appreciation of the work; and, indeed, on occasion Gersaint would say that he would leave the attribution of the painting to the connoisseur.[78] Pierre Remy addresses himself to the true connoisseur, and in his foreword to the catalogue of the sale of the Duc de Tallard in 1756, he emphasizes that, by collecting Italian paintings, the connoisseur is distinguished from other types of collectors: 'Les tableaux des grands maîtres d'Italie ont toujours été regardés comme des chef d'oeuvre de l'Art

[75] John Locke, *An Essay Concerning Human Understanding* (London, 1690). These were followed by Johan Richardson, *Essay on the Theory of Painting* (London, 1715); and idem, *Essay on the Whole Art of Criticism as it Relates to Painting, in Two Discourses* (London, 1719).

[76] Iain Pears, *The Discovery of Painting* (London, 1988), pp. 36–39.

[77] See David Hume, 'Of the Standard of Taste', in Tom Beauchamp (ed.), *An Enquiry Concerning Human Understanding: A Critical Edition* (Oxford, 2000): 'Thus, though the principles of taste be universal, and nearly if not entirely, the same in all men; yet few are qualified to give judgement on any work of art or establish their own sentiment as the standard of beauty ... But though there be naturally a wide difference in point of delicacy between one person and another, nothing tends further to increase and improve this talent, than *practice* in a particular art ...'

[78] Godefroy sale, Paris, 1748. *Catalogue raisonné, des tableaux, diamans, bagues de toute espèce, bijoux & autres Effets provenant de la Succession de feu Monsieur Charles Godefroy, Banquier & Joaillier. Par E.F. Gersaint*, lot 3: 'Quoique ce Tableau soit recommandable, il seroit difficile de lui donner un nom sur lequel on pût ne pas craindre de contradiction. Pour éviter cet inconvénient, nous avons crû qu'il étoit plus convenable d'en abandonner la décision aux Connoisseurs.'

de la Peinture: ils sont les seuls qui puissant acquérir à un Cabinet l'estime des vrais Connoisseurs.'[79] Although it was accepted that not all collectors could rely on their own judgement and might need the help of an advisor, his collection remained an expression of his wealth, status and selection of choice works (Figure 11.2).[80]

However, the relationship between taste and connoisseurship was already a matter of discussion in the seventeenth century, primarily in the Netherlands.[81] As Elizabeth Honig says:

> Authorship acquires not merely value but a new definition: the relationship between the work and its maker is redefined within the boundaries of connoisseurship. Connoisseurship relies on the premise that each artist has his own, individual style ... The work of art is seen as inevitably marked in these terms from the moment of its making, leaving it open to assessment by the informed beholder.[82]

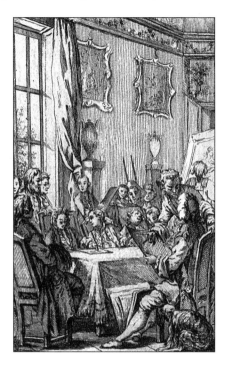

Figure 11.2 Frontispiece of Pierre Remy and Jean-Baptiste Glomy, *Catalogue of the Sale of the Duc de Tallard* (Paris, 1756).

[79] Pierre Remy and Jean-Baptiste Glomy, *Catalogue of the Sale of the Duc de Tallard* (Paris, 1756), Wallace Collection, London.

[80] John Richardson, *An Essay on the Whole Art of Criticism, Two Discourses* (London, 1791), pp. 15–16: 'There are two ways whereby a Gentleman may come to be purswaded of the Goodness of a Picture or Drawing; He may neither have Leisure or Inclination to become a *Connoisseur* Himself, and yet may delight in these things, and desire to have them; He has no way then but to take up his Opinions upon Trust, and Implicitly depend upon Another's judgement ... And this may be the Wisest and Best Course he can take all things considered.' Quoted in Pears, *The Discovery of Painting*, p. 162.

[81] When Charles I came to view the gift from Francesco Barberini referred to above, the Papal agent added: 'As the King had removed the names of the painters, he [Inigo Jones] also boasts of having attributed almost all the pictures correctly.' The labels with the artists' names had been attached by the Papal agent. Thus here too there was also a game of connoisseurship, although as the account is given by the Nuncio, the story possibly cannot be taken at face value.

[82] Honig, *Painting and the Market*, pp. 197–210.

Honig further argues that the motive behind the creation of gallery paintings in seventeenth-century Antwerp was that it allowed the circle of connoisseurs to stand in front of the painting and display their connoisseurship.[83] The implication of this is that the value for the collector was located not just in demonstrating the individual's connoisseurship but also in creating social networks through this exchange of opinions and information.[84]

Thus, connoisseurship moves from being a reflection of social or cultural significance to a factor in the pricing of works of art for sale in the market. Collectors in the markets of the seventeenth century were already aware of the relationship between connoisseurship and price. According to Abraham Bosse in his *Sentiments*, connoisseurship is needed:

> ... when it is a question of wanting to use large sums of money to buy and thus to attract to their homes by their fame the true connoisseurs and learned practitioners of such works, in order that they should receive the satisfaction that they expect, in viewing, recognising and valuing these curiosities according to their merits (Figure 11.3).[85]

As the market developed, the issue of authenticity became increasingly important for the collector. The resulting emphasis on the value of the original contributed to the professionalism of both seller and buyer in a market where open sales through auctions became more widespread. During the eighteenth century, catalogues began to stress the importance of attribution and provenance, in what has been seen as a growing appreciation of the authentic attribution.[86] The aesthetic vocabulary continued to be used, but whereas in the sale of Jean de Julienne words like 'touche' were frequently found, in the Remy catalogues for the sale of Randon de Boisset's collection in 1777, although such descriptions are still to be found, the name of the artist was prominently placed and if possible the provenance was also given.[87] Whether a work was attractive, or whether it represented

[83] Ibid., p. 210.

[84] For further examples in Amsterdam and England, see Jonckheere, 'Supply and Demand', p. 88.

[85] Abraham Bosse, *Sentiments sur la distinction des diverses manières des peinture, dessin et gravure et des originaux avec leurs copies* (Paris, 1649), quoted in Honig, *Painting and the Market*, p. 200.

[86] Krzysztof Pomian, 'Dealers, Connoisseurs and Enthusiasts in 18th-Century Paris', in Pomian, *Collectors and Curiosities*, pp. 139–168; Neil De Marchi and Hans Van Miegroet, 'Transforming the Paris Art Market 1718–1750', in De Marchi and Van Miegroet, *Mapping Markets*, pp. 383–405.

[87] Pierre Remy and Claude François Julliot, *Catalogue des livres du cabinet de feu M. Randon de Boisset, receveur général des finances: dont la vente se fera au plus offrant & dernier*

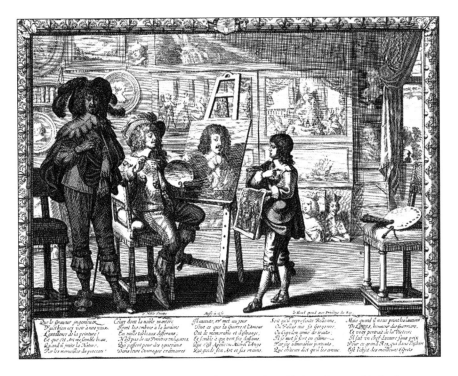

Figure 11.3 Abraham Bosse, *L'Atelier du peintre* (c. 1642), etching published by Jacques Leblond. By kind permission of the Trustees of the British Museum.

the style of an artist, was no longer enough; the auctioneer/dealer brought in additional criteria, such as provenance or previous prices fetched at auction, to underpin the value of the work.[88] While these concerns may be those of the dealer in establishing the market for the works he was willing to sell, they also must be a reflection of the values of the collector, who was now the buyer and the seller at these sales.

The shifting status of the copy and its importance for the issues of connoisseurship and authenticity is particularly indicative of the relationship

enchérisseur en la maniere accoutumée, le Lundi 3 Février 1777, & jours suivants de relevée, en su maison, rue Nueve des Capucines. This is true for both paintings and works of art.

[88] See Neil De Marchi and Hans Van Miegroet, 'The Rise of the Dealer-Auctioneer in Paris: Information and Transparency in a Market for Netherlandish Paintings', in Tummers and Jonckheere (eds), *Art Market and Connoisseurship*, pp. 157–167. Of particular interest might be the chart of paintings sold by Lebrun at the sale of the Compte de Vaudreuil, where the provenance and price fetched in previous sales are noted.

between market values and social values.[89] Owning copies of important works had a long tradition, going back at least to Antiquity, when the Romans filled their houses and baths with marble copies of famous Greek statues. Copies of antiquities during the Renaissance gained acceptability as they could provide an indication of the taste of the collector, who might not be able to own the original but nonetheless could show his appreciation of famous classical statues. Copies ranged from the small-scale bronze statues by Tetrode for Cosimo I de Medici to the full-scale bronze copies made by Primaticcio for François I of statues in the Papal collections, or to marble copies commissioned by Grand Tour collectors such as the Duke of Northumberland for Syon House in the 1750s. These copies were analysed and critically assessed for their aesthetic value from the Renaissance to at least the end of the eighteenth century. Thus, there were hierarchies in the aesthetic appreciation of classical sculpture, and a language of appreciation was developed that reflected these aesthetic values.[90] That this in turn influenced the discussion of valuation of other works of art, such as paintings, may have been the case.[91]

In the seventeenth century, copies of originals were to be found in the collections of Charles I, as well as in the homes of his courtiers: at Ham House, owned by the Duke and Duchess of Lauderdale, copies of some paintings in Charles' collection hung on the staircase.[92] The collection of the Duke of Hamilton contained 'A coppie of yᵉ great Venus after Titian at White hall, a copie after Coregio of yᵉ Mercurie Venus & Cupid, A copie after Coregio of Venus and

[89] This discussion excludes artists' copies of works done for their development or interest, and workshop copies of portraits, commissioned in large numbers by the monarchs who were represented. (Rubens, Delacroix and Degas all copied directly works of the great masters.) Also excluded from this discussion are copies made by artists of their own works or copies made by their workshops.

[90] Thus, appreciation of the copy of an antique sculpture changed or shifted between c. 1500 and c. 1750. The moment when this change occurred is not easy to define and the collectors of the eighteenth century again often had problems in identifying the changes that had taken place or were taking place in their appreciation of such statuary.

[91] Thus, the Papal Antiquarian and writer Giovan Pietro Bellori (1613–1696) developed his critical approach to contemporary art through his appreciation and writings on antiquities. See Janis Bell and Thomas Willette, *Art History in the Age of Bellori: Scholarship and Cultural Politics in Seventeenth Century Rome* (Cambridge, 2002), p. 48. Bell quotes Giovanna Perini, who argues for this relationship in 'L'arte di descrivere. La tecnica dell'ecfrasi in Malvasia e Bellori', *I Tatti Studies*, 3 (1989): pp. 175–206.

[92] For further discussion of the paintings at Ham House, and in particular the copies in the collection, see Susan Bracken, 'Copies after Old Masters at Ham in the Context of Caroline Patronage and Collecting', in Christopher Rowell (ed.), *Ham House: 400 Years of Collecting and Patronage* (New Haven and London, 2013), pp. 37–48. I am very grateful to Susan for discussing her research with me.

the satyr, A copie after Titian of Christ at supper wth his two disciples, A copie after Titian of Christ laying into y[e] sepulcure'.[93] These were more than likely to be paintings copied in London, specifically for courtiers, who by displaying the works were showing their appreciation of paintings in the Royal Collection and possibly that they were linked to the king by their mutual taste. What is not known is whether the copy also signified a mark of favour by the king, who presumably had to authorize the making of the copy. The copy could still be acceptable as a representation of a work of importance, placed within a private collection, particularly when the original was no longer available. However, the fact that they were not placed in the most important rooms at Whitehall or Somerset House, but, for example, at Hampton Court, suggests a possible lower status in the collections of the time.[94]

The emergence of the copy in the art market can be seen in the case of the copies by Pieter Brueghel the Younger (1564/65–1637/38) of his father's works, which were in enormous demand both during and after his lifetime.[95] Because of the great number of copies made of some of the paintings, it has been suggested that Pieter Brueghel's market was to be found among collectors in the medium and even lower end of the market, which places the copy in a new social context. Although this has been debated, it would suggest that buying a work of a famous artist was now part of the tradition of collecting among the new purchasers on the art market.

Once copies appear on an open market, then they are subject to a different criteria and set of values, most specifically price and its relationship to authenticity.[96] However, it is also indicative of the importance of copies in the

[93] 1643 Inventory, Hamilton Palace, quoted in Klara Garas, 'Die Entstehung der Galerie des Erzherzogs Leopold Wilhelm', *Jahrbuch der Kunsthistorischen Sammlung in Wien*, 63 (1967): p. 72. I am grateful to Susan Bracken for this reference.

[94] Many of the copies are after masterpieces in Spain, almost certainly made for Charles by Michael Cross, and when his authorship is given in the inventory, they were valued at £2 or £2.10s; Susan Bracken suggests that Cross painted the more expensive copies as well. Where we have evidence that they were hung in the royal apartments, it would suggest that they were at the very least on display, together with original works in the king's collection.

[95] Peter Van den Brink, 'The Art of Copying', in Peter Van den Brink (ed.), *Brueghel Enterprises* (Maastricht, 2001), pp. 36–39. As early as 1572 Provost Morillon wrote to Cardinal Granvelle: 'If I were you, I wouldn't count on finding more paintings by Brueghel unless you are prepared to pay a very high price. For they are in even greater demand since his death than they were before; they are now valued at 50, 100 and 200 crowns, which puts a strain on one's conscience.' Van den Brink, *Brueghel Enterprises*, p. 60.

[96] The most notable examples of copies being made by artists of works by older masters come from the Netherlands, where a thriving open market made for a more flexible approach to authenticity. Followers of artists such as Van der Weyden produced copies of his works both within his lifetime and for generations afterwards. The works of Hieronymous Bosch were copied and possibly even forged, it is suggested, for specific

Antwerp art market.[97] The fact that so many copies were available made the issue of authenticity and copies a concern, not just for the dealer but also for the collector. De Marchi and Van Miegroet begin their discussion on pricing invention in seventeenth-century Antwerp with an account of a collector in 1663, who was told that paintings he had bought as originals were in fact copies.[98] Although the guilds of painters in Antwerp and again in Amsterdam made it clear that originals should be considered as works by the masters, there were many variations possible, with copies being made in the masters' studios as well as by artists working in other workshops. With the export of paintings and the large numbers of paintings from painters' workshops, the seventeenth-century market was one in which conditions of price could be seen to reflect the concerns of the purchasers. Thus, De Marchi and Van Miegroet price invention at approximately two to three times the price paid for the copy.

In a similar way the inventory taken between 1649 and 1651, when the works of art from the collection of Charles I were put up for sale, estimated the prices for which the works of art were to be sold.[99] We are thus given an insight into what the commissioners believed to be original and those that were accepted as copies, and how they were valued.[100] Although given lower values than originals, they hung in the royal collections as examples of great masters. In general the prices for copies ranged from £2 to £10, but copies after Titian or Veronese might go up to between £15 and £20,[101] or even £30 when the copy was attributed to Rubens.[102] This was when the self-portrait by Artemesia Gentileschi, also at Hampton Court, was valued at £20,[103] a

collectors by small workshops. In a similar way, Michelle O'Malley has traced the copies and variations made by Neri de Bicci and his workshop in Renaissance Italy, suggesting that here, too, copies and workshop imitations were part of the Italian Renaissance art market, although the evidence suggests at the lower end of the market. See Garas, 'Die Entstehung der Galerie', pp. 131–160.

[97] As one example, Cardinal Federico Borromeo asked Jan Brueghel the Elder for a work by his father, and when that was impossible to acquire, Jan Brueghel bequeathed his own painting to the cardinal, who instead had it copied and returned it to Brueghel's son. Van den Brink, *Breughel Enterprises*, p. 41.

[98] Neil De Marchi and Hans Van Miegroet, 'Pricing Invention: "Originals," "Copies," and their Relative Value in Seventeenth-Century Netherlandish Art Markets', in Victor Ginsburgh and Pierre-Michel Menger (eds), *Economics of the Arts* (Amsterdam, 1996), p. 27.

[99] Oliver Millar, *The Inventory and Valuation of the Late King's Goods 1649–1651* (London, 1970–1972), p. 43.

[100] One of the commissioners was the painter Jan van Belcamp (noted as a copyist) and thus he was probably quite well informed.

[101] 'A True Inventory of the Pictures at Hampton Court', Lots 4, 6, 12: Millar, *The Inventory and Valuation of the Late King's Goods*, pp. 186–188.

[102] Lot 19: ibid., p. 187.

[103] Lot 5: ibid., p. 186.

Giorgione knight in armour at £20 or a Mary Magdalene given to Titian at £25.[104] Another comparison can be made with the lowest prices in the inventory, for unattributed works which were given similar prices, that is, between £5 and £12, or even lower; equally even paintings by Del Sarto might be listed at £6 or £15, so again some of the prices estimated for the copies were not negligible, suggesting that authenticity was not the key factor in the estimates given, unless for very important paintings when the prices were clearly on a very different level.[105]

Value in Investment

Investment in art is often seen as primarily a nineteenth-century phenomenon; however, it clearly goes back to the early markets in the Netherlands and the eighteenth-century market in France, and indeed, it seems to follow the development of a market in which auctions play a role. Investment further reflects a belief in a rising market and as such may have a long tradition in collecting. Diderot, for example, commented:

> Here is how the majority of opulent people who employ the important artists reason: 'The amount which I will put on a drawing by Boucher, a painting by Vernet, by Casanova, by Loutherbourg is placed at a high interest. I will enjoy the view of a nice piece my whole life. The artist will die and from this painting my children and I will make twenty times more than when it was first bought'.[106]

This might reflect the views of some collectors of his time and corresponds with the presentation of the value of investment given by the dealer Lebrun, who wrote in his *Reflections*: 'An owner has the advantage always desired by a responsible man, of enjoying his wealth and seeing it increase.'[107] Usually, of course, investment is criticized as a motive and in the eighteenth century was

[104] Lot 77: ibid., p. 190.
[105] Thus in the Whitehall inventory, the *Sleeping Venus* (lot 112) was valued at £1,000, and the *Venus de Pardo* by Titian (lot 184) at £500. Millar, *The Inventory and Valuation of the Late King's Goods*, pp. 305 and 320. Even here, there were many paintings at much lower valuations, between £20 and £25 on average.
[106] Denis Diderot, 'Salon de 1767', in Denis Diderot, *Oeuvres*, vol. 7 (Paris, 1970), pp. 29–30, quoted in Patrick Michel, 'Le tableau et son prix', in Jeremy Warren and Adriana Turpin, *Auctions, Agents and Dealers: The Mechanisms of the Art Market, 1660–1830* (Oxford and London, 2008), p. 63.
[107] Quoted and translated in Colin Bailey, *Patriotic Taste: Collecting Modern Art in Pre-Revolutionary Paris* (New Haven, 2002), p. 17, note 13.

combined in a criticism of the tastes for Dutch seventeenth-century paintings by newly rich Parisian bankers and financiers.[108]

Buying for investment continued to play an important role in nineteenth-century collecting, as has been discussed in the literature on the purchasing and collecting of contemporary artists by nineteenth-century industrialists in Britain.[109] The Birmingham industrialist, Joseph Gillot, seems to have taken this further than most in his willingness to act as a dealer at the same time as a collector.[110] His passion for paintings seems to have equalled his love of buying and selling. His attitude, though extreme, reflects the approach of these new collectors, who have been seen as transferring their commercial approach to the art market. James Morrison, industrialist, banker and member of Parliament, differentiated himself from many of his fellow industrialists by buying important and often expensive old master paintings, including *The Rape of Europa* by the artist possibly most admired in England, Claude Lorrain, for which he paid £1,000, or *The Virgin and Child with St John* by Parmigianino at £660, which had a provenance to a collector of discernment, George Watson Taylor. His choice of paintings would have fitted into an aristocratic collection. Nevertheless, his collection was not only put together as a matter of status, but he saw the works within it as commodities to buy and sell.[111]

[108] The rise of the market for Dutch and Flemish seventeenth-century paintings has also been attributed to the fact that authenticity was not the same problem as it was for Italian paintings (see Michel, 'Le tableau et son prix'). De Marchi and Van Miegroet develop the argument that dealers promoted buying Dutch Italianate landscapes to collectors as substitutes or matches for rarer works by Claude in their cabinets of curiosity. See Van Miegroet, 'The Market for Netherlandish Painting in Paris', in Warren and Turpin (eds), *Auctions, Agents and Dealers*, pp. 41–51; and De Marchi and Van Miegroet, 'Transforming the Paris Art Market', pp. 383–406. See also Bailey, *Patriotic Taste*, pp. 17–20. In this discussion, a caveat must be mentioned, namely the reliance on published catalogues in the discussion, when printed catalogues represented a fraction of the sales taking place in Paris or London. See the PhD dissertation by François Marandet, 'Marchands et collectionneurs de tableaux à Paris (1710–1756): les acteurs et les mécanismes de circulation de la peinture en France dans la première moitié du 18ème siècle' (unpublished doctoral dissertation, Paris, Ecole Pratique des Hautes Etudes, 2009).

[109] For the most comprehensive account of this group of collectors, see Donna Mcleod, *Art and the Victorian Middle Class: Money and the Making of Cultural Identity* (Cambridge, 1996). For an account of prices fetched at sales by British contemporary artists, see Gerald Reitlinger, *The Economics of Taste: The Rise and Fall of Picture Prices 1760–1960* (London, 1963).

[110] Jeannie Chapel, 'The Papers of Joseph Gillott (1799–1872)', *Journal of the History of Collections*, 20/1 (2008): pp. 37–84.

[111] Caroline Dakers, *A Genius for Money: Business, Art and the Morrisons* (New Haven and London, 2011), p. 185. Morrison's relationship with the dealer Buchanan seems to have involved Morrison advancing Buchanan money to buy paintings, some of which were sold

The Value of a Collection: Collecting Practices in Early Modern Europe 281

Against the backdrop of extraordinary prices for contemporary artists in Britain, the case of the Impressionists in France was markedly different. The initial lack of financial success is one of the stories of the art market. However, here too there were collectors who acquired the works of these new artists for a variety of reasons, one of which, it has been suggested, was a form of investment. Thus Anne Distel proposes that the singer Jean-Baptiste Faure might have started his career as a collector, already aware that art could be an investment. His friend, Paul Baroilhet, had assembled a collection of the Barbizon painters in the 1830s, which he sold in March and April 1860 for excellent prices. Faure himself began by collecting these artists: Rousseau, Millet, Corot and Troyon, as well as Delacroix and Dupré, which he sold at auction on 7 June 1873.[112] That year Faure started to acquire paintings by Edouard Manet from the dealer Durand-Ruel, who had bought them from Manet, paying 800 and 3,000 francs for *The Port of Boulogne in the Moonlight* and *The Spanish Singer*. Faure himself paid 3,000 francs and 7,000 francs, so the profit margin of the dealer was already a given factor in the collector's purchase. Faure continued to buy Manet's paintings throughout the 1870s, generally paying similar sums.

He has been considered to be motivated primarily by investment as a result of the bitter comments from the Impressionists themselves, who are said to have resented the way he associated their work with market value. It may be true that the reason he made no purchases at the sale, following Manet's death, of the contents of his studio – where Madame Manet apparently said: 'Faure seems to be holding back ... you know what a dealer he is ... he makes his calculations and wants to get what he desires'[113] – was that he had tried to sell two of his Manets two years earlier, without success. He may therefore have been concerned at their loss of market value. Nonetheless, and in spite of already owing a considerable number of works by Manet, he purchased two more in 1894. Thus his motives may be much more complicated than simple buying for investment. The artists he bought throughout the 1870s in exceptional quantities, such as Manet, Sisley, Monet and Degas, no longer interested him when their styles changed to become less recognizable. Apart from the 1878 sale, the only public sale of his collection was in 1907 but it has been suggested that he sold works privately, based on the fact that the catalogue of his collection of 1902 no longer contains works that he is known to have acquired. However, as we have no record of the prices he achieved, it cannot be certain that profit was his only motive – he seems instead to have re-invested in artists of the academic tradition. It thus leaves us with

to other collectors; for example, in 1839 he sold Aelbert Cuyp's *View of Dordrecht* to the Marquess of Lansdowne for a profit of £200.

[112] Anne Distel, *Impressionism: The First Collectors* (New York, 1990), p. 76. It is worth noting that many of the paintings were bought back by Paul Durand-Ruel, a common practice for Durand-Ruel and indeed many Parisian dealers still today.

[113] Ibid., p. 83.

the question as to whether, as a continuing and compulsive collector, he was as much motivated by changes in his own taste as the desire to invest.

Investing in contemporary art in the nineteenth century shows the multiple interconnections between fashion, market values and signalling values. Both artists and collectors were working within increasingly open market conditions, where prices could be established through auction results. At the same time, the collection continued to play an important role in creating value for the collector – by showing his wealth, and by creating links and networks, using art collections to separate as well as to link the collector with specific groups. Thus, some of the early collectors of the Impressionists came together at the salon of Madame Charpentier; others, such as Victor Choquet, may not have been attached to this group directly, but nonetheless there is a connection through the figure of Zola. It is not by chance, perhaps, that the notion of avant-garde, revolutionary and progressive are attached to the works of the Impressionists by critics, so you would expect to see their early collectors perhaps associating themselves with these ideas through their support of these emerging artists. This may again be an association that Faure wished to remove himself from in old age; the fact that critics saw the Impressionists as reforming painters, who wished to create the same sense of the modern as some of their collectors and patrons, would indicate that, although not limited to one group, the links and networks between collectors were there and were to be found among the new industrialists and bankers, those who were also concerned with reform and modernity.[114] Buying and supporting artists, collecting works at what were very low prices throughout the nineteenth century, was thus a statement of modernism as well as a possible investment. Being avant-garde could be said to have replaced taste as the criterion to judge the worth of a collection.

In fact, as has been shown, this is not new; however, the balance between aesthetic importance and monetary significance seems to have shifted with the widening market. As William Beckford complained in the early nineteenth century, he could not afford certain works that he desired because, with a rising market, there were too many competitors for him to acquire what he wanted at the price he was prepared to pay.[115] This is perhaps in contrast to collectors who were prepared to pay any amount they

[114] This is certainly true of Théodore Duret, critic and journalist, his friends Albert and Henri Hecht, Georges de Bellio, a landed Romanian who worked in Paris as a homeopathic doctor, Jean Dollfus, an industrialist, Charles Deudon and Charles Ephrussi. In spite of their different lifestyles, there is a common thread of standing outside the mainstream of Parisian society.

[115] Jeannie Chapel, 'William Beckford: Collector of Old Master Paintings, Drawings and Prints', in Derek Ostergard (ed.), *William Beckford: An Eye for the Magnificent* (New Haven and London, 2001), pp. 238–239.

were asked, where indeed the added value that they saw in collecting works of art was that the price itself was an expression of power.

Conclusion

In all the examples discussed, it can be argued that the collection itself is of value to its owner through its associations. The mechanism by which the owner associates certain values to his collection can derive from many cultural and social values. As described by Throsby, these are:

> ... aesthetic value, or properties of beauty or art shared in a culture; spiritual value or value to a religious group; social value, expressed in terms of identity and location; historical value, reflecting things as they were within a culture through time; symbolic value, as a purveyor of representational meaning; authenticity value, accruing to the original work.[116]

Equally the collection provides the owner with status, prestige or fame, either linking the collector through networks or separating him from others who cannot or do not wish to enter the field. The collector engages in the exchange of works through acquiring or disposing of works of art, which, when they take the form of gifts, places him in an exchange entirely based on values of status.[117] Once the exchange takes place in the market, then the collector pays for the work of art, with his judgement of what it is worth to him dependent on the many factors discussed in this chapter: issues of taste, connoisseurship or knowledge distinguish the collector or link him with those that he would see as his equals.[118] These 'added values' then determine the price fetched by a work of art. This seems to be a reflection of Michael Spence's signalling theory, in which he argues that precise economic benefits can result from the additional value accrued to non-quantifiable cultural or social considerations.[119] This

[116] David Throsby, *Economics and Culture* (Cambridge, 2008), pp. 28–29, quoted in J.P. Singh, *Globalised Arts: The Entertainment Economy and Cultural Identity* (New York, 2014), p. 26.

[117] See also the literature on gifts in anthropological discussion, beginning with Marcel Mauss, *The Gift: The Form and Reason for Exchange in Archaic Societies* (New York, 1954), pp. 66–83; David Graeber, 'Marcel Mauss Revisited', in *Towards an Anthropological Theory of Value: The False Coin of Our Own Dreams* (New York, 2001), pp. 151–228.

[118] Pomian creates a hierarchy in which money is at the lowest level and taste and learning are given higher status. In this, he follows Bourdieu's argument that taste is used to create distinctions between groups within society. Pomian, *Collectors and Curiosities*, p. 41.

[119] Michael Spence, *Market Signaling*, quoted in Nelson and Zeckhauser, *The Patron's Payoff*, p. 5.

is particularly apposite when the collection is associated with *magnificenza*, with power or status. During the Renaissance, owning works of art added to the power of the new rulers, who could show taste, but also demonstrate that they had the status to buy. Taste and connoisseurship added to the importance of authenticity on the market, as has been seen in the case of the attitude to the copy in early modern Europe. During the eighteenth century, as the market became increasingly international and open to a wider public, the acquisitions of the collector both reflected and established contemporary standards of taste. As the number of wealthy collectors increased, one motive for the newly rich industrialist or merchant was the visible demonstration of his ability to acquire the same works as his peers. On the other hand, status could be given to the collector for precisely the opposite reason, that he accrued status by acquiring works before they gained market value. Even this, however, is a reflection that increasingly the value was seen in its expected resale value, whether this was actually put to the test when the collection was sold or in the implied value when it was given to the public.

This chapter has of necessity left out various areas of discussion and can be nothing more than a preparatory sketch of a fascinating topic. Nonetheless, it is hoped that, by bringing together examples from different time periods, the values of the individual collector and the motives for his acquisitions can be placed in a wider time frame. Thus, if the over-riding value seems to be providing the collector with a representation of himself, the mechanisms or shifts in how these values are described take ideas from studies on art markets and apply them to the collector.

It would appear that a new form of value, marking the collection primarily in economic terms, appears at the point when the work of art has been turned into a commodity, when the price paid provides status and thus replaces – or at least is as important to the collector as – any other value he might give it. Where this transformation takes place needs to be further investigated, but during the nineteenth century it was visible in the accumulation and presentation of many new collections. Why it might have taken place seems to be a reflection of the values placed on art within the market, on the value of the price realized and on status reflecting wealth rather than magnificence. Can it be said that this reflects the changing types of networks, the widening of the market and the more public display of the individual? Or is it simply the power of the commercial world, when art becomes more obviously a form of investment, to be sold at the moment when, as a commodity, the price satisfies the needs of the owner? Nonetheless, as this chapter hopes to have shown, there is no point at which the European collector did not realize that, by acquiring works of art and displaying them as a collection, he was adding to his status and reputation; however, when that work was bought or sold, it had a price.

Index

A

Académie Royale de Peinture et de Sculpture, Paris 19–20, 151
advertisements 94–95
aestimatio 137–138 *see also* architectural estimates
Alberti, Leandro 217
Albrecht V of Bavaria 264
Aldovrandi, Ulysse 266
almanacs 203–205
Altare 228, 234, 235
amateurs 20, 114–115, 121–128, 163–165
Amsterdam 36, 46, 50, 52, 54, 269
Angelo Murano 216
'antique' 249
antiquities 261–264, 276
Antwerp 59–60, 61–62, 69n40, 70, 79–101, 84–85, 86, 87, 88, 90–94, 99, 101, 244, 251, 278
Antwerp silk 85
apprentices 39
apprenticeships 18, 172–173, 174, 195
architectural estimates 133–138, 143–145
Aretino, Pietro 218
art auctions 13–14, 23–24, 57–73, 103–130
art collections 117–118, 120–124, 127, 264, 282
art collectors 121, 123, 255–256, 257–260, 280–282
art dealers 59–60, 113–114
art dictionaries 68, 70
art exhibitions 115–116
art experts 116–117
art historical literature 68–70
art lovers 70, 114–115
art market 7–8, 15, 255–256

Art Sales Catalogues Online (ASCO) 106–107
art valuation 20, 67–70
artisans 11, 19, 34
artisanship 156–158
artist-friends 163–168
artistic autonomy 151–155
artistic emancipation 7–8
Ascension Fair, Venice 224
ASCO (*Art Sales Catalogues Online*) 106–107
auction catalogues 14, 58, 60–66, 72–73, 106–108, 115, 117, 119–121, 124–126, 280n108
auction houses 59–60, 104, 108–114, 115, 118
auctions 13–14, 23–24, 57–73, 103–130
Austrian Netherlands 57–73
authenticity 125–126, 246, 274–276, 278–279, 280n108
Averlino, Antonio 216

B

bargaining markets 268
Bellini, Jacopo 218n40
Berbie, Gerard 69n40
Bernardo Buontalenti 218
biographies of artists 161
Borghorst 48n48
Bouchardon, Edmé 165
branding strategies 23, 75–101
brands 35, 75–78, 82, 83, 100–101, 226–228
brass-makers 184, 188–189, 191
breakability 243
breit linen 38–47
bright-cutting 250

Britain 239–254, 280 *see also* London; Norwich
British Museum 267n56
broad linen 38–47
bronze urns 241
brotherhood of weavers 39–42, 44–53
Brueghel, Jan 278n97
Brueghel, Pieter 277
Brussels 61–62, 70, 103–130
buckle and button manufacturing 172–206
Buontalenti, Bernardo 218
button manufacturing 172–206
button-maker guilds 188, 193
buttons 179–188
Buzzi, Carlo 133–134

C

calculability 10
Cambrai 86
capitalism 1–2
cast engraving 177–178, 197–200
catalogues 14, 58, 60–66, 72–73, 106–108, 115, 117, 119–121, 124–126
Caylus, Comte de 162–163
ceramics 227n82
Charles I, King of England 270, 273n81, 276–278
Charles V, Holy Roman Emperor 266n50
children 258
China 241
civilization process 22
collecting 14–15, 166
collecting for knowledge 265–268
collections 117–118, 120–124, 127, 255–284
collectors 121, 123, 255–256, 257–260, 280–282
College of Engineers, Architects and Land Surveyors (Milan) 17, 133–134, 144–148, 162
colonial trade 12–13
coloris 160
comb numbers 43–44, 47–50

commercial directories 106
commodification 6, 10
commodities 28–29
commodity exchange 5
commodity fetishism 100
commodity markets 78–82
commodity marking 85–89
connoisseurship 272–275
conspicuous characteristics 84–85
consumer durables 15
consumer preferences 2–3, 4–5
consumer revolution 209–210
consumption 6, 21–22
convention of production 40
convention theories 8–10
conventions 13–14, 17, 136–138
conventions of art valuation 67–70
copies 275–278
craftsmanship 24, 27
credit 81–82
crieurs jurés 116
cristallo 213, 214–215, 216, 223
cultural practices 57–58
culture 1–2, 6
customs tariffs 201–203
cut steel 250n50

D

De Bolla, Peter 154n6
De Piles, Roger 67, 160, 271
Descamps, Jean-Baptiste 68–69
d'Este, Isabella 223–224, 268–269
Diderot, Denis 159–160, 167, 279
directories 106
directors of auction houses 117, 119
discursive shifts 58, 60–66, 72–73, 114
dissociated property 141
Douwe Egberts 76
drinking glasses 220–221
durability 243
Durand-Ruel, Paul 281
dyes 227

E

economic practice 3–8
economics of convention 8–10
ekphrasis 65–66
embroiderers 27, 177, 184, 186, 188–189, 195
enamelling 213–214
engravers 184, 188–189, 191
engraving 167–168, 177–178, 197–200, 250, 251–252
entrepreneurs 98–99
estate sales 103, 105, 107, 116
Este, Isabella d' 223–224, 268–269
estimates 133–138, 143–145
evocative value 251
excellence 192
exhibitions 115–116
experts 116–117

F

façon d'Altare glass 234n111
façon de Boheme glass 237
façon de Venise glass 211–237
Falconet, Etienne-Maurice 159–160
Farnese, Margherita 221
fashion 243–246
fashion magazines 203–205
Faure, Jean-Baptiste 281–282
Filarete 216
flint glass 237
fraud 35, 80
Frederick III, Holy Roman Emperor 221
free market economy 9, 15
French glass-makers 234–235
furnace owners 224–225, 233
furniture 88, 245–246

G

Galerie Saint Luc 118
Gersaint, Edme-François 67–68, 272
Ghent 60
gifts 1–2, 28, 164–165, 268–269

gilding 213–214
Gillot, Joseph 280
Giovanni da Udine 218
glass 24, 25, 27, 210–237
glass furnace owners 224–225, 233
gold and silver thread buttons 192, 194–196
goldsmiths 172, 177–179, 183–184, 186–192, 194–195, 200
Gonzaga, Vincenzo 221
Greek pottery 245
guild marks 86–89, 96–100
guilds 17–21, 27, 39n20, 152, 173, 174, 188–189, 193

H

hallmarks 173, 247–248
Harrison, William 222
hats 88
heirlooms 252–253
houses 135–136, 146
housing valuation 17

I

imitation 35
import substitution 12–13
impressionism 281–282
industrious revolution 5
information asymmetries 4, 18, 80–82
inland shipping 13
inspection of linen 37–38, 43–47
institutions 3–8, 10, 16–21
intellectual property 84n34
intrinsic value 27, 28, 139–140, 146–147, 247–249
investment 279–283
Italy 172–206 *see also* Altare; Mantua; Milan; Turin

J

jewellers 172, 175, 177–178, 184, 189, 194
journeymen 39

K

Kant, Immanuel 153
knowledge 265–268
kunstkammern 265–266

L

labelling of textiles 33–38, 40, 44–45, 47–50, 54–55
labour value 247–249
Lampe, Louis 122–123
Le peintre amateur (Mensaert) 68–69, 70
leather 88
legal context of real estate transactions 140–142
legge 36–38, 43–47, 51–52
leisure culture 59–60
Leonardo da Vinci 24
liberal arts 24–25
Liguozzi, Iacopo 218–219
linen production 13, 16, 36–43, 36–50
location of value 10–12, 41
locational rent 140
Lohnwerk 40
London 105
London cloth 84
Louis XIV, King of France 264
luxuries 5, 16, 18, 27, 172–174, 197, 209–212, 219–222

M

magazines 203–205
maiolica 214
Manet, Edouard 281
Mantua 230
Mariette, Pierre-Jean 165, 271
market devices 10–11
markets 1–2
marques 86–87
Marx, Karl 100
Massé, Jean-Baptiste 156–158
master marks 97–99
material culture 3–8
measuring 17
mechanical arts 24, 152
Medici, Anna Maria Luisa de' 264
Medici, Cosimo I de' 262–263
Medici, Ferdinand I de' 269
Medici, Francesco I de' 217–218
Medici, Lorenzo de' 262
Medici, Piero de' 262
medicine businesses 94
Mensaert, Guillaume 68–69, 70
mercantile expressions 64–65
merchant-entrepreneurs 98
metal alloy buttons 175, 178, 182, 189–190, 193, 196–199, 203, 204–205
metal objects 171–172
middlemen 23, 24, 89–95
Milan 133–149, 186, 190n56, 198, 199–200, 205, 216
models 159–160
modernism 282
Moggi, Giovanni 218
money 6
Morrison, James 280
Münster 36–50
Münsterisch linen 38, 49, 50, 51
Murano, Angelo 216
Murano glass *see* Venetian glass
museums 123, 264–265, 267n56

N

narrow weavers 46–47
natural history 266
negotiations 80–82
Netherlands 231–232, 280n108 *see also* Amsterdam; Antwerp; Ghent
Nieuwen almanach der konst-schilders, vernissers, vergulders en marmelaers 70
Northumberland, 1st Duke of 271
Norwich 244
notaries 116, 144
nude models 159–160

P

Packwood shaving blades 76
painters 7, 19–20, 24, 67, 157–164, 218, 271
paintings 14, 58, 64–66, 70–72, 103–130, 151–169, 264
paper 266
Paris 105, 112–113
Paris Academy 155n8, 160–162
patina 15–16, 239–254
patronage 261–262
Percy, Sir Hugh (1st Duke of Northumberland) 271
Peter the Great, Czar of Russia 269
Pevsner, Nikolaus 151, 152
Piles, Roger De 67
pinchbeck 190n56, 198
plane table 147
Polanyi, Karl 1–2
Poussin, Nicolas 166–167
Pozzo, Cassiano del 266
pragmatic turn 8–10
precious metals 172
prefaces of auction catalogues 106, 108, 114–115, 120–122, 126, 127
pre-industrial brands 77, 82
private exhibitions 115–116
privileges 174, 196–201, 228–231, 235
product diversity 79
product quality 4, 10–11, 18, 20, 22–23, 192–196, 200–201, 231–232
production markets 40–41
'product-producer' names 98
property values 142–143
proto-brands 77, 82
provenance 126, 274–275
public exhibitions 115–116
public pricing 79, 81
public sales 58–60

Q

quality 4, 10–11, 20, 22–23, 57, 192–196, 200–201, 231–232

quality control 41–43, 172–173, 177–178
quantification 15–16

R

real estate 17, 28, 133–149
recognizable goods 82–85
Remy, Pierre 272–273
Renaissance 24–27, 180, 210, 260–261, 276, 284
rental value 139–140, 146
Resta, Sebastiano 166
résumés 65–66
retailers 91–92, 95, 99
Reynolds, Sir Joshua 271
Richardson, Jonathan 67
road infrastructures 13
Rubens, Pieter Paul 97
rural industries 13

S

sales rooms 59–60, 104, 108–114, 115, 118
salesmen 95
salles de ventes 119
Salons 163
scholarship 267–268
Schweppes 76
sculptors 24
sculpture 152
second-hand dealers 60
semiotic socialization 57–58, 65, 70–73
serial production 41–42
Sforza, Galeazzo 262
Sheffield plate 244
shop design 94
shop signs 92–93
signs, systems of 5–6
silk buttons 193
silk manufacture 218n40
silver 239–240, 243, 245–254
silversmiths 248
silverware 16, 244, 246–254

sociability 162–168
social distinction 59–60, 219–222
social relations 1–2, 28
social status 142–143, 260–265, 268–269
southern Westphalia 48, 50–51, 53
Spanish wood 87
Spencer, John (1st Earl Spencer) 271
stamps of provenance 126
standardization 10, 23
status 142–143, 260–265, 268–269
steel buttons 190n58, 198, 204–205
studios 164
supply and demand 6, 13, 26, 57, 78, 209, 231
sworn criers 116

T

tableaux 167
tailors 184, 188–189
tariff tables 179
taste 269–273, 282
tavoletta pretoriana 147
tea urns 249–250
technique 164
textile labelling 33–38
ticketing of goods 79, 81
Titian 276–277, 278–279
tombac 198
toys 172
trade cards 94–95
trademarks 23, 82, 89–92
Tradescant, John 266
travel guides 68–70
trust 80–81
Turin 188, 189n55, 190n56, 192–195, 232n102

Tuscan tax tariff 201–203
'type-town' product names 83–86, 98, 99

U

Udine, Giovanni da 218
untransparent commodity markets 78–82
urns 249–250

V

value 1–29, 105, 255–257
Velthuis, Olav 57–58
Venerable Factory of the Dome (Milan) 133–134
Venetian glass 24–25, 211–237
Veronese 218
Versailles 264

W

Walpole, Robert 271
warranty marks 88
Watteau, Antoine 165
weavers 39–42, 44–53
weaving combs 43–44, 47–50
Wedgwood pottery 76
weights and measures 91n64
Westphalia 48, 50–51, 53 *see also* Münster
Wille, Johann Georg 167–168
window displays 93
workshops 139, 146
wrought silver 246–254
wunderkammern 14, 265–266

Y

yarn 42